asmp **Professional Business Practices in Photography**

asmp Professional Business Practices in Photography

SEVENTH EDITION

American Society of Media Photographers

Allworth Press

AMERICAN SOCIETY OF
MEDIA PHOTOGRAPHERS

Allworth Press books may be purchased in bulk at special discounts for sales promotion, corporate gifts, fund-raising, or educational purposes. Special editions can also be created to specifications. For details, contact the Special Sales Department, Allworth Press, 307 West 36th Street, 11th Floor, New York, NY 10018 or info@skyhorsepublishing.com.

15 14 13 5 4

Published by Allworth Press, an imprint of Skyhorse Publishing, Inc.
307 West 36th Street, 11th Floor, New York, NY 10018.

Allworth Press® is a registered trademark of Skyhorse Publishing, Inc.®, a Delaware corporation.

www.allworth.com

Cover design by Derek Bacchus
Interior design by Kristina Critchlow
Page composition/typography by Sharp Des!gns, Lansing, MI
Cover photograph by Arnold Newman. Photo courtesy of Getty Images.
 *"We don't take pictures with our cameras, we take them with
 our hearts and our minds."* —Arnold Newman
Arnold Newman, ASMP Member #181, was a unique and visionary master of the art of photography. He created and took to its highest form the genre of the environmental portrait. We are all in his debt not simply for his creative genius but also for his good business sense and courage.

LIBRARY OF CONGRESS CATALOGING-IN-PUBLICATION DATA
ASMP professional business practices in photography / by the American Society of Media Photographers ; [edited by Susan Carr]. — 7th ed.
p. cm.
Includes bibliographical references and index.
ISBN-13: 978-1-58115-497-9
ISBN-10: 1-58115-497-6
1. Photography—Business methods. 2. Commercial photography. I. Carr, Susan.
II. American Society of Media Photographers.
TR581.A86 2008
770.68—dc22
2008021021

Printed in the United States of America

Contents

Acknowledgments

This book has been made possible by a grant from the ASMP Foundation.

The American Society of Media Photographers, Inc. (ASMP) wishes to thank the following people who contributed to this book, the seventh edition of the ASMP's *Professional Business Practices in Photography.*

EDITOR: Susan Carr

ASMP EXECUTIVE DIRECTOR: Eugene Mopsik

ASMP GENERAL COUNSEL: Victor S. Perlman, Esq.

ASMP COMMUNICATIONS DIRECTOR: Peter Dyson

WRITERS, REVIEWERS, CONSULTANTS AND OTHER CONTRIBUTORS:

Richard Anderson	Steve Grubman	Stanley Rowin
Paul Aresu	Michal Heron	Ethan G. Salwen
Jay Asquini	Judy Herrmann	David Sanger
Lon Atkinson	Chase Jarvis	Jim Scherer
Kate Baldwin	Henry W. Jones, III	Aaron D. Schindler
Brian Beaugureau	Kim Kauffman	Barry Schwartz
Amy Blankstein	Richard Kelly	Jeff Sedlik
Leland Bobbé	Bruce Kluckhohn	Peter Skinner
Barbara Bordnick	Peter Krogh	Brian Smith
Lou Carr	Pamela Kruzic	Scott Taylor
Susan Carr	Paula Lerner	Mark Tucker
Lynne Damianos	David MacTavish	Emily Vickers
Leslie Burns-Dell'Acqua	Eugene Mopsik	Nancy Walker
Blake Discher	Victor S. Perlman	Jill Waterman
Rivaldo Does	Jeff Pflueger	Richard Weisgrau
Peter Dyson	Alan Rabinowitz	Elyse Weissberg
Paul Elledge	Robert Rathe	Shannon Wilkinson
Jim Flynn	Betsy Reid	Nancy E. Wolff
Steven Gross	Ken Reid	Colleen Woolpert

Introduction

Welcome to the seventh edition of the *ASMP Professional Business Practices in Photography*. This book represents contributions from a wide range of industry experts creating an unprecedented collection of insights and information on running a successful photography business.

The goal of this book is to provide you the tools necessary to build a sustainable and successful photography career. From pricing to marketing to needing an accountant, this book has the answers. The sections and chapters of this book are organized to provide a progressive and thorough overview of being a professional photographer, while simultaneously allowing you to look up a specific topic quickly. We hope it becomes your definitive photography business resource.

If you embrace the business challenges of this industry with the same enthusiasm you give to making photographs, you will succeed. On behalf of the many people who have contributed to this publication, I wish you the best in your career.

SUSAN CARR
Editor

THE BASICS

Understanding Licensing

"Images are the intellectual property of the creator, but for that property to generate income, photographers have to know their production costs, the value of their work, and the value of the usage their client is licensing."
—Susan Carr

Industry Overview

UNDERSTANDING LICENSING—THE KEY TO BEING A PROFESSIONAL PHOTOGRAPHER

by Susan Carr

Susan Carr specializes in architectural photography and has served commercial clients for more than twenty years. Her work is exhibited widely and is included in corporate and private collections, most notably the Pfizer Corporation and the Museum of Contemporary Photography. Susan was president of ASMP from 2004 to 2006; she lectures and writes on the business of photography and continues her work for ASMP by coordinating educational events, including the Strictly Business 2 conferences. *www.carrcialdella.com* and *www. susancarrphoto.com.*

———————————— • ————————————

The following text was adapted for use in *ASMP Professional Business Practices in Photography* from the Licensing Guide published by the American Society of Media Photographers at *www.asmp.org/licensing.*

MOST PHOTOGRAPHERS GO INTO BUSINESS FOR THEMSELVES BECAUSE THEY ARE passionate about making pictures—not because they want to be in business. The irony is that photographers who do not learn and implement sound business practices will not be able to continue photographing professionally.

Images are the intellectual property of the creator, but for that property to generate income, photographers have to know their production costs, the value of their work, and the value of the usage their client is licensing.

This section provides an overview of the professional photography business and outlines a practical methodology for licensing images—the key to a successful and sustainable photography career.

CATEGORIES OF PHOTOGRAPHY USE: COMMERCIAL, EDITORIAL, AND RETAIL

The business of professional photography is broken into three main categories of use.

Commercial refers to photography that is used to sell or promote a product, service, or idea. *Editorial* refers to photography used for educational or journalistic purposes. *Retail* refers to photography commissioned or purchased for personal use.

The difference between these categories is not in the type of photography but in the use of the images. For example, a corporation hires a photographer to document a product launch event. For the corporation, the type of photography being commissioned is event coverage, and the use is *commercial* because the corporation will use the photographs to promote its new product. For a local newspaper covering the same product launch, the use would be *editorial*.

An example of *retail* photography would be a wedding, which is also event coverage—but now the work is categorized as *retail* because the end use is personal.

While some photographers concentrate in one of these three areas, it is not unusual for a photographer to work in multiple arenas, making it imperative to understand the business practices and pricing structures of each.

Commercial, editorial, or retail: photographs are intellectual property. Unless the photographer is an employee or has contractually transferred ownership, the creator of an image is the owner of this property. Licensing this property for specific uses is how your business generates gross income.

COPYRIGHT PRIMER

The ASMP's Copyright Tutorial (*www.asmp.org/copyright*) is a concise and thorough handbook on copyright for the photographer. This tutorial outlines why it is important to register your images with the copyright office and shows you the easy steps involved.

Copyright is the legal bedrock upon which your photography business is built. It gives you the sole right to decide who can use the work you create. These simple basics will change the way you think about your images.

- **You create it, you own it.**
- **Any person or business must have permission (a license) from you to publish (reproduce) your images in any medium, whether physical or electronic.**
- **You do not have to register your work with the copyright office to acquire your copyright.** However, the legal protections available to the copyright holder are limited if the photographs are not registered. Those limitations can translate into lost income.
- **Your name and/or the copyright symbol do not have to appear on or next to your image to have copyright protection.** There are practical business reasons for labeling your work, but you do not lose your rights if that label is removed or was never present.

Exceptions to these copyright truths:

- **Work Made for Hire (W.M.F.H.) Agreements** (sometimes called "Work for Hire")—These agreements state that the copyright to any work created for a specific project (as outlined in the contract) belongs to the commissioning party—*not* the creator of the images. Photographers who sign a "Work Made for Hire Agreement" supplied by the client relinquish their rights to the photographs and any future income from those photographs.

 Even when photographers specify the usage rights, it is not unusual for clients to attach W.M.F.H. agreements to purchase orders and editorial contracts, so read carefully any document you are asked to sign.

 The term "Work for Hire" gets used freely, but the legal definition is very specific. For complete information on this complicated topic, go to the ASMP's copyright tutorial (*www.asmp.org/commerce/legal/copyright/wfh.php*).
- **Employees**—If you are an employee, your employer most likely owns the copyright to the images you create as part of your job description and duties. Check your employment contract to be sure or, in the absence of a contract, speak to the Human Resources Department or an attorney.
- **Transfers of Copyright**—If you sign a transfer of copyright, you relinquish all your rights to the specific photographs designated in the agreement. Without the new owner's permission, you cannot display or use the photographs in any way.

WHAT IS A LICENSE?

PLUS introduction: The Picture Licensing Universal System (PLUS) is a nonprofit initiative created to help users and creators clarify and standardize the image licensing process. The first component of the PLUS initiative is a glossary of terms available on-line at *www.useplus.com/useplus/glossary.asp*. The ASMP supports PLUS and encourages photographers to use the PLUS glossary when writing licenses.

PLUS defines licensing as: "A legal agreement granting permission to exercise a specified right or rights to a work, often encompassed in an invoice, or the act of granting same."

You own the rights to your images and by means of a contract, you license specific rights to the client that wants to use the photographs. The client paying for this license does not have the right to use your images beyond the scope of the agreement.

WAYS TO OBTAIN A LICENSE TO USE PHOTOGRAPHS

Warning box—Model and property releases may be necessary for you to license a particular image. Go to section 6 for details.

There are two ways for clients to obtain a license to use images: by commissioning a photographer to fulfill a specific request, commonly called *assignment photography*, or by licensing the use of an existing image, known as *stock photography*. Many photographers license their images in both ways, and much like the three types of uses discussed above, each has distinct business norms of which you need to be aware.

Assignment photography is primarily a service business that creates photographs. Assignment photographers are predominantly independent photographers hired directly by the end user or by a representative of the end user, like an advertising agency or design firm.

ASMP has one of the oldest and most trusted searchable databases, *www.findaphotographer.org*, enabling potential clients to find assignment photographers based on specialty and/or location. Any General member can have a listing, with portfolio samples, in this database.

Stock photography is a commodity business, dominated by a handful of large distributors, each selling photographs that already exist. These companies license photographs they own through Work Made for Hire agreements (keeping the entire fee), or license photographs they represent (paying royalties back to the copyright owner).

WAYS TO LICENSE PHOTOGRAPHY

Assignment

A photographer is commissioned to fulfill a specific request.

Assignment photographers are predominantly independent photographers hired directly by the end user or by a representative of the end user.

Stock

Licensing the use of an existing image.

Vehicles to license stock photography:
- *distributors*
- *portals*
- *independent photographers*

Categories of Use Being Licensed

Photographs licensed through assignment or stock fall into one of these three categories of use.

Commercial

Photography used to sell or otherwise promote a product, service or idea.

Examples

Paid media advertising
- *print advertising*
- *billboards*
- *web advertising*

Corporate
- *public relations*
- *annual reports*
- *product packaging*
- *web sites*
- *brochures*

Business to business
- *brochures*
- *web sites*
- *product packaging*

Editorial

Photography used for educational or journalistic purposes.

Examples

Editorial content in
- *magazines*
- *newspapers*
- *on-line news sources*

Textbooks

Encyclopedias

Retail

Photography commissioned or purchased for personal use.

Examples

Weddings

Senior portraits

School portraits

Posters

T-shirts

Greeting cards

Fine-art prints

Independent photographers can also license their images directly to clients—without going through a distribution company—retaining the entire fee. There are increasing numbers of services designed to enable creators to market—and in some cases, price—their own stock images. ASMP offers a member service (*www.findaphoto.org*) and has member discounts available through two portal services, the Independent Photographers Network and Digital Railroad.

TERMS YOU NEED TO KNOW
The source for these definitions is the PLUS glossary.

- **Buy Out**. An imprecise term used to describe acquisition of broad usage rights to a work, sometimes in a particular market or medium.

 Buy Out is a slang term, often misinterpreted as a transfer of copyright ownership of a work from the copyright holder to the client or client's agent. In the absence of a specific copyright transfer agreement executed by the copyright holder, there is no copyright transfer. If this term is used, an additional, precise list of rights granted or transferred should accompany any license.
- **Creative Fee**. A charge by a creator for his or her efforts to complete a project, which is not based on time alone. Factors may include compensation for trade experience and special capabilities, or for any creative effort, contribution or process required to complete a project.

 Note: Some photographers separate Creative fees and Licensing/Usage fees while others combine them into one number.
- **Exclusive License**. A privilege that, when granted, limits how a copyright holder (and other parties permitted) can offer a work to a third party for reproduction.

 An exclusive license may be broad or specific. The rights granted may provide the licensee with exclusive rights to use a work singly or in any combination of: a specified media, industry, territory, language, time period, product and any other specific right negotiated by the licensor and licensee.
- **Flexible License Pack**. A license model permitting the use of one or more images in multiple media without requiring individual license fees for each image or use.
- **License Fee**. The price charged by a licensor to a licensee in exchange for a grant of rights permitting the use of one or more images in a manner prescribed in a license. A variety of factors, such as circulation, the size of reproduction and specific image qualities affect the determination of a particular license fee.

RETAINING CONTROL OF YOUR IMAGES

Work to retain control of your images! This chart shows you the potential for income an image can have. The stock licenses illustrated below are only possible if you retain the © to your work, your paper work is in order and proper releases are executed.

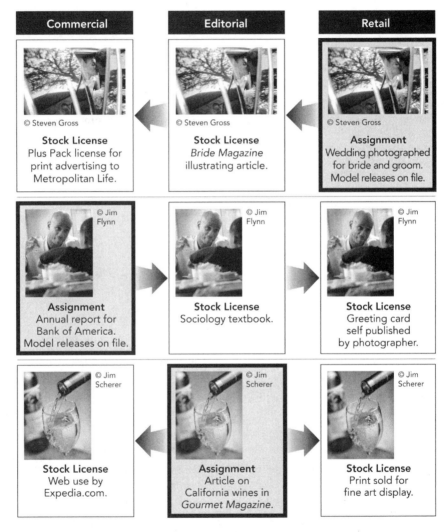

Commercial

© Steven Gross

Stock License
Plus Pack license for print advertising to Metropolitan Life.

Editorial

© Steven Gross

Stock License
Bride Magazine illustrating article.

Retail

© Steven Gross

Assignment
Wedding photographed for bride and groom. Model releases on file.

© Jim Flynn

Assignment
Annual report for Bank of America. Model releases on file.

© Jim Flynn

Stock License
Sociology textbook.

© Jim Flynn

Stock License
Greeting card self published by photographer.

© Jim Scherer

Stock License
Web use by Expedia.com.

© Jim Scherer

Assignment
Article on California wines in *Gourmet Magazine*.

© Jim Scherer

Stock License
Print sold for fine art display.

The images used here are for illustration purposes only. We thank the photographers who generously donated the use of their images for this illustration.

- **Non-exclusive License**. A grant of rights issued by a licensor to a licensee that does not preclude the licensor from granting the same rights to other licensees. Unless otherwise negotiated, licenses are non-exclusive.
- **Postproduction**. Everything that happens to a visual work after production, typically after images (either still or moving) have been recorded to film or digital media. Postproduction might include editing, color correction, etc.
- **Preproduction**. Work on a project or job that is related to preliminary preparations. Includes all planning and the making of any arrangements necessary to enable or facilitate final production. Typically billed as time plus any costs expended.
- **Production Fee**. A charge related to the preparation, planning, setup, props and styling, gaffers, grips and assistants. After production, it is related to post-processing and delivery.
- **Unlimited Use**. A broad grant of rights that permits utilization across all media types and parameters. Can be restricted in any usage type or parameter, singly or in groups; can include all uses, all media, all time.
- **Usage Fee**. A charge made for a work to be shown in a specific media, based on terms in a license or contract agreement.

THE POWER OF LICENSING

Work to retain control of your images! The chart on page 9 shows you the potential for income an image can have. The secondary (stock) licenses illustrated below are only possible if you retain the copyright to your work, your paperwork is in order, and proper releases are executed.

When a photographer is commissioned to do a project, the paperwork—estimate, assignment confirmation, and/or the final invoice—should all contain the "license" being granted for the agreed upon price. Even if you are granting very broad usage to a client, that usage is a "license" and should be treated as such.

The licensing terms for a given assignment are a valuable tool when negotiating price. Clients will frequently ask for more rights than they need and, if their budget is lower than your price for the job, limiting the rights of use is something you can offer as a way of cutting their costs. If broad rights, particularly exclusive rights, are critical to clients, you can negotiate a higher fee due to the extreme use. Listen carefully and be flexible because licensing your work is a powerful tool.

Here are some examples that illustrate the importance and power of licensing your work and retaining your copyright:

A photographer is hired to photograph a building for the owner of that building. The images are licensed for very broad use, allowing the owner to market the rental spaces available in a variety of media. The license clearly defines that the rights are granted only to the building owner. A month later, the architect approaches the owner about obtaining some of the photographs for her Web site. The owner, because the terms of use were clearly defined, correctly refers the architect to the photographer, who is able to generate income from these existing images through a new license to the architect.

A photographer is commissioned by a trade magazine to photograph a corporate CEO for an editorial piece on the company. The publication licenses one-time North American print rights and editorial World Wide Web use exclusive for six months. A year after the project the CEO is indicted for fraud and pictures of him are in great demand. The photographer is able to re-license this portrait many times over in various editorial outlets.

How to Price Professional Photography

by Susan Carr

The following text was adapted for use in *ASMP Professional Business Practices in Photography* from the Licensing Guide published by the American Society of Media Photographers at *www.asmp.org/licensing.*

ANY CONVERSATION ON PRICE HAS TO BEGIN WITH THE FACT THAT NO PHOTOGrapher is working in a bubble. Business location, the state of the economy, and the prevailing fee structure for a specific type of photography are all factors in what photographers will be able to charge.

What the market will bear plays a key role in pricing photography.

Some examples:

- A photographer working in a metropolitan area will have higher expenses and production fees than his small-town counterpart. The basic costs of running a business—studio rental, models, transportation, food, and assistants—is simply higher in a city.
- A photographer in a remote, less-populated area, hired by a national magazine to cover a local story, will likely be able to demand higher fees than his city counterpart simply because the editor has fewer options. The lack of competition gives the remote photographer an advantage.
- A photographer working in an area where the economy is based on manufacturing has likely seen fees stagnate and even drop, while a photographer located where the dominant industry is healthcare or technology has fared much better. Economic conditions will affect what can be charged.

HOW CAN THE SAME IMAGE HAVE DIFFERENT LICENSING FEES?

Photographers price their work based on the creative and production needs of each project, in combination with the specific use of the images. In other words, the exact same image can cost different amounts, based on what is needed by different kinds of clients.

For instance: a photograph of a coffee cup in a nice setting with a book and some flowers. One-time editorial rights in a regional magazine would cost significantly less than a nationally run ad for a large coffee house chain. The creative and production requirements for the assignment are identical, but the use is dramatically different.

Most likely—for the same image—the editorial use would be billed at a fraction of the advertising rate. The use was the primary factor in determining the fee.

AND WHAT ABOUT PRODUCTION COSTS?

Production needs can vary greatly as well. Is a permit needed to shoot in a specific location? Are assistants needed? Will special props need to be selected, or will you use what is on-site? Are you lighting to document the subject or create a mood? Is an extreme time of day needed to pull the image off successfully? All these and more must be considered when pricing the production end of any assignment.

Putting this idea in real terms, take that same coffee-cup image above and add these parameters: the client requires that the location be a specific outdoor café, at dusk; specific furniture must be used that is different than the style used by the café; it must look like it just rained; and the café must contain lots of fresh flowers and no people.

These requirements turn this photograph into a high-production image; therefore the cost should reflect these detailed demands. Regardless of use—editorial or commercial—the cost of this image just increased significantly.

Usually, but not always, a project with high production expenses will have higher usage fees. This is simply practical since few clients want to pay for elaborate sets, models, or props unless the image is going to be used extensively. Generally, a client's early production requests are an indication of her overall budget. For instance, if the client answers every production-related question with, "No, we will just shoot what is available when we get there," you have just been given a tip that the budget is small.

Production questions answered with "We don't know yet" means you will not be able to accurately quote the job. You can offer ranges or a best-estimate, but it's critical to your bottom line that all numbers be qualified on your paperwork (estimate) to cover this lack of information.

The ASMP Paperwork Share, available at www.asmp.org/licensing. Photographers helping Photographers is a grand tradition of the ASMP. Due to antitrust laws, ASMP cannot set or suggest prices, but we can share information provided to us by our generous members. The ASMP Paperwork Share provides a look at the terms, licenses, and pricing details of actual jobs. More than fifty assignment estimates and invoices, representing a variety of clients and types of work, are available for review.

STEPS TO DETERMINE LICENSING FEES

This process may initially feel daunting, but, with a little patience, once you have calculated the fees for a few projects and/or stock licenses, you will develop the skills and experience to get through this process efficiently and with confidence.

1. CREATIVE FEE

Use your Cost of Doing Business (C.O.D.B.) as the starting point. You must know your own C.O.D.B. You need to know your own minimum income needs to cover your non-reimbursable business expenses and draw a salary. Once you know your own minimum, you can factor in the specifics of a given job, what you bring to each project that is unique, and what you want for profit, to determine your creative fee.

Your C.O.D.B. + the unique quality you bring to the job (the price you put on your creative work) = the creative fee.

Your C.O.D.B. is easy to calculate.

Non-reimbursable expenses + desired salary = your total annual overhead/ number of billable days = your C.O.D.B.

Do not confuse non-reimbursable expenses with expenses you bill to a client for a specific project. Non-reimbursable expenses are the costs of running your business. Examples include rent, computer, phone, Internet access, insurance, equipment purchases, office supplies, repairs, utilities, server hosting fees, accountant, bookkeeper, taxes, depreciation, replacing equipment, and saving for retirement.

Desired salary. Most of us, naturally, want this number to be as high as possible, but it is important to be realistic and practical. Base this number on a small increase in your salary from the prior year or, if you are starting out, put your salary in at a level that can support your current cost of living.

How to determine your number of billable days? Again, be realistic. Most assignments need pre- and postproduction time, plus you need a vacation, and

few projects are scheduled around the holidays. Right off the bat, there are only forty-four to forty-eight weeks a year to consider. Then, depending on the type of photography you are doing, you can bill only one to three days per week. Few photographers will do more than this. Look at past years or, if you are doing this for the first time, talk to fellow photographers. Remember, you need to allot time for marketing, portfolio development, and administrative work. These are all critical to your business, but they are not billable days.

Once you have your C.O.D.B. calculated, you know your minimum fee for any billable day. Going below your calculated C.O.D.B. means you are losing money. Naturally, some business common sense has to be considered. For example, an editorial assignment may be a good business decision, even though the pay scale is lower than commercial work. A particular assignment may offer you access to people and places you want to photograph, an opportunity to produce a great portfolio piece or additions to your stock library. You cannot, however, take repeated jobs that fall below the C.O.D.B. without getting into financial trouble. Like any business formula, it is necessary to be flexible and smart.

The intangible addition to your creative fee—creativity! Add the C.O.D.B. to the special talents or services offered for a specific job and that total becomes the creative fee for this particular project. Your C.O.D.B. will stay relatively consistent, but the creative needs of each assignment will vary dramatically. This is why one creative fee does not fit all jobs.

Here is a sampling of items to consider when arriving at your fee. If any of them are critical to the successful execution of the job or important to the client, they should increase the fee. All these things have value and should be reflected in the price.

- Tight deadline
- Specific style
- Creative solutions needed (looking for conceptual input)
- Expectations of high-end service (catering lunch rather than McDonald's)
- Logistical difficulties (a factory that cannot stop production or a mountain to climb)
- Experience
- Extreme limits on subject availability (like two minutes with the CEO for a portrait)
- Technical expertise
- Geographic location
- Reputation

2. THE USAGE OR LICENSING FEE

What is the client going to do with your photograph? The more the photograph is used, the higher the usage fee. Is the use commercial, editorial, or retail? Is the client looking for a package of rights or a single use?

Typically the larger the audience for a specific use the higher the usage or licensing fee. For example, a photograph used in a print and Web ad campaign for a consumer product would have a much higher licensing fee than a photograph used in a business-to-business company brochure. The former has an audience in the millions, the latter perhaps a few thousand.

More Use = Higher Fee. Remember that the licensing fee of your overall price is not affected by how difficult the photograph is to execute or what the production expenses are. Those issues are calculated elsewhere. This fee is all about the use by the client. It is possible for a photograph, executed with minimal expenses or expertise, to generate an extremely high licensing fee. The point here is the use, *not* what it took to create the image.

There is no one true way to structure your fees. Some photographers separate creative fees and licensing/usage fees while others combine them into one number. Develop a system that feels comfortable for you and, most important, one that you can articulate clearly when talking to clients.

3. PRODUCTION NEEDS OF THE JOB—THE EXPENSES

Carefully add it up. Ask lots of questions and make sure all the details are covered. Once you accept a job at an established price, you will rarely be able to increase the expenses with the excuse, "I didn't think of that."

Always remember that each job is unique and you must ask lots of questions. Make no assumptions when pricing a job. Even if you are not in doubt about a detail, ask and confirm it. With practice you will find that you are frequently reminding the client what is needed or taking care of a detail he didn't even consider and, in the process, you are instilling confidence. If you are questioned about all your questions, assure the client that this is the only way you can provide him numbers that are realistic. You ask the questions now to make the assignment run smoothly and stay on budget.

Expenses are typically billed with a mark-up. This is a customary and expected business practice. When preparing your estimate, make sure you add the mark-up to quotes you are given from vendors.

As a professional, you would be well advised to set established charges for expenses that are consistent—a Web gallery or FTP delivery, for example. You should also evaluate those charges annually and adjust as needed.

Here is a partial list of possible expenses for a photography assignment.

- Equipment rental
- Digital processing fee
- Proofs/Web gallery
- Retouching
- Master digital file
- Repurposed digital files
- Prints
- Archiving
- CD or DVD
- FTP
- Assistant
- Models
- Casting director
- Wardrobe, prop or food stylist
- Hair and/or make-up artist
- Location scout
- Carpenter
- Set designer
- Props—purchase/rental
- Background
- Location rental
- Wardrobe
- Catering
- Trailer rental
- Permits
- Hotels
- Airfare
- Mileage/tolls/parking
- Car rental
- Customs/carnets
- Gratuities
- Meals
- Tips
- Miscellaneous supplies (for example: tape, bulbs, gels)
- Messengers
- Shipping

Photographers differ on how they illustrate their pricing to clients. Some separate fees and expenses, a few show every cost itemized, and others give one total price. Regardless of how you break your price out in an estimate, it is critical that you calculate your price considering all three of these distinct fee areas.

4. KNOW YOUR MARKET

You must learn what price your market (or the market a particular project is in) will bear for the specific type of work you are pricing. Consider not only geographic and economic conditions, but also the standard for a particular level and/or kind of work. For example: Advertising pays more than editorial, and annual report photography pays more than event coverage.

General economic condition of the area you are working in. Read the news. Seriously, pay attention to the business environment you are working in. National and regional business publications (most are both in print and online) are a great resource. You need to focus on the local economy if the photography will only be used locally and, conversely, if you are working for an international company where the use is global, you need to pay more attention to the specific industry's current economic climate.

Research to gain valuable insights on the client. The Internet is a savior in this area. You can learn a great deal by simply doing an Internet search of a company name. This should be your first stop when someone calls asking for a quote. If it is a third party calling, ad agency, or graphic designer, make sure you get the name of the ultimate client. You can research both the party calling you and the end user. Frequently, when hired by a third party, you will be billing that agency or design firm, so it is important to know the legitimacy of its business, too. The client actually using your images, however, is the primary consideration when determining your price.

The client's Web site can tell you:

- How much photography does it use?
- Is the photography on the site professionally done?
- What is its preferred style; are you a good fit?
- How well designed is the site?
- What does the client do or sell?
- How large or old is the client?
- Where is the headquarters?

Then look for other sites that mention this business. Look for:

- Customer reviews
- Articles about the company
- Financial information if publicly traded

Research the industry practices for a particular kind of work. The photography industry is made up of various strata of work. For example, the following project types each have distinct client expectations and pricing norms.

- Story for a national consumer magazine
- CEO portrait for a trade magazine
- Event coverage for a corporation
- Architectural photographs for the architect
- Product illustration for the manufacturer
- Packaging photograph for a consumer product
- Annual report photography for a Fortune 500 company
- Advertising photograph for a consumer product

Fellow photographers are your greatest resource for appropriately evaluating where a particular job falls on the spectrum of service and price.

Review the ASMP Paperwork Share at *www.asmp.org/licensing.* Members have generously allowed us to post the terms and pricing for actual jobs, giving you access to a variety of real-world pricing examples.

Build a personal network you can rely on. Finding peers who will give you candid and honest information takes time, but it is an essential ingredient to understanding your market.

Your ASMP membership gives you access to fellow photographers over a wide geographic reach. Using ASMP's *Find a Photographer* database, *www.findaphotographer.org*, you can locate members doing the same type of photography and with similar types of clients. By contacting a photographer not in your own backyard, you immediately eliminate the fear of competition factor that sometimes makes it tough to share information. It is best to approach a peer with a specific question. For example, "I am _____, a fellow ASMP member in _____. I am struggling with pricing a project. Based on your Web site, I think you do this type of work. Can I give you the details of the project and get your feedback?"

By immediately offering to share the details of your job, you will gain a photographer's trust. If you are not willing to share this information, do not expect any candid help or guidance. This technique is particularly helpful when you find yourself quoting a job that is a step up for you. Say you have been doing brochure work for a company and this client asks you to quote an

advertising assignment. If you have never priced advertising, you need to call a fellow member who does this all the time. It is in her best interest to help you since she does not want advertising work to be devalued.

Not every photographer is open to this kind of networking, but if you get a cold shoulder do not despair. Simply call someone else. Most photographers join ASMP to be part of a community and want to help. Just like pricing a service you need for your home or making a financial decision, it is best to get more than one opinion. And remember to return this favor when those starting out come to you.

Participate in your ASMP chapter and other industry-related events. Social settings are frequently the most advantageous for getting quality information on the specific business climate of your city, region, or client industry.

Industry listservs can be amazing resources literally at your fingertips. Specialty listservs are particularly helpful for finding relevant answers. Listservs can be a challenge because you will read various, and often conflicting, opinions and answers to any given business question. Questions that have more clear-cut answers are best researched through qualified educational sites. For example: How do I register my copyright? Or, when do I need a release to license this image? These are best answered through ASMP's online modules.

More and more industry blogs are available all the time. You can learn a lot from these sources, but, like the listservs, be smart and remember they are equivalent to reading the editorial page of any newspaper. The opinions offered up by others can help you build your own unique answers for your business, but nothing in this business is one size fits all.

Use these four factors and calculate your price on a job.

1 + 2 + 3 (adjust for 4) = Price

Creative fee + Licensing fee + Expenses (adjust for the market) = Price

Warning: If you discover that your cost of doing business is dramatically higher than the prevailing fees charged for the type of photography you want to do, you must reevaluate your business plan. Either change your overhead and salary goals or change the type of photography you are doing. There is no way to build a sustainable business if these two financial aspects are consistently out of sync.

Most photographers do not engage in "lowball" pricing on purpose. More often, pricing that is out of sync with the prevailing norm for a particular type of work is the result of ignorance. Educate yourself and price to build a sustainable and successful business.

How to Write a License

by Jeff Sedlik

ASMP member Jeff Sedlik is a commercial photographer of twenty-five years experience. Clients include Nike, FedEx, Sony, AT&T, Blue Cross, Paramount Pictures, Microsoft, Toyota, MTV, Bank of America, and many others. Sedlik recently served as president of the Advertising Photographers of America and now serves as president of the PLUS Coalition. Sedlik also provides expert witness and consulting services in matters related to professional photography. A recipient of the 2005 International Photography Council's Industry Leadership Award, Sedlik was named 2006 Photography Person of the Year by PhotoMedia and 2007 Photography Industry Advocate of the Year by APA. *www.sedlik.com.*

———————————— • ————————————

LICENSE DESCRIPTIONS ARE USED IN ESTIMATES, INVOICES, PROPOSALS, CORRE-spondence, and other documents to communicate the scope of usage allowed for a particular image or group of images. An image license typically defines a grant of one or more of your exclusive rights under copyright law: to reproduce, distribute, transform, display, and/or perform your photographs. In granting a license, you are the "licensor" and your client is the "licensee."

In describing a license, the goal is to:

- Grant (or offer to grant) your clients an agreed scope of usage, permitting only specified usages, while constraining all other usages.
- Ensure that your clients and others reading the license will precisely understand what they can (or cannot) do with your photographs.
- Protect your photographs from unlicensed usage.

A license description should include the parties, permissions, constraints, requirements, conditions, image information and other relevant information. The wording should be clear and concise. If you are not an attorney, don't try to write like one. Just state the information in simple terms, to communicate the image usages that you are offering to grant to your client.

While it is common to write a license description in paragraph form, the accuracy of such descriptions relies entirely on a photographer's ability to structure sentences in such a way as to permit only certain usages. This might seem easy, but accurately representing a license in paragraph form can be challenging. In such descriptions, misplaced punctuation or swapping *and* for *or* can have a very significant effect on the rights granted. The interpretation of such paragraphs by clients is highly subjective and can lead to misunderstandings that can destroy client relationships and even result in unintentional infringement.

To address this issue, the ASMP and other associations representing photographers, illustrators, ad agencies, designers, publishers, museums, libraries, and educational institutions formed the PLUS (Picture Licensing Universal System) Coalition to develop international standards for the communication of image licenses. By using PLUS terminology to describe your licenses, you will allow your clients to rely on standard definitions approved for use by all industries.

We recommend that you write your license in list form, rather than in paragraph form. This method will minimize misunderstandings, allowing anyone to easily read and understand the allowed usages of your images. The PLUS standards define numerous fields for your use in writing image licenses. We provide examples and recommendations below.

THE PARTIES
When defining a license, it is important to establish the names of the relevant parties. These typically include the licensor (the party offering the license), the licensee (the party receiving the license), and the end user (the party that will ultimately use the image).

MEDIA PERMISSIONS
This is the central element of the license description. It is an accurate description of the media in/on which you will permit your client to use the image, and the extent to which your client may use your image in that media.

- **Media:** Describe the category/type of media in which your image may be reproduced. Example 1: *Consumer magazine advertisement.*

- **Distribution format:** State the format in which the specified media may be distributed. Example 1: *Printed*. Example 2: *Electronic download.*
- **Placement:** State the locations/positions at which your image may appear in/on the specified media, and state the maximum number of placements permitted in each instance of that media. Example 1: *Single placement on the front cover.* Example 2: *Multiple placements on cover and interior.*
- **Size:** State the "image size"—the maximum size at which the image may be reproduced in/on the specified media. Example 1: *up to one-half page.* Example 2: *up to 8½" × 5½".* Where applicable, also state the "media size"—the maximum size of the media on which the image may be reproduced or the maximum size of the reproduction of the design in/on which the photograph is reproduced in/on the specified media. Example 1: *full page.* Example 2: *8½" × 11".*
- **Versions:** State the maximum number of design versions, editions, or issues in/on which your image may be reproduced. Example: *First edition only.*
- **Quantity:** State the maximum number of reproductions of your image that may be distributed or displayed in the specified media. This may be stated as the total copies distributed or displayed. Example 1: *10,000 brochures.* For magazine or newspaper advertising, multiply the number of insertions of the advertisement times the circulation of each magazine in which the advertisement will be inserted. Example 2: *Total circulation of 850,000.*
- **Duration:** State the scope of the time period during which your client may exercise the license. Example: *Six months.*
 Region: State the geographic locations in/to which your image may be distributed or displayed in/on the specified media. Example: *Philadelphia only.*
- **Language:** State the language/s of text that may be reproduced in the specified media in/on which your photograph is reproduced. Example: *English only.*
- **Exclusivity:** State the exclusivity provided. Example: *Non-exclusive.*

CONSTRAINTS

In addition to listing the media permissions, also describe any limitations that further constrain your client's right to use the image within the stated media.

- **License start date:** The date on which the license commences. This is different than the duration and must be stated separately. It is among the most important and critical elements of your license description.

- **License end date:** The date on which granted rights expire. The license start date plus the duration equals the license end date. It should be stated separately from the duration and license start date, leaving no ambiguity.
- **Media constraints, region constraints, product/service constraints, if applicable:** Specific limitations on or exceptions to the licensed media. Media example 1: Sports Illustrated *only*. Media example 2: *Only at the following URL: www.acmedeoderant.com/specialoffer.* Region example: *Only in South Pasadena.* Product/service example: *Only for Acme Deodorant.*

REQUIREMENTS

State any requirements or obligations that are placed on your client under the license. Examples include a credit line requirement and the credit line text.

CONDITIONS

State any additional terms and conditions applying to the license. We suggest that you copy the ASMP terms and conditions onto the back of your estimate or invoice documents, or include them as an additional page in electronic versions of those documents.

IMAGE INFORMATION

One of the most critical elements of any license description is the description of the image or images that are associated with the license. Without a stated quantity of images, your client may assume that the license allows usage of all images captured. The license description should precisely define or identify the quantity of images that may be used under the license. When you are generating a license description for a stock image invoice, this is a simple matter. However, describing a proposed license on an estimate for commissioned work that has not yet been created can be more challenging. Under some instances, a client may not know the exact quantity of images that might be used. In that case, determine an approximate and mutually acceptable maximum quantity of images, and state that maximum in your license description. If you then proceed to create additional images that the client finds valuable, he may later license those images separately. In the image information of your license description, describe the quantity of images included in the license, and where applicable describe the images by image title and/or image file name.

LICENSE INFORMATION

It is often helpful to note the transaction date, the client's purchase order number, and other relevant information on your invoice.

ADDITIONAL TIPS

ABOUT DURATION

The duration of your license is a window of opportunity during which your client has the right to make use of your image under the license. The extent to which your client elects to make use of the licensed rights during that period is entirely up to him. When the license expires on the end date, your client cannot continue to reproduce, distribute, display, transform, or perform your images, unless he acquires additional licensed rights. If during the license period your client elects not to make use of the images or elects to make use of only a portion of the rights granted, this is his choice, and has no bearing on the license fees paid by your client to you. For this reason and others, it is essential that you state a duration, start date, and end date in every license. Example: Client licenses the right to print 10,000 brochures and to distribute the brochures for one year. If after one year, the client has mailed out only 8,000 brochures, the remaining 2,000 brochures cannot be distributed without an additional license.

ABOUT SIZE

It is important to clearly define not only the size at which your image may be reproduced, but the size of the media in/on which your image may be reproduced. The sizes may be relative (percentages/fractions) or absolute (specific maximum measurements). License fees are typically based on the scope of usage granted under the license. It follows, then, that smaller usages are associated with a lesser fee than larger usages. Stating the media size alone is not fair to your client, as your image may occupy only a portion of that media size. For example, if there are two photographs reproduced on a large billboard, one of which is full bleed and the other of which is a smaller insert, basing the fee for each image on the size of the billboard alone would be unfair to the client. For this reason and others, it is appropriate to state both a media size and an image size in your license description, where applicable.

Selling Your Pricing Structure

by Susan Carr

The following text was adapted for use in *ASMP Professional Business Practices in Photography* from the licensing guide published by the American Society of Media Photographers at *www.asmp.org/licensing*.

It is important that you learn to articulate your pricing structure in a clear and concise manner. If you sound unsure of yourself or unsure of the methods used to determine your fees, you will not build confidence in your client. This is why it is critical to follow the pricing steps outlined in chapter 2. You must know your actual costs and your unique worth, or you will not be able to successfully sell your services.

Fair compensation for the rights granted is the goal of any assignment negotiation. As discussed, that price is dependent upon a number of factors, from creative fees to production needs. The most contentious factor, however, is clearly the right to use the photograph—the actual license.

Most, if not all, of your clients have heard of copyright. How much they know about copyright law and how they feel about it will vary dramatically. Some are strong supporters of artists' rights. Others believe that copyright law has gone too far and feel the use of creative works should be more open and democratic. Still others will be focused on, and bothered by, the idea that you can re-license images originally created for them. Finally, another faction will simply be unfamiliar with the business of licensing photography altogether.

You must listen and ask questions to determine where a particular client falls on this spectrum of possibilities. For example, you do not want to come out with your guns blazing about your rights without knowing where the client stands on the issue. She may be a strong artist advocate, and you will offend her if you assume she knows nothing about copyright law, or worse yet, assume she will battle you on your rights. Equally problematic is assuming the client

knows the ins and outs of licensing photography when, in fact, he may truly be uneducated on the topic. Starting either of these conversations from a position of respect, asking questions, and listening will lead you to the appropriate next step. Photographers must simultaneously educate and sell in order to build a sustainable business.

Key things to remember when talking to a client:
- Listen carefully and never assume you know or understand your client's position.
- Explain your price with confidence.
- Being flexible is not a sign of weakness—it is smart business.
- If you compromise on an issue, the client should give on another.
- Treat clients with respect, and that respect is usually returned.
- There are times when an equitable agreement cannot be found and you need to move on.

Typical client comments when negotiating the terms of a photography assignment and possible responses may include:

- **"Why isn't your price simply time and materials?"** or **"What is your day rate?"** I do not charge on a day rate or hourly basis. Each project is unique, and time is only one factor I consider when determining my price for a specific assignment. Photography is a creative process, and production time is rarely an indicator of value.

TIP: *Remember that pricing based on time punishes you when you buy better equipment, or simply gain experience and work faster. Efficiency should demand a higher price,* not *a lower one.*

- **"Why do you need to know how I am going to use the photographs?"** Photographs are intellectual property, and licensing their use is how I generate income. The fees for a specific project are based on the use of the photographs because the more the images are used, the greater value they have. Since they're worth more, they cost more.

TIP: *Use an extreme example to illustrate why usage affects the price. If you are pricing a job for a corporate brochure, compare it with a consumer ad campaign run in magazines and billboards worldwide. By giving an example of very large use, the client sees the wisdom of paying less when the use is smaller. You can also use*

the software example in which a business has to license the use of software based on how many computers will be running it. Higher use = higher price.

- **"You cost more per hour than my attorney."** I do not charge by the hour, so dividing the total cost for this project by the hours estimated for me to be on site photographing does not give you a clear explanation of my fees. My fees are based on the creative and production needs of the job, the expenses, and the license terms we agree upon for use of the images. Factors other than time are frequently more influential in determining my price for a job.

- **"You mean I pay you and I don't own it?"** Photographs are the intellectual property of the creator. Much like software or a book, you can purchase the use, but the creator still owns the material. I own the rights to my photographs, but I can write a license that will let you do whatever you need to do. My price will reflect the value of that license.

- **"I do not want to come back to you each time I need to use these pictures."** I am more than happy to license a package of rights for these photographs, but you may be paying for uses you do not really need. I am service oriented and accessible if additional uses arise. My goal is, of course, to build a long-term business relationship, so tell me what your plans are and we can work out an equitable license.

TIP: If the client is concerned that you will gouge him on re-use fees, set up a pricing structure now for the future. Put it in your agreement and put his mind at ease.

TIP: It is becoming more common to license a broad package of rights to the commissioning client. (See PLUS packs at www.useplus.com/useplus/pluspacks.asp.) Care must be taken to make sure you achieve fair compensation when multiple uses are negotiated. It is critical to maintain control of your images even if the commissioning client has broad usage. Without preserving the copyright to your work, you cannot use the images in your portfolio, on your Web site or add them to your stock library.

- **"I do not want someone else using my images."** I am happy to provide you a price for exclusive use of these images, but because this type of license prohibits me from generating any additional income, it will significantly increase the cost of the project. I suggest we compromise and extend you a limited exclusivity—say six months. This gives you premiere use of the images, but it doesn't restrict my ability to earn additional income forever.

TIP: Adding exclusivity to a license for a limited time period can be a powerful negotiating tool. You can give it without losing much and build a positive relationship.

TIP: Think about the project when negotiating terms and price. Do the images have resale value? If the answer is unequivocally no, do not lose the client over a nonissue.

EDITORIAL CLIENTS

Publications frequently have a standard contract for hiring photographers to fulfill editorial assignments. Typically, the contracts ask for very broad usage rights (especially considering the pay scale being offered). Some publications are flexible, and the terms of these contracts can be negotiated.

The ability to negotiate successfully for improved terms and rates will depend largely on your relationship with the editor, your reputation, the urgency of the assignment, and the special qualifications or benefits that hiring you affords. For example, if you are traveling in a remote area and an urgent story arises close by, you are in a strong position to change the contract and raise the rate. Conversely, if you are in a large metropolitan area being asked to cover a story that is not time-sensitive or "special" to the editor, your negotiating position is weaker.

> **The ASMP reviews and fights to change the most egregious editorial contracts.** Check out these critiques at *www.asmp.org* and develop your own contract analysis skills.

A few truths about editorial work:

- Editorial work usually pays less than commercial.
- Photo credits can be valuable to building a career, but you cannot pay your rent with a photo credit. Be smart about when and where you exchange photo credit for appropriate compensation.
- Trade publications, although not as glamorous, generally pay better than consumer publications.
- Most publications will pay for production time and expenses.

ADVERTISING AGENCIES AND GRAPHIC DESIGN FIRMS

Traditionally, agencies and design firms negotiate terms and fees directly with the photographer on behalf of their client. The actual license, however, grants rights to the end user of the images—the ultimate client. Estimates and invoices are generally sent to and paid by the agency or design firm, not to the

end user. It is a normal trade practice for agencies and design firms to mark up the photographer's fees just as photographers mark up services, such as models, stylists, and digital services.

When working with an advertising agency, the art buyer is generally the person who vets photographers and collects the quotes on any given assignment. In the absence of an art buyer, the art director or creative director will contact the photographer. Either way, it is important to learn about the client and how the images will be used in order to prepare a quote.

Graphic design firms are frequently smaller operations, and the designer on a given job is usually the photographer's contact person. Again, you will want to ask for details on the client and how the images will be used to provide a quote.

A NOTE ON LICENSING STOCK PHOTOGRAPHS

There are two factors to consider when pricing a license for stock photographs.

- The uniqueness of the image.
- The terms of the license—the use.

Production and creative fees are not considered when licensing existing photographs.

Stock photographs are predominantly sold through online distribution channels. Whether the source is large mega archives like Getty and Jupiter Images or, at the other extreme, an independent photographer's Web site, the Internet is the vehicle for most stock photography sales.

If a photographer places work with a distributor, a signed contract gives the distributor the authority to set the prices and transact the sales. The photographer is sent a contractually agreed-upon percentage of each sale.

Licensing stock imagery directly eliminates the middleman, and the photographer keeps the entire licensing fee. That may sound great, but stock photography is very competitive and the difficult part of being independent is marketing your images. If only a few buyers see the available images, you will not make a significant number of sales.

Image portals are a sort of hybrid of the larger distributor and the independent seller. These businesses bring many independent collections together, providing a better market presence. Some set the pricing; some allow photographers to control it. Portals take a percentage of each sale, but that percentage is dramatically smaller than the commission taken by the traditional archive structure. [More detailed information on the business of stock photography can found in section 4 of this book.]

Copyright— Protecting Your Assets

"Controlling copyright is the most important aspect of being a creative person."
—Paul Elledge

Understanding Copyright

by Richard Weisgrau and Victor S. Perlman

Richard (Dick) Weisgrau's career in photography spanned more than forty years. During that time he worked as a professional photographer for twenty years. He was an ASMP member for fifteen of those years. After that he served as executive director of the ASMP for fifteen years, and then as a consultant and expert witness in photography-related matters. He is the author of four books about the business of photography. Today, his interest in photography is limited to shooting subjects of his choice, and exhibiting and selling prints.

Victor S. Perlman is general counsel to the American Society of Media Photographers, Inc. He has also served on the boards of the Copyright Clearance Center and the Philadelphia Volunteer Lawyers for the Arts. His writing has appeared in *Communication Arts* and *Popular Photography*, and he is the co-author of *Licensing Photography*. He frequently testifies in Congressional hearings and proceedings held by the U.S. Copyright Office.

———————————— • ————————————

The following text was adapted for use in *ASMP Professional Business Practices in Photography* from a chapter originally published in *Licensing Photography* by Richard Weisgrau and Victor S. Perlman (2006), published by Allworth Press and the American Society of Media Photographers. In addition to this chapter on copyright, this book covers licensing, pricing, and negotiating for professional photographers. *www.allworth.com.*

WHAT IS A COPYRIGHT?

Without copyrights, there would be no licensing. It is that simple. So what, exactly, is a copyright? Actually, referring to *a* copyright is a bit misleading. A copyright is really a collection or bundle of separate rights that relate to original

creations. The Copyright Act refers to those creations as "works," and they include literary, musical, dramatic, pictorial, audio-visual, and other works. Since this is written for photographers, we will generally refer to photographs or images, instead of works.

Copyrights are basically limited, legal monopolies that allow the copyright owners to use and exploit or capitalize on their copyrighted photographs, and to prevent others from doing so without their permission. There are some exceptions and limitations, which will be discussed later. Generally, only the copyright owners and people who have permission from them, can legally use copyrighted photographs for any of the basic uses or purposes that relate to photographs and that are specified in the Copyright Act. These are usually referred to as the author's "exclusive rights." The ability of copyright owners to allow others to exercise those exclusive rights to copyrighted photographs serves as the basis of licensing.

The owners of copyrights in photographs and that are part of the bundle of rights that comprise a copyright have these exclusive rights:

- To reproduce the copyrighted photographs in copies
- To prepare derivative works based on the copyrighted photographs
- To distribute copies of the photographs to the public by sale or other transfer of ownership, or by rental, lease, or lending
- To display the copyrighted works publicly
- To publicly perform certain types of works, including audio-visual works such as movies and multimedia productions

In practical terms, this means that generally, the copyright owners and people who have their permission (i.e., their licensees) are the only people with the rights to use copyrighted photographs: to make copies of them, to display them to the public (including on the Internet), to sell or otherwise distribute those copies to the public, and to create other works in which the photographs are used or on which they are based ("derivative works"). So, if you own the copyrights to your photographs and someone else wants to (or does) use them to make things like prints, posters, advertisements, calendars, greeting cards, T-shirts, coffee mugs, Internet Web site displays, coffee-table books, audio-visual programs, and so on, those people must get your permission and (presumably) pay you for that permission. If they do not, they are probably violating your copyrights and are subject to the remedies and penalties provided in the Copyright Act, which we will discuss later in this chapter.

Copyrights in the United States exist because of a statute, the current version of which is called the Copyright Act of 1976. Its legal citation is 17

U.S.C. (which stands for Title 17 of the United States Code), and it applies to all photographs made from January 1, 1978, to the present (as well as to those earlier photographs that are still under copyright). Even though you may never have wanted to go to law school, you will need to know the basics of what the Copyright Act says, and that means you may actually have to read the thing, or at least some parts of it. Fortunately, unlike the Internal Revenue Code, it is a fairly short document (by legal standards), and most of its language is relatively easy to understand. You can find it at a number of government and other Web sites without cost, but the most useful Web site to use for viewing and downloading the Copyright Act and for getting huge amounts of helpful information and vital forms is the U.S. Copyright Office's Web site, *www. copyright.gov*. Print copies of the Copyright Act are also available.

In addition to the exclusive rights granted under the Copyright Act, in a token effort to bring the United States in line with the copyright laws of most other countries and meet our obligations under the Berne Convention, Congress gave photographers and other visual artists some extremely limited rights. These are generally referred to as the moral rights of paternity and integrity. In most European and other countries, artists and other creators have the right to have their works attributed to them (the right of paternity). They also have the rights to prevent alterations of their work and to disclaim affiliation with altered versions of their works (the right of integrity). In the United States, those rights by and large do not exist. The limited exception is contained in the part of the Copyright Act known as the Visual Artists Rights Act of 1990 (VARA). Basically it provides moral rights for your photographs, but only if they are produced in signed and numbered limited editions of 200 or fewer copies. That means, in practical terms, that the United States generally continues to ignore the moral rights of photographers.

WHAT DOES A COPYRIGHT REALLY PROTECT?

Almost all original photographs are subject to copyright protection, but what does that really mean? To answer that question, we have to think on almost a philosophical or metaphysical level. We have to distinguish between the idea or concept that is embodied in a photograph and that gave rise to it, on one hand, and the individual expression of that idea or concept, which is what you execute when you make a photograph. For example, the windsurfer jumping the crest of the wave against the sunset is the concept; your particular photograph of that concept is your expression of it.

For good and obvious reasons, ideas and concepts may not be copyrighted. Remember that copyrights are monopolies. Can you imagine what the world would be like if people could own monopolies on ideas? For instance, consider

the consequences if someone could own a monopoly on all photographs of exhausted soldiers in combat, or of attractive blonde women in red bathing suits, or of executives in business suits shaking hands. It would mean that there would be only a handful of photographers who made the first legal images embodying those concepts, and everyone else would be either infringing their copyrights or paying them royalties. The situation would be even worse in fields other than photography. For example, what would happen to literature if someone had a monopoly on literary works based on the idea of unrequited love; or to physics if Einstein had owned a monopoly on the general theory of relativity?

While copyrights cannot protect ideas or concepts, they do protect the individual *expressions* of those concepts. For this reason, copyright lawyers talk in terms of the "idea-expression duality," which is legal speak for the fact that you cannot copyright the idea of a photograph of the Eiffel Tower, but you can copyright your particular photograph of it because it contains not just the concept but your individual expression of that concept. Since the concept cannot be copyrighted, those elements of your individual expression are protected by copyright.

Distinguishing between an idea and the expression of that idea can be difficult. Often the nature of a particular subject or idea can be expressed in so few ways that the distinction between it and the expressions of it becomes impossible. When that happens, the idea and the expression are said to "merge." That is, some ideas are such that every expression of them *has* to look substantially similar to every other expression of them. Therefore, if copyright protection were granted to any one of that kind of photograph, it would be the practical equivalent of granting a monopoly on not just the expression but also the idea itself. As we discussed above, that is something that copyright law will not allow.

For example, if you were to look at all of the photographs of the Grand Canyon taken from a specific location, such as one of those "scenic view" highway stops, they would all look pretty much alike. While all of those photographs are probably protected by copyright, the protection of the copyright has to be pretty limited (what copyright lawyers call "thin"), or else the first person who got there with a Kodak Brownie would have owned a very valuable monopoly, and everyone who came afterwards would be either a copyright infringer or a licensee. Obviously that would not be a desirable result, and it is not a result that the law allows. As we said, those photographs are probably copyrightable, but the copyright protection would extend only to those aspects or elements of each of those photographs that are unique to them; the choice of exposure, film, lens, camera angle, and so on, would probably be protected

by copyright, but the typical elements in the photograph such as the blue sky, sun, and the Canyon itself, would probably not.

WHAT DOES IT TAKE TO BE COPYRIGHTED?

Earlier, we referred to original creations. Exactly how much originality and creativity does it take, and what else is required, for a photograph to be eligible for copyright protection? Sadly the Copyright Act does not define originality. Fortunately, at least as far as photography is concerned, the answer is "not much." Under the 1976 Act, copyright protection exists in "works of original authorship fixed in any tangible medium of expression, now known or later developed, from which they can be perceived, reproduced or otherwise communicated, either directly or with the aid of a machine or device." That means that most photographs become copyrighted the moment they are created, as long as they have been captured in some storage medium. For example, as soon as the shutter opens and closes, and a latent image is captured and stored in some medium, such as unprocessed film or any digital storage medium, that photograph is generally copyrighted. Conversely, you can make the greatest photo on earth, but if there is no film or digital storage medium, there is no copyright (and no photograph, either, for that matter, just the proverbial fish that got away).

We said that *most* photographs are copyrighted as soon as they are created. The reason for the "most" is that there is also the requirement of "original authorship." Fortunately the threshold of required originality is very low. While it is possible to make photographs that do not meet the originality requirement, they are rare. Typically, they are photographs of basic design elements, such as repeated patterns of light, or copy photography that simply makes an exact duplicate of another work. For our purposes, we will assume that just about every photograph that you make is copyrighted, as long as film or digital media captured the image.

You may have noticed that nothing was said about registration at the Copyright Office as a requirement for copyright protection. In fact, registration is *not* required for copyright to exist for a photograph. However, there are lots of good reasons why you should register your copyrights (and register them as early as possible), and there are situations where you will have to register your copyrights. We will discuss both later in this chapter.

WHO OWNS THE COPYRIGHTS?

Let's assume that you are a freelance photographer. It does not matter whether you are an amateur or a professional, or whether you are working on an assignment, building a stock photo library, or just shooting for personal fulfillment.

Unless and until you enter into some kind of an agreement that changes things, you start out owning the copyrights to your photographs. It's that simple. As we suggested, it is possible to change that status by contract, but the usual situation is that freelance photographers start out owning the copyrights to the photographs that they make. We should note that, under the Copyright Act of 1909, which was in effect until January 1, 1978, the result was often quite different.

What if you are a staff photographer? In that case, your photographs fall into a category in the Copyright Act called "work made for hire." If you are an employee who makes photographs as part of your regular duties ("within the scope of your employment"), then your photographs are works made for hire, and the result is just the opposite from the freelancer's situation: Your employer is considered the copyright owner from the outset. In fact, you are not even considered the creator ("author," in the language of the Copyright Act) of the photographs—your employer is the creator. In that case, you may not make *any* use of those photographs, such as including them in your portfolio or Web site, without your employer's permission.

These results are not carved in stone. It is always possible to enter into agreements that change those consequences, so that a freelancer can end up producing photographs that are considered works made for hire or otherwise transferring the full copyright to the client. Conversely, a staff photographer can have a contract with his or her employer that would make the employee the copyright owner. The ownership of copyrights can be completely transferred. All that is required is that the transfer be: (1) in writing, and (2) signed by both of the parties.

On the subject of ownership, what happens when you sell prints or other copies of your photos? Does the buyer of the prints get any kind of ownership of the copyrights, not just ownership of the prints? Fortunately for photographers, the answer is no. The Copyright Act clearly and directly states that ownership of copyrights is completely separate and distinct from ownership of copies, and that ownership of one does not have any effect on ownership of the other. Again, it is possible to change that result by agreement, but the starting concept is that buying copies has nothing to do with buying copyrights or copyright licenses, and vice versa. That is why most reputable labs will not make duplicate prints of photos like wedding and school portraits without written permission from the photographer or studio that created those prints.

That is not to say that owners of prints cannot do *any*thing with them. Under something called "the first sale doctrine," the buyers can do almost anything they want with the prints, as long as the things they do are not included in the list of exclusive rights that belong to copyright owners (making copies, etc.).

HOW LONG DO COPYRIGHTS LAST?

Copyrights generally last for the life of the creator plus seventy years. Keep in mind that we are talking about the copyrights in photographs made under the laws of the United States on or after January 1, 1978. There are lots of rather complex rules about the duration of copyrights in photographs created before then, but we will not try to cover them in this book. Earlier we mentioned that for works made for hire, the photographer is not considered the creator, but the employer is. For that reason, works made for hire have a different copyright life span: ninety-five years from the date that the photograph is first published or 120 years from the date of its creation, whichever is shorter.

Occasionally Congress has increased the term of protection for copyright. This happened most recently a few years ago (which generated a lot of opposition by some groups and some unsuccessful litigation challenging the constitutionality of the extension and even of the Copyright Act itself). Whatever the duration may be of your copyrights, the important thing to remember is that they will outlast you by many years, and can be a valuable legacy for your family and loved ones. You should give some thought to arrangements for licensing your images after you are no longer able to do it, whether you license them directly or though a third party. Estate planning is a subject to which every successful photographer needs to pay attention, particularly with regard to the continued licensing of his or her photographs. [For information on estate planning see chapter 36 in this book.]

WHAT IF SOMEBODY USES YOUR PHOTOGRAPHS WITHOUT YOUR PERMISSION?

If someone uses your photograph by exercising any of the exclusive rights granted to copyright owners without your permission, he or she is probably infringing your copyright. In order to prove an infringement, you need to show only two things: that the unauthorized user had access to your photo and that the unauthorized use bears a "substantial similarity" to your photo. Let's look at those two requirements.

Access is usually easy to prove and is generally presumed for photographs that have been published. An unpublished photo is another story. In that case, you need to be able to prove that the infringer actually had access to your photo in some way. Often that happens if you sent your photo to a prospective client who then ended up using someone else's photo that looks remarkably like yours, instead. For example, a client may look at your photo and like it but decide that your price is too high, and go out and hire someone else to create a very similar image for less money. In that sort of situation, you need to be able to prove that you sent your photo to the infringer.

For that reason, and for many others if you want to use photography as a business, you should always be in a position to prove that your photos were actually delivered every time you sent them out. You should use some kind of delivery service that will provide you with written proof of delivery, and you should keep that evidence in your files, just in case. Also if your photos are being submitted because the prospective client requested them, it may be important that you be able to prove that fact. You should document that request, usually in the form of a confirming cover letter or delivery memo that mentions the fact that the submission is pursuant to a request by the recipient.

Substantial similarity is usually much harder to prove than access and often requires the testimony of an expert witness to analyze the various elements and similarities in both photographs. If there has not been direct copying (e.g., where your actual photo is scanned or otherwise duplicated), the question of similarity can become quite muddy.

Remember that you cannot copyright your idea or concept; you can only copyright your unique expression of that concept. Because of that, what looks like an obvious rip-off of your photo may not be an infringement in the eyes of a judge or jury. We once had a situation where it seemed obvious to us that a photograph of a person in a swimming pool with a distinctive background of blue sky and white clouds had been used as the basis for producing a strikingly similar photo that appeared on a magazine cover. When we met with the magazine's editor, he pulled out a file folder filled with equally similar but slightly different images. It became immediately obvious that, if the magazine cover was an infringement of our photographer's photograph, it (along with our photo) must also have been an infringement of dozens of others.

Once you are able to prove infringement, several forms of relief are available to you. First, you can ask the court for an injunction. That is a court order that tells the infringer to stop the infringing activities, to destroy all infringing copies, and/or take other actions that your attorney and the court may decide are appropriate.

Second, you are entitled to make the other side pay your damages (the extent to which you have been financially hurt by the infringement) plus the part of his net profits that are attributable to the infringement. Those elements, especially the infringer's profits, can be difficult to prove with the precision required by the courts. For that reason, in certain circumstances, the Copyright Act allows you to ask for something called "statutory damages" instead of actual damages and profits. We will tell you more about when statutory damages are available later in this chapter. In the case of statutory damages, you

do not have to prove your actual damages and the infringer's net profits from the infringement with any accuracy. Instead, you can leave the question of how much money you receive to the court's discretion.

Generally courts will try to make the statutory damage award bear some relationship to their reasonable estimate of your actual damages and the infringer's net profits attributable to the infringement. Contrary to the belief of many photographers, the Copyright Act does not provide for any punitive damages, so they will not usually enter into the calculation of either actual damage and profits or statutory damages. However, as of this writing, there is at least one case in the U.S. District Court for the Southern District of New York in which the judge allowed punitive damages as part of the calculation of the award. He noted in his opinion that his actions would be subject to review by higher courts. In our estimation, the odds are that this decision will prove to be a rare exception, at best, and will not provide a reliable precedent for other cases, even if a higher court does not reverse it.

Sometimes, photographers will submit paperwork to their clients stating that unauthorized uses are subject to a multiplier that will be applied to what their usual fees would have been for the same use if the use had been licensed. Unfortunately, a 2004 decision in the U.S. District Court for the Southern District of New York (where many infringement cases start) ruled that multipliers may not be taken into account when courts calculate damages. That does not mean that you should not include that kind of provision in your paperwork; it just means that you cannot expect the courts to enforce it.

Under the Copyright Act, statutory damages can be as high as $150,000 for each of your infringed photographs (not for each act of infringement). In some cases, however, that number can be reduced to as low as $200. Because of that, you should always attach a copyright notice to each of your photos. A copyright notice consists of the word *copyright* or the copyright symbol ©, followed by your name, followed by the year that the photo is first published. For example, you will see the photographs in this book noted as something like © Richard Weisgrau 2005. In addition, in order to obtain the maximum protection available under certain foreign copyright laws, many people add the words, "All rights reserved" immediately following the copyright notice.

Until 1989, publication of a photograph without a copyright notice was enough to terminate your copyright and place that photograph in the public domain. Fortunately, copyright notices are no longer required to accompany all published versions of your photographs. However, as mentioned in the preceding paragraph, there are advantages to using a proper copyright notice (not the least of which is the free advertising component), and we urge you to use one whenever possible.

In addition to damages, under some conditions you may be able to ask the court to make the infringer pay *your* lawyer's fees if you win. That is a very important thing, beyond the money. Legal fees for a copyright infringement case are substantial, usually in the five- and six-figure range. Most photographers simply cannot afford to pay fees like that, and you have to have an exceptionally attractive infringement claim (and a wealthy defendant) to convince a reputable copyright attorney to take your case on a contingent fee basis. Even then, you will probably have to pay the costs (separate from the legal fees) as you go, and those costs will usually be thousands of dollars. When expert witness fees are involved, those costs can skyrocket.

Finally, you need to know that there is a three-year statute of limitations for civil actions for infringements. That three-year period is measured from when the claim accrued, meaning roughly from when the infringement took place and you knew, or should have known, that it had.

WHY, WHEN, AND HOW DO YOU REGISTER YOUR COPYRIGHTS?

Obviously the ability to ask the court for statutory damages and attorney's fees is a great advantage in a copyright infringement situation, both in settlement negotiations and litigation. So how do you become eligible for them? The answer is simple: register your copyrights, and register them as soon as possible. Although registration is not necessary to obtain your copyrights (that happens as soon as you make your photos), you have to register before you can sue for infringement. Even more importantly as a practical matter, you are eligible to ask the court for statutory damages and attorney's fees only if you have registered before the infringement or, in the case of published photographs, within three months of the date of first publication. The lesson here is clear: You should register your copyrights, and you should register them as soon as possible after you have made the photos.

The registration of photographs is relatively straightforward, and the fees are inexpensive. As with most procedures controlled by the government, the devil is in the details. Both the Copyright Act and an extensive body of regulations and Copyright Office rules cover registration. You can find an excellent guide to registration at the Web site of the American Society of Media Photographers at *www.asmp.org/copyright*, and you can find the Copyright Act, forms, FAQs, regulations, circulars, bulletins, and so on, at the Copyright Office's Web site, *www.copyright.gov*. In addition, you can order forms and other materials from the Copyright Office by calling (202) 707-9100.

You may have noticed that the eligibility for attorneys' fees and statutory damages is based in part on the date of registration in relation to the date of

publication. You may also have noticed that a copyright notice calls for inclusion of the year of first publication. Because of factors like these, applications for registration of published photographs require the inclusion of the date of first publication. In fact, when you start looking at applications for registration and the related instructions and other materials, you will find that when you submit more than one photograph in a registration, published and unpublished photographs may not be registered together. Even the requirements for the materials that must be submitted for registration are different for published photographs than for unpublished ones. It is, therefore, crucial that you know which photographs fall into which category at the time of registration.

Exactly what constitutes publication is a difficult question, and there is no definition provided in the Copyright Act. It is far too complex an issue to address here, but you can find helpful materials at both the ASMP and Copyright Office Web sites mentioned earlier.

WHEN IS AN INFRINGEMENT NOT AN INFRINGEMENT?

Not every unauthorized use of a copyrighted image is an infringement of its copyright. For example, a use can be of such a small part of an image, or can be for such a brief period of time, that it may be too small ("de minimis") to be considered actionable.

A more significant exception falls into a category known as "fair use." There is no hard rule in the Copyright Act as to what constitutes fair use—only some general guidelines. Each use must be evaluated individually to determine whether it is a fair use, and ultimately only the courts can say with any real authority whether a particular use is a fair use.

Generally, the Act says that fair uses are ". . . for purposes such as criticism, comment, news reporting, teaching . . . , scholarship, or research. . . ." Those specified uses, however, are just by way of example, and it is possible for other types of uses to qualify as fair uses. In determining whether a use is fair, the Act provides a list of factors that the courts should take into consideration in making their determination:

- The purpose and character of the use, including whether such use is of a commercial nature or is for nonprofit educational purposes
- The nature of the copyrighted work
- The amount and substantiality of the portion used in relation to the copyrighted work as a whole
- The effect of the use upon the potential market for or value of the copyrighted work

Again, that list is not comprehensive, and other factors may be taken into account. Certain educational uses are specifically authorized without compensation under the Copyright Act, and others have led to the creation of formal guidelines for determining when an educational use is fair and when it is not. Those guidelines are available through the U.S. Copyright Office. In addition, certain copying by libraries and archives are specifically permitted in the Copyright Act. Most other potential fair uses, however, are undefined and have to be analyzed on a case-by-case basis.

As you wander through the world of copyright, there is a hazard of which you need to beware: the realm is filled with myths, urban legends, and wrong information. For example, many people believe, or at least claim, that all educational uses are fair uses. That is just plain wrong. If it were true, there would be no copyrights on textbooks, and nobody would ever publish any because everyone would be free to photocopy them. Another absurdity that we have heard more than once is that, once a photograph has been published, it has become a public domain work and is available for everyone to use without permission or compensation. A third example is the mistaken belief that mailing yourself a copy of your photograph is an effective substitute for registering it at the Copyright Office. If you believe any of these myths, you need to reread this chapter.

A more insidious hazard is the fact that the Internet is filled with bad information. Often, that kind of misinformation comes from well-intended photographers passing along legal advice. You wouldn't ask your lawyer whether Tri-X is better than T-Max or whether RAW files are better than JPEGs. You should be equally careful about using legal opinions issued by nonlawyers who are not accountable to you for any bad information that they may unwittingly pass along. In fact, the situation is even worse than that. We have seen Web logs ("blogs") of respectable attorneys that have referred to court decisions that, in reality, simply do not exist. Whenever possible, you should try to rely on resources that are impeccable and authoritative, such as the U.S. Copyright Office, and on lawyers whom you have hired and who are responsible to you for the accuracy of their advice.

HOW CAN YOU MAKE MONEY OUT OF YOUR COPYRIGHTS?

Like most legal rights and assets, copyrights can be transferred from the original owner to others. Most of the time, those transfers are accompanied by payments to you. If people want to use your photographs, the law says that they need your permission in the form of copyright transfers or licenses. Those transfers can consist of outright sales of entire copyrights, or they can be transfers of limited aspects of the bundle of rights that make up what we call a

copyright. Copyright licenses are really limited transfers. For example, a license can be limited as to the kinds of uses that can be made, the length of time that the permission lasts, whether the license is exclusive (i.e., the person holding the license will be the only person allowed to make the permitted uses for as long as the permission lasts), the geographic areas in which those rights can be exercised, and so on. It is important to remember that copyright consists of a bundle of exclusive rights, and that bundle can be divided up in an almost infinite number of ways.

Most licenses do not need to be in writing. However, the absence of a written agreement or other document detailing the terms of the license can prove to be a big problem. There are often breakdowns in communication and misunderstandings, especially where both sides are nonlawyers making agreements based on legal rights, which is exactly what happens in most cases when photographs are being licensed. Often words do not have precisely the same meanings to different people, and differing or incorrect assumptions are frequently made. Also human memory is marvelous in its limitations, imperfections, and inadequacies.

To make the situation worse, questions about what people agreed to do not usually occur right after the agreement is made; they usually occur months or years later. At that point, it would be the rare case that both sides recalled all aspects of the agreement in precisely the same way. For those reasons, it is crucial that your copyright licenses be in writing and contain as much detail as possible.

In the last paragraph, we said that *most* licenses do not have to be in writing to be valid. There are, however, some major exceptions. First, remember that in a work-made-for-hire situation, the employer or client is considered the author of the work and the owner of the copyright. The only way to change any aspect of that (i.e., the only way to give the photographer any or all of the copyright rights) is in a written document signed by *both* of the parties. So if you are photographing under a work-made-for-hire arrangement and you want to be able to use any of your photographs for self-promotion (or any other purpose), you need to get written permission from your employer or client and have that document signed by both your employer or client and yourself.

Two other kinds of transfers that have to be in writing are the outright transfer of ownership of the full copyright and the license of any right on an exclusive basis. Unlike licenses of a work made for hire, however, these need to be signed only by the person granting the license.

The Copyright Act contains a provision that was intended to benefit freelance creators like photographers. It says that the photographer or his or her heirs can terminate *all* transfers of copyrights, including the limited or partial

transfers that we call licenses. The only exception is works made for hire. The termination right has a five-year window in which it can be exercised. That window opens thirty-five years after the date of the grant or license; or if the grant or license allows the work to be published (which is usually the case), the window opens thirty-five years after the date of publication or forty years after the date of the grant, whichever comes first. Exercising the termination right requires a written notice from the photographer or his or her heirs (specified in the Copyright Act) to the holder of the copyright or license.

You may have noticed that we started the last paragraph by saying that the termination right was *intended* to benefit creators. Right now it appears that its practical effect is just the opposite. Because works made for hire are not subject to the termination right, clients have started to demand work contracts specifying work-made-for-hire arrangements more frequently and more adamantly. The earliest that the termination right will actually start to be exercised is 2013 (thirty-five years after 1978). As we get closer to that date, we can expect increasing numbers of users of photography to start thinking about the termination right and contracting around it by demanding work-made-for-hire agreements. Unfortunately, the law specifically says that the termination right cannot be waived or changed by contract—the only way around it is through work made for hire. So you should prepare yourself for the prospect of being faced with clients demanding work-made-for-hire agreements.

Registering Your Work

by Stanley Rowin

Stanley Rowin is a Boston-based editorial and corporate photographer. He served on the board of the ASMP from 2000 to 2006 and as its president from 2002 to 2004. In 2004 he received the Professional Photographer Leadership Award from the International Photographic Council, a nongovernmental organization of the United Nations. He has a B.S. in Interdisciplinary Engineering and a Masters in Business Administration. *www.stanstudio.com.*

———————————— • ————————————

The following text was adapted for use in *ASMP Professional Business Practices in Photography* from the Copyright Tutorial published by the American Society of Media Photographers at *www.asmp.org/copyright.*

YOUR ORIGINAL IMAGES ARE YOUR LEGACY. EARLY PLANNING, ESPECIALLY WITH proper copyright protection, is a critical step in reaping long-term financial rewards from your photographs. Although every original photograph you create is automatically copyrighted the instant the shutter is clicked, you don't get much legal protection unless you follow through on a few things. So it is important for you to develop an easy system that will allow you to quickly and regularly register your copyrights as soon as possible.

In most cases, unless you specifically signed away your rights, you—the photographer—own the copyright and the right to license and re-license the image in any way you choose. This is true even if you have not registered your copyright or put your copyright notice on the image. Where registration makes a real difference is when something has gone wrong and your rights are being infringed.

Proper copyright registration of your work establishes a public record of your copyright claim. You cannot start a valid lawsuit until after you have registered the copyright to an image; therefore it makes sense to register the copyright to your images before they are published.

STEP ONE: WHICH IMAGES CAN BE COPYRIGHTED?

Two things must be true in order to copyright your photo:

1. The image must be original (in the sense that it was not copied from someone else and represents your own creative expression). If you make an exact copy of something like a painting or another photo, your copy cannot be copyrighted because it is not original.
2. You must not have signed away your rights to the image, whether through a "work-for-hire" situation, an employment contract, a contract that assigns the copyright to someone else, or other types of written agreements (such as a purchase order with work-for-hire provisions in the terms and conditions).

If your photo is original and you didn't sign away your rights in a specific contract, you own the copyright to your image. Although registration is not required, we must stress the business value of registering your copyright with the Copyright Office in Washington, D.C.—ideally within a few days of taking the picture, but in any case within three months of first publication. If you do not register your copyright within certain time limits, you put yourself at risk should someone infringe your photograph.

STEP TWO: PUBLISHED OR UNPUBLISHED?

To begin the process of copyright registration, you first must determine whether your work has been published or not, since each situation requires a different registration procedure.

Under copyright law, the word *published* is defined as "the distribution of copies of a work to the public by sale or other transfer of ownership, or by rental, lease, or lending. Offering to distribute copies to people or businesses for purposes of further distribution, public performance, or public display constitutes publication." Therefore, simply by submitting images to your stock agency, which will do further distribution (submission and licensing), you have probably legally published your work. Exhibiting your photographs in public does not constitute publication, unless you exhibit them through another party, such as a gallery, which offers them for sale.

FREQUENTLY ASKED QUESTIONS ON DETERMINING
PUBLISHED OR UNPUBLISHED

Q *Is a photo published if it is on my Web site?*

A If it is in a public area of the Web site, it is probably published. If it is in a private area of the Web site, it is probably not published.

If you have unpublished images that you want to post on your Web site, you can avoid the published/unpublished issue by registering them as unpublished images before you upload them. It is also important to be aware that registering the Web site is different from registering the images on the Web site.

Q *When I deliver photos to a client, even if none of the photos delivered is actually printed, has it been published?*

A This depends on your paperwork and your delivery memo. In some cases the photos may be considered "published" because their delivery constitutes "an offering to distribute, for purposes of further distribution, public performance, or public display."

Q *My work is hanging on a gallery wall. Has it been published?*

A Exhibiting your photographs in public does not constitute publication, unless you exhibit them through another party, such as a gallery, which offers them for sale (for further distribution).

Q *Can I register published work and unpublished work at the same time?*

A You must do each on a separate form, with separate fees for each registration.

Q *How long do I have, after delivering the image, to register the work at the Copyright Office?*

A You can register at any time, but to preserve the protection of collecting attorney's fees and statutory damages for infringements, you have to register either before the infringement occurs or within three months of publication. If you do this, you are retroactively covered back to the actual day of publication. If you don't make the three-month window, you are only covered after your actual registration date. If you are infringed after this three-month window yet before you have submitted a registration deposit, you can still register your copyrights and file suit, but you will not be eligible to ask for statutory damages and counsel fees. If you then register and another infringement occurs after the registration, you will be entitled to ask for statutory damages and counsel fees in connection

with this later infringement, as long as the Copyright Office has received your properly completed application.

Q *What if some of my images were published before 1989?*

A If your work was published before the Berne Convention was adopted (that is, prior to March 1, 1989), there is another condition to fulfill. Each photograph published before this date must have contained a printed copyright notice that named the applicant as the copyright owner in order to file for registration. If the publication has the printed notice, the image is covered. The deposit to the copyright office must show the photograph as it actually appeared in first publication, with proof of copyright notice. You should send tear sheets, or copies or scans of the tear sheets. You may make a group registration or individual VA registration.

STEP THREE: THE FORM(S)

COPYRIGHT REGISTRATION OF PUBLISHED IMAGES

For works that have been published, you should send in your registration within three months of the actual publication.

To register one single published image, fill out one Form VA, which you can freely download from the Copyright Office Web site, *www.copyright.gov*. For tutorial purposes, you may wish to look at our annotated PDF sample form located at *www.asmp.org/copyright*, but for your actual filings, you should always obtain the latest version from the Copyright Office. Using Adobe Reader or Acrobat, you can type directly into the fields to enter your data—except for the signature, which must always be hand-written—or you can simply print out the form and write or type your information using black ink. (Either way, be sure the two pages of the form are printed as front and back of one sheet of paper, correctly aligned top-to-top.)

You must also supply two copies (tear sheets, scans or photocopies of the printed page) of the image in its original published form.

It is most practical and efficient to register published images in groups. First, the deposit requirements state that you need only one copy of each image for group registration. Second, you pay only one fee. The published images can be grouped if they meet certain date and authorship requirements. Read the requirements below and decide for yourself.

To register a group of two or more images published within the same calendar year, you can use the Form VA with the Group Registration of Published Photographs Continuation Sheet (Form GR/PPh/CON) both available at *www.copyright.gov*. Again, for tutorial purposes, you may wish to examine

the ASMP annotated sample form at *www.asmp.org/copyright*, but get the latest version from the Copyright Office when you file. The form will ask you to give the publication date for each individual image. You do not need to supply copies of the "original published version" of each photo in the group, as you do for a single image, but you still need to supply a copy of the photos in some form.

As of March 2005, you may use no more than fifty continuation sheets with a single Form VA. This means you can register up to 750 images in a group. If you have more published images than that, simply divide them into several groups, submitting each with its own Form VA (and its own fee).

In order to group-register published images, you must meet all of the following requirements:

- The images must have all been published within the same calendar year.
- All of the works must have the same copyright claimant.
- All of the photographs must be by the same photographer. If an employer for hire is named as author, only one photographer's work may be included.

If you are registering a number of images from several different calendar years, you must separate them by year and submit one Form VA for each year with a separate fee for each form.

It is best to file within three months of publication. You can register at any time, but to preserve the protection of collecting attorney's fees and statutory damages for any infringements that have taken place before registration, you have to register within three months of first publication. If you do this, you are retroactively covered back to the actual day of first publication.

What if you missed the three-month deadline? Well, you're not doomed, but you are running a risk. If you don't make the three-month window, you are only eligible for attorney's fees and statutory damages for those infringements that occur after your actual registration date. If you are infringed after the three-month period and you have not submitted a registration, you can still register your copyrights and file suit, but you will not be eligible to ask for statutory damages or attorney's fees. Instead, you will have to show actual damages, which puts a heavier burden of proof on you.

If you then register and another infringement occurs after the registration, you will be entitled to ask for statutory damages and attorney's fees in connection with the latter infringement, as long as the Copyright Office has received your properly completed application.

COPYRIGHT REGISTRATION OF UNPUBLISHED IMAGES

To register any number of unpublished images, use Form VA. The PDF of Form VA, available for download from the Copyright Office Web site, *www.copyright.gov*, has interactive features. Using Adobe Reader or Acrobat, you can type directly into the fields to enter your data—except for the signature, which must always be hand-written—or you can simply print out the form and write or type your information using black ink. (Either way, be sure the two pages of the form are printed as front and back of one sheet of paper, correctly aligned top-to-top.)

To make a "deposit" or copy, you must first create one copy of every image to be registered. You may create a contact sheet of images, make digital scans of transparencies or prints, or create video captures of still images. Further information about the process for creating this deposit of your work can be found in the tutorial section on meeting the deposit requirement. Since you can register an unlimited number of unpublished images, regardless of how long ago they were taken, on one form for one fee, it is most practical to gather up every image that has not been published and register it now.

After you have created the deposit, count the number of images that you are submitting and fill out Form VA. For tutorial purposes, you may use our annotated form at *www.asmp.org/copyright*; but for an actual filing, we always recommend getting the latest version from the Copyright Office.

Important Note: For a photograph published before March 1, 1989, the copy of the photograph must show the photograph as it was first published. This copy must show the copyright notice, if any, that appeared on, or in connection with, the photographic work. This is necessary because the copyright law in effect from January 1, 1978, through February 28, 1989, required that a work be published with a copyright notice identifying the owner of the copyright and the year of first publication of the work. The deposit copy for a photograph published prior to March 1, 1989, may conform to any of the above-listed formats as long as the format deposited faithfully reproduces the photograph in its exact, first-publication appearance.

STEP FOUR: THE DEPOSIT REQUIREMENT

Currently all copyright-registration applications require a deposit of the photos, with the application. If you are registering a single published image on Form VA, you must submit two copies of the published work. The technical description from Circular 40a is:

Two complete copies of the best edition if the work was first published in the United States, or, for certain types of works, identifying material instead of

actual copies. . . . A complete copy of a published work is one that contains all elements of the unit of publication, including those that, if considered separately, would not be copyrightable subject matter. The copies deposited for registration should be physically undamaged.

Basically, you must submit two copies showing the photograph in its original published form, probably a tear sheet. Submit originals or color copies if published in color, black-and-white if published in black-and-white. You may scan or photocopy the original page.

If you are registering unpublished images on Form VA, or a group of published images on Form VA with the Continuation Form: Form GR/PPh/ CON, you do not need tear sheets or whole-page copies. Instead, you only need one copy of each image. The copy has to be recognizable, but it can be on paper, a digital file on disk, or videotape.

It is important to establish an efficient and comfortable workflow in order to create these deposits and to use this procedure regularly. Some photographers routinely copy of all of their work before delivery to their clients and register their photos before they are published. ASMP views this as good practice.

Size limits. If your deposit is the actual published form of the work, there are no size requirements. (The work is the size that it is.) For "identifying material," which is everything else, Circular 40a sets minimum and maximum sizes:

Photographic transparencies must be at least 35 mm in size and, if 3 × 3 inches or less, must be fixed in cardboard, plastic, or similar mounts; transparencies larger than 3 × 3 inches should be mounted. All types of identifying material other than photographic transparencies must be not less than 3 × 3 inches and not more than 9 × 12 inches, but preferably 8 × 10 inches. The image of the work should show clearly the entire copyrightable content of the work.

The size limits apply to the print, not each image. For an image, the final sentence above is what matters: The examiner must be able to see the image clearly—and the Copyright Office does not provide jeweler's loupes to its employees. If the examiner, sitting at his desk, is able to identify the image content, the deposit is probably going to be accepted. If not, it will be bounced.

Because of this human factor, the practical size requirement can depend on the nature of the image. Shots of sky or waterscapes probably need to be bigger than portraits, for instance. If you are in doubt, our advice is to cut the examiner a break and make the image bigger.

Go to *www.copyright.gov* for the latest information and details about registering your images online.

STEP FIVE: COMPLETING THE PROCESS

The final step is gathering all the paperwork and image copies to send to the Copyright Office.

Verify that you have all of the required items:

- A Form VA that has been properly completed and signed.
- If you are doing a group registration of published images, you will also need a properly completed Form GR/PPh/CON.
- A copy of the images being registered in the form of a deposit. You will probably include image files on CD together with a printed copy of image thumbnails, a contact sheet, or duplicate slides.
- A signed check for the current registration fee.

Be sure to keep a set of copies for yourself. Not only might the package get lost in transit, but the Copyright Office itself might lose the submission. (It's rare, but it has happened.)

Please note that getting the package to the Copyright Office has become increasingly problematic due to fears of terrorism. Check with the Copyright Office and ASMP Web site advisory area for any current updates. We recommend sending the submission via traceable courier shipment, such as FedEx. Send the package to the address on the back of the Copyright Office form. The Copyright Office does not provide a confirmation of receipt, so make sure that you ask the courier for a delivery receipt.

The date that all the required elements are received by the Copyright Office in acceptable form is the date of the registration. It does not depend on how long it takes for the application to be processed and the certificate of registration to be mailed back to you. Once your submission has been processed, you will receive either a certificate of registration (sent by regular mail in four to nine months) or an e-mail or letter requesting further information if your submission is incomplete.

COPYRIGHT OFFICE APPEALS PROCESS
(IF YOUR REGISTRATION IS TURNED DOWN)

It is possible that the Copyright Office will reject your request for copyright registration. Section 410(b) of the current copyright law states that if the

Register of Copyright determines the material deposited for registration "does not constitute copyrightable subject matter or that the claim is invalid for any other reason," the Copyright Office can refuse registration.

If your registration deposit is refused, the Copyright Office must notify you in writing and provide you with the reasons for the rejection. If you feel the rejection has been wrongly or unjustly made, you have the right to appeal this decision.

The process for appealing a rejected registration is outlined in detail at *www.asmp.org/copyright*.

EXCEPTIONS TO THE LENGTH OF REGISTRATION RULE

There's no confusion about how long you and your estate will have copyright protection for current material: life plus seventy years. But for those whose careers and images go back to the middle of the last century or earlier, here are some important things to note:

Works originally copyrighted before 1950 and renewed before 1978: Copyrights already in their second term (an extension of twenty-eight years of protection following an initial twenty-eight years, for a total of fifty-six years) on January 1, 1978, automatically received an extension for up to a maximum of ninety-five years (a twenty-eight-year term plus sixty-seven years, expiring at the end of the calendar year in which the ninety-fifth anniversary of the original date of copyright occurred). No further renewal is required.

Works originally copyrighted between January 1, 1950, and December 31, 1963: Any copyrights whose first twenty-eight-year terms were secured between January 1, 1950, and December 31, 1963, did not receive automatic extension when the new copyright laws went into effect and had to be renewed within a strict one-year time limit. If those copyrights were renewed in time, they received a second term of sixty-seven years, instead of twenty-eight, adding up to a full ninety-five years of protection. If those copyrights were not renewed in time, they expired at the end of their twenty-eighth calendar year, and protection was lost permanently.

Works originally copyrighted between January 1, 1964, and December 31, 1977: Any copyrights that were secured between January 1, 1964, and December 31, 1977, received automatic renewal, even if renewal registration was not made. Those whose work falls into this area can still file a renewal application because certain legal benefits may come from doing that, but to do so is not strictly needed.

Basically, copyrights that had already been renewed and were in their second term at any time between December 31, 1976, and December 31, 1977, were automatically extended for a total length of ninety-five years from

the end of the year in which they were originally secured. The example the Copyright Office gives to clarify this is the following: A work that was first copyrighted on April 10, 1923, and renewed (after its initial term of twenty-eight years) between April 10, 1950, and April 10, 1951, for another twenty-eight years, would formerly have fallen into the public domain after April 10, 1979. The current law extended that copyright through the end of 2018, or to a total of ninety-five years.

Works originally created on and after January 1, 1978: These works, which include all those being created now, receive a single copyright term of the creator's life plus seventy years after his or her death. When two or more authors have created a work, the term lasts until seventy years after the last surviving creator's death. If the work was "made for hire"—and in cases of anonymous and pseudonymous works, unless the author's identity is revealed in Copyright Office records—the term of copyright is ninety-five years from first publication or 120 years from creation, whichever is shorter.

Remember: If your work is entered into the public domain, either because it was time for it to do so, or because you failed to renew the copyright in a timely manner, that copyright has been lost forever. There is no procedure for restoring protection for works in which copyright has been lost for any reason.

WHEN IS AN IMAGE A "DERIVATIVE WORK"?

Whenever you take an existing image and modify it to create a different image, you are making a derivative work. For example, you might make a composite of several images in the darkroom, or you might use Photoshop's tools to distort a digital photo. Another kind of derivative is the compilation, such as a coffee-table book. In law, it does not matter whether the change is great or small, or whether the result is recognizably like the original; what matters is whether your creative process began with an existing image.

There are three copyright issues that may affect a derivative: original rights, new copyright, and disclosure.

ORIGINAL RIGHTS

One of the many rights that a copyright owner enjoys is control over the preparation of derivatives. Thus, if you are building on the work of others, you must obtain permission (unless the original is in the public domain) and you must respect any limitations that the respective owners of the originals may impose. Obviously, if you own the original copyrights, this is not a problem—unless you have sold an exclusive license to someone else. There are some circumstances in which you don't need the blessing of the original copyright holder,

such as for a parody or other fair use. However, you can expect some hostility if you take this route, and you should probably consult a lawyer early on.

NEW COPYRIGHT

The law holds that there can be original authorship if the derivative contains a significant amount of new material or is sufficiently different that it can be regarded as a new work. For instance, in a coffee-table book, the selection and arrangement of the photos is considered "new material" that is worthy of copyright. If there is a new copyright, it covers only the aspects that are original. Thus, the book's copyright doesn't affect the copyrights of the photos.

DISCLOSURE

Even though your derivative work is entitled to its own copyright, you must reveal the work's ancestry when you register. This is the purpose of Section 6a of Form VA. Then, in Section 6b, you note the original aspects. Details are available at *www.copyright.gov*.

Metadata Basics

WHAT IT IS AND WHY YOU NEED TO USE IT

by Judy Herrmann

Judy Herrmann of Herrmann+Starke specializes in digital still life and life-style photography for advertising. Her work has appeared in *Lurzer's Archive*, *Graphis*, *Communication Arts*, the *How International Design Annual*, and *Pix Digital Annual*. She has been recognized as an Olympus Visionary since 2000. She lectures extensively about digital photography and offers consultations on building a successful photography career. She served as national director, secretary, first and second vice president and president of the American Society of Media Photographers.

———————————— • ————————————

The following text was adapted for use in *ASMP Professional Business Practices in Photography* from an article originally published in *Olympus VisionAge*, a *Photo District News* custom publication (*www.pdnonline/visionage*) assigned and edited by Sarah Coleman.

WHETHER YOU'RE MANAGING A COMPLEX COLLECTION OF IMAGES FROM A WIDE variety of sources or trying to stay on top of your own image archives, applying and using metadata—often described as "data about data"—will make a huge difference in your ability to find specific images quickly and easily. It will also enable people who come across your files to find vital information such as who created the image, and when and where it was created.

Metadata is a powerful tool, and software developers are rapidly designing improved methods for entering, viewing, and searching metadata. To manage metadata appropriately, you must first understand what metadata is and why

it's important. You'll then be able to determine the best approach to managing metadata for your specific needs.

WHAT IS METADATA?

In the context of digital photographs, metadata refers to text-based information about image files. Each and every digital photograph—whether produced by a digital camera or a scanner—can contain metadata. The metadata for images can generally be divided into two types of information: machine-generated and user-generated.

Both machine- and user-generated metadata fields can be viewed in Adobe Photoshop by using the File > File Info command. They can also be viewed in Adobe Bridge, Adobe Lightroom, Apple Aperture, Extensis Portfolio, Canto Cumulus, Microsoft Expression Media, and other image editing, browsing, and management programs. Obviously, how you view and embed the data varies from program to program but a quick search for "metadata" in the help menu should give you the access you need.

MACHINE-GENERATED METADATA

Generally, the devices that create images—digital cameras and scanners—write data into the file using Exchangeable Image File Format. This type of metadata is commonly referred to as "EXIF data," and it describes the technical specifications of the image file. It includes information about the physical characteristics of the image (pixel dimensions, resolution, bit depth, etc.), how and when the image was created (date, time, f-stop, shutter speed, etc.), and the device that created the image (make, model, serial number, etc.).

Machine-generated metadata occurs automatically and requires no effort on the part of the user. Most standards bodies, such as the Universal Photographic Digital Image Guidelines (*www.UPDIG.org*) and the International Press Telecommunications Council (*www.IPTC.org*) recommend that it be left intact.

Some photographers don't want to share certain proprietary information such as when an image was captured or the specifics about the lens or flash used. Since this type of metadata generally can't be edited in Photoshop or other digital asset management (DAM) software, photographers who wish to change this data must obtain a special stand-alone EXIF utility. Several options for both Mac and PC platforms are available for sale, through shareware and as freeware. You can also remove it entirely by creating a brand new file in Photoshop and pasting the image data into it.

USER-GENERATED METADATA

User-generated metadata gets added after capture by a human being. The International Press Telecommunications Council (IPTC) developed the most commonly used schema, or collection of data fields, for our industry. Photographers frequently refer to user-generated metadata as "IPTC data." The IPTC core schema has already been incorporated into several programs including Adobe Photoshop CS. It contains fields that identify the creator (author, job title, address, phone, etc.), and describe the image (headline, description, keywords, etc.) and its origins (date created, location, etc.) as well as any special instructions and allowed usage.

Completing all of the IPTC core fields can take a lot of time and effort, so you'll want to evaluate all of your files to decide which fields are necessary and determine the fastest method for applying the appropriate metadata. Many applications like Adobe Bridge and Microsoft Expression Media provide tools for easily embedding the same information into multiple files at one time. When possible, organize your photos into groups that share the same location, date, and so on, and batch-apply the fields they have in common. For shots with similar content, even fields like Headline or Keywords can sometimes be batched. You can even batch-apply shared keywords and then go back to apply the unique ones to individual files as needed.

MINIMUM METADATA REQUIREMENTS

The amount of user-generated metadata that's truly necessary depends largely on how the file will be used and distributed. Remember, the goal of metadata is to help people either find the image in the first place or track important information about an image that's already in their possession.

At an absolute minimum, standards bodies, trade associations, and industry experts all agree that the creator's name, contact information, and copyright notice should be embedded into every image file that leaves the creator's computer for any reason. After all, as long as the creator can be found, any other information that's needed about the file can be traced. If you can't find the creator, though, there's no way to negotiate usage rights and payment, to track releases for any people in the photo or to determine the five Ws (Who, What, Where, When, and Why) behind the shot.

Luckily, since the creator's name, contact information, and copyright notice are generally the same for every image produced by that individual, this information can be embedded in multiple images at the same time with little effort. Many applications, such as Adobe Photoshop, Adobe Bridge, and others, provide tools to easily create and save metadata templates. Unlike batching metadata where you apply metadata to multiple files on the fly, templates let

you store collections of fields that you know you'll want to apply to files in the future as well as the present. Each application handles this process a little differently. The user manual or help menu will provide step-by-step instructions for creating and saving templates. Once saved, these templates can be applied to files individually or as part of a batch process.

When you set up your "creator ID" template, be sure to complete all identification fields in the "IPTC Contact" field. In the "Description" panel, select "Copyrighted" in the Copyright Status pop-up menu and complete the Copyright Notice field using the traditional format "Copyright" or © followed by the year of first publication and the rights holder's name. You can also include your Web site or other contact information in the Copyright Notice field.

Metadata, however, can do far more than simply allow people to find the creator. It provides fantastic tools to communicate how the image can or can't be used, to make the image keyword searchable and to provide caption and other critical information about the image itself.

These days, once an image leaves the creator's hands, it can be very difficult to control how it might get used. Images that land on the Internet can wind up literally anywhere, and many companies maintain internal databases of images that allow any employee access to any image the company has ever used. By embedding the usage rights you're willing to grant into the metadata of your file, you're accomplishing two things. First, you're making it clear that the end user really does have the right to use the image for the intended purposes. Second, you're providing fair warning that any unauthorized uses—by your client or anyone else—are an infringement of your copyright.

Within the IPTC core schema (which is found in many image processing programs, including Photoshop CS), the IPTC Status panel provides a *Rights Usage Terms* field. If you're licensing images to a client, you can copy your exact licensing language from your invoice into this field. Just be sure the license includes the name of the client to whom those rights are granted, so that anyone who stumbles across the file won't assume that those rights apply to them. For other images (e.g., images provided for review, self-promotion, etc.), you should use the *Rights Usage Terms* field to convey that no usage rights have been granted and that the image may not be used without your express written permission.

If you need a little help figuring out how to write a license for the *Rights Usage Terms* field, chapter 3 of this book offers clear explanations and sample license language. The Picture Licensing Universal System (PLUS) Glossary at *www.USEplus.org* provides excellent definitions of common licensing terms. Many of the most commonly used PLUS terms can be found in the Glossary of Industry Terms in this book.

Protecting your rights by embedding appropriate language in the *Rights Usage Terms* field is an excellent first step. Learn more about your rights as a creator, including when and how to register your copyrights, in chapters 5 and 6 of this book.

Completing the other fields in this panel may be more or less appropriate, depending on your needs. Use Title to convey a shorthand reference to the photo—this can also be a good field in which to store the original file name as captured or scanned. Job Identifier allows you to embed an internal ID code of your choosing. Instructions provides a space for any messages you wish to convey to the client or printer; it's the ideal place to warn of any embargoes or restrictions on the image. Use Provider to indicate who's providing the image and Source for the original creator or copyright holder.

The IPTC Content panel provides fields for describing your image. Headline lets you summarize the contents of the photograph, while Description gives you space to outline the five Ws (Who, What, When, and Why) of the image. Depending on the context of how the image is being used, the contents of the Description field may become the caption for the photograph. The IPTC Subject Code field need only be used if required by your client. Though widely adopted by news agencies, it's rarely used by any other industry sectors. Use the Description Writer field to list the people who wrote, edited, or corrected the description. Finally, the IPTC Content Panel provides a space for embedding keywords.

Making your images keyword-searchable makes it much easier for you and others to find them. Keywords, words or phrases that describe the specific image, can be literal or abstract. Literal keywords can describe the subject matter (e.g., girl, flower), elements of the photograph (e.g., sky, field), the type of photo (e.g., portrait, still life), and so on. Abstract keywords might address the feeling of the photograph (e.g., mysterious, stark), an interpretation of the image (e.g., happiness, energy), the category or topic of the photo (e.g., business, recreation), and so on.

Embedding keywords can be enormously time-consuming. Keep in mind that it's not necessary to embed keywords into every image you've captured. Keywords serve the function of making a specific image or images with similar characteristics easier to find. If you don't need to find your images using keywords, don't spend the time embedding them.

For photographers licensing stock images, however, the increased value provided by proper keywording outweighs all other considerations as stock images can only be licensed if they are found. For many stock photographers, hiring a keywording service may be more cost-effective than doing it themselves.

If you choose to keyword your own photographs, you'll want to take advantage of any opportunities to reduce the amount of effort expended.

Organize your photographs into groups of similar images, and batch-apply all the keywords that the images have in common first. Then go through the images one by one and append any additional keywords that apply to just that image or to a smaller subset of the images. Using a controlled vocabulary can also speed up the process. A controlled vocabulary limits your keywords to a predefined list. Most controlled vocabularies will also automatically provide synonyms and related terms so you don't have to figure those out on your own. Learn more about controlled vocabularies at *www.controlledvocabulary.com.*

Finally, the IPTC Image panel provides fields to describe the specific details of when and where the image was captured. The Intellectual Genre and IPTC Scene fields are primarily used for news and need only be completed if required by your client. Use the remaining fields, Date Created, Location, City, State/Province, Country, and Country Code, as needed to record appropriate information about the image.

Completing all of the IPTC metadata fields can be a lot of work, so use your judgment to determine which fields are critical for each of your images. At a minimum, though, by embedding your creator contact and copyright information into each and every image that leaves your hands, you're increasing the likelihood that someone who wants to use your image can find you. Adding your license to the Rights Usage Terms field notifies everyone who comes in contact with your image of what they can legally do with it. The Title, Description, and Headline fields, along with the fields in the IPTC Image panel, make it easier for people to identify what's in your photo, while the Keywords field helps you and others find your image along with others that share similar characteristics.

Using Metadata is Key to Photographic Professionalism

IN THE DIGITAL AGE, ADDING CONTACT AND COPYRIGHT METADATA IS ONE OF THE MOST CRITICAL ASPECTS OF THE PROFESSIONAL PHOTOGRAPHIC PROCESS

by Ethan G. Salwen

Ethan G. Salwen is an independent writer and photographer currently based in Buenos Aires, Argentina. In addition to covering Latin American cultures, Salwen writes extensively about technical, artistic, and marketing aspects of photography. He is a regular contributor to the *ASMP Bulletin, The Picture Professional, Rangefinder,* and *After Capture. www.ethansalwen.com.*

———————————— • ————————————

The following text was adapted for use in *ASMP Professional Business Practices in Photography* from an article originally published in the *ASMP Bulletin*, assigned and edited by Jill Waterman.

WHEN ARCHITECTURAL PHOTOGRAPHER COREY WEINER PHOTOGRAPHED A plush spa for a PR firm, he granted the agency very liberal usage rights. However, along with his basic contact and copyright information, Weiner added boilerplate language to the IPTC Rights Usage Terms metadata field in all the hi-res files he delivered. "No usage rights without written agreement with photographer," the language read in part. It also noted that his images were registered with the Copyright Office at the Library of Congress.

As a result, when Weiner's client tried to use one of his images for a piece in the *Miami Herald*, the newspaper's picture editor was compelled to check whether the photographer had authorized these rights. "Besides being against our policy," the editor wrote to the agency, "based on the information embedded in the photo, this guy knows his rights."

This is a success story illustrating the positive impact of adding basic metadata to all images, indicating image ownership and copyright status. The photographer embedded the metadata; the metadata remained in place as the file was passed along; the editor knew how to check this metadata; and he respected the photographer's rights.

Unfortunately, there are fewer metadata success stories than there are tales of woe. Many photographers simply do not add basic metadata, which is both understandable and ironic. Ongoing improvements to software applications make adding metadata easier than ever. Yet these very improvements open the doors to greater workflow confusion. Even when photographers ensure every image is delivered with metadata in place, the metadata is often unintentionally stripped out by software incompatibilities or user error. And even when metadata remains in place, not all end users are as knowledgeable or diligent as the editor at the *Miami Herald*.

When these metadata woes are combined with the impending Orphan Works legislation, the situation created becomes a dark, deadly storm on the horizon for professional photographers. However, a little metadata savvy can go a long way.

ADDING BASIC CONTACT METADATA IS CRITICAL AND EASY

The most basic and the most critical metadata that photographers absolutely must add to their images includes the name of the photographer, her contact information, and the copyright status. While there is no statistical information available, strong anecdotal evidence collected from a broad range of ASMP members who specialize in digital workflow suggests that fewer than 50 percent of professional photographers add this basic metadata to their images. It seems that photojournalists and stock photographers are among those who add the most metadata, while portrait and wedding photographers seem to add the least.

The bottom line is that regardless of the industry she is in, it is equally possible and equally important for every single photographer to address this vital aspect of her workflow process. Metadata templates in programs such as Photo Mechanic, Adobe Photoshop, Adobe Lightroom, and Apple's Aperture make adding basic contact metadata to all images easily accomplished during

the ingestion processes. This assures that critical authorship details are attached to every file at the very beginning of a photographer's digital workflow.

"Delivering an image file without basic metadata is like sending out a chrome without attaching your name, contact information and a copyright symbol," says digital standards expert Richard Anderson. "Absolutely no professional photographer would do that." Anderson says that adding basic metadata should be the first stage of the digital workflow and should take no thought. However, he points out that even later in the workflow, automated batch processing makes it simple to add metadata to hundreds or thousands of images.

If adding metadata is so easy, why are photographers failing to do it? Digital workflow guru Peter Krogh explains that the photo industry continues to go through huge growing pains as digital technologies evolve. Understandably, photographers have focused most of their initial digital learning efforts on creating great images with a new media. The result is that a clear understanding of metadata at even the most basic level has gotten lost in the lurch.

THE UNAVOIDABLE PAIN OF STRIPPING

Unfortunately, adding metadata at the beginning of a digital workflow does not ensure that this information remains with an image. It is as easy to strip a file of metadata as it is to add the metadata in the first place, intentionally or otherwise. Metadata is unintentionally stripped by photographers and clients who are not fully in control of their metadata workflows. And of course there are image thieves who intentionally strip metadata from files.

The accidental loss of metadata starts with the nature of the raw file format. Most pros shoot in raw format. And except for Adobe's DNG, raw files cannot safely hold additional metadata beyond the EXIF data the camera writes to the file. Different software applications attach metadata to raw files in different ways. For example, Adobe applications like Bridge and Lightroom store metadata in XMP "sidecar" files. Some software developers have adopted Adobe's XMP standard, but others have developed their own database solutions for tracking the metadata associated with raw files. Whether XMP is being used or not, compatibility issues among applications create numerous opportunities for data loss.

Even when dealing with JPEGs, Photoshop files, and TIFFs—in which the metadata is a more integral, more secure part of the file—metadata is still easily lost. One unfortunate example: Photoshop's Save For Web. Photographers have long used this function to prep images for Web sites, not aware that until Adobe recently made an adjustment to Photoshop CS3, this function was stripping files of vital metadata and contact information. This shocking fact

is one reason why increasing numbers of photographers are demanding that software and hardware developers create ways to "lock" metadata.

The desire to somehow lock metadata is understandable, but experts insist that such technology is not practical and that it will not be developed any time soon, if ever. Even if metadata locking technology were developed tomorrow, experts agree that people intent on stealing images would quickly find ways to defeat this. Therefore photographers must focus on keeping close track of metadata in their evolving workflows to ensure that their images remain metadata-rich. Equally important, photographers must establish excellent communications with clients regarding metadata practices.

A METADATA-UNFRIENDLY WORLD

Even images that leave the photographer's workflow with metadata fully in place are up against a lot of hurdles to keep that information intact, and not just from malicious thieves or uneducated clients. Commercial photographer Dan Stack ran into one of these problems when creating publicity images for a rock band. The band intended to use the images on the popular Web site *www.MySpace.com*. Stack was aware of this when he negotiated the job, but he was not aware that MySpace does not allow users to upload images with embedded contact metadata.

Although it is not entirely clear, this anti-metadata policy is apparently designed to protect the privacy of MySpace users. However, Stack doesn't understand this logic, pointing out that users have the option to strip their own files of metadata before uploading. On the other hand, photographers intent on keeping metadata with their files have no defense against third parties uploading their images to MySpace without permission.

The metadata policy of MySpace is a good example of a world that is increasingly favoring the commercial interests of image uses over image makers. "The situation with MySpace put me between a rock and a hard place," says Stack, who decided to allow his clients to upload his images without metadata. "I had agreed to the usage and I wanted to support my clients, but in doing so I distributed images that cannot be traced back to me."

WITHOUT METADATA, EVERY IMAGE IS A POTENTIAL ORPHAN

"It has always been incumbent on photographers to be as findable as possible," explains Victor S. Perlman, the ASMP's general counsel and managing director. "Because if clients can't find you, they are not going to use your services or pay you to license your images." Perlman says that the proposed Orphan Works legislation adds a major wrinkle to this issue of findability. Essentially, Orphan Works promises that the public will have the right to use

any image commercially after "due diligence" has been performed to identify the image creator.

Every expert consulted on the topic, including Perlman, is convinced that Orphan Works will become legislation, and that it will not be a good thing for photographers. "ASMP has been working behind the scenes to make improvements to the legislation," says Perlman. "But no matter what, Orphan Works will be a change to copyright law in a way that benefits the user community at the cost to the creator community." Perlman goes on to say that the pending legislation puts pressure on photographers to be proactive in leading the user back to the photographer.

Past ASMP President Judy Herrmann could not agree more wholeheartedly. "Every day photographers are putting thousands of images on the Web without basic contact metadata," Herrmann says. "This will result in millions of images that will fall under the influence of Orphan Works." Herrmann is well aware of how easily metadata can be stripped from images, but she still insists that embedding metadata and educating clients is crucial to good business practices.

NO WAY TO STOP THE BAD GUYS

The ability to easily strip metadata combined with the prospect of Orphan Works is sure to make any photographer feel queasy. "Someone will be able to steal a picture that I made yesterday and sell it today as their own without any ramifications," says Jeff Sedlik, commercial photographer and president and CEO of the nonprofit PLUS (Picture Licensing Universal System) Coalition. Supported by ASMP and a broad range of image creators, distributors, and users, PLUS is developing technology to help ensure that anyone in possession of an image file has access to the rights and ownership information for that image—whether it contains contact metadata or not.

"Bad people will do bad things," says Sedlik. "Good people will try to do good things." He believes that PLUS offers the most promising potential for supporting the "good people" and reducing the threat from the "bad people."

Herrmann agrees that photographers need to focus on the "good people" and not get overwhelmed by the "bad people" as they develop sound metadata workflows and embark on educating clients. As the entire photographic industry increases its understanding of best metadata practices, the advantages will be multifold for photographers: protection against images accidentally becoming "orphaned," payoffs from accidental infringements, more efficient in-house workflows, and smoother interactions with clients.

CLIENT METADATA EDUCATION AND COMMUNICATION

"It won't take photographers long to get up to speed on systematically and automatically adding basic contact metadata to all of their files," says metadata expert David Riecks. "It's really not that difficult, and more than anything it requires motivation and the willingness to experiment." However, Riecks points out that educating clients about metadata is an ongoing process.

Just as with contract negotiations, it is the photographer's professional responsibility to communicate about metadata as clearly and as often as necessary to minimize misunderstandings. This kind of regular, thorough communication about metadata is critical, especially when a Photoshop function like Save for Web—used by many clients—strips out all contact information.

A LITTLE METADATA GOES A LONG WAY

Professional photographers have grappled with a dizzying, constant shift in photographic technology simply to be able to make images. While dealing with the likes of megapixels, DPI, color space, and sharpening, something critical has been given short shrift: basic metadata. Maybe this should not be surprising, as photographs convey visual information and metadata holds invisible data. But even though metadata is invisible when viewers look at an image, it is the image's metadata that provides the surest way those viewers will be able to identify and contact the photographer who created the image in the first place.

Enforcing Copyright: Dissecting the Infringement Case

by Nancy E. Wolff

Nancy E. Wolff practices primarily in intellectual property and digital media law. Clients include trade associations PACA and PLUS, Inc., stock photo libraries, individual photographers, authors, illustrators, designers, publishers, and digital media companies. She counsels clients in copyright, trademarks, licensing, contracts, rights of publicity and privacy, and libel. In addition to transactional work, she represents clients in arbitration hearings as well as state and federal court civil actions.

———————————— • ————————————

The following text was adapted for use in *ASMP Professional Business Practices in Photography* from a chapter originally published in *The Professional Photographer's Legal Handbook* (2007), published by Allworth Press and the Picture Archive Council of America (PACA), Inc. In addition to this chapter on infringement cases, Wolff's book covers copyright law, trademark law, and the law of privacy and publicity. *www.allworth.com.*

THE CIVIL INFRINGEMENT SUIT IS THE MEANS BY WHICH A COPYRIGHT OWNER enforces her rights. When bringing a copyright infringement claim, parties who claim their work was infringed must establish two main points. First, they must prove they own a valid copyright in the work. Second, they must show that *protected* elements in their work have been copied.

THE TWO-PART TEST FOR COPYING: PART 1—ACCESS
When the work itself is copied, proof of copying is obvious. However, many infringements are alleged based on works that look similar to the original but

actually contain differences. In such cases, proof of copying is required. The test for unauthorized copying has two parts. The first part requires proof that the infringer had access to the copyrighted work. The second part requires substantial similarities to the items that are considered subject to copyright protection.

What constitutes access is the subject of a number of cases. With respect to access, it is not enough to simply show that the accused party had a bare possibility of access. You are required to prove access by showing a particular chain of events or link by which the alleged infringer might have gained access to the work. For instance, an owner of a copyright in a song in *Jorgensen v. Careers BMG Music Publishing* claimed that a record company copied elements in his music resulting in two other songs. The original copyright owner, Jorgensen, had recorded a demo tape of his song, "Lover" and sent the unsolicited demo tape to a record company. Later, after hearing songs entitled "Amazed" and "Heart," Jorgensen became convinced that his work had been copied. He argued that since employees who regularly interact with industry artists received the demo tapes, it is possible that his music was disseminated through the industry system and somehow got into the hands of the writers of "Amazed" and "Heart." Jorgensen could not mention any specific instances or factual occurrences by which the demo tape was allegedly circulated through the industry and into the hands of the writers of the two songs. However, he argued that access was possible by virtue of the demo tape being sent in and the record company's natural association with other artists.

The court was not persuaded by the evidence of access Jorgensen put forth to support his claim of copyright infringement. Jorgensen could have attempted to prove access by showing a particular chain of events by which the alleged infringer might have gained access to the work. But merely alleging receipt of an artist's work by a corporate defendant is insufficient to establish access, according to the court. Furthermore, the court noted that Jorgensen could not even prove that the tape had actually been received but only that he sent it in. His speculation as to what happened after he submitted his demo tape included a myriad of possibilities and neglected to offer evidence of meaningful access and opportunity to copy. The court found it too far-fetched.

The general rule is, absent proof of access, courts turn to the works and compare them for striking similarities. In instances where the similarities are so pronounced as to preclude any possibility of independent creation, access will be presumed. In cases where the similarities are subtle, as in this music case, a stronger showing of access is required.

THE TWO-PART TEST FOR COPYING:
PART 2—SUBSTANTIAL SIMILARITY

The second requirement is that the copied image be "substantially similar" to the original. In the event of a lawsuit, a court or jury must compare the two images to determine whether the images are substantially similar. The standard of comparison is the "Ordinary Observer Test." That is, would the images look substantially similar to the layperson? In examining the photos, the court will pay attention to those elements that are within the photographer's control, such as lighting, posing, angle, background, perspective, shading, color, and viewpoint. The original photographer will, of course, point to the similarities in the two works while the alleged copycat photographer will point to the differences. There is no mathematical calculation that the court applies, such as a percentage of similarity. The word "substantial" really refers to those elements that give the work originality. Remember, "originality" is the *sine qua non* of copyright—meaning that a copyright can be held only in a work that can be considered original. If the alleged copycat has deviated from the original image to the extent that the copy contains enough originality that it is really not a copy at all, no infringement will exist. A simple photograph, such as one of an existing natural subject, will gain less protection than a complex photograph—one that is more contrived. In other words, the two "simple" photographs must be nearly identical for there to be infringement.

A good example of how a court compares photographs is the case of *Sahuc* v. *Tucker*, concerning two photos of a well-known gate located in the French Quarter of New Orleans—a famous tourist spot. "Decatur Street Gate" was taken by Sahuc, while "Breaking Mist" was taken by Tucker. No people are present in the Sahuc photograph, and fog obscures the view of St. Louis Cathedral. In his photograph, Sahuc chose to include the surrounding banana leaves, which appear vivid and bold against the foggy backdrop and stand out more prominently than the grand cathedral, which towers over them in the background. According to the court's description, the "photograph includes the statue of Andrew Jackson, the urn located centrally in the Square and the Mediterranean palms." It was established that Tucker took his photograph after having viewed "Decatur Street Gate" in Sahuc's gallery and after having a poster in his possession that included Sahuc's photograph. "Breaking Mist" is a photograph of Jackson Square in the early morning hours when the fog is rolling in off the Mississippi River. The Decatur Street gate is open in the photograph and the lights on the fences are illuminated. "Breaking Mist" includes St. Louis Cathedral, the statue of Andrew Jackson, the urn in the center of the square, banana leaves, and the Mediterranean palms. There are no pedestrians present in Tucker's photograph. "Breaking

Mist," unlike "Decatur Street Gate," includes puddles of water at the bottom of the frame.

The appeals court found the images were not substantially similar. Expert testimony as to their similarity was introduced at trial, but the testimony was deemed irrelevant on appeal. The appeals court noted that the framing of the cathedral is different; specifically, "Decatur Street Gate" does not show the curb, while "Breaking Mist" does. Also the lighting is different. "The banana leaves frame the shot, protruding more boldly than even the Cathedral in the background, which is muted by the fog. All objects appear to be perfectly placed by Sahuc: the urn, the Mediterranean palms, the gates, and the Cathedral." The feeling was that these differences would be evident to a layperson despite what the expert said. This may be an example of a simple photograph of a common subject that was afforded less copyright protection than if it had been an uncommon scene.

IDEA/EXPRESSION AND *SCENES A FAIRE*

The idea/expression and *scenes à faire* doctrines show up primarily in the substantial similarity analysis. For instance, the case of *Ets-Hokin* v. *Skyy Spirits, Inc.* In this case, a photographer who was originally hired to take a product

shot of a vodka bottle sued for infringement when Skyy hired another photographer to take a similar shot after rejecting the first photographer's image. The court found that there is a "narrow range of artistic expression available in the context of a commercial product shot." Remember, under the merger doctrine, courts will not protect a copyrighted work from infringement if the idea underlying the work can be expressed only in one way, lest there be a monopoly on the underlying work's idea. Also recall that under the related doctrine of *scenes à faire*, courts will not protect a copyrighted work from infringement if the expression embodied in the work "necessarily flows from a commonplace idea." In *Ets-Hokin*, though the photographs were similar, their similarity was described as "inevitable, given the shared concept, or idea of photographing the Skyy bottle." The court went on to say that the two shots must therefore be virtually identical for an infringement to exist. In denying the infringement claim, the court stated, "The lighting differs; the angles differ; the shadows and highlighting differ, as do the reflections and background. The only constant is the bottle itself."

The case of *Gentieu* v. *Getty Images, Inc.* is again instructive as to how these two issues play out in an infringement case. The court ruled that: "Gentieu cannot claim a copyright in the idea of photographing naked or diapered babies or in any elements of expression that are intrinsic to that unprotected idea." The only thing that would be protectable would be the "particular compositional elements of her expression that do not necessarily flow from the idea of photographing naked babies." Penny Gentieu lost the case because she cannot hold a copyright on the idea of babies against a white background.

In line with cases that flesh out the idea/expression issues of the substantial similarity analysis, the New York case of *Kaplan* v. *Stock Market Photo Agency, Inc.* appears to be the highest hurdle for plaintiffs. As we've pointed out, the court denied the original photographer's claim of copyright infringement even though it was established that the defendant used the photograph in creating his own.

According to the *Kaplan* court, the idea of a businessman about to jump from a building is simply not protected despite the similarities. The court went on to say that the similarities in the expression are a product only of the similarities in the idea. Our *scenes à faire* doctrine embodies the oft-told principle that "sequences of events necessarily resulting from the choice of setting or situation . . . are not protectible under U.S. copyright law." The judge felt that the second photographer added his own originality to the underlying unprotectable idea. The judge went on to explain, "Moreover, as the situation of a leap from a tall building is standard in treatment of the topic of the exasperated businessperson in today's fast-paced work environment, especially in

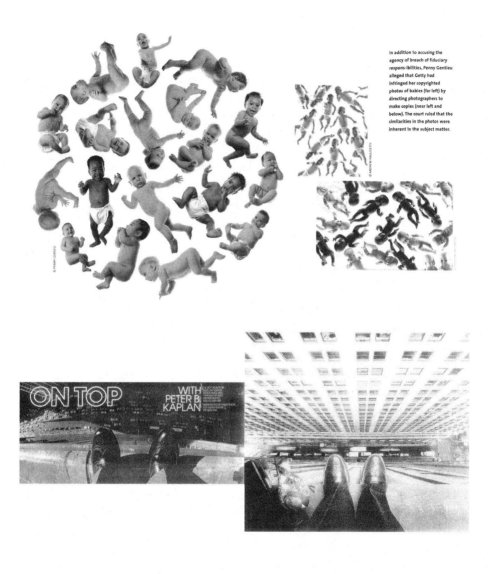

New York, the subject matter of the photograph is also rendered unprotectable by the doctrine of scenes a faire."

Again, the *Mannion* case really took this line of reasoning to task. In *Mannion*, the defendants again relied on the old axiom that copyright does not protect "ideas"—only their expression, urging that: "When a given idea is inseparably tied to a particular expression, courts may deny protection to the expression in order to avoid conferring a monopoly on the idea to which it is inseparably tied." As the above examples show, this merger doctrine in its

various forms has historically stymied many a copycat photography plaintiff.

Yet here, Judge Kaplan tries to move away from this type of reasoning. He begins by pointing out that the "idea" put forth by defendants "does not even come close to accounting for the similarities between the two works, which extend at least to angle, pose, background, composition and lighting." Employing a little imagination, Kaplan points out that it is quite possible to imagine any number of depictions of the subject in question which might look nothing like either of the photographs at issue. As we discussed before, Judge Kaplan averred that this contributed to his finding that the "idea/expression" distinction is "useless" when dealing with works of visual arts.

One should be aware that in a few states, such as New York and Georgia, there is a legal concept known as "Total Concept and Feel." When one photographer has copied the overall concept and feel of another's photograph, an infringement may exist. This is difficult to determine because no photographer may own a copyright in a style. In *Leigh* v. *Warner Brothers, Inc.*, two images of the famed Savannah, Georgia "Bird Girl" sculpture were compared. The appeals court determined that there could be copyrightable elements for a jury to decide. Such elements included lighting, shading, timing, angle, and film and the overall combination of elements in the photograph.

In *Fournier* v. *Erickson*, a photographer took a picture for a Microsoft Windows 2000 advertisement. When negotiations broke down, the ad agency hired a second photographer to recreate the image for the final ad. The advertisement was to illustrate a slogan stating, "The old rules of business no longer apply" alongside an image of a young businessman in casual dress walking down the street. The court ruled there was no protection as to the irreverent casual business dress but there are for some "protectable elements." Again, the artistic elements are the posing of subjects, lighting, angle, and selection of film and camera, all of which contribute to total concept and feel. After this decision, the parties reportedly settled the matter for a confidential sum.

RESHOOTING IMAGES

Examples like these are typical of the infringement claims we see in commercial photography, and there has been an increasing trend in re-shooting stock images. As a bit of background, for years ad agencies have used stock images in making "comps" for clients. Clients like the idea but want an element in the image changed—for example, a different model, the removal of a prop, or the alteration of the background wall color. Often, instead of obtaining permission to alter the image, the ad agency will hire another photographer and recreate the shot. The question becomes: Do you really need permission to re-shoot to change an element within a photograph?

The answer is yes, because you are creating an infringing derivative work. Photographers, as "authors," are granted exclusive rights, among which is the right to create a derivative work, which means the right to adapt or modify a work. A derivative can be created in a number of ways such as combining different elements, or adding or subtracting elements in a photograph.

The cases we've outlined above, whether or not they made an ultimate finding of infringement, all assume that you can violate the right of reproduction and the right to create a derivative work by creating a photograph that is substantially similar to someone else's work. As explained, the courts determine whether two photographs are substantially similar by comparing the two photographs to identify whether copyrightable elements have been taken. In examining the photos, the court will pay attention to those elements that are within the photographer's control, such as lighting, posing, angle, background, perspective, shading, color, and viewpoint. The likelihood of finding substantial similarity is much greater when the image has been set up by the photographer and contains creative and original elements, in contrast to a photograph of a familiar tourist site like the Statute of Liberty.

These are often factual questions for a jury to determine. Since lawsuits can be quite expensive, most cases are settled if they are not dismissed early on in the summary judgment stage. The best advice is to contact the stock library and inquire about obtaining a license to create a derivative work. Otherwise, the ad agency and the client can be liable for copyright infringement.

The damage caused by recreating photographs is significant. Rights management cannot be maintained if clients recreate photographs without permission. If one client shells out for an exclusive license, and a second company uses the same image to create a similar photo with many of the same elements, the first company will be furious for paying a premium and not getting the rights for which it bargained. Photographers work hard to develop original ideas that will be selected for stock use, often coming up with innovative ways to express an idea. If these shots are ripped off, the value of the original is greatly decreased. The copycat photograph will have gained advertising exposure, diminishing the market for the original photograph.

Smoking Guns

HOW TO HANDLE CLIENTS WHO EXCEED PRIOR LICENSES

by Henry W. Jones, III

A twenty-six-year business and copyright lawyer based in Austin, Texas, who has assisted photographers in four states, Henry W. (Hank) Jones, III is also an amateur musician and can be reached via e-mail at *memphishank@aol.com*.

———————————— • ————————————

The following text was adapted for use in *ASMP Professional Business Practices in Photography* from an article originally published in the *ASMP Bulletin*, assigned and edited by Jill Waterman.

AS AN INDEPENDENT BUSINESSPERSON IN A GRUELING ECONOMIC CLIMATE, YOU may find little wiggle room built into your margin for financial success. So when your client exceeds established boundaries in a prior, agreed-upon image license, what do you do? Must you lose (money) when a client doesn't comply with the time duration, media, geographic and/or other parameters in your contract? No.

Do you have options that aren't too painful, scary, or expensive to better your situation? To increase post-shoot revenue? To protect your rights without burning your bridge to possible repeat business? The answer to all of these questions is yes.

Your challenges in finding, delivering, and getting paid for your work are already substantial. Your chosen calling forces you to be salesperson, project manager, strategist, small business CEO, and maybe even part-time accountant. But you also need to add "advocate" to your professional skill set.

Digital technology allows thoughtless use and distribution of electronic versions of creative work such as your images. That's why the *New York Times* called our era a "culture of copyists." Even those who are not computer savvy or technically adept are accustomed to on-demand downloading of music, graphic art, text, and other electronic content. So prudent processes, questions, and clearances are sometimes forgotten, including by client personnel.

The good news is that recent court rulings show that *additional*, realistic, proven action items exist to help you avoid revenue "leakage" (loss). Smart photography businesspeople can implement straightforward processes to enable extra revenue, rather than generate mere resentment and remorse. This chapter summarizes savvy *supplemental* techniques to consider and adopt, other than "just bear it" or "litigate it."

INITIAL RECORDS CREATION

"Smoking guns" aren't just for crime movies. Send your client a memo or letter confirming or summarizing the pricing for "paths not taken." By documenting today your pricing for extra-use options, you reduce the risks of later uncertainty, haggling, low-balling, collection efforts, and costs when setting the fee for customers who exceeded their license. Such documentation can change the collection conversation from "We didn't know" to "How do we make out the check?"

ONGOING RECORDS-KEEPING

Prudent packrats can win. In every industry, monetary "valuation" is often an exercise in documentation: The party with better documents about pricing (including possible escalated pricing for unauthorized uses) dominates the discussion.

As the following example illustrates, it's crucial to document your initial notice(s) to errant clients. In 2006 a federal appellate court upheld a trial court judgment of $665,000 in favor of a wronged photographer, after a corporate customer *continued* to use the images licensed beyond the initial approved usage, *despite* its receipt of a cease-and-desist letter from the photographer's counsel.

WRITTEN CLIENT COMMUNICATIONS

U.S. copyright law reflects a moral component, enabling higher monetary damages for "willful" infringements, if copyright registration was made on a timely basis. Do your business practices and records enable you to show or prove when unauthorized use was "willful," rather than accidental? Your communications to inquire about unauthorized usage should not be primarily verbal. Voicemail

is ephemeral. Evidence is essential. To enable "moral leverage" and ultimate fair payment, use faxes (keep those fax machine receipts!) and certified, return receipt U.S. Postal Service letters, to enable future demonstration that "you did the right thing" while the infringer ignored you or dallied. Written records provide a clearer view of who did what to whom, when, and without permission.

Of course, e-mail is easy for normal operations and communications. But it can be inadequate to capture real remedial action from recalcitrant customers. If litigation is necessary to enforce your contract(s) and/or copyrights, you'll want proof of your client's receipt of notice of license breach. And in prelitigation negotiation, receipts from faxes and the postal service help focus senior management's attention, and perhaps even the client's lawyer, a judge, or a jury, on the fact that you're serious, and that you tried to highlight and halt the unauthorized use.

LOOK HARD AND WIDE BEFORE YOU LEAP

The unauthorized use(s) of your images that you spot may be solely a *subset* of the big picture. Your prior delivery of digital images means there may be *more* image misuse than you initially see.

When you find a license-breaching customer, don't immediately reach for that phone or your e-mail screen to complain. First, study up:

- Find and collect as many of your client's marketing materials as you can.
- Track superseded iterations of the client's Web site(s), using *www.archive. org*.
- Investigate whether your client shared the images with its resellers, suppliers, and other third parties, which may mean more revenue owed to you.

It's Not Just Business: It may be Personal (Liability) Too. Did you know that your customer's corporate officers, directors, and owners sometimes can be individually liable for their company's copyright (or patent) infringement? Most customers don't. And many clients' lawyers don't. They assume corporate status is an invincible, perpetual force-field.

CLIENT EDUCATION FOR POST-USAGE REVENUE

When you send a client a proposal or written confirmation of a sold project, consider adding text to remind the customer of what he is buying—and what he isn't. You might deter later requests for a low-dollar so-called "buy-out" by stating in print (not just verbally) from "day one" that you sell your services, as a professional, based on years of training, business experience, collaborations,

and other efforts. Include mention of qualifications like your ASMP membership, supplemental training, and additional services and expertise you provide that are value-added to your client.

These smart, relatively painless business practices supplement *primary* best practices like clear, complete contracts and prompt, correct copyright registrations. By upgrading your communications, contracting, record-keeping, and collection practices, you can and should optimize the odds of better outcomes when you discover customers who break the rules.

Negotiate or Litigate? When collecting from a party who exceeded an agreed license, it is essential to understand and carefully weigh the actual attributes, risks, and rewards of litigation. Sometimes negotiation can be a faster, less painful, and less complicated route. (But will it yield only inadequate, unfair payment?) These are just some of the issues that can arise in a lawsuit to enforce your rights:

- When your customer is based in another city or state, in which court(s) will the case proceed? Can you choose and control the venue?
- What are your chances for having litigation costs reimbursed by the client? Here, prompt copyright registration is key.
- Will a "multiplier" of the licensing fee be owed when unauthorized use is discovered after the fact? What's the multiple (number)?
- Is interest owed on payments that the customer should have made to you earlier? At what rate?
- Did your photographs help to significantly drive the success of the product or branding campaign? If so, can you collect payment for a portion of the client's revenues or profits?
- Might "alternative dispute resolution" outside court (e.g., binding arbitration and/or nonbinding mediation) be agreeable to both parties? Will that really reduce costs, and delay any ill will, or will it only yield further complexities?
- Do you have a choice? Will this customer pay up, without hearing "Ready for trial, Your Honor" or believing that you'll sue to enforce your rights?
- Will a jury or judge "see it my way" (e.g., as abuse of your rights) or be uninformed about the issue of rights (e.g., "anybody could make that photo")?
- When will it be over? (Can the customer stall, by procedural moves? Will one party or both appeal?)

But if individuals profit from their company's misuse and/or have but don't use the ability to prevent it, then they can be personally responsible. Educate your former client about such potential additional financial exposure. Such news can increase attention and respect for photographers' rights.

One recent case of photography license-enforcement litigation is particularly instructive. In late 2006, after a photographer complained about excessive use of licensed work, the former client's Chief Communications Officer simply removed the images from the *electronic* version of its annual report (an easy, cheap task). But he failed to recall and replace the *hard copy* version of that same document. The judge chided both the corporate *and* individual defendants for their deficient remedial actions.

This chapter is general information and not legal advice, and doesn't reflect the views of the author in particular facts or of his clients.

Frequently Asked Questions

by Stanley Rowin

The following text was adapted for use in *ASMP Professional Business Practices in Photography* from the Copyright Tutorial published by the American Society of Media Photographers at *www.asmp.org/copyright*.

GENERAL ISSUES

Q *How long is my registration valid?*

A In most cases, your life plus seventy years. There are, however, a few important exceptions.

Q *Do I have to renew my copyright?*

A No. Works created on or after January 1, 1978, are not subject to renewal registration. For works published or registered prior to 1978, renewal registration is optional but advised after twenty-eight years. See Circular 15, "Renewal of Copyright," and Circular 15a, "Duration of Copyright."

Q *What is "fair use?"*

A Although many people have their own notions about "fair use" of an image, there is a specific statutory definition restricting this category "to purposes such as parody, criticism, comment, news reporting, education (including the distribution of multiple copies for classroom use), scholarship, or research."

Q *Suppose that I have a contract with a client stating that no rights to my work are granted until I am paid in full, and this client publishes my photos before I have been paid. Can I sue for breach of contract, or is it a copyright violation? Or don't I have a case at all?*

A Generally, if your paperwork clearly and consistently states that no

rights are granted until and unless payment has been received in full, you probably could sue for copyright infringement, rather than breach of contract.

Q *When I submitted my images to a stock agency, I retained the copyright. Yet when I recently saw one of my images on a Web site, it had the stock agency's name next to the copyright symbol. What gives?*

A If you retained the copyright, as you should have, then the situation here is that the agency is protecting the digital file of the photo, which is displayed on the Web site you saw. The copyright to the original photo is not what is being claimed by this copyright notice. If you have questions, concerns or even suspicions that the stock agency might have overstepped its legal and contractual bounds—if, for example, your agency agreement limited the use of your images to certain media types, of which this is not one—contact the stock agency to inquire further.

Q *I sold a print of one of my images. Does that mean I sold the copyright to it too?*

A Not unless you agreed to, or the purchaser demanded, a transfer of the copyright as a part of the deal. The Copyright Office states: "Mere ownership . . . does not give the possessor the copyright. The law provides that transfer of ownership of any material object that embodies a protected work does not of itself convey any rights in the copyright."

Q *I gave my work a specific title. I have now seen another work, created after mine, that is using the same title. Is this an infringement of my copyright?*

A No. Titles, names, short phrases, ideas, and slogans cannot be copyrighted.

Q *It can take as long as eight months to receive a certificate of registration. What if there is infringement of my copyright during that time? Do I lose my ability to sue for statutory damages or ask for the other side to pay my court costs?*

A In the words of the Copyright Office: "A copyright registration is effective on the date that all the required elements (application, fee, and deposit) are received in acceptable form in the Copyright Office, regardless of the length of time it takes the Copyright Office to process the application and mail the certificate of registration."

Q *If I do work for a large company and make a licensing arrangement with it, can the company turn around and grant usage for the photos to one*

of its subsidiaries, without added compensation to me? Is this a copyright violation?

A Trying to resolve this issue could be long, nasty, and expensive. The best way to avoid such situations is to design your contracts and licensing agreements to include the granting of specific and thorough terms, as well as specifying any usage that you wish to exclude. Identify the specifics of all usage you are granting, including territory, duration, degree of exclusivity, and so on. Before you sign, make it clear in the document exactly who is receiving the license, whether that entity can or cannot assign its rights, and to whom (if anyone) it can assign them.

Q *If I am photographing a public building, am I violating the copyright of the architect?*

A Maybe. It depends on what you will be doing with the image (see fair use, above) as well as on specifics about the building and the architect.

Q *Long ago I transferred my copyright to a publisher. Now I wish I had it back. Is there anything I can do?*

A Sometimes there is a way. The Copyright Act provides for recapture of rights after fifty-six years for pre-1978 copyrights and after thirty-five years for newer copyrights. But we should warn you that the rules are quite technical and full of special cases; you will want professional advice. For starters, you can read Copyright Termination: How Authors (and Their Heirs) Can Recapture Their Pre-1978 Copyrights on the *CopyLaw. com* Web site.

QUESTIONS ON REGISTRATION

Q *Is the copyright registration process still suffering delays, backlogs, and inconveniences stemming from anthrax scares and other threats after the World Trade Center disasters?*

A The enormous backlog of registrations caused by post-9/11 security measures has now been almost entirely eliminated: In 2002 there were 187,000 open cases; in 2003 there were 21,000; in 2004 there were 3,000. The current time lag from receipt of a registration application to completion is approximately ninety days. Applications sent by U.S. mail to the Copyright Office are received approximately three to five days after arrival at the building.

Upon arrival, applications are immediately routed off-site for security inspection and irradiation. (The office has had to hire additional staff dedicated to the issue of registration materials that are received there,

damaged by irradiation.) To give some relief to copyright applicants, the Copyright Office records the applications sent by mail as being received two days earlier than the date of actual receipt at the office. Private couriers, who used to be allowed to bring registration materials directly to the office, are now directed to an off-site central security screening facility. The receipt of these registrations is recorded by the Copyright Office on the same date they are received at the facility, so there is still increased value in shipping registrations by private courier if the date of registration is likely to be significant.

Obviously, you should keep a backup copy of all materials you submit, in case a package gets lost, damaged, or destroyed somehow.

Q *I sent in my copyright form, along with images for deposit and my fee. But I haven't gotten a confirmation of this receipt. Should I be worried?*

A Since the Copyright Office receives well over a half-million applications every year, it cannot feasibly respond with a notice of receipt of every application. Once your application is successfully processed, you will receive a certificate of registration; if there is a problem with your application, you will get either a letter, phone call, or e-mail from Copyright Office staff requesting more information or letting you know why your submission cannot be copyrighted. In either case, it may take eight months or more for you to receive this correspondence. To be certain that your application was delivered, you should use a shipping method that allows package tracking and delivery confirmation, such as Federal Express or UPS.

Q *Can I register both published and unpublished images on the same form if they were taken in the same 12-month period?*

A No. A separate filing is required for each category. You must group published and unpublished work separately and make different filings for each.

Q *I expect that my images will be published, but I don't know when this will happen. How can I register when I don't know the date of publication?*

A Three strategies are possible. First, if you expect that publication is several weeks in the future, you can register the images right now as unpublished. As long as the effective date of registration (namely, the date the application is received at the Copyright Office) is earlier than any infringements, your rights are fully secured.

Another strategy is to publish the images yourself: Put them in a publicly accessible section of your Web site. Under U.S. law (as currently

interpreted by the Copyright Office), an image is published when a member of the public could obtain a copy. Thus, you technically would have to offer the images for sale; but the rights could be quite narrow, the price could be quite high, and you don't have to promote the offer very hard. (Obviously, this isn't a good approach if you are already bound by exclusive marketing or licensing deals.)

The third strategy is to wait for publication and take advantage of the three-month grace period that the law provides. As long as the copyright is registered within three months of actual publication (again, defined as the date when the public can get a copy), your rights are protected regardless of when an infringement may occur.

Q *So, just how many images can I register for one fee?*
A If you are registering published images using the Continuation Form (Form GR/PPh/CON), you may attach up to fifty continuation forms to one Form VA. That means you can have up to 750 images in each group. For unpublished images, see the ASMP's copyright tutorial for alternatives to using the Continuation Forms.

Q *I would like to register an old published image, but I don't have tear sheets. What can I do?*
A Although you need tear sheets or whole-page photocopies to register a single image, the requirement for a group of images is just "one copy of the image." It doesn't have to be a tear sheet; it can be a print, a digital file on disk, or a short appearance on videotape.

So all you need to do is find another published, unregistered image from that year and register them both as a group.

Q *What if I make a mistake in filling out the form?*
A The most likely consequence is that an examiner in the Copyright Office will notice the error and ask you to correct it. This may delay the date of registration (which could be a problem if you are already embroiled in a lawsuit) but otherwise is not harmful.

One error that an examiner is not likely to catch, especially in a group application, is registering a published image as unpublished, or vice-versa. If you notice that this has happened (or find any other mistake after your registration is granted), you can use Form CA to amend your registration. The fee for this is $100.

Why bother? If you sue an infringer, the first thing the defense lawyer will check is whether your registration is valid. If he finds a mistake, he

will try to use it against you. There is a precedent in your favor, but it is far better to present an airtight registration in the first place.

Q *When I download and print out the copyright registration form from the Web site, it comes out on two pages. Yet the form received directly from the Copyright Office is only one page, with printing on both sides. When I submit an application, can it be on two pages, or do I have to print it on both sides of one page?*

A One page, both sides. The Copyright Office won't accept your application if it's on two pages. Furthermore, you've got to print it head-to-head; that is, so that when you turn the page over, the top of page 2 is directly behind the top of page 1. If you don't follow this procedure, your application will be returned to you as incomplete. This will delay the date of your registration. The same regulation applies to photocopying an application form: two sides of one page, top to top.

Q *I use a pseudonym for my photo credits. Should I register my copyrights with my real name or the pseudonym?*

A It depends on what you prefer. If you use a pseudonym on the work but want to be identified by your real name for purposes of copyright, you can easily do this on Form VA: In Section 2a, where it asks for Name of Author, write in your real name followed by "whose pseudonym is" and then the pseudonym. Additionally, in the same section, check the box next to "Pseudonymous" where it says, "Was This Author's Contribution to the Work?" On the Short Form VA, you should write in your real name, then include your pseudonym, followed by "pseud."

However, if you don't want your name to appear on the copyright form, and you merely want the work to be registered under your pseudonym, you should write only your pseudonym in the space that asks for your name, followed by the word "pseudonym."

In either case, you must put a name in Section 4 of Form VA—you cannot leave it blank. You can put your pseudonym on that line, but the Copyright Office warns, "if a copyright is held under a fictitious name, business dealings involving that property may raise questions of ownership of the copyright property." In other words, should there be doubt about who owns the copyright at some time in the future, having only your pseudonym appear on the application might not make a case for you. This is where a good copyright attorney can be helpful to guide you in how to proceed.

Q *I'm publishing a book of my photos. Instead of going to the trouble of registering the photos, can I just copyright the book to cover the images as well?*

A If you own the copyrights to all of the components of the book, the registration will cover all of the materials in it. However, if there is more than one copyright owner involved (Web site, you own the rights to the photos, but someone else owns the copyright to the text), you should register the photos separately.

Q *Now that I shoot digitally, how do I submit my images for copyright registration?*

A Burn them onto a CD. The Copyright Office will accept CD-ROMs and DVD-ROMs as deposits for registration. It is not necessary to submit prints of the images along with the files on disk. Some photographers suggest that you send along a "contact sheet" — a page of thumbnails (or multiple pages, if you're registering a large group of images) to display the contents of the CD, with coordinated information (numbers, names, whatever) that links the thumbnails to the more substantial images on the disk. (Low-resolution JPEG is the preferred graphic format, as opposed to GIF or TIFF.)

Q *I know that after I register I'll get a certificate in the mail indicating and proving my registration. But I'd still like to see the official registration information as it exists at the Copyright Office. Is there a way to do this?*

A If you registered your copyright after January 1, 1978, you can search online at the Copyright Office Web site. (From the site's home page, you would click on "Search Copyright Records," then on the "Books, Music, etc." section.) Indicate the type of search and the term you're searching for, and your record should be accessible. If not, get in touch with the Copyright Office to find out why it's missing. One important note: It will take several months after you receive your registration certificate for your record to go up online, so be patient.

PRACTICAL CONCERNS

Q *My image has not been published. Can I still put a copyright notice on it?*

A You don't need to—as soon as your image was fixed in a tangible medium, it was automatically protected by copyright, whether published or not— but it can't hurt to let others know. Including a copyright notice may also have some legal benefits by putting the world on notice that the material is copyrighted. The standard format applies—© followed by the date, followed by the copyright holder's name—although another way

of noting that it is not a published work is to write the copyright notice using the following format: "Unpublished work © year + copyright holder."

Q *I've sent in an application to register some of my unpublished work. Do I have to wait until I receive the certificate of registration before I am allowed to publish it?*

A No. You do not have to receive your certificate of registration before you publish your work.

Q *I'm self-publishing a small run of a book with some recent images. They're probably not very commercial, I don't expect the book to sell well (or at all), and I don't feel like spending the time or money to copyright them. What is the least I can do?*

A The instant you made each photograph, it received immediate copyright protection. If you wish, you could just put a copyright notice at the front of the book and call it a day, although you don't even have to do that. You don't have to register all or any of the images, but if you don't you could run into trouble in the future if someone "borrows" and uses one of your photos without your permission.

There is one thing you must do, however: As owner of the copyright of a work published in the United States, you have a legal obligation to deposit with the Copyright Office two complete copies of the best edition of the published work, within three months of publication. The Library of Congress and the Copyright Office consider this mandatory, and they can fine you if this is not done. Submitting these copies does not start the copyright registration process, but it could if you also submit the necessary copyright registration forms and fees along with the deposit.

Q *I'm putting together a Web site to show and promote my work and business. Does putting images up on a Web site constitute publication for copyright purposes?*

A What constitutes "publication" for copyright purposes is a difficult question, with very little practical guidance for those things that fall into the vast gray area. Marybeth Peters, the Register of Copyrights, has publicly stated on multiple occasions that her opinion, and the position of her office, is that images uploaded onto a Web site in an area that is available to the public for access constitutes publication of the work. Assuming that this area of your Web site isn't password-protected or otherwise restricted, it is probably safe to take the position that those photographs are published.

There is also a second question to consider: Were any of these images previously published before appearing on your Web site (and if so, when?), or is this the first publication for all of this work? If none of your images were ever published before, you can register the whole collection in a group registration. If some of the images have been previously published, your best bet is most likely to register the unpublished work as a group, and to deal with the others separately, perhaps individually or perhaps in another group or groups. This gets confusing, and you may want to visit a copyright attorney for guidance in this matter. Further information about registering online works can be found in the Copyright Office's Circular 66. You will also want to read the information on our Group Registration tutorial section.

Q *How much money can I sue for in a civil copyright lawsuit?*

A If the lawsuit is for a work that has been registered at the Copyright Office, the damages can be quite stiff. A copyright owner may elect to recover statutory damages under Section 504 even if actual damages (such as lost profits) can't be proved. Statutory damages are amounts set by law. A copyright owner whose work was registered with the U.S. Copyright Office before the infringement (or within three months of publication) can elect to choose statutory damages or actual damages. Actual damages (also known as compensatory damages) are the dollar amount of any demonstrable loss suffered because of the infringement. Most copyright owners will choose statutory over actual damages because there is less to prove in order to obtain payment. Statutory damages are set by law at a minimum of $750 and a maximum of $30,000 per infringement, "as the court considers just." If, for example, the court finds that a defendant infringed on ten photographs with registered copyrights, he may be facing a $300,000 judgment. If you can prove the infringement was committed willfully, the court has the discretion to increase the damages up to $150,000 per work. Furthermore, the court may determine that the losing party must pay the winner's costs and attorneys' fees, under Section 505. On the other hand, if the infringer can prove he was not aware and had no reason to believe the act was an infringement, the court may reduce the award to $200.

Q *Can two or more people own the copyright to a single work?*

A Yes. It creates joint ownership of the copyright, which can produce problems down the road. Each owner is an equal partner and might be able to make independent negotiations for licensing and might be able to sell or assign his rights independently of the other owner.

Q *Someone has linked to one of my photos on his Web site. Is this legal?*

A There are basically two ways in which your photos may appear on someone else's Web site. The first is by someone else actually copying your image file and putting it on his server for display on another site. In most cases, this is blatant copyright infringement, with or without a credit line. In some cases, the alleged infringer might claim this to be fair use, and it may very well be. But it will be up to you to contact him and to inform him that he is violating your copyright.

In the second case, the image file is actually not being copied to another server; someone else's browser is just being pointed to your server so that the image appears to come from his page. This situation is a little more problematic. Most copyright laws were written before the Internet. Until legislation catches up to the technology, we have to rely on case law for direction, and little exists in this area.

Sample terms that can be used on a Web site generally specify the following: ". . . the images, text and coding on these pages may not be copied to another computer, transmitted, published, reproduced, stored, manipulated, projected, or altered in any way, including and without limitation to any digitization or synthesizing of the images, alone or with any other material, by use of a computer or other electronic means, or any other method or means now or hereafter known, without permission of the creator."

If you use these terms, infringers may be held liable for "contributory infringement." A contributory infringer isn't controlling any copying but has taken actions solely to cause other people to make allegedly illicit copies for themselves. (This was part of the Napster suit, for example.)

If the link showing your photo on someone else's site is hidden, he is probably violating your copyright. If there is only a link to your photo on another site and a user has to click on this link to view your image, then your copyright has probably not been infringed.

Your next step would be to contact the owner of the page and the Internet host of the page to alert them to the situation and to request that your image, or the link, be removed.

Q *What if an American photographer gets ripped off by an overseas publisher? What about foreign photographers operating in the U.S. market? Which country's laws apply?*

A Lawsuits for copyright infringement are always filed in the nation where the infringement occurs. Each nation that has signed the Berne Convention promises to protect the rights of others as well as those of its

own citizens. However, each nation has its own procedures for filing suit and its own rules that govern the damages that might be awarded. (If you are infringed in another country, you will certainly need a local lawyer.) One of the major differences between procedures in the United States and other nations has to do with registration.

Very few nations require registration as a condition of suing for infringement; if they have a registration system, it's designed mainly to support the national licensing agency. For U.S. citizens, this means that satisfying American law is usually all that's needed to be eligible to file a claim in another country.

Non-U.S. citizens are allowed to register their copyrights in the United States, and if they regularly market their photos to U.S. publishers, they probably should make the effort to do so. Whether their copyrights are registered or not, foreign nationals are able (under the Berne Convention) to file infringement suits in U.S. courts. But if they have not registered, they can seek only actual damages. If they have registered, they can seek statutory damages, which reduces their burden of proof.

Assignment Photography

"You need a particular configuration of skills in this business, and only one small part is being a photographer and creating good pictures."

—Paula Lerner

The Assignment Photographer

UNDERSTANDING THE VALUE YOU PROVIDE

by Susan Carr

Susan Carr specializes in architectural photography and has served commercial clients for more than twenty years. Her work is exhibited widely and is included in corporate and private collections, most notably those of the Pfizer Corporation and the Museum of Contemporary Photography. Susan was president of the ASMP from 2004 to 2006; she lectures and writes on the business of photography and continues her work for the ASMP by coordinating educational events, including the Strictly Business 2 conferences.

————————————— • —————————————

INDEPENDENT ASSIGNMENT PHOTOGRAPHERS ARE AMAZINGLY VERSATILE INDIviduals who solve creative, technical, and business challenges in an integrated and often seamless manner. The value of this to the buyer of our services cannot be emphasized enough, yet in this day of price-driven shopping and difficult business contracts, it is a value that often is overlooked. A talented and experienced assignment photographer becomes a partner with her client, turning an idea into a meaningful communication tool—the photograph. Whether selling a product, a building, an emotion, or a service, nothing is more important to communicating the client's message than the visual representation of the concept. The photographer is the key to making this happen successfully.

Assignment photographers are being hit from all sides by slashed advertising budgets, rights-grabbing contracts, and technology demands. Add the explosion of the stock photography business over the past decade, and sustaining an assignment business becomes very difficult.

Assignment photographers have long rested their futures on the belief that

the unique and specific needs of buyers would remain under their exclusive purview. Like so many other things in our industry, this long-held truth is changing. Knowing that the largest market in commercial photography is in fulfilling extremely specific image needs, stock photography distributors are developing ways to expand their services and grab a piece of that $4 billion assignment market. This isn't inherently malicious, nor does it mean that photographers will not still be needed in the future. But it does signal that the owners of the mega-archives and distribution channels will play an ever-increasing role in how independent assignment photographers fit into the landscape.

The assignment photographer lost the business of creating generic photographs when the stock photography business became part of the mainstream advertising workflow. No buyer needs to commission a photograph of a woman at a computer or a pastoral landscape anymore, as a selection of these types of images are just a click and credit card purchase away.

The lines of our job distinctions are getting blurred. Rental studios now hire photographers on a work-for-hire basis, putting themselves in direct competition with independent photographers who used to be their client base. Corporate photographers with less work are taking on wedding photography and, sadly, often deliver digital files to the client with no restrictions. This is contrary to established procedures of image use based on specified rights. Ad agencies are using online job bidding systems, adding to the commodification of our services. Large stock agencies are becoming assignment agents, putting them in competition with the Associated Press, Magnum, and independent artist reps.

In order to combat these changes, it is imperative that independent assignment photographers understand the value that they provide their clients. Each photographer will likely have additional items on his individual list of "value-added" qualities, but these six basics apply to all professional assignment photographers:

- Unique imagery—the photographer's vision.
- Fulfilling the client's specific imagery needs—communication followed by interpretation means the photographer produces images customized for the project.
- Client protection—from having liability insurance, to proper licensing paperwork and securing necessary releases; the photographer protects her client from legal headaches.
- Tailored and appropriate licensing—whether exclusive or one-time print, the independent photographer can customize the usage to carefully fit the needs of her client.

- Customer service—professionalism from planning to postproduction gives the client an efficient and positive experience.
- Digital expertise—by adhering to industry standards, the professional photographer will deliver quality digital images ensuring that the photographs, and by association the client, look good in any media.

Professionalism for the photographer means consistently delivering in these six areas.

More than ever, it is important for photographers to focus their business strategy, service, and marketing on the unique things they bring to the table.

Images are so abundant in our current culture that we often become numb to them. We need to empower ourselves by acknowledging the value of what we create. A well-seen photograph is, as it has always been, the most powerful communication tool available. The stagnation of our fees appears to contradict this claim. But ask yourself—if photographs did not have value long into the future, why would all of these publications, corporations and archives be scrambling to grab our rights to those very same images?

In the face of forces telling us otherwise, we need to support each other, to recognize that quality still counts and that our work is still valuable.

Interviews with Assignment Photographers

by Leslie Burns-Dell'Acqua

Leslie launched the oddly named Burns Auto Parts in September 1999, continuing her career of helping creatives make a living doing what they love. In addition to her consulting work, Leslie has written many photo business book chapters and articles, and her own photo biz book, as well as lectured to creative groups across the United States. She also produces the monthly Creative Lube podcast and the Super Premium blog.

—————————————— • ——————————————

THERE HAVE ALWAYS BEEN THOSE PHOTOGRAPHERS WHO SPECIALIZE IN ONE OR maybe two particular areas. We all know Arnold Newman and his environmental portraits, or Richard Avedon's fashion images, but until fairly recently specialization in commercial photography was more often a case of market than style. For example, a hypothetical Betty Photographer in 1987 may have self-defined as an advertising photographer, but she would shoot people or objects or even food as needed for those clients. This made sense as each city or region (geographic market) could only sustain x number of working pros, and then only if each could shoot a variety of subjects for local clients.

Over time, photographers in local markets began to specialize more. You may have had the "people guy" or the "product guy," but again often the style was less than visionary as they would shoot in the style necessary to please whichever client they were serving rather than making images fully in their own vision. The big budget project requiring true specialists often went to photographers in New York City, London, and so on. Local markets still could not sustain the true visionaries. These photographers would still generally be

forced to move to major markets to have a chance at having a sustainable business doing their work, their way.

Now, the rise of the Internet, with instant and cheap global communications, has changed the way business works. The digital revolution has also contributed as photographers can send FTP images to whomever and wherever, eliminating delivery delays and making long-distance approvals simpler and more efficient. Thus the trend is toward clients in whatever locale, selecting photographers for assignments not based primarily on proximity or existing relationships, but rather on whose vision most closely matches the art director's/designer's for any given project. Art buyers, designers, and marketing managers—every client now has the ability to review literally thousands of online portfolios via portals and photographers' own sites. They are no longer faced with saying, "I guess LocalBob can do this project well enough," instead saying, "PhoenixJim and SeattleSusan and BostonBill are really close to my vision for this project. Let's talk to them!"

While there will always be local clients and those projects awarded because of location as well as style (for example, *Forbes* may need a CEO in Cleveland shot and it's likely to get someone from that area to do it), this evolution in the business now means that photographers can truly specialize and create sustainable businesses in any location. If a photographer shoots well enough and with enough sense of vision she can now market relatively economically to clients nationally, and even globally, thus finding the best potential clients for her business. She'll also be shooting work much more like what she creatively loves to make, wherever the client may be.

Thus the very notion of how photographers classify themselves is changing. Some self-define in the minutest stylistic detail ("I shoot interior environmental portraiture, only in color and natural light, and with no postproduction manipulation," for example) while others are less specific. Nonetheless, there are still certain broader categories which even the highly defined can find themselves part of.

The following descriptions are the result of interviews with individual photographers in various specialties. While there are clearly consistent threads in each category (like the use of contracts and licensing), there are also significant variations with each specialty. It is important to remember, however, that these individuals are only examples and that your business, even within any of these categories, may very well be different. Let these interviews function as helpful references and examples then, not idealized definitions nor directives to follow without significant attention to the context of your own business.

We suggest you review each photographer's Web site to get a better understanding of the work and how she is marketing their business.

Also, the ASMP would like to thank each of the interviewees. Most of them not only helped by being so open in these interviews, they also provided examples of their paperwork for the ASMP Paperwork Share (*www.asmp.org/licensing*). Their kindness and generosity are deeply appreciated.

ARCHITECTURAL PHOTOGRAPHY

Lynne Damianos is an architectural photographer in the Boston area. As such, the majority of her clients are architects and general contractors. Architectural photography differs from some other specialties because of the nature of the architects' and contractors' needs as well as the technical considerations of shooting large objects (which still often need to be lit) and the creative issues all of that can evoke.

Damianos lists safety gear (hard hat, safety glasses, work boots, reflective vest), a six-foot ladder, a cleaning kit, and walkie-talkies among the items that she needs for her specialty that other photographers might not need for theirs. She points out that she definitely makes sure she has covered "the basic requirements needed for Certificates of Insurance (COI for Worker's Comp insurance and liability insurance). Many of our clients will not allow us to work for them unless we have certain coverage. We also need to be able to reach our insurance agent while on a photographic assignment so that he may fax over a COI in a moment's notice if we need to get access to a roof top of another building to photograph for our client, or for a similar situation."

Estimating for architectural photography brings up its own issues. Damianos explains her process this way: "First, we need to know what direction the building(s) face, number of views, costs if time allocation or number of views exceeds estimate, weather, time frame, end needs including usage, multi-party information if applicable, what's included in file processing, what is considered retouching, and delivery of final images."

When it comes to figuring the fee portion of her estimates, she makes sure to include the following in her calculations: time spent traveling, photographing and nonexclusive general marketing use (combined into one number). She also notes that her business requires 50 percent of the estimated fee to be paid up-front by new clients.

As most of her clients are using her images for their Web sites, short-run collateral and for competition entries, this combination of use ("general marketing use" mentioned above) is the basis of her usage rates. Damianos notes, however, "Advertising usage would be an additional fee, based on specifics." Damianos makes sure to include pre- and postproduction into her calculations as well. She estimates that on an average project, "We average about one to one and a half hours, including getting project specifics, directions to site, creating

the estimate, checking on weather" and so on for pre-production. For post, the figures are "approximately one hour for each photography hour. For interior views, we allow an average of 45 minutes for file processing/basic retouching. For exterior views, we allow 30 minutes."

For architectural photographers, she notes the following as special concerns she makes sure are covered: weather, corporate approval from the location's headquarters (if a franchise or bank, etc.), security access, purchasing parking meters and hiring police detail (so cars don't park in front of a building), meeting insurance requirements (as discussed above), property and model releases.

While architectural photography isn't often considered a strong category for stock relicensing, it can happen and client relicensing can happen as well. Damianos estimates that for each of the past three years between 9 and 19 percent of her photo income has derived from relicensing of existing images.

Like most photographers, her business has shifted to exclusively digital photography. Digital technology, however, has affected her specialty in other ways she specifically wanted to voice: "It's one field that isn't really being hurt by stock. However, many of our clients are photographing the simpler projects with their own digital cameras. We rarely photograph construction progress now because of that. Undercutting by emerging photographers and pros that have other specialties is hurting our business."

CELEBRITY PHOTOGRAPHY

From his base in Miami Beach, Florida, Brian Smith has built a successful business doing celebrity portraiture. He works with clients in advertising, editorial, and the corporate arenas including TV and movie studios.

Working with celebrities and other high-power people can be significantly different from shooting "normal" people. Time is one of the major issues. Smith makes the most of the brief time he has with his subjects by planning ahead: "If we're planning three shots, we generally rent enough lighting so we can prelight all the shots to save time."

That planning carries over into other aspects of the shoot. "We always have back-ups for the camera and everything else that will only break down at the worst possible time. When catering, find out how many people are in the celebrity's entourage, so that everyone gets fed. Hungry posses are not happy posses."

At other times, catering might not be an issue (if you only have fifteen minutes with the subject), but knowing the personality of the subject can make or break the shoot: "Certain athletes will give you the look of death if you even suggest grooming and others will ask why you bring a groomer. Their agent or the team PR can usually tell you what to expect."

Obviously, preproduction is an important part of Smith's business. However, depending on timing, it can vary in its complexity. He offers this example: "Even on editorial, I have some shoots where you rehash every minute detail over a month and others where it's like, 'Serena is flying to Europe first thing tomorrow morning, but if you want she'll give you two hours if you can be at her place by five . . .' and you end up doing production on your cell as you drive."

Postproduction is dependent on the number of shots and the amount of retouching needed. He switched to shooting only digital in 2006 but states that he'd still shoot film when it was right for the project.

Smith also includes coverage in his terms and conditions for uncontrollable issues like weather. "I've never had a client complain if we needed an extra day because of weather because it's always cheaper to pay you an extra day in the event of weather delays than to re-shoot the job," he said. Again, planning and experience can save the day even in these situations: "Generally the issue is the availability of the subjects, so more often it's a case of coming up with Plan B to salvage the job."

Smith licenses usage and prices his fees accordingly: "In editorial, the fee is whichever is greater between the day rate and space rate. If a photo is planned for a cover or double-page spread, I generally try to get that rate as a guarantee. On commercial shoots, the creative fee is based on usage and the complexity and number of shots."

Because he licenses his work and protects his copyright, he has a secondary income stream from stock/secondary relicensing of his images. He points out that not every image will generate this additional revenue, saying "The top 10 percent of assignments probably generate 80 to 90 percent of all relicensing income."

Model releases can be difficult to get from some celebrities. Smith uses them always for advertising projects, but for editorial they aren't needed. However, that doesn't limit him from generating additional revenue from these shoots: "Even without releases, it's still possible to syndicate [the images] for editorial use and with celebrities even editorial can be licensed for decent money. It's also pretty common for celebrities to approve photos for commercial use just so they wouldn't have to sit for another shoot—provided they like them." Like many good businesspeople in photography, Smith asks for advances: "I generally request a 50 percent advance on advertising, though I've waived that if it's a client that I work for a lot who pays quickly." He adds that editorial clients are generally exempt from advances unless "the client is notorious for not paying, in which case it's a good idea to get the entire amount up front."

Smith wanted to share these final thoughts with photographers:

Diversify, diversify, diversify. . . . If you shoot assignments, don't overlook stock as an additional income stream. If you're a successful stock shooter, consider assignment work that takes you out of your comfort zone and allows you to grow.

If you can imagine doing anything else for a living—you should. But if you can't imagine doing anything else, you're a photographer . . . so go out and make the pictures you love to shoot.

EVENT/WEDDING PHOTOGRAPHY

Colleen Woolpert is a Syracuse, New York photographer in transition. She has been shooting event photography for several years and is now moving out of that arena and more into advertising/assignment work. However, for this interview she kindly discussed her event and wedding photography business. As is usual for this specialty, her clients have generally speaking been consumers rather than businesses, which brings a unique set of challenges.

One of the most important aspects of this specialty Woolpert wanted to share with emerging photographers is that a "lack of confidence is the biggest handicap I can bring to a shoot." Technical ability reduces the chances of that happening: "For event photography and editorial assignments, I better be extremely comfortable working with available light and off-camera flash." She goes on to say, "When shooting in real-life situations where the light is changing or the environment is changing, it's most important that the photographer can quickly analyze the scene and make technical decisions in a split second to make the shot that she envisions."

In a fast-paced situation as one often faces in event photography, backup gear is also extremely important. Woolpert suggests having at least two camera bodies, flashes, and wires. She also emphasized the need for a battery pack to charge your flash: "I use a Quantum Turbo 2 x 2 and I don't know how I survived without it. I used to lose two out of four flash shots relying only on my flash batteries. Especially when you're firing rapidly to catch actions that will never be repeated, you need your flash to fire each and every time, and a high-quality battery pack provides that assurance."

When it comes to pricing and producing estimates for event photography, the time required is a significant factor, much more so than in other specialties; usage is rarely a factor. "My fees are different for shooting six hours versus ten," says Woolpert. Travel also plays a significant role in pricing, and the end product must be considered as well. "I need the location of the event up front to figure travel costs. Lastly, I need to know the final products that the client wants (e.g., albums, prints, etc.)."

She says, "My creative fee is based on what I must earn to stay in business

plus other factors specific to the job (i.e., difficulty of shoot or what special skills I bring). When I started my business in 1996, I studied the ASMP's Business Bible and came across the chapter on determining your cost of doing business. I still use this basic formula, but I have to remember to adjust it each time I move locations or when some other factor in the equation changes."

This is not to say that Woolpert ignores usage for her event work. Relicensing can and does happen, and she is clear about the differences in pricing: "The fee for the same image varies widely depending on the end user. I might sell a reprint to someone who attended a wedding but then license that same image to a magazine for ten times that amount. Advertising usage would command still greater fees."

Pre- and postproduction are often rolled into the price for event photography and that changes the profitability significantly from what one might think. Woolpert explains it this way:

> For a Saturday shoot, I start working Thursday. I clean and prepare my gear and review the information about the wedding. If a wedding is out of state, I often do this on Wednesday and travel on Thursday. On Friday I scout the location at roughly the same time of day that either the ceremony or posed portrait session takes place, and I attend the rehearsal that evening. I might do more preproduction than a lot of other event shooters, but this helps me feel comfortable on the day of the event. After the shoot, I spend five to seven days on postproduction. This involves downloading and backing up memory cards, editing the selections, color correcting the final images (up to 800!), and posting the images to my Web site. I could spend less time on postproduction if I shot JPEGs instead of RAW files, or if I hired someone to help with the postproduction, but I'm unwilling to do either of those things.

Woolpert uses contracts in her business to make clear the usage granted to the client ("Personal use only, and they may not scan, photocopy, or download images. However, I allow one print to be reproduced for newspaper announcements.") and to ensure additional income streams by requiring products (e.g., reprints, cards, etc.) to be ordered through her studio. She also protects herself from future problems by including clauses covering "inherent qualities" and liability releases for claims based on fading or discoloration of prints over time.

She also uses releases whenever she can and in one additional situation very specific to her specialty: "The bride and groom [must be released] before a magazine will publish their wedding story. I don't understand this, as the usage is editorial, and I do not need to get releases for other guests in the photos. For

editorial photography a release is [generally] not necessary, but for advertising it is essential."

Advances are typical for event photography. Woolpert points out, "For weddings, payments are in thirds with the balance due the day before the wedding ceremony."

Interestingly, Woolpert is not fully on the digital wagon. While she does shoot digital often, she continues to shoot film as well, noting that

> My favorite camera is a film-based twin-lens reflex camera called a Flexaret that I picked up in Prague for $20. I also have a Russian 3-D camera that takes 120 film. I shoot these cameras at waist level and love how they make me see things differently, so I will continue to use them. I do miss Fuji film, but I love the control that shooting RAW digital files allows.

Lastly, Woolpert offers advice that she herself has clearly followed: "Get to know yourself, and then be yourself. You'll stand out for it."

FINE ART

Kim Kauffman has a dual photography practice—a business-to-business commercial photography studio and a fine art practice, both based in Lansing, Michigan. For this interview she focused on the fine art side of her business. For this she shoots primarily digitally, but makes it clear that if the project would be better served using film, she would not hesitate to do so.

Not surprisingly, as a fine art photographer, Kauffman's clients are art galleries (who also act as agents for her work), museums, interior designers, art brokers, corporate art buyers, and individual collectors.

The fine art photographer faces technical challenges which most commercial photographers do not have to consider. Kauffman describes them: "Archival considerations have always been the concern of photographers printing work for display and purchase by collectors, using the best methods to ensure that prints are properly processed, fixed, protective toned, washed, and stored. Keeping up with archival processes for making prints from digital files (as I do) seems far more daunting. It is essential to keep up with the newest introductions in processes, printers, ink sets, and papers."

Other digital considerations are more typical of all photographers shooting digitally today: "Add to that the necessity of understanding and applying color management in the digital world. The digital darkroom is a wonderful new way of working, but the learning curve is steep and the learning does not seem to end."

Kaufmann wanted to emphasize the importance of written contracts and

confirmations in the fine art world. For example, she learned the hard way that what is said and what is heard can be two very different things. She once quoted a wholesale price to a gallery owner on the phone, expecting the owner to add in her commission to then get the retail price for her client. Unfortunately, Kauffman didn't follow up with a written confirmation of the details and, when the check came, it was for a much lower fee than she had expected. The gallery owner had heard "retail" when Kauffman said "wholesale" and thus took her cut from the lower price. She's learned from that ordeal, however: "Always follow up any prices you may quote to a client over the phone or in conversation immediately with a written estimate. Now I may quote a price over the phone but note that it is a ballpark price and ask that the client wait for my written estimate/order confirmation. I have a template for this form in my computer and can generate and e-mail a PDF in minutes."

There are other contractual/paperwork issues in the fine art world:

It is critical when dealing with galleries that are taking work on consignment, rather than buying it outright, that a detailed delivery memo/consignment agreement is used. It will list the works consigned, with title, medium, size, description, edition number, and retail price. It also specifies the percentage of retail price that the artist is paid, terms of payment, who is responsible for the work while it is consigned, and what might happen to the work if the gallery were to close during the period of consignment.

I use a predelivery memo that serves as an order confirmation when a gallery or art broker orders prints. This details the work requested, with title, medium, size, description, edition number, and retail price. I must receive a signed confirmation before making the prints. The confirmation can be converted to an invoice upon delivery of the photographs.

Fine art generally does not involve usage, as prints are sold for display only. However, to calculate her prices Kauffman needs to consider other factors. Chief among these is whether or not a print is a limited edition. Limited editions are more valuable "because you are guaranteeing that only a specific number of prints of a certain image will be sold and/or enter the art marketplace." Generally speaking, "the factors to be weighed when defining what a particular image will cost per print and earn over the life of the entire edition are similar to the factors I consider when estimating a creative fee for my commercial assignments: my overhead, the exclusivity of what I do, the experience I bring to the work, and the weight that my name and reputation carry in relation to other artists doing similar work."

Kauffman was sure to note that she uses the usage-licensing model in her non–fine art (commercial) work. And while releases are not required for fine art, she definitely uses them in her commercial business.

As for advances, they are a good idea in the fine art world, when possible. Kauffman points out that "most galleries only accept work on consignment, especially if you are not a well-known artist," but on commissions she expects one-third of the fee in advance, one-third at final approval, and the final third when she delivers the print. She also explains, "If I receive an order for prints from my catalog of limited-edition photographs, I will request an advance if the order is large or the client is new to me. It will range between 30 percent and 50 percent of the total fee."

When asked whether she would like to share anything else about being a fine art photographer, Kauffman said,

Seek other people's comments on your work, hear them and analyze them, then make your own decisions and guide your work from your experience, instinct, and heart.

When doing fine art work you need only to satisfy yourself. This is a great luxury but also a burden and requires that you develop confidence in yourself and your vision. Authenticity in your work—work that is genuinely yours— is essential for your photography to speak to others. There is a fine line to walk. On the one hand, it is good to seek and evaluate others' responses to your artwork. We necessarily are so close to our work that we see it only from our own point of view. Another person's opinion can help us see the work differently, and that can lead to insights. These insights can help us continue to push and evolve our work. On the other hand, we need to see how these suggestions feel and incorporate into our work only that which fits for us (it may take a while to find that fit, so give it time). It is easy to be swayed by current trends or what others think will sell, but if it is not a good fit it will be forced and the work will look that way.

In commercial work we are happy when our client is happy. It is the same in fine art work—only we are the clients, and we can often be confused and extremely hard to please. You know when your work excels and when it falls short. Trust your instinct.

[For more information on working in this arena, see chapter 14, "Making Strides with Your Fine Art Career."]

Specialty Groups. Specialty groups within the ASMP provide a unique opportunity for photographers to exchange information and techniques among themselves, and with other photographers within a defined specialty or segment of the business. These groups maintain listservs and mobilize as necessary to address specific trade issues of concern to the specialized members. Go to *www.asmp.org/community/specialty.php* to learn more.

- *Architecture.* The Architectural Photography Specialty Group serves as the leading forum for architectural photographers around the world. Formed in 1994, this group's members create images of architectural designs that further the appreciation and understanding of architecture. The group's aim is to foster greater communication within the photographic community, and to increase understanding and cooperation among architectural photographers, clients, related trade organizations and the entire design community.

 Among the group's projects are various publications (such as the joint AIA-ASMP Best Practice papers on Commissioning Architectural Photography) and cultivating contact with the architecture and building industries. The group also maintains an active Web site for its members.

- *Fine Art.* The Fine Art Specialty Group is a community of photographers interested in creating, exhibiting, and selling fine art photography. It works to network, educate, and promote ASMP fine art photographers. To achieve this goal, it has created a Web site for the exchange of information, is working to create a resource guide, and helps the ASMP Fine Art Specialty Group members produce and host events and panel discussions in coordination with their respective chapters.

- *Food.* The Food Specialty Group works on education and outreach to people involved in culinary photography and related industries. It supports an enthusiastic Web site, which is open to both ASMP members and nonmembers.

FOOD PHOTOGRAPHY

Seattle-based Kate Baldwin shoots many things but is primarily known for her food work. In this area her clients are diverse and include "magazines, book publishers, frozen food manufacturers and resellers, client direct (all kinds, for annual reports, Web sites, etc.), design firms, and occasionally ad agencies."

She's learned from experience that hiring stylists whenever she can helps her create her images and that, when traveling, remembering extra sync

cords (or transmitters and receivers) can save the day. Because lighting is very important in food, having a good lighting kit is a necessity even when the images are supposed to look "natural." When she's creating her estimates, Baldwin, who shoots digitally, makes sure to include her digital postproduction costs: "It's absolutely essential to cover yourself for all of the time you spend downloading, editing, perfecting exposures, archiving, disk-burning, etc." whether the client is editorial, advertising, or whatever. Preproduction is also important:

> With food photography I often hire a food stylist who provides all the pre-production shopping time for food items, and a good rule of thumb is forty to sixty minutes per photo (unless these are specialty items, in which case this will increase drastically). I almost always need props (dishware, tablecloths, backgrounds), and I do most of this preproduction/propping (unless I have a prop stylist), and I spend anywhere from one to two hours per basic photo (and many more for unusual/large sets). I always try to prop for multiple jobs at once, when possible.

As for her fees, she tries to keep things simple for certain projects: "For packaging I have one rate per package (assuming one photo per package), which includes my photography production and packaging use (including sales sheets showing this packaging) for five years of usage. I am sometimes able to give quantity discounts for multiple packages done at one time, but I don't use a day rate." She also notes that, like in other specialties, editorial rates are significantly lower than other uses.

While property releases are rarely a part of her business, Baldwin is sure to use model releases. Her rationale sets a wise example:

> Even if it's unlikely I'll ever actually "need" to resort to it, it's nice for my client to know that they are covered by the release. Let's say I'm shooting for a restaurant, and one of their employees appears in a photo. The employee may be very happy to do it, but what if a year from now they leave on bad terms and want their photo pulled from my client's marketing materials? If I have a model release, my client is protected.

Also, having releases makes later stock licensing easier. And, as she estimates 15–20 percent of her assignments result in relicensing and/or stock licensing, this makes good business sense.

Speaking of good business practices, Baldwin believes in getting advances. She requires 50 percent advances on all jobs over $1,000, which, as she points

out, means most jobs. She has been known to relax this rule with long-term clients, but only those who have a record of paying in a timely manner.

As in all specialties, pricing and professionalism are important to Baldwin. Her final thoughts to photographers in her specialty make this clear:

> It is very important to charge a professional rate for professional work. If you low-ball someone in order to get a foot in the door or agree to a discount because they have 'loads of work down the road,' that client will most likely never continue to hire you as you raise your rates and there is rarely 'loads of work down the road.' Don't forget that you need to cover *all* the time you spent on the job (whether you charge by a day rate or a project/shot rate, don't cheat yourself by not charging for, say, preproduction, editing, etc.). In addition, you must cover your overhead, including your camera and lighting gear (purchase, repairs, cleanings), rent, insurance, advertising, computer equipment, etc. Last, always be professional. Leave this industry better than how you found it.

GENERALIST

Brian Beaugureau is a photographic generalist with more than twenty years experience shooting primarily for advertising clients from his Chicago-area studio (and on location). He shoots food, people, still life, product, and so on, and feels comfortable in all these areas. He also works with design firms and with end-clients directly.

With a broad "specialty" Beaugureau has amassed a lot of specialty equipment:

> I need high-speed strobes and infrared triggering devices for capturing splashes, pours, and fast motion. Since I shoot a lot of food, I need a full commercial kitchen stocked with everything that is needed to prepare food for shooting. Also I need to have an extensive collection of plates, bowls, glasses, flatware, serving dishes, tablecloths, and surfaces. This list goes on and on. You also need a place to store all of this stuff. Since I do a good deal of location work, I also need cases packed and ready to go with everything I need for a location shoot. In these cases, we not only have a studio's worth of lighting equipment, but anything else we may need at a shoot. Some examples are tools, paper towels, tacki wax, string, tape, razor blades, sharpies, Windex, clamps, scissors, rulers, disks, model releases, etc.

Beaugureau's also learned from experience how having backups of the vital equipment is absolutely necessary. He said, "We were on location once and the

computer that my Sinar camera is tethered to conked out on us. Fortunately we were shooting in town, so we called our studio manager at the studio and she brought us down another computer that had all of our software on it. The problem with the digital equipment is that one malfunction with your computer, camera, or cables can shut down your entire shoot unless you carry a spare of everything. That could be disastrous, especially if you have talent, stylists, and clients on the shoot, not to mention permits, location fees, etc."

Being a generalist means that estimating can be a challenge. Each project can be significantly different and making sure everything is included is vital. Beaugureau explains, "Every client has different needs and expectations, and you need to cover yourself whatever the situation. Trying to figure out each client's expectations is one of the most difficult areas of our business. It helps to have as much communication as possible with your client regarding needs for a shoot." This is reflected also in the preproduction times he faces: "Every project is unique, especially being more of a generalist. Some projects may require extensive propping, preproduction meetings, testing of lighting, and casting and booking of models. Other projects, the client may not want to have you spend any billable time for preproduction."

This variability affects postproduction as well, but, generally speaking, "We do quite a bit of postphotography Photoshop work. I prefer to do the Photoshop work myself rather than counting on someone else down the line to take care of it. Often I have in mind what I want to do later in Photoshop as I'm shooting, and it just makes sense to have the photographer in on it." He's been shooting digital exclusively for a few years but, he says, "I don't have any issues shooting film if a client wants it, but I haven't been asked to shoot film in over three years."

Beaugureau licenses usage and figures that into his pricing. He approaches the issue of pricing through a combination of time and usage, often including one year's usage in the basic quoted creative fee. However, he makes sure to point out that "any further usage is negotiated from there." His pricing also varies with the client. Beaugureau says, "If I shoot a project for Pepsi, it will typically bill out higher than if am shooting a project for a small local specialty soda company. Your smaller companies or start-up companies may not have the budget that larger, more established companies have."

He also estimates about 10 percent of his work gets relicensed.

Model releases are a regular part of Beaugureau's paperwork. And though he doesn't have paperwork for every single contingency, he says he tries "to work certain things out beforehand, such as contacts, maintenance people, security issues."

This attitude carries over to getting advances, as Beaugureau doesn't have a

solid policy on the subject. However, he certainly doesn't ignore it: "We sometimes require an advance for assignment projects. Usually we only require it when there will be a lot of outside expenses such as models, stylists, props, etc. Also it is nice to get an advance when it will be an ongoing shoot that will last for a good deal of time. Usually the advance is one-third to one-half of the estimate total."

Being a generalist has its advantages and disadvantages. Beaugureau likes to look at the good side:

> I would like to say that the best thing about not having a very specific specialty is that I get the opportunity to always be doing something different. That makes it very exciting and fun for me. I can shoot food for three days, then go on location for a couple of days, and shoot people the next day. What could be better than that? If I shot the same thing day after day, month after month, year after year, it would probably burn me out. I really see no reason for photographers to have to pigeon-hole themselves unless they only love to shoot in a particular area. As Confucius once said, "Do what you love, and you will never have to work a day in your life."

HIGH-PRODUCTION PHOTOGRAPHER

Paul Aresu is a New York–based photographer with around twenty years of experience shooting what he calls "sporty/action lifestyle," some fashion with that same feel, and portraits. He has a studio and an in-house staff of seven, but on an average project, there are easily twelve people on the set (stylists, assistants, etc.), not including talent or any of the client-end people like art directors and accounts people. Add them in and the total quickly surpasses twenty or more. He shoots primarily for advertising clients like Budweiser, Circuit City, and Under Armour but also does some editorial work for publications like *ESPN* and *Source*. He is a Canon Explorer of Light and an adjunct professor at the New School for Design.

Doing large productions requires a lot of attention to detail. One way that Aresu makes sure the details are covered is by working with producers. He has an in-house producer who does the bulk of his productions, but he also hires freelance producers when needed. The value of a good producer can't be overestimated in Aresu's opinion. Such a producer helps to make sure everything on the legal end is covered as well as provide value in arranging and wrangling other parts of any production. He recounts the recent story of shooting for a drug company: The producer had the models sign affidavits stating that they had not worked for a competitor of the client in the past. Not very long after the shoot, it was discovered that one of the models was featured in ads by the main competitor of the client. All the images with that model had to be re-shot

but, because they had that signed document from the model, Aresu did not have to eat the cost of the re-shoot, which was easily $50,000–60,000.

Aresu has in-house policies to get releases (model and property) signed, and his producers often take care of this as well. He has several different standard forms of model releases depending on the model (adult or minor) and the needs of the project.

Another policy he has is never to start a production, not even booking a stylist, until he receives a signed purchase order (PO) from the client. He checks to make sure that the terms of the PO match his estimate and he also requires an advance of 50 percent of production charges. Starting a production before the paperwork is done is a recipe for disaster: You can lose money holding time for a project that isn't going to happen, and canceling out on crew can hurt your reputation, making it much more difficult to get the best crew possible for future projects.

When it comes to his fees, Aresu lists each separately. His fee list can easily include not only his creative fee and usage fee but also a casting fee, scouting fee, and preproduction fee. He explains that clients like to see specifically what they are getting so breaking things out is needed, especially since for an average two-day shoot there will be about three days of preproduction and another two or three of post. He subscribes to the theory that usage fees are the same for the same usage across clients, but he does adjust his creative fee as needed depending on client size/importance and project complexity/creativity. And, of course, his editorial rates aren't even close to his advertising rates. He has five reps, all of whom are on the same page when it comes to pricing projects and producing estimates.

Aresu shoots editorial work not as a prime direct financial component of his business but because he loves it and he gets something else from it. He can get significantly higher rates from his advertising clients, but the editorial clients give him creative freedom. He art-directs his own editorial projects and he notes that often his editorial projects end up in his portfolio—because they are "his" work rather than the collaborative results from advertising projects. So his editorial projects contribute significantly to his marketing, which helps his business bring in the high-paying advertising projects.

Aresu is quick to point out that photography is a service industry and that one of the best things photographers can do for their businesses is to give great service. He points out that clients aren't the enemy: "It's just the opposite—it works best as a [creative] collaboration." One way he services his clients and works with them is by shooting beyond the parameters of a project. For example, maybe the contract is for five images but Aresu will shoot a few alternatives or additional images beyond those five. Clients are not only thrilled

Specialized Listservs. To sign up go to *www.asmp.org/community/on-line_comm.php.*

- *ASMPproAdvice* is a listserv in which students and emerging photographers can seek answers from established, experienced working professionals. Started in 2005, ASMPproAdvice is one of the most vibrant online professional photographer communities. Known as a place where every photo business question is answered with care and respect, ASMPproAdvice is a valuable resource for photographers at any career level.

- *Architecture.* The operates a listserv for ASMP members interested in discussing the concerns that are unique to architectural photography and the business issues that commonly arise in the process of capturing images of the built environment. List subscribers must be general or associate members of the ASMP.

- *Corporate.* The ASMPcorporate forum addresses the business issues of corporate and annual-report photography. It is open to both ASMP members and nonmembers.

- Fine Art. The Fine Art Specialty Group maintains an online community for ASMP members who create, exhibit, or sell fine art photography.

- *Food.* ASMPfood is a forum for discussion of issues related to culinary and food photography. The emphasis is on business practices and professional standards, but discussion of technique and equipment is also appropriate. This list is open to both ASMP members and nonmembers.

- *Video.* The ASMPvideo forum addresses the business issues surrounding video and multimedia photography. It is open to both ASMP members and nonmembers.

with the additional choices; this service often results in additional images being licensed.

Speaking of additional licensing, Aresu does a lot of that: "I don't know what it is about this year, but we're getting calls every week for relicensing—sometimes right after a shoot the clients want additional usage or they come back later for more." It may be that this is a reflection of the general economic concerns as relicensing is less expensive than paying for another full production, but it is also a reflection of client satisfaction with the original work.

Economic considerations figure into Aresu's advice for anyone following in his footsteps: "Save money for a rainy day. You never know when you'll suddenly need another new computer or something." Or business may slow down due to

factors out of your control. He also encourages photographers (of all levels and specializations) to pay attention to paperwork to protect themselves and their businesses. His last comment in this interview was poignant: "If you don't love what you are doing, then don't do it. Competition and business is so hard that you need to love what you do first. If you love it, it will show in the work too."

LIFESTYLE PHOTOGRAPHY

Jim Flynn shoots people/lifestyle, or as he puts it, "people on location, both real and models, for corporate and advertising lifestyle assignments." Working from his base of operations in Texas, he has business services clients in the healthcare and finance industries, among others, as well as advertising clients. Flynn rarely does editorial work.

Technically, he likes to keep things simple and, considering the amount of location work he does, that makes sense. Generally, he has what he needs to get most projects done, but he'll rent large silks or RVs when that is what the project requires.

While Flynn doesn't think he generally needs anything out of the ordinary in his specialty to achieve his vision, he does think lifestyle photographers should remember one thing: copyright. Copyright, with a twist: "One thing we hear a lot about is protecting our copyright but we often overlook the copyrights that belong to others that we may be inadvertently violating. If your images are going to be used for commercial applications, be sure that the contents within your images do not violate the copyright or trademarks of others."

What he does need for his shoots depends on the project itself. Different projects require different things, and Flynn has a good solution for making sure the bases are more than covered in his estimates:

> When I estimate a shoot, I determine what level of production it will take to achieve the client's vision for the end shot(s). If it means renting a location then we budget for location scouts; if we need models then we have to budget for some level of casting. If there are models then you need to have hair and makeup along with a clothing stylist. This is just a partial list. What's vitally important is that you don't forget to include something. The way I do this is by having an "item list" which consists of just about everything I would need to produce a shoot. When I do an estimate, I simply go down the list and ask myself whether I need a specific item or not in order to properly execute the shoot.

Flynn makes sure to cover his pre- and postproduction, including digital charges, in his estimates as well:

[Preproduction] can take as little as an hour to as much as a week. The more complex shoots require a lot of coordinating, decision making, and preparation. Most of this takes place during production meetings typically held at the clients' offices. All of this is time which I estimate for under "preproduction." Post time is not as big an issue. Generally it involves backing up the image files, and then later I do file preparation on the images selected by the client. And then there's the best postproduction part, preparing and sending the invoice.

Like many photographers, Flynn has his own "system" for determining his rates: "Actually, I have a rough starting point that I use for determining fees which is based on historical data of fees from past clients. From that starting point I then make adjustments up or down based on factors such as the size of the company and the usage." He also presents to his clients a single combined usage and creative fee, noting that the only time he separates them is "when a corporate client has asked me to estimate a shoot based on a rough idea of how many people will need to be shot." When that happens he lists both a "photography fee" and a "per-person usage fee," so that he's covered. "If they think we're going to shoot five people and we then end up shooting eight people, they will know that the extra three people will cost them the additional amount. If only two people show up, I make less but I'm still making enough money because I guaranteed that with the photography fee."

As previously noted with other specialties, on the rare occasions when Flynn shoots an editorial assignment, the rates are significantly lower. However, the usage is limited.

Flynn protects himself by using model and property releases as well as including contingencies based on special considerations in his terms and conditions. For example, he has terms that cover late cancellations. However, he has been known to waive the fee for good, repeat clients, when appropriate. Enforcing or waiving the terms and conditions with any client "all depends on the relationship and the tone of our discussions." Advances are also a regular part of Flynn's business. As he put it, "In big letters at the top of my estimate it reads: 'Require a 50 percent retainer prior to shoot day. All balances—net 30 days.' The 50 percent is of the entire estimate including fees." Sometimes the check isn't delivered on time but, again depending on the relationship with the client, "As long as they keep me informed of the check status, I don't give them a hard time." He also notes: "There are times when the up-front production costs are so large that I will insist that the check arrive prior to the shoot so that I don't have to cover those expenses with my money." A wise business decision.

Because Flynn employs a usage licensing system and protects his copyright, he generates income with relicensing: "Somewhere between 40 percent to 50 percent of my clients relicense work that they have previously commissioned. I don't release my assignments to stock because models and their agents are [usually] unwilling to sign models releases allowing us to do so."

His last piece of advice for photographers transcends his specialty:

> In my specialty and any other specialty for that matter, if you want to be in business for a long time you need to be more than just a talented photographer. It is essential to be a good businessperson because photography is a business first and taking pictures second. I tell all my emerging assistants that the most important purchase they will ever make is not an expensive camera or new souped-up computer but a good accountant who will help keep their business and finances in healthy, compliant order.

PHOTO-JOURNALISM

Jeff Pflueger is a freelance photo-journalist who shoots primarily for magazines and the *New York Times* from his base in the San Francisco Bay Area. His main focus is travel-related imagery and he has been shooting professionally, and always as freelance, for five years.

One of the first things he mentioned as important for anyone interested in following in his specialty was very practical: have "a backup system that will work for you in the field, light and fast, and a good camera bag."

Perhaps less pragmatic but certainly no less important was his second piece of advice:

> Working with magazines and newspapers makes you a journalist. And as a journalist, there are ethics you need to be aware of behind how to tell your visual story and maintain journalistic integrity. Publications will have different guidelines around issues such as what to do when offered a free room. Just be up front and ask the publications about their policies. Ultimately you are representing the publication, so be sure that you do nothing that will make the publication look disreputable.

Because of travel and the demands of digital processing, Pflueger notes that he needs to schedule and financially cover both for pre- and postproduction. For example, he may need a day to make the travel arrangements and another to do basic image processing and make a rough edit. Yet rates are often set by the publications themselves, and this can make things financially complex. "If I have room for negotiation it is in the numbers of days that I am

working. Sometimes a magazine will only have a certain amount budgeted for the story, period, and the number of days that the assignment itself will take might make the day rate look pretty sad." He does add, however, "I have been able to negotiate more of a day rate based on the difficulty of the shoot and the equipment required."

Contracts are always important in commercial and editorial photography, but as most of the contracts in editorial originate with the client (as opposed to the photographer), each is quite different and requires individual attention. Pflueger explains that he goes through each "carefully and if I have questions I call them and discuss them. It takes time and is a pain, but it is really important. Often the editors don't know the answers." While many photographers have had success with contract cross-outs and modifications, he has not been so lucky: "I've tried, and they can't do it because there is no practical way that they can have individual agreements with all the photogs that they work for." However, he does point out, "Often, when pressed, I have found that there is an alternative photog-friendly contract that they can produce when they absolutely have to."

Though model and property releases aren't usually needed for editorial work, Pflueger does try to get them signed as often as he can, noting, "Having [a release] is vital if I intend to relicense an image later." He estimates about half of his assignments result in images he later licenses as stock, and adds that it could even be a higher percentage if he spent even more time and attention to marketing and selling his stock images.

As is typical for editorial, advances are rare and occasionally frustrating. Pflueger says, "Many publications can do the travel arrangements for me—so that helps. But ultimately, getting reimbursed in a timely manner can be really exasperating. And I've gotten in finicky disputes when the client hasn't liked the receipts I produced. Lesson: Bring a receipt book and write your own receipts for those occasions when you pay for something and can't get a receipt."

When asked what he would most like to share with anyone thinking of becoming a photo-journalist today, Pflueger has a lot to offer, starting with this comment: "I see the freelance editorial work rather as a means to other more sustainable types of work in photography." In other words, for Pflueger editorial work is a means of marketing, of getting one's name and vision out to people with deeper pockets. While photographers in the past made their livings entirely from editorial/photo-journalism, that is happening less frequently now.

He continues:

I think that we should look at the present facts: The magazine and newspaper industry is imploding. What this means is that the magazines are getting

thinner, there are less assignments out there, contracts are getting bad, and there is less money [and] the photographers are feeling the squeeze. Additionally, the ever-increasing use of the ubiquitous digital camera combined with the massive "sharing" and access to photography over the Web means that there is a huge supply of images out there. What happens to the value of the photograph is simple supply and demand at that point.

Pflueger is also concerned, however, about photographers not standing up for the value of their images in editorial new media:

As an example, most contracts now from magazines and newspapers have added unlimited Web use, but there is no additional compensation to represent this—and the Web may now in fact represent a huge chunk of their audience and indeed even income. The Web is sort of assumed by them as a sort of a "we don't pay for content" zone, and photographers go along with this because they have to until they can start to collectively negotiate for something reasonable.

In the past this was because the Web was a losing operation for the newspapers and magazines. They knew that they had to be there on the Web but didn't know how to make it profitable. This is changing now. I was just talking with the *New York Times* [and their online Web revenue is increasing double-digits]. So now that the *Times* is starting to make money on the Web, photogs need to begin to make money on the Web too.

PRODUCT PHOTOGRAPHY

Lon Atkinson is primarily a product photographer for advertising agencies. He also does some client direct (corporate) work, including catalogues, out of his San Diego–based studio. When asked what one thing he would like to share with emerging photographers in his field, one thing that he never thought he needed to know ahead of time, he replied, "Dealing with the varied personalities of the clients." This is something not often taught in school but which can make a significant difference in business. Atkinson went on to say, "You have to realize and act on the fact that you are a service. Service is the key to success. I have [direct] clients that have been working with me for fifteen to eighteen years. Ad agencies also this long, because we treat them with respect and provide tremendous service."

Estimating in his specialty generally requires including the following items: photography, usage, product stylist, digital image [capture] fee, purchased props and backgrounds, and set building. While each project is different, of course, these are the usual core items.

Atkinson is very practical and concise in how he determines his fees: "For product photography we start with how long it will take us to shoot the product. This fee has been determined by calculating our overhead and profit. Then we add in usage." Speaking of usage, he points out that "catalog companies are charged differently than ad agencies. [Usage is] also based on the 'life' of the photo. Some catalog photography only has a life span of one year," while advertising clients can easily need longer and more extensive usage.

Pre- and postproduction considerations can vary greatly in Atkinson's world: "On some product photography we are designing the image, creating the set, finding props and so forth. Other times we set it on a seamless background. We provide postproduction, including retouching, color correcting, converting, sizing the image and delivery. A typical photo will have about 45 minutes to an hour of postproduction work. Some images, where we are doing compositing, can take all day."

As an early adopter of digital technology (shooting only digital since 1992), Atkinson definitely knows what he's talking about in that arena. And while he doesn't see any particular technical or other considerations in his specialty, he does note the importance of releases. He gets signed property and model releases as needed, and points out that these can also include releases for animals.

Up-front payments are also *de rigueur* for Atkinson's newer clients: "We require deposits on new clients of 25 percent. Once a client is known to us, we waive the deposit. However, they are made aware that they are not given a license to use the photo until the bill is paid in full. We ask for advances when there will be extensive prop procurement."

Licensing is important to Atkinson's business. He estimates that his stock licenses and other relicensing of existing images account for about 20 percent of his fee income annually. If he didn't license his images, he would lose that income.

SPORTS/ACTION PHOTOGRAPHY

Minneapolis-based Bruce Kluckhohn shoots sports. He shoots other people on location as well, but mostly sports and for editorial, advertising, and corporate clients, including teams themselves.

Kluckhohn, in addition to the usual gear location photographers might need, includes in his kit long fast lenses, digital cameras with fast buffers that work well in low light, and stadium strobes. Speed is clearly of the essence in his work, but he also points out that there is a lot to be toted about: "Work ergonomically, as all the equipment weighs a lot and long shoots go better if you do not needlessly stress your body." He adds, pointing out the danger of being sloppy or rushed, "400mms don't bounce."

When Kluckhohn produces his estimates, he makes sure to include a digital image processing fee of some sort: "So often, clients feel digital is free and so many photographers have given it away. But it takes a lot more money to deliver a better product to the client, so charge for it." Other items you'll find on his estimates are things like shipping, assistants, parking, and so on.

As he often works with teams who need extensive rights on the one hand and individual project clients on the other, Kluckhohn handles pricing two different ways. In the first case he has long-term contracts which grant broad rights and in the second, he says, "I try to apply usage against my minimum fees for editorial, PR/corporate, and advertising. Each category has a different set of minimum fees, and the usage gets applied against it. If the usage goes over the fee, I charge additional fees."

In other words, he bases his pricing on the usage of the images: "The end fee is based upon how the image is used and how many people will see it. But since the market pays more for a one-page ad than for a one-page photo in a story, the ad pays more. But all are based upon analyzing how the client uses the image."

Preproduction doesn't factor often in Kluckhohn's work. As long as he is given the needed access to games and players, he can take it from there. However, with the large volume of images he may produce for any one event, post work can be significant. He notes, "Working with captioning and other aspects of metadata to allow for search abilities for the client can mean a lot of time at the computer."

Somewhat surprisingly, model releases are not often used in his sports work. He explains that "the primary use falls within the team' promotional efforts, and those terms fall within the players' collective bargaining agreements. For commercial use outside of that, the client needs to have a contract with the player and league rules need to be followed, but the clients usually know this and have taken care of it." So he is not ignoring the need for legal protection but rather has it covered differently.

Advances are also relatively rare for Kluckhohn. While he requires them for larger projects, many of his assignments, especially editorial, do not meet the threshold.

Because he protects his copyright and licenses usage, Kluckhohn generates additional fees through relicensing. He estimates that 5 to 10 percent of his work gets re-used.

[A growing niche in our industry is the addition of video capabilities to the still photography studio. Read more about this in chapter 15, "Moving into Motion."]

Making Strides with Your Fine Art Career

BEING SUCCESSFUL RARELY MEANS WALKING A STRAIGHT LINE

by Amy Blankstein

Amy Blankstein is a freelance writer and editor based in Brooklyn, New York.

———————————— • ————————————

The following text was adapted for use in *ASMP Professional Business Practices in Photography* from an article originally published in the *ASMP Bulletin*, assigned and edited by Jill Waterman.

NO ONE PURSUES A PHOTOGRAPHY CAREER SOLELY FOR THE MONEY. MAKING A living with your craft often translates into a lifetime of commercial work, but it's the rare photographer who doesn't pursue his or her artistic vision. Some receive recognition in the form of exhibitions and publications, and some are even fortunate enough to make a living off of their art, but as the following photographers who are, to one degree or another, "making it" will tell you, the path to success is rarely as easy or straightforward as it may appear.

CREATING YOUR OWN OPPORTUNITIES

New York City–based Wyatt Gallery would acknowledge that luck has played a role in the progress he's made. "The key is being prepared to take advantage of luck. Luck gets you a heads up, but I have to be prepared with my own work to get it out there."

He shows frequently, is represented by Watermark Gallery in Houston,

and has work in private and corporate collections. At the same time, Gallery supports his personal work with editorial and commercial architectural assignments. Pursuing personal projects in tandem with his commercial work, plus the consistent effort he makes to market his fine art can be tough, but Gallery keeps it all in perspective: "You see others achieve success and it looks like it happened overnight, but you don't know how long they've been in the game. You can't expect to reach stardom overnight. You have to be patient, resilient, and diligent. You don't give up on your own vision and your own work—you continue to produce."

Some of his opportunities have come about organically—a chance meeting in the street can turn into an invitation to participate in a show—but Gallery makes it a point to network actively. In addition to the networking that happens naturally within the creative community, he submits his work to juried shows, selecting those with jurors he wants to meet or those that will afford him greater exposure, and he participates in portfolio reviews around the country. Although a tough skin is a must to bear the concentrated scrutiny of one's work, Gallery feels that these opportunities are well worth running the critical gauntlet; he made the connection with Watermark Gallery at Houston FotoFest in 2004.

The Chicago-based architectural photographer Barbara Karant would agree. Earlier in her career, she actively promoted her personal work and gained critical acclaim within the Chicago art community. But she says, "If you stop promoting for any length of time, people forget who you are. You have to make it a job, along with your commercial job, to get yourself out there." Although she's consistently worked on personal projects throughout the years, she only recently has renewed her efforts to push them out into the world.

FINDING TIME AND SUPPORT

In order to get her work out there, Karant submitted a portfolio to attend Review Santa Fe in July 2005. "It was a way to make contacts that hopefully will be helpful in the future with this body of work," she says. In addition to making contacts with curators and gallerists who could potentially further her goals, Karant got a chance to connect with fellow photographers: "It was great for me to be within a community of artists for a period of a few days. It was an opportunity to get feedback about the work from people I really respect. If you're not in an academic setting, you don't often get feedback. As a commercial photographer, there's just not much time to ruminate with colleagues and friends."

Finding such opportunities is critical for photographers trying to balance their commercial and personal work. "It's important to build a network," says

Susan Carr. "Having a support system in place is critical; it's very difficult to keep motivating yourself if exhibitions aren't coming through." She suggests building support networks by going to portfolio reviews and joining groups such as the ASMP's Fine Art Specialty Group or the Society for Photographic Education.

Motivation is one hurdle; finding the time to create and promote your personal work is another. In addition to lending feedback and moral support, Carr and her business partner Gary Cialdella, both documentary photographers, made it a goal for their architectural photography business to accommodate their personal pursuits. Even with that mindset, it was a while before they could follow through with this objective. "It took about five years to set aside time to make my work a priority," says Cialdella. "I would cancel personal work to do assignments. Today I'm more careful about that, more apt to book [a personal project] as an assignment and build in the same emphasis that I would for my commercial work."

DEFINING YOURSELF AND YOUR MARKET

"I was not represented until I sent my text work, cold, to W. M. Hunt at New York's Ricco/Maresca Gallery in 1997," Susan E. Evans relates. "As soon as he received my packet he called me up laughing and demanded to know who I was. He loved the work and has been a great supporter and advocate ever since."

That support has been most obvious, says Evans, in Hunt's endorsement of her work, as well as his ability to find opportunities that she would not have access to alone and his help in placing her work in important shows and institutional collections. But behind the scenes, Hunt—who recently opened the Hasted Hunt Gallery with former Ricco/Maresca colleague Sarah Hasted—also provides professional advice, as well as a positive support system.

Not everyone takes to her work as readily as Hunt. Evans' word pieces, which are black and white text images, push the boundaries of the definition of photography. "It's really hit or miss because many traditional photographers really hate my work and think of it as anti-photography," says Evans. As a result, she's aggressively directed her marketing efforts toward galleries, curators and institutions that are receptive to conceptual work.

Being able to define yourself as a photographer is the lynchpin to getting your fine art career up and running. Once you know who you are as a photographer, you can streamline your marketing efforts by identifying the institutions to approach that are best suited to your work. "You can't be all things to all people," says Susan Carr. "Find out where your type of work is being shown. If you're pursuing funding opportunities, look at the last five years of who an institution has given money to. Otherwise, it's not worth the effort."

Don't be afraid to look beyond galleries, museums and art spaces, especially if the niche style of work you do does not fit prevailing trends in the art world. Kim Kauffman's camera-less botanical images might not find wide acceptance within contemporary galleries, but an exhibition at the North Carolina Museum of Natural Sciences in Raleigh has not only enhanced her resume, it also exposed her to a much broader audience. The Lansing, Michigan photographer plans to actively pursue such targeted opportunities in the future.

BE AWARE OF THE MARKET

Because of his dual roles as photographer and gallery owner, New York City–based Thomas Werner has a unique perspective on the pursuit of success in the fine art arena. He urges photographers to get an understanding of how the art world is evolving as a business. Just as the commercial photography business model has shifted, so too has the business model for fine art. "You have to be willing to work within the framework of the marketplace," says Werner. "I'm not advocating selling out—just understand the nature of the business."

In addition to staying current on broader trends in the art world—especially if you're working in a contemporary style—Werner says it's vital to a photographer's career to understand the time and financial pressures that drive gallery owners and curators. A gallery owner may personally love your work, but that doesn't always translate into an opportunity to exhibit with him or her. Given the costs of producing exhibitions, gallery owners need to be confident not only that your work will sell, but that it will build their reputation as curators.

WHEN DO YOU HAVE IT MADE?

By art world standards, Lynn Saville has made it. She has commercial gallery representation in Paris, New York, and Atlanta, shows frequently and makes a solid income from her nocturnal cityscape and landscape photographs. Still, the art market is a fickle place, so Saville maintains her commercial portrait studio. "I don't want to put too much commercial pressure on my art work. It's an important avenue of expression," she says.

Attaining success is rarely a linear process. In 1949, Don Normark photographed a poor Mexican-American enclave in an area of Los Angeles called Chavez Ravine, which was destroyed a year or so later, ostensibly to create public housing, but which ultimately became Dodger Stadium. It was the McCarthy Era, and aside from Normark's inclusion in an exhibition at the Los Angeles County Museum of Art, there was no interest in work that glorified the daily life of a working-class community. The images sat in a box for decades.

In the intervening years, Normark worked as an editorial photographer for *Sunset* magazine, occasionally showing other bodies of personal work. After

being laid off from the magazine in 1995, Normark revisited the Chavez Ravine images and began to research Chavez Ravine's history with the intention of producing a documentary. At the same time, he looked for opportunities to show his work, and in 1996 the Los Angeles Public Library produced an exhibition on Chavez Ravine using Normark's images. Although the venue wasn't Normark's first choice, the media covered the show extensively, and the images took on a life of their own. The images have been exhibited frequently and in 1999, San Francisco–based Chronicle Books published a book on the series. The documentary Normark initiated about the area aired on PBS during the summer of 2005. No one involved in the project profited directly from the film, but the exposure continues to focus attention on his work. "I've been fortunate," Normark says. "They've been in the news and generate their own publicity. I'm not an aggressive marketer, but between what I have done and the nature of the material, there have been results."

Of course, opportunities attract more opportunities. Several years ago, after seeing his Chavez Ravine work, a Los Angeles gallery owner urged Normark to cover the story of a fourteen-acre community garden in the South Central section of the city. Although Normark is still documenting its fortunes, an exhibition and publication are already being discussed.

Success in the fine art milieu can be elusive, and persistence is a must. Silence or a firm rejection from a curator now doesn't mean she won't be interested in the future. And if a gallery owner isn't interested in your work, maybe he knows of another gallery who could be and will pass your name along if you are careful about cultivating the relationship. The key is to keep a positive attitude, develop the ability to absorb and learn from both negative and positive criticism, keep following your vision, and above all, be prepared to take advantage of opportunities whenever they come along.

Moving into Motion

ADVENTUROUS STILL PHOTOGRAPHERS EMBRACE INNOVATIVE NEW TECHNOLOGIES TO ADD MOTION SERVICES TO THEIR BUSINESS OFFERINGS

by Ethan G. Salwen

Ethan G. Salwen is an independent writer and photographer currently based in Buenos Aires, Argentina. In addition to covering Latin American cultures, Salwen writes extensively about technical, artistic, and marketing aspects of photography. He is a regular contributor to the *ASMP Bulletin*, *The Picture Professional*, *Rangefinder*, and *After Capture*. *www.ethansalwen.com*.

———————————— • ————————————

The following text was adapted for use in *ASMP Professional Business Practices in Photography* from an article originally published in the *ASMP Bulletin*, assigned and edited by Jill Waterman.

"I couldn't be more excited about the expanding opportunities that emerging technologies are giving me to produce and distribute motion projects," says Gail Mooney of Kelly/Mooney Productions, a well-respected travel and documentary photographer who began shooting 35mm motion footage in the mid-1990s. "I remain passionately dedicated to still photography," she emphasizes. "But I have always thought of myself as a storyteller first, and sometimes the story is best told in motion."

Compelled by the desire to work beyond the scope of still images, many photographers have transitioned into filmmaking and video production over the years. However, increasing numbers of photographers are expanding into

the realm of motion because it is easier and more affordable than ever before. The production of motion pieces is also a way to expand business opportunities by meeting clients' evolving needs.

A number of factors are contributing to this new development in the world of professional photography. The most fundamental are: increased distribution methods for motion; closer technological alignments between still photography and motion production; dramatic reduction in technology costs for video production; and clients' increasing demands to spread their messages through motion.

"The worlds of making and distributing still images and movies are colliding," says San Antonio, Texas–based photographer Clem Spalding, who feels that the writing is on the wall for photographers to be proactive about finding new income streams. Mooney agrees, noting that current technologies provide photographers the opportunity to produce professional, affordable motion services in a way that was completely out of reach only a couple of years ago.

Spalding notes that many still photographers seem hesitant to even consider the possibility of offering motion services to clients. "But," he explains, "the great news is that photographers who have already mastered the complexities of digital image making are closer to producing and licensing motion pieces than they might imagine." As Mooney, Spalding, and many other photographers have already discovered, the benefits of expanding into motion can be tremendous, both in terms of creative satisfaction and financial rewards.

The three ASMP members highlighted in this article have approached the realm of motion in extremely different ways. However, all three share fundamental qualities that mark the cornerstone of success for making such a transition. First, they are dedicated visual communicators who remain committed to the craft of still photography. Second, they share a proactive, enthusiastic attitude, seeing the opportunities in motion as exciting and rewarding. Finally, they believe that savvy professional still photographers—great image makers and keen entrepreneurs—hold a distinct advantage over the scores of would-be filmmakers who have access to affordable equipment, but not the skills to profit from a business standpoint.

THE EVOLVING WORLD OF MOTION

When it comes to the topic of images in motion, the words "movie," "video," "film," and even "motion" are often used interchangeably and often have nothing to do with how a piece was actually created. "Motion is such an incredibly broad subject," says Mooney. "It includes everything from simple flash animations and basic Web slide shows to feature-length films and every imaginable hybrid in

between." She points to the fact that—in a very real sense—the options for creating and distributing motion projects are limited only by the artist's imagination.

New distribution technologies—most notably the Web—have tremendously impacted the landscape of video production. The emergence of broadband and its global reach has fueled the need for motion content. Businesses of every nature and size are eager to post short videos online to reach specific target audiences. Podcasts and videocasts—downloadable movies that can be played on video iPods and other handheld devices—are quickly growing in popularity and feeding the demand for quality content. And, as with still images, the Web has changed the distribution channels and increased buyers' eagerness to acquire stock motion footage.

Ultimately, changes in the still photographic process have played the biggest role in allowing photographers to enter the world of motion with relative ease. "Like most photographers, I was only thinking about still images when I was building my computer-based digital editing system," says Spalding. "However, I was also creating a system that very closely resembles the current generation of video production stations." What's more, as he mastered digital image manipulation and workflow, Spalding was acquiring some of the fundamental skills underlying today's video postproduction practices.

MAKING MOTION FROM STILLS

At the most basic level, photographers can enter the world of motion by creating fairly straightforward multimedia movies using still images. Photographs can be edited into a timeline employing intuitive software programs like Apple's iMovie. Such movies can even include pans, zooms, additional graphics, music, and narration. They can be posted on Web sites, played on laptops or TVs, projected for larger audiences, or distributed on DVDs—all powerful ways for photographers to promote their services. Such still image–based motion projects greatly enhance Web sites, and they can be offered to clients as a value-added service, increasing profits from a shoot.

Yet motion pieces based on still images do not have to be limited in complexity. Dallas, Texas–based commercial photographer Stewart Cohen has had tremendous success entering the motion industry, and he has produced broadcast commercials using both still images and motion footage. He warns against underestimating the tremendous time and effort it can take to create more complex still-based movies. "We produced one broadcast commercial using digital stills because that's what we needed to do to achieve the aesthetic that the client was seeking," Cohen explains. "But the postproduction costs on that piece were higher than any of our motion pieces."

CAPTURING MOTION

There are a number of ways to capture moving images for use in motion production. Until very recently, 35mm and 16mm analog formats remained the predominant choice for feature-length films and broadcast commercials. In video technology, the most common formats are HD (high-definition) and HDV, a compressed version of HD. The HD format is becoming the standard for corporate films, music videos, documentaries, and many TV shows. HD and HDV are recorded on tape, and the digital signal can be directly imported into an editing station. Traditional film must be processed and transferred to tape. Regardless of capture method, all video editing is performed in digital workstations.

Fierce debates about quality of capture formats are currently raging, with 35mm film still considered the gold standard. "I shoot 35mm whenever possible," says Cohen. "Anything less might limit eventual distribution. Also, the quality is awesome." However, Cohen also shoots a lot of 16mm as well as some HD. He says that the important thing to understand regarding HD technology is that HD equipment quality varies tremendously—as much as it does among digital Single Lens Reflexs. "In fact," says Cohen, "Some HD productions are as expensive and complex to produce as 35mm shoots."

Mooney says that HD and HDV are more than fine for Web distribution as well as corporate and industrial productions. She also says these formats offer wonderful opportunities for documentary filmmakers with small budgets and solo photographers eager to begin experimenting with video. Both Cohen and Mooney agree that, just as with still technology, the most important considerations boil down to personal preference, client needs, budget and, most important, how the motion piece will be used and distributed.

MAKING MOVIES FOR CORPORATE AND INDUSTRIAL CLIENT

Clem Spalding has had a longstanding interest in motion pictures. When Apple added iMovie to the Macintosh operating system, it was only natural for him to explore this easy-to-use program first with his still images, then with motion captured on his home camcorder. Once he mastered iMovie, Spalding began producing pro bono motion pieces for local nonprofits. "This gave me the confidence to consider offering video services to my clients," Spalding explains.

In producing his first commercial video project, Spalding found that the greatest challenge was addressing the business aspects of moviemaking, including licensing concerns and how to determine competitive rates. He didn't find much help regarding business practices from the local videographers he consulted. "Many people producing corporate videos seem to be willing to

work for extremely little money," Spalding explains. "As an industry, they have nowhere near the consistency of business practices and advocacy efforts that we have developed in the still picture industry."

After being hired by a regular client to shoot catalog images on location, Spalding decided to pitch producing a video for the client to use at trade shows and online. "I asked many videographers what they would charge for such a job," he recalls. "One told me that he would charge maybe $300," says Spalding, who was shocked. "As a professional photographer I wouldn't even get out of bed for $300." Spalding eventually determined a fee that made the project worth his while, and was sufficient for him to hire a cameraman and an assistant, license some music, cover his overhead, and compensate him competitively.

Spalding says that two factors were critical to success in his first foray into commercial video production. First, he mapped out a very tight shot list. "This made the shooting and editing process go much smoother, much faster," explains Spalding. Second, he hired a capable, professional cameraman with his own HD video camera to shoot the footage. "Outsourcing this service freed me up to concentrate on directing," Spalding says. "This man also served as my guide through parts of the production process." The cameraman sat side-by-side with Spalding while they downloaded only the best take from each shot directly into Spalding's computer, greatly easing his postproduction efforts.

Spalding edited his movie in Apple's Final Cut Pro, which he says is a must-have for any serious production—the Photoshop of the motion industry. "Final Cut Pro is a complicated program that can take years to master," explains Spalding. "But like Photoshop, it can be used at a more basic level. And I was quickly up to speed for my needs because of my experience with iMovie." Spalding's final piece employed music and voice-over narration, also simplifying the overall process.

EMBRACING THE FULL RANGE OF POSSIBILITIES IN MOTION

"My move into motion was natural," says Gail Mooney. "I've always thought of still photography in terms of a timeline, and video is all about the timeline." These days Mooney sees herself more as a "multimedia producer" than a "photographer," and she enjoys the creative satisfaction of learning and using new visual communication techniques firsthand. She has shot motion in multiple formats, recorded sound, and executed the editing for both small and large motion projects—from short Web movies to a thirty-minute documentary. For one of her latest still-based image projects, Mooney even created the graphics and used a basic sound program to author an original soundtrack.

Mooney is somewhat of a cheerleader for photographers to expand into video. "The key point about the new technologies of video is that they enable

creators to deliver a professional product affordably," she says, explaining that photographers can do this by keeping crews small and performing postproduction in-house. "Ultimately this makes new income streams available to these creative professionals," she says. "For example, a corporate client recently approached us to produce a five-minute Web movie. Historically, the budget on such a movie would have been out of their price range. "But now we provide this critical service to them, while also making a good profit."

On productions Mooney often chooses to get her own hands dirty as much as possible. "Of course we sometimes hire crew members and outsource certain services, depending on the project and the budget," she says. "But as a photographer who spent decades traveling the world and working solo, I guess it is just in my nature to do as much of a project myself as I can." Mooney says that ultimately the nature of the job and the budget will determine how to execute the project in terms of format, crew size, and postproduction.

"The important thing is that photographers enter video in a way that best suits their creative natures and that fits with their current and developing business goals," Mooney advises. "As with success in their still businesses, photographers must constantly reconsider their clients' needs, the state of the industry, and evolving trends." She strongly recommends attending conferences and workshops, renting equipment before buying, and researching what's being done online.

SHOOTING MOTION FOR BROADCAST

Although he continues to run his still photography studio, Stewart Cohen now regularly produces witty broadcast commercials for major clients. One distinct advantage Cohen brings to the table in his broadcast work is his expertise in orchestrating large commercial production photo shoots. However, while Cohen agrees with Spalding and Mooney that technology has increased the opportunities for photographers to enter motion production, he downplays the significance of these advances in his case. "My move into making commercials really had nothing to do with technology," he says. "It was just my desire to see things move in my work, as well as my commitment to make it happen."

"Many photographers feel the need to start at the bottom, figure out how to make motion pieces themselves, and then slowly build up services from there," says Cohen. "My attitude is to start at the top, to aim for the big leagues." While Cohen encourages his ASMP colleagues not to limit their aspirations, he sounds a note of caution to photographers considering filmmaking. "It is not a natural evolution, nor is it easy," he says. "The film production community is totally different from the still world, with different people and different business practices." He points out that while a solo photographer

might be used to working with one assistant, a small film set typically employs fifteen to forty people.

To enter the big leagues of motion, Cohen suggests that photographers start by going out and experimenting with filmmaking to see whether they like it. "Then they will need to produce a test reel to show work and get assignments," he says, noting that sample reels do not have to be of broadcast quality or involve costly productions. "More than anything, production companies want to see your unique, strong sense of vision as a photographer."

Instead of trying to get assignments directly—which can be extremely difficult—Cohen suggests that photographers get representation by a production company. "Once a photographer is working with a good company, an entirely new level of opportunities will emerge," says Cohen, who was amazed by the amount of support and handholding he was given when making his first commercial. "They provided me with a producer who led me through the entire process—taking care of contracts, hiring talent, and coordinating almost all my efforts."

When signing on with a production company, Cohen says it is critical to ensure it is eager to actively promote you. "Otherwise they will be doing little more than making profits off the mark-up on your productions," he explains. To investigate potential agencies, Cohen suggests going to Web sites that feature professional commercials, searching for work that seems like a fit, and noting the company that produced it.

TIME TO GET MOVING

The evolving landscape of image making almost demands that photographers consider entering the realm of motion, if only at a basic level using still images to promote their still services. "These are the most exciting years of photography," says Spalding. "Photographers should realize that there is an incredible range of ways to expand into the world of motion that can give them amazing opportunities to remain competitive and increase personal and professional satisfaction."

Is Shooting Motion Stock Profitable? Stewart Cohen and Gail Mooney have both found financial success shooting motion for stock sales. Both agree that issues relating to stock motion quality, distribution, competition, and profitability are changing rapidly and dramatically. Therefore, photographers considering shooting motion stock must pay close and constant attention to industry trends in relation to their business goals. "If you have the desire to do it, the opportunities are there," says Cohen. "But it is not for everyone, and you need a deep desire to succeed."

Cohen and Mooney have both shot stock footage extensively in 35mm as well as 16mm formats. They both note that more of their 16mm footage has been licensed, and at greater profits. "The 16mm clips sell for less, but more clips sell," says Cohen. "Also production costs are significantly lower with 16mm." However, Cohen enjoys working in 35mm, as well as making sales for use in big budget features.

When it comes to 35mm and 16mm, Mooney says what gets licensed all depends on the director. She says that shooting in 16mm allowed her a kind of spontaneity in working that was not possible with 35mm. "The resulting footage has a different feel, which appeals to a different buyer," she says. "What's important is to choose the right tool for what you are trying to achieve in terms of aesthetics and distribution."

Mooney has currently put a hold on shooting stock because she now only shoots in HD, which her current distributor will not accept. She believes this will likely change soon and notes that many stock motion distributors already accept HD and even HDV, especially those licensing royalty-free footage. Mooney sees the future of HD and HDV as very promising but also has concerns. "New technologies come with a double-edged sword," she says. "On the one hand, the lower equipment costs make it more practical and affordable for creators to produce. However this results in lots more competition, the market gets glutted, licensing fees drop, and more footage goes to royalty-free sales."

Book Publishing

by Shannon Wilkinson

Shannon Wilkinson is president of Cultural Communications, a promotional agency in New York City specializing in the creative and cultural industries, including art, photography, visual books, and style. *www.culturalcommunications.info.*

———————————— • ————————————

The following text was adapted for use in *ASMP Professional Business Practices in Photography* from an article originally published in the *ASMP Bulletin*, assigned and edited by Jill Waterman.

PHOTOGRAPHY BOOKS ARE A MAJOR CAREER-BUILDING TOOL. NO OTHER INSTRUMENT launches, revives, and sustains a reputation like published books. They can turbo charge exhibition opportunities and sales for photographers. Dealers and museum curators who have passed over a promising photographer's work often take a second, more serious look when his or her book crosses their desks. For commercial photographers, a new book can double or triple assignments.

But unless a well-thought-out promotion and marketing plan is in place several months before your book is released, it will die an early death. So it is essential that you create a comprehensive plan at least six months in advance of publication, either independently or in conjunction with your publisher (if you have one).

When creating this plan it is important to realize that publishers are in business to sell books, not to promote photographers: They may not market your book the way you want (or expect) them to. Publishers invest in publicizing a book based on an expected sales goal and a break-even point. They

know which marketing actions are required for them to reach that goal while still turning a profit. Unfortunately actions that may help a photographer's career—a launch party, a speaking tour, or other activities often used to promote books—may not help a publisher meet its specific goals.

To minimize disappointment, schedule a meeting with the publisher's marketing department well in advance of your book's publication. Find out what they will be doing to promote it . . . and what they won't be doing. Avoid putting them on the defensive. Since the marketing department may not be thinking about your book's promotion at this point, it is vital to explain to them before promotional activities begin that you'd like to know how you can help make the book a success. Prepare a promotional planning toolkit (see sidebar) for the meeting, one you can also adapt for your own promotional plan.

The time and resources publishers are willing to dedicate to publicizing your book is limited by their profit margin, which is often quite narrow. In order to maximize exposure and sales of your book, you might consider hiring your own publicist. When deciding whether it is worthwhile to make this investment, analyze the amount of publicity a publisher has garnered for similar projects. If you'd like a greater amount of publicity, it might be in your interest to bring in an outside resource. An effective publicity campaign isn't just integral to the success of your book. It will promote your career as well.

Identify your most valuable relationships. Connect with every potential supporter of your book project very early in your campaign. Showing publishers that you have strong resources behind you makes you a greater asset. Publishers value the opportunities afforded by:

- An agent who will guarantee the purchase of a set number of books before publication, helping the publisher to offset printing costs
- Relationships with commercial clients (or friends with lofts, galleries, or interesting shops) who may sponsor or host a splashy launch party at which books can be sold
- VIPs or high-profile people who will allow their names to be listed as co-hosts on invitations for a launch party or signing
- Galleries that will host exhibitions of your work to help promote the book and sell copies (as well as your prints)
- Printers and other businesses that will sponsor advertisements for your book
- Institutions that will host (and publicize) educational programs, such as film screenings, slide shows, and discussions that involve your book.

USING OUTSIDE CONSULTANTS

Publicists, public relations firms, and event firms are the most commonly used outside resources for book promotions. Event firms specialize in parties and can often add celebrities or socialites to an existing guest list. Most PR firms and publicists (independent operatives who usually have past experience working for top firms) specialize in niche areas. Matching their niche to your target audience is an important consideration in selecting the best person or firm to represent your work.

The most important clues as to a publicist's potential are his or her publicity clips for other projects in your field. These clips will demonstrate which outlets and media figures the publicist routinely deals with. When you interview potential publicists, review their clips to assess their prior success in promoting photography books and to ensure they have cultivated relationships with photo editors.

Publicists maintain close contact with their clients once a campaign begins. In addition to regular updates, you should receive periodic written activity reports from a publicist, with details of inquiries made and reactions of each journalist contacted.

For book promotions, these consultants charge a project fee, which usually spans three to six months of work. Clients typically pay incrementally throughout the period covered (most publicists invoice on a monthly basis). Out-of-pocket expenses are estimated in advance and billed separately, with half or more being paid up front.

A publicist will generally use the first four weeks of the campaign to develop comprehensive publicity materials. Then he or she must initiate media contacts three to four months before a book's release. Monthly magazines require this much or more lead-time for articles. The two months immediately preceding a book's publication are used to approach blogs, weekly magazines, daily and weekly newspapers, online 'zines, and, if appropriate, television, and radio. That is why it is absolutely vital to contact a publicist five or more months before your book's release. Waiting a month before its launch guarantees a major loss of publicity opportunities. Even the best-connected publicist cannot fight those odds.

Before a campaign begins you should expect to see a list of the names, with titles and media affiliations, the publicist plans to contact. Then you should receive written activity reports on a monthly basis (supplemented with weekly e-mail or verbal reports).

Publicists work on a "no-guarantee" basis. That is, they cannot promise that their work will result in publicity coverage. You are paying for the time they spend on your book's campaign—and for their expertise. The good news is that no publicist wants to take on a project with the likelihood of attaining

little publicity. Most are candid with their opinion of a book's prospects. I ask potential clients to describe their media goals, and I decline the project if I do not feel my work will support this. However, the most common reason a publicist will decline a project is that the timeline is too short to allow for magazine deadlines. Once you miss those, you've lost many of your best opportunities.

KEEPING A BOOK ALIVE

Keeping a book "alive" becomes the central goal three to six months after its publication. Start thinking about how to keep your book alive as soon as you sign a contract.

One way is to mount a multi-city exhibition tour. This creates new publicity at every stop, even after the book has been out for months. A frequently overlooked alternative to commercial galleries is university galleries. These venues are plentiful, and many are dedicated solely to exhibiting photography. They will sometimes help with resources such as shipping, framing, special events, and promotions.

If you set up an exhibition tour well in advance, the exhibition venues can be included in the press release your publicist sends to the glossy, high-circulation magazines. The level of publicity these magazines can generate is a tremendous sales tool for your book and for the galleries.

What to include in your promotional planning toolkit:

1. List every publication you aim for your book to be featured in.
2. Identify every possible angle for approaching those publications. Examples include pitching:
 - Articles covering the "back story": how the book concept came about or circumstances surrounding its preparation. (Did you travel cross-country? Spend three months in the Sahara?)
 - Blurbs and pictures of the cover in prominent magazines
 - Reviews
 - Photo spreads excerpted from the book
 - Profiles about you
3. Create a promotional timetable that begins six months in advance of publication.
4. Plan a strategy to keep the book alive after publication, such as a speaking tour that lasts several months, a blog campaign, and an exhibition series.
5. Determine third parties that can help you pursue any of the publicity options listed above that your publisher might not be pursuing.

EXHIBITIONS, PANELS, DISCUSSIONS, AND BOOK SIGNINGS

Galleries generally plan their exhibitions up to two years in advance. But many have some flexibility and can shift their schedule around, especially for a show that will add to their stature, potentially make them a profit or help them gain new clients, which include your friends, clients, and collectors.

Some books are appropriate for panel discussions at nonprofit organizations, where signings can be held. Institutions and special-interest groups have their own mailing lists that will reach new audiences. It may be worthwhile to donate books to charity auctions and other events, if they can guarantee the book will be prominently displayed and credited. Displays in retail shop windows can also serve as a good source of advertisement for new books and photographs. Look beyond the major bookstore chains to seek out stores that cater to your book's audience.

Book signings are increasingly difficult to arrange unless you can guarantee an audience, so include as many friends, family members, and clients as you can on the invite list. Bookstores are fighting to attract crowds for nightly signings. When considering a signing, some stores check their sales database to see how similar books have sold. If sales have been low, they don't see an opportunity. So it is important to convince them you can bring in a crowd. The same is true of speaking engagements.

NO PUBLISHER? SELF-PUBLISH

New technology and low digital printing costs have resulted in scores of self-published books. Self-publishing may be an effective solution for photographers who have a niche body of work that reaches a small audience. It is also worthwhile for photographers with built-in audiences, such as instructors and those running seminar businesses. Self-publishing in very limited editions can also be a powerful promotional tool, if you can afford to create them solely for that purpose.

In today's economic climate, book publishers are less likely than ever to publish a book that doesn't have a high probability of commercial success. If industry professionals (and the all-important bookstores) don't react with interest to a prospective book, it is unlikely the buying public will. But you may still want to print a book for your own reasons.

There are many downsides to self-publishing. Most mainstream publications will not review books that are self-published. Distributors are hard to find because self-published books generally aren't profitable. And without a distributor and publicity, it is almost impossible to break into bookstores.

On the other hand, there are upsides to consider. A self-published book will greatly increase your visibility if you are willing to send it to leading photo

editors, dealers, curators, and photography critics. (Don't expect it to be returned.) Think carefully about how a self-published book may help you attain your professional or sales goals, and whether having your book showcased on *www.amazon.com* and other online book vendors will translate into sales, commissions, and more opportunities.

Before taking this route, decide whether you can afford to implement the promotional program that will generate these and other positive results. Your investment is not only in money but time.

The Press Kit. Press kits have largely gone digital. The ideal place to create one is on a Web site dedicated to the book. Stylish and succinct is the way to go, with minimal text and images—just enough to convey the media message.

A blog can also generate an audience for your book. It can be created to document the book's production or comment on your work in general. Not only can the blog itself be promoted through traditional channels, you can use it to connect with like-minded audiences by posting to and trading links with related blogs and sites; all this will drive traffic to your site and further increase your visibility. Don't create a blog if you cannot maintain regular postings (at least three a week).

An online press kit should include:

- A press release/artist statement
- A narrative bio that tells the story of your career using fresh, engaging language
- Press clippings from magazines or newspapers that have reported on your work
- An interview with the author or testimonial quotes
- Digital images

Stock Photography

"Everywhere you look, in print and electronic media, you'll see stock images . . . on Web sites and banner ads, in magazines and newspapers, in brochures and ads, on point-of-purchase displays, credit cards, cell phone displays and more."

—Betsy Reid

A Brief Explanation of the Business of Stock Photography

by Betsy Reid

Betsy Reid is executive director of the Stock Artists Alliance, where she leads the SAA's advocacy and educational efforts. Betsy edits the SAA's magazine, *Keywords*, and is primary author of the association's industry white paper reports. Also active as a producer of stock images, Betsy provides an insider's perspective on the issues and challenges of careers in photography and image licensing.

———————————— • ————————————

The following text was adapted for use in *ASMP Professional Business Practices in Photography* from an article originally published in the Stock Artists Alliance's *Keywords* magazine, assigned and edited by Betsy Reid. The SAA is the only trade association dedicated to the business interests of professional stock photographers. The SAA supports its members with substantial information resources, ongoing advocacy initiatives, and the benefits of a professional community. More information about the SAA and free resources are available at *www. stockartistsalliance.org*.

STOCK PHOTOGRAPHY IS THE BUSINESS OF LICENSING IMAGES THAT WERE PREVIOUSLY shot and are therefore "in stock." Stock images are widely used by art directors, designers, corporations, publishers, and others for every conceivable kind of commercial and editorial (publishing) use. Everywhere you look, in print and electronic media, you'll see stock images . . . on Web sites and banner ads, in magazines and newspapers, in brochures and ads, on point-of-purchase displays, credit cards, cell phone displays, and more.

Images are made available for licensing through a variety of stock

distribution outlets that may be referred to as agencies, portals, archives, brands, collections or picture libraries. There are hundreds of these companies, each with its own approach to the stock business, but what they have in common is that they are all involved in either developing image collections, marketing them, or doing both.

Today the vast majority of stock searches and transactions are made online, and the business is dominated by three mega-distributors (the largest being Getty Images, followed by Corbis and Jupiter). These companies have been consolidating the industry through aggressive marketing and continuing acquisitions of major collections. There are also a few larger independent collections (like Masterfile), portals (like Alamy), and many small specialized (niche) collections.

Stock collections are commonly subdistributed through one or many sites (sometimes hundreds), each taking a share of the licensing revenues. For example, a U.S.-based collection may have a subdistributor in France, and a small collection is represented on a mega-distributor site.

The dominant stock licensing models in use today are commonly referred to as "rights-managed" and "royalty-free." Rights-managed licenses grant specific usage rights for an image, such as a one-time magazine cover or one-year billboard use. In contrast, royalty-free licenses grant virtually unlimited use of an image, and pricing is based on image file size or subscription period.

Stock photographers sign distribution agreements with one or more distributors, authorizing them to market and license their images. The most typical contract is for self-funded contributors to submit their images for representation and receive royalties based on a percentage of the licensing revenue received by the company. These contracts often contain complex legal language that can be difficult for a layperson to understand.

Today stock companies are looking to grow their collections (and their revenues) by reducing their royalty expenses. A growing trend is building wholly owned collections where distributors are buying image collections or contracting with contributors to produce images on a work-for-hire basis.

Another trend is increasing interest among photographers to pursue more self-directed approaches to stock licensing. They are developing niche collections, building independent Web sites, marketing their images on portals, and forming cooperatives. A new generation of technology and distribution services is emerging to support the independent self-marketer.

TOP STOCK SUBJECTS

What kinds of images do designers and art buyers use most in stock? There's demand for images in a wide spectrum of areas, and key industry surveys

indicate that the following are the top stock subjects. It is not surprising that the need for images of people, business, and lifestyle top the list year after year, followed by more specialized subjects.

People
Lifestyle

Business and Industry

Abstracts

Backgrounds

Concepts

Medical

Science and Technology

Travel and Transportation

Nature

Wildlife and Agriculture

Food and Beverage

Fine Art

Sports and Entertainment

Historical and Vintage

Source: Graphic Design USA

Stock Licensing Models

by David Sanger and Betsy Reid

David Sanger is a travel stock and editorial photographer, based in the San Francisco Bay Area. He has been active in photographer-agency relations, serving as president of the Stock Artists Alliance, board member and legal chair. His images are represented by Getty Images, Alamy, and Digital Railroad. In addition to licensing images from his own Web site, *www.davidsanger.com*, he photographs for editorial and commercial clients in the United States, Europe, and Asia. David has been an ASMP member since 1992.

Betsy Reid is executive director of the Stock Artists Alliance, where she leads the SAA's advocacy and educational efforts. Betsy edits the SAA's magazine, *Keywords*, and is primary author of the association's industry white paper reports. Also active as a producer of stock images, Betsy provides an insider's perspective on the issues and challenges of careers in photography and image licensing.

———————————— • ————————————

The following text was adapted for use in *ASMP Professional Business Practices in Photography* from an article originally published in the Stock Artists Alliance's *Keywords* magazine, assigned and edited by Betsy Reid. The SAA is the only trade association dedicated to the business interests of professional stock photographers. The SAA supports its members with substantial information resources, ongoing advocacy initiatives, and the benefits of a professional community. More information about the SAA and free resources are available at *www. stockartistsalliance.org*.

HOW ARE STOCK IMAGES LICENSED? ASK TEN PEOPLE AND YOU'LL LIKELY GET TEN different answers. That's because the terms and the terminology are, well, less

than clear. Today there are basically two ways that stock images are licensed: rights-managed and royalty-free. Why should you care? If you're looking to get into stock, there are very different deals out there, so you need to think it through before you commit yourself and your images.

DEFINITIONS

- **Rights-managed** (RM) licensing is priced on use, so the particulars of the use—such as medium, territory and duration—all are considered in determining the license fee. RM is based on the simple pricing logic that big uses pay more, and small uses pay less. So, a national advertiser pays more to feature an image on their billboards than a local business pays to use it in their store display.
- **Royalty-free** (RF) licensing offers essentially unlimited, nonexclusive use of an image for a one-time fee. RF images are most commonly priced by file size. Newer variations, such as subscription and microstock, have offered deeper discounts to buyers, reducing the price per image from hundreds of dollars down to as low as one dollar.

Rights management, on the other hand, is another important concept to understand. Rights are "managed" if every license of an image is defined with clearly specified end-user and usage rights, and if these are all recorded in a license history. This is much easier when a single distributor is the only one authorized to license the image, and more of a challenge when multiple distributors are involved.

There are a number of benefits to rights management. For the photographer (as a copyright owner), it enhances control over intellectual property. Keeping track of the "who, what, where, and when" of usage rights granted makes it possible to track use of your image, to identify infringing usages, and so to recover revenues. For the stock buyer, knowing the complete history of licenses granted for an image allows him to determine whether there have been competitive uses, and it also allows the possibility of licensing an "exclusive" within the industry or a territory—something which can be quite valuable for high-end advertising buys.

Rights-managed licensing, by design, enables effective rights management. Royalty-free licensing does not. Since there is no end user specified in RF licenses, they cannot be tracked and rights cannot be effectively protected.

CHOICES

Today most stock buyers source images from both of these licensing models. They usually search both RM and RF collections, though they sometimes

specify one over the other. Overall buyers are attracted by the ease, low price, and flexibility of royalty-free yet continue to value the quality, diversity, and inherent benefits of rights-managed.

Which is the better model for photographers? How can your images be marketed most effectively? It is a critical decision because once the licensing model is set for an image, it rarely (if ever) can be changed. These two extremely different approaches to stock licensing can both be profitable in the right circumstances. Here are some factors that deserve serious consideration.

Speaking in generalities, RM commands higher license fees per image but generates less volume. RF generates higher volume but on average smaller license fees. RM contracts tend to offer substantially higher royalties to photographers, while RF royalties tend to be much lower. Often RF images are widely subdistributed which further dilutes the royalty payments to photographers but adds some additional volume.

Search RM and RF collections online and look at the kinds of images offered. You'll tend to see more specialized, high-production and distinctive images in the higher value RM collections. These kinds of images also tend to have a longer life span. On the other hand, more ordinary, generic, or easily reproducible images are seen more often in the more volume-oriented, lower value RF collections. These images tend to have a much shorter lifespan. Most stock collections are edited, and a distributor may be willing to accept an image under one licensing model but not another.

Faced with a choice between placing an image as RF or having it rejected by the distributor, you may decide to take the image elsewhere and consider other options.

Another important consideration is that rights-managed images offer much better copyright protection. Because licenses are defined, infringements can be identified and revenues recovered. Consequently, there is likely more illicit usage of RF images, and less protection for the photographer.

Finally there are the differing contact terms offered. Most distributors have a separate distribution contract for their RM and RF collections with different royalty rates, terms, and protections. Whereas RM contracts have traditionally offered royalty rates of 40 to 50 percent, RF contracts offer less than half of this rate, generally 20 percent. This was initially justified because of an early emphasis on retail CD sales and expensive subdistribution arrangements, yet nowadays almost all sales are direct online and there is little or no difference in the work to prepare or distribute an image as RM or RF. In fact, rights management can involve more work in tracking and recording licenses. Comparable revenue sharing is further justified as the photographers are today taking on an increasing share of the workload in delivering finished digital

files—work which the distributors once did themselves. As the burden (and costs) of image preparation have now shifted to the photographer, there is even less justification for differential royalty rates.

Some distributors have recognized this and began to offer the same royalty rate to contributors for RM and RF image licenses. SAA applauds such efforts and urges all distributors to equalize royalty rates at the higher level of RM rates.

The SAA advocates for business models that best serve the interests of photographers, and we believe that rights-managed terms and contracts continue to offer photographers more equitable terms and revenue sharing, as well as more control over various forms and terms of usage.

As a stock photographer and individual business owner, you need to assess and determine what business models work for you by understanding and carefully evaluating the differing terms before signing on the dotted line. Stock contracts can commit images for many years . . . and that's a lifetime in this business.

EVOLUTION

There is clearly room for improvement in the licensing models of today. For example, rights-managed licensing need not be complicated or inflexible, just as royalty-free licensing need not give users so much more than they actually need.

One answer to this challenge is to simplify rights-managed licensing to make the process easier, more transparent, and more flexible while also preserving the ability to manage rights and ensure royalty compliance. This concept has been introduced in license "packages" by several major stock distributors and is at the forefront of industry discussions.

Taking the lead is the Picture Licensing Universal System (PLUS)—a multi-industry coalition that has come together with the mission of simplifying and facilitating image licensing through the development and universal adoption of standards, *www.useplus.com*. The SAA is an active supporter of PLUS and has contributed to the development of universal license packages within the PLUS system.

As envisioned, PLUS Packs will provide an option for licensors of all sizes to offer a streamlined form of rights-managed licensing that offers buyers the flexibility of broadly defined licenses in conveniently standardized, numbered packages. PLUS Packs are designed to offer licenses for a specified end user within a broadly defined category of use, such as display or marketing materials. A short list of licensing options (including duration and region) keeps the process simple, while enabling licensors to scale pricing to accommodate the needs (and budgets) of both a large international company and a small local business.

Editorial + Commercial Stock: Worlds Apart

by Rivaldo Does

Rivaldo Does is a stock photographer, illustrator, and art director. He was born in Brazil and over the last two decades has created diverse imagery for a global market, including works in print, film, TV, and interactive media. *www. doesimages.com.*

———————————— • ————————————

The following text was adapted for use in *ASMP Professional Business Practices in Photography* from an article originally published in the Stock Artists Alliance's *Keywords* magazine, assigned and edited by Betsy Reid. The SAA is the only trade association dedicated to the business interests of professional stock photographers. The SAA supports its members with substantial information resources, ongoing advocacy initiatives, and the benefits of a professional community. More information about the SAA and free resources are available at *www. stockartistsalliance.org.*

STOCK PHOTOGRAPHERS TRYING TO FIGURE OUT THE INS AND OUTS OF THE market invariably face what appears to be a world of contradictions. They turn to their peers for help only to find that answers are all over the map. No surprise there. After all, the world of stock is, well, a world. Obviously it is very diverse. So much so that what is a success recipe for some could turn out to be the ticket to failure for others.

There are two large continents in the world of stock: editorial and commercial. There are islands scattered all over the ocean as well but those two continents account for the bulk of this world's land mass. Needless to say, the climate and requirements for survival on each continent are entirely different.

Furthermore, upon close inspection you will see that each continent is divided into a myriad of subregions, each with its own characteristics.

Therefore, to pick relevant advice out of that mess of conflicting opinions floating out there you need a world map. Once you study the stock world map, you should have a better idea of where you fit in and what is relevant to your career. In other words, the best advice will come from those whose goals are more or less similar to yours. Anything else could be dangerously misleading.

A TRANSCONTINENTAL PERSPECTIVE

Certain questions keep coming up on stock photography forums, and there are always a number of people ready to offer answers. The problem with the answers however, is that more often than not people fail to account for the huge continental differences that define the world of stock. Let's look at some of those questions once again, this time from a transcontinental perspective:

CAN I MARKET MY OWN IMAGES ON MY WEB SITE?

Editorial image buyers usually have plenty of time to plan their purchases and are willing to research a variety of image sources, one of which could be you. So yes, you can market to those buyers, as well as to some small, niche commercial markets. On the other hand, high-end commercial art buyers work under insanely tight deadlines and cannot afford to visit dozens of individual photographers' Web sites just to find the one image they need. Not to mention their demand for 24/7 live customer service and high-res downloads. For these buyers, it is a safer bet to simply go to a big stock distributor where they have the work of thousands of photographers at their fingertips, all at once. This "one-stop shop" requirement makes it virtually impossible for you to reach high-end advertising buyers directly. There are a few ways around it but those are so difficult, the vast majority of photographers who try, fail.

DO I WANT OR NEED EXCLUSIVE DISTRIBUTION?

Editorial photographers have good reasons to avoid exclusive distribution. It brings them no benefit whatsoever; on the contrary, it only deprives them of potential sales. Some commercial photographers, on the other hand, could end up shooting themselves in the foot by going nonexclusive. This is because commercial stock buyers—especially in the high-end advertising region— almost always inquire about the image's history before buying an image license. This has nothing to do with exclusivity. They simply want to know where the image has been. Problem is, such buyers are often in a hurry. To get such sales, your distributor needs up-to-the-minute sales history data, which currently is difficult to obtain in a multiple, nonexclusive distributor setup. Hopefully,

the right mix of technology and adaptive business attitude on the part of both photographers and distributors will eventually remove this logistical difficulty, but that's another story.

HOW MANY IMAGES SHOULD I PRODUCE? HOW MUCH SHOULD I EXPECT TO MAKE PER IMAGE?

You may hear of editorial photographers placing 12,000 images on the market, while commercial photographers may only place a few hundred. The former group relies on a high volume of lower fee licenses, while the latter relies on a lower volume of higher fee licenses. Obviously, income comparison across such different models is a pointless exercise. If you insist on making these kinds of comparisons, at least focus on photographers who operate on the same "continent" as you do—unless you are considering migration.

HEY, DOES ANYONE KNOW OF ANY GOOD AGENCIES?

Good for what? Good for whom? Too often we see photographers placing their hopes in the wrong distributor, for failing to see the differences in chemistry between editorial and commercial buyers. In fact, even some distributors fail to see the distinction! Commercial and editorial buyers have very different needs, often times directly opposite. Very few distributors are well tuned to both. So before placing your images in any outlet, ask yourself: "Is this environment inviting to the typical buyer of my images?"

As you can see, life can be dramatically different depending on where in this world one has chosen to live. The good news is, if you have a good map in hand—and take the time to study it—you will notice differences you had not noticed before and will be able to zero in on the answers that are truly relevant to your particular area.

CULTURE CLASH

Visual language is yet another source of divergence among stock regions. Differences can be huge, especially when you compare the extremes of both continents. For instance, some areas of editorial photography require a very transparent, straightforward approach that barely leaves room for the photographer's interpretation. In this case, the photographer acts—or makes it look as if she is acting—as an impartial observer.

Advertising, on the other hand, usually goes the opposite direction. The photographer is expected to interpret, recreate or even fabricate things, while covering everything with a thick layer of styling (or the absence of it as a subverted form of styling). If you are a natural-light only, natural-everything photographer, you are probably not going to connect with the commercial

photography market. Likewise, a photographer whose style draws as much attention as the subject of the image probably will never attract, say, textbook editors.

Extremes aside, there are a few overlapping areas. Since the continents influence each other to some extent, it is possible for certain kinds of images to work equally well in both cultures. Magazines for instance, while editorial in nature, often illustrate articles with conceptual images that could just as easily be used in advertising. Photographers who figure out how to transcend borders and seize such opportunities obviously stand to increase their sales—although that sounds easier than it really is.

UNDECIDED?

If you have not yet decided where you fit in this world, you might want to start by learning as much as you can about the world of stock while being careful to identify the origin of every single piece of information you gather. Always ask: "Is this editorial or commercial?" Then plot your newly acquired information in the appropriate map coordinates. As your data builds up, you should see a world map emerge. This should give you a sense of where you want to go. Are you inclined to settle in either continent? Or are you headed for that sparsely populated strip of land that connects them? Do you want to roam an entire continent like a nomad, never knowing what the next day will bring? Or do you want a place to call your own? Are you going for a big farm, or a small plot of land where you can grow very specialized images that do not grow anywhere else? Remember, you need to think about these questions in order to filter out irrelevant advice.

ENOUGH OF GEOGRAPHY

Be careful not to confuse the map with the territory. There is a right time for everything, and at some point you have to put the maps away and go create images. Just remember to fence your intellectual property and lock the gate when you leave for a shoot. Some things never change, no matter where you go.

Stock Contracts: Look Before You Leap

by Robert Rathe

Robert Rathe photographs people for advertising, corporate, and editorial clients nationwide. Throughout his career, he's been active in industry affairs: serving as a board member and vice-president of the ASMP and as a founding board member of the SAA. He is the co-author of the ASMP publication *On Buying Photography* and has been featured in interviews in *Photo District News*, *Rangefinder* magazine, *In-Print* magazine, and the book *Industrial Photography*.

———————————— • ————————————

The following text was adapted for use in *ASMP Professional Business Practices in Photography* from an article originally published in the Stock Artists Alliance's *Keywords* magazine, assigned and edited by Betsy Reid. The SAA is the only trade association dedicated to the business interests of professional stock photographers. The SAA supports its members with substantial information resources, ongoing advocacy initiatives, and the benefits of a professional community. More information about the SAA and free resources are available at *www. stockartistsalliance.org*.

OK . . . SO YOU'RE READY TO TAKE THE LEAP. YOU'VE SENT IN A SAMPLE SUBMISsion to a stock agency, they love your work, and they've sent you a contract. Now what?

You look through the contract, but it's really boring and tedious. Sure, you're tempted to sign just to get it over with. But somewhere in the back of your brain might be a little voice telling you, "Wait. This is a legal document. Do I really want to just sign it without understanding what it means?"

Nah. What you're hearing is the other voice . . . the one that says, "What's the big deal? It's a standard contract, just like everyone else signs, I'd better not rock the boat . . . they want me . . . this is such a great opportunity. . . ."

Yes, the second voice is easier to listen to, but it's also a great way to put yourself out of business. We've all been there, but those who have survived in this business have learned the hard way that paperwork *is* important. This article contains a brief (and by no means complete) description of some of the things you're likely to see in many stock distribution contracts. However, keep in mind that it's not a substitute for qualified legal advice.

A LEGALLY BINDING AGREEMENT

A stock agency contract is a legally binding agreement that outlines the terms under which you and the distribution entity will do business. In some cases it may be negotiable; in others there is no flexibility at all. Either way, understanding what you're signing is crucial to protecting your interests and minimizing your business risk. If you don't know what something means, ask. Check with the ASMP, the SAA or one of the other major photographic trade associations. Before signing any contract, you should talk to an attorney. Good legal advice up front can save you money, time, and headaches later on.

It's important to understand at the outset that the contracts are generally drafted by the stock agencies. Even if they are attempting to be completely fair (and that's a big "if"), the reality is that contracts almost always favor the drafting entity. In years gone by, many agencies allowed for individual changes and negotiations, but in today's business climate (especially among the larger distributors) the trend seems to be moving toward contracts that are nonnegotiable. From their perspective, it's simply too costly in terms of accounting and administration to have different deals with their many contributors.

AGENT OR DISTRIBUTOR?

While we use the term "agent" or "agency" for brevity and a common understanding, in reality the company that distributes your images is no longer your agent. This is a very important legal distinction. A true "agent" has certain legal responsibilities to the "principal" (you). Distributor relationships carry no such fiduciary (meaning: special relationship of trust) responsibilities beyond the terms actually stated in the contract. Because of this, it's more important than ever to be certain that the contract you sign will protect your interests now and into the future.

ASSIGNABILITY

Most contacts are assignable by the agencies (but not you) to another entity. Why is this important? Well, it's very possible that your distributor, regardless of size, might someday be bought by another player (either from inside or outside our industry). By making the contract assignable, they can sell their agency and pass your contract along to the new owners. This isn't necessarily bad, just something you should be aware of. You might think you're signing with an agency because of the relationships you've established or the way it does business, but in another year you may be involved with a large multi-national conglomerate that doesn't even know your name. Protect your interests by viewing the contract as a document separate from the people you think you'll be dealing with.

TERM LENGTH

Check out the contract term (the length of the agreement to represent your images) and look at the renewal terms. Almost all stock contracts will last at least a few years, with post-termination (after the contract is over) obligations lasting years longer. Look carefully at your post-termination rights and obligations. It's not uncommon to have to leave images that have been licensed (or have been published in catalogs) with an agency for up to five years or more beyond the contract termination date. Sure, you're supposed to be paid if they're licensed, but you may be missing a better opportunity to market them elsewhere.

RENEWAL PROVISIONS

Does the contract automatically renew unless terminated? Is the renewal term the same as the initial term? How do you prevent the contract from renewing automatically? Must you give notice six months ahead? Ninety days? Thirty days? Can you terminate the contract before it expires? It's bad enough signing a lousy contract; it's worse to be stuck in a renewal because you were unaware of how to terminate it. If it says you must notify the agency by certified mail, do exactly that. As a matter of fact, do it anyway or use an overnight courier that gives you proof of delivery.

ROYALTIES

How are your royalties calculated? In many ways this is the heart of the contract but often where clarity and transparency are sorely lacking. Ideally, royalties should be based upon the actual license fee paid by the end user (less sales taxes or value-added tax). So if a client licenses your image for $100 and your royalties are 50 percent, you'd get $50. Unfortunately, this approach is becoming less and less common.

More likely, your royalties will be based on a percent of *net* fees received by your agency. This often leaves considerable wiggle room in how your actual share will be calculated. Are any expenses deducted? What about withholding or other income taxes? If there are subagents (intermediary agencies) involved in the transaction, your net percentage will drop, but few contracts spell out how much subagents are taking off the top (or even obligate your agency to disclose when a subagent is involved).

LEVEL OF EXCLUSIVITY

Is the contract "agency exclusive," "image exclusive," or "nonexclusive"? If it is agency exclusive, you can only sign with that one agency. If the agency rejects your work, it will sit in your file cabinet. With an image-exclusive contract, you may file nonaccepted images with another agency as long as it is not considered a "similar" (see next paragraph). With a totally nonexclusive contract, you may be able to file the same image (or any image "similars") with another agency that is also totally nonexclusive. But be aware that licensing the same or similar rights-managed images from multiple sources can cause serious problems for clients and may create a situation where the buyer can force the price down by playing one distributor against the other. While unlikely given the ever-expanding pool of work available to clients, it is a possibility.

"SIMILARS"

How does your agency treat similar images? The definition of "similars" varies from agency to agency, so it's very important to have a complete understanding of your agency's policy. It usually revolves around images from the same shoot, with similar models, location, propping, and wardrobe. You don't want to be in breach of your contract for having similar images on file at two agencies if either one is "image exclusive."

BREACHES

A breach is a situation when one party or the other has violated the terms of the contract. Sounds simple, but depending on the nature of the violation and the resulting damages, it can be cause for contract termination (at a minimum) or an expensive lawsuit that may put a real crimp in your equipment budget.

WARRANTIES AND OBLIGATIONS

Look carefully at the areas that define your warranties and obligations. Make certain that you understand what you are agreeing to and plan to fulfill these with each and every submission. Failure to do so can lead to problems down the road.

Tied into the warranties is something called indemnification. While very common in one variety or another in stock distribution agreements, the impact of such clauses can vary widely with just minor changes in wording. When one party indemnifies the other (safe bet it's going to be you indemnifying the agency), that party is agreeing to pay for any damages (often including attorney fees) for a variety of causes. Some indemnification clauses are not unduly harsh or unreasonable, and may be covered under errors and omissions insurance that you can purchase.

For example: You might be asked to indemnify the agency and/or its client for damages that result from a missing model release or copyright/trademark infringement in an image you have submitted. Or you may mistakenly mark an image as released when it is not. While most agencies now require a copy of the release, this may be a situation where the agency has a legitimate expectation of indemnification because it is relying upon your warranties and obligations being properly executed under the contract.

On the other hand, many indemnification clauses want you to cover the agency and client for any problems that result from the use of the image, even if it's not your fault or something totally out of your control. An example might be a situation where the actual use creates a problem and even though you have a valid signed release, the model files a lawsuit. Perhaps it will get thrown out of court, but you could be on the hook for everyone's legal expenses. If at all possible, avoid these very broad indemnification clauses.

PROMISES VERSUS CONTRACTS

Good business practices involve using written agreements to protect everyone's interests and provide a framework of mutual understanding. There's nothing inherently wrong with a detailed contract, but beware of contracts that are overly complex when simple language would work or those that appear to be an attempt to confuse or cloud the real issues. Never rely on statements like "Oh, don't worry about that" or "Sure, it's in the contract, but we don't enforce that clause." Verbal commitments that contradict the contract are useless, and worse, can be an attempt to mislead you. Always get it in writing.

If terms like indemnification, warranties, post-termination rights, similars, royalties, gross and net license fees, and so on make your head spin and hair hurt, you're not alone. Many photographers have neither the training nor the temperament to deal with the legal mumbo jumbo in contracts. For some, the solution is simply to sign and hope for the best, but the smart ones and those who want to succeed in business will make the effort to understand these critical business documents and seek competent advice through a trade association or attorney.

Going Portal

CLEARLY DEFINING STOCK PHOTOGRAPHY PORTALS

by Ethan G. Salwen

Ethan G. Salwen is an independent writer and photographer currently based in Buenos Aires, Argentina. In addition to covering Latin American cultures, Salwen writes extensively about technical, artistic, and marketing aspects of photography. He is a regular contributor to the *ASMP Bulletin*, *The Picture Professional*, *Rangefinder*, and *After Capture*. www.ethansalwen.com.

————————— • —————————

The following text was adapted for use in *ASMP Professional Business Practices in Photography* from an article originally published in the *ASMP Bulletin*, assigned and edited by Jill Waterman.

WHILE THE VERY NAME SUGGESTS SOMETHING MAGICAL, THERE'S NOTHING miraculous about stock photography portals. They are just tools. Exactly how, or even whether, portals can support an individual photographer's business goals depends on that photographer's specific circumstances, as well as how successfully he or she manages portal activities. One photographer might gain tremendous marketing and sales advantages with a minimal investment of time. Another might sink huge amounts of time, energy, and money into portal activities and gain nothing.

Stock photography portals do not offer a universal marketing and distribution solution, yet they do offer unique opportunities for both new talent and seasoned pros alike. Not only can they connect photographers with buyers and add visibility for those looking to break into the industry, but portals enable

photographers to create a more robust Web presence with ease, gain exposure in new markets, and increase distribution channels.

Portal services vary dramatically. By describing the general types of portals available, I will seek to help you determine which portal will best serve your specific needs.

DEFINING PORTALS FOR STOCK PHOTOGRAPHERS

If you have a precise, unshakeable definition of the term "stock photography portal," you're probably the only one who does. Portals are often defined vaguely as sites that "market and distribute images from multiple agencies and photographers." That's certainly one way that picture professionals use the word—especially those seeking images. But such a broad definition presents serious drawbacks, as it includes *all* online agencies, regardless of size or functionality. Of greater concern, this definition doesn't distinguish the type of stock portal of most interest to photographers: Web sites that offer photographers control over unique marketing opportunities that don't exist elsewhere.

The need to concretely define stock photography portals is less important for clients than it is for photographers. As Michael Masterson, the director of marketing and communications at *www.workbookstock.com* points out, "What do researchers care if the site is called an online agency or a portal? They're looking for the right image at the right price with minimal effort."

Yet both photographers and buyers can benefit from a better understanding of the way portals work and the types of relationships that are cultivated through different portal structures. From the photographer's point of view, two critical factors distinguish stock photography portals from online agencies and other marketing outlets:

1. *Portals give photographers control.* Photographers must initiate portal activities, and then they must continue to oversee those activities. Unlike traditional stock Web sites, where the photographers' representation is controlled by their agencies, portal sites work directly with photographers.
2. *Portals provide nontraditional, Web-based marketing opportunities.* A few of these include: promotion of the photographer's individual Web site at low cost, easily accessible e-commerce functionality, and the ability to track which images buyers are reviewing.

To assess the different functionality options portals offer, let's separate them into three general categories: pure, enhanced, and full-service. Keep in mind that one type of portal is no better or worse than another; it all depends on your needs.

THE PURE PORTAL

The pure portal is one that acts *only* as a conduit for connecting buyers *directly* with photographers. Portals in this category offer a wide range of services, but ultimately they serve as marketing tools for photographers and as research tools for buyers—and that's it. After the buyer locates the photographer, the photographer takes over everything from searches and negotiating to image delivery and invoicing. Pure portals cut out the middleman.

One way to think of a pure portal is as a room filled with nothing but doorways. Each door leads to the gallery and office of an individual photographer, who is standing right there, ready to provide visitors with direct service. When you enter the pure portal, a directory points you to the doors of greatest interest. Posted on each door is a detailed description of the photographer's collection of images and services, and maybe even a few samples. If you like what you read, you step through. If you like what you see, you buy. If you don't, you step back into the main room and then try another door. Essentially, the pure portal is both a directory and a super shortcut rolled into one. Its convenience and efficiency allow buyers to locate and investigate many photographers they might have otherwise overlooked.

The pricing structure for pure portals is simple: Because buyers and photographers are working together directly, the image makers bill their clients directly. The portal charges its contributors flat rates for set services. Examples of pure portals include ImagePond, Photosource International, *www.PhotoServe.com*, and the ASMP's "Find a Photographer" database.

THE ENHANCED PORTAL

Like the pure portal, the enhanced portal aims to maintain a strong relationship between buyer and photographer. However, enhanced portals provide more than just a conduit for connecting buyers with photographers. Image search engines, e-commerce licensing, lightboxes, customized Web site building, and customer service functions are typical features that enhanced portals offer contributors. These tools—costly for even the most successful photographers—are put easily within a photographer's financial reach.

When a user steps into an enhanced portal, he still encounters a room full of doors. However, the directory by the doorway—the search engine—is more complex and allows visitors to gain a much better understanding of what they'll find behind each door. When you pass through a given door, you'll still find the galleries of one photographer and you'll learn how you can contact and work with that photographer directly. But before interacting with the photographer, you'll have the opportunity to work with a representative from the portal who's helping oversee the galleries.

Pricing structures and service charges vary considerably among enhanced portals. However, like pure portals, enhanced portals tend to offer specific services for set fees. Photographers generally set their own licensing fees and handle their own sales, but some enhanced portals offer sales support for images that have been uploaded to the portal. Therefore enhanced portals typically charge one-time set-up fees along with monthly or yearly maintenance fees. By paying more, contributors can often increase functionality to their portals or upload new images to the site. Examples of enhanced portals include IPNstock and AGPix.

THE FULL-SERVICE PORTAL

The full-service portal offers photographers the behind-the-scenes control and marketing advantages of the other types of portals, but it concentrates on connecting buyers with an image, not a photographer. From the client's point of view, using the site is just like using an agency's Web site. The significant factor for the photographer is that the full-service site takes care of all customer interaction—from helping with searches to licensing and delivering images.

Because full-service portals offer different services, pricing structures vary dramatically. However, like traditional agencies, they tend to take a part of the licensing fee. Some full-service portals charge up-front fees to place images. Some don't. The greater the up-front costs, the greater the percentage of the licensing fee photographers pocket. Many even offer photographers the opportunity to select among two or more pricing models with different licensing percentage splits. And like other portals, full-service portals typically offer contributors more services for extra fees. Examples of full-service portals include Alamy and *www.Workbookstock.com*.

KEEPING UP WITH PORTALS

The tremendous rate at which digital imaging and distribution methods are evolving ensures that tomorrow's stock photography portal will look very different than today's—and that tomorrow will almost certainly have arrived by the time you read this chapter. This, however, does not make the value of portals any less useful to the resourceful photographer.

But it demands that photographers navigating the ever-changing waters of the portal world remain diligent in their research, selection, and use of portals. Just as important, photographers should not feel allegiance to a given portal. With the arrival of a new portal that better serves your needs, it's time to make a savvy, guilt-free change.

Interviews with Stock Photographers

by Leslie Burns-Dell'Acqua

Leslie launched the oddly named Burns Auto Parts in September 1999, continuing her career of helping creative people make a living doing what they love. In addition to her consulting work, Leslie has written many photo business book chapters and articles, and her own photo biz book, as well as lectured to creative groups across the United States. She also produces the monthly Creative Lube podcast and the Super Premium blog.

———————————— • ————————————

THE STOCK PHOTOGRAPHY INDUSTRY HAS BEEN IN A SIGNIFICANT PERIOD OF flux in the recent past. Because of the rise in the availability of royalty-free and so-called microstock image companies, many photographers have seen their stock businesses change. However, stock is still an extremely important part of the photo industry as a whole (Corbis and Getty alone had combined revenues over $1 billion in 2006), and some photographers continue to specialize in shooting stock. With advances in technology making it easier for individual photographers to license stock to their own clients, stock is still a viable subset in the photo industry.

The ASMP would like to thank the stock photographers who agreed to participate in these interviews. Their openness helps the industry, and that professionalism is very much appreciated. Readers should take advantage of these examples by visiting the interviewees' Web sites to learn more about their businesses and see how they are marketing their images.

COMMERCIAL STOCK

Leland Bobbé specializes in shooting people—portraits and lifestyle—both in his New York City studio and on location. He has an impressive list of advertising clients, and he also shoots for stock. In fact, he estimates about two-thirds of his income last year derived from his stock photography. His stock images are offered through companies like Getty, Corbis, and Retna. For this interview we focused on his stock photography.

Releases, both model and property, are particularly important for stock photographers, and Bobbé takes care of this part of his business early on his stock shoots. He explained it this way: "I always get my releases signed before the shoot. Since I often shoot with real people, the last thing I want to do is spend a day shooting and then have someone balk at signing a release."

Bobbé's attention to the business side of things extends to his planning and production as well:

> The main difference between producing a stock shoot and an assignment is that with stock I am spending my own money. To maximize my return on investment, I need to be very aware of what I am spending and at the same time produce high-end images. This is more important currently than even a few years ago when the value of any one stock image was higher.

That is, in the past the overall return from any stock image was generally higher than the average return today.

In his assignment photography Bobbé generally requires about 70 percent of estimated expenses up-front, and he licenses usage in his assignment work as well as for his stock. He estimates that about 10 percent of his assignment images are relicensed for additional usage by the original client, but he rarely if ever licenses assignment images as stock. He notes, "My stock is shot as original material specifically for stock."

The effect of more images in the stock market is definitely being felt. Bobbé expands on this phenomenon:

> The stock world has changed greatly over the last five years. Return per image has gone way down with the proliferation of images available. Royalty-free has become so popular that it has become necessary to consider different licensing models outside of traditional rights-managed. Because search order has become so important, it is necessary to produce images regularly as older images drop rapidly. Now look out for microstock.

Preproduction for stock shoots varies as much as for any kind of shoot, depending on the complexity of the individual project. An interesting difference,

however, appears in postproduction for stock images today: The need for complete retouching and also effective metadata inclusion prior to release to his stock houses. This means Bobbé has to figure on more postproduction time than in the past.

Obviously Bobbé is fully aware of the impact of digital technology on his business. He has shot exclusively digital for the last couple of years, and his clear understanding of the changes in the stock industry reflect how he has kept abreast of the changes in his specialization.

COMMERCIAL STOCK

Ken Reid is an Atlanta- and Florida-based photographer who shoots a lot of stock. He also does assignments for editorial and advertising clients, but commercial stock is a significant part of his business. Often his stock images involve autos, though he also shoots people and other still life.

Because he shoots cars so often, he's had to hone a certain set of skills. Reid says, "I shoot cars, which require big metal skills, table top lighting skills, portraits lighting, and directing skills." He's also learned from his experience that, as we see in many specialties, "*Everything* needs a spare/backup."

As is typical for commercial photographers, Reid's pricing varies significantly with usage. He particularly noted the difference between license prices for editorial versus advertising use, saying, "My editorial rates are *way* below my ad rates." Reid also notes that there are differences within categories. For example, "My ad rates are higher for larger end clients too," meaning that, for example, a small company will likely pay less than a large one for similar use.

When it comes to producing his shoots, whether for stock or assignment, Reid incorporates all the usual needed items, depending on the project. For example, he hires hair and makeup stylists for people shoots, buys props as needed, and so on. He takes into account issues of weather and protects himself legally through the use of contracts, terms and conditions, and releases when appropriate (and especially for stock projects). He also makes sure to include plenty of postproduction time to cover his digital workflow. He estimates it roughly as "a day in the computer for every day of shooting."

What is more stock-specific, however, is deciding what projects to shoot. His first consideration when conceiving a stock project is, as he put it, "that it will return a profit on the investment. Money, time, and effort are also considerations." Like most stock photographers, Reid understands that he must invest his time and money to make the images he offers for stock licensing, and there is always the possibility that some images will not to pay off on that investment. The idea is for most of the images to pay off, though, and therefore this is a top consideration for any project.

However, somewhat surprisingly, Reid says that he rarely relicenses as stock the work he shoots for advertising assignments.

Marketing his stock photography is something he does both through the stock houses and on his own. He is a member of the Stock Artists Alliance and maintains a separate site of stock imagery though that organization. In his stock image marketing, he emphasizes his car images. His theory, both in marketing his stock and assignment work, is: "It is important that you show a clear front to new clients; when they get to know you, it is possible to expand your areas of shooting."

EDITORIAL STOCK/TRAVEL

San Francisco Bay–area stock photographer David Sanger shoots primarily travel images for editorial (and commercial) projects. His work can be found in collections with Getty Images, Alamy, and Digital Railroad.

As a travel photographer, Sanger understands the need to travel easily anywhere, make arrangements in locations all over the world, and come back with the shots no matter the weather or circumstances. Sanger says that many younger or inexperienced travel photographers might not expect the long hours involved. He suggests having "persistence and always be prepared for the unexpected."

Though 80 percent of his business is stock, when he shoots assignments Sanger is very aware of the problems travel delays may cause and of "understanding [the] postprocess workload and factoring [all] that into the estimate." He makes sure to include a digital postprocessing fee and fees for master file preparation.

Because so much of his work is self-assignment to produce images for stock sales, the cost to produce shoots is very much in Sanger's mind. He suggests, "Keep expenses down by working with destinations and properties for a comped room if the budget is slim."

He also points out a few other important differences in his specialty:

Shooting stock is quite different, especially travel stock. [You] need to plan a trip based on likely sales potential, shoot to script, and process and deliver to agency. Plan for two-year payback.

Understanding [the] mind of [the] photobuyer is key—anticipating potential uses in advance changes the way you shoot and edit.

Sanger also suggests keeping very good track of what does and doesn't sell for future shoot planning.

Of course, as a stock shooter Sanger also protects himself by using model releases "almost always" and property releases "sometimes." Many stock houses will not accept images that aren't released, and even when they do they present a potential legal issue down the line.

Paperwork

"Developing strong client relationships is all about communication. By talking about any potential conflicts up front and using paperwork that accurately reflects the deal you've made, you can save yourself a world of pain."

—Judy Herrmann

Why These Forms Are Critical to Your Business

by Richard Weisgrau and Victor S. Perlman

Richard (Dick) Weisgrau's career in photography spanned more than forty years. During that time he worked as a professional photographer for twenty years. He was an ASMP member for fifteen of those years. After that he served as executive director of the ASMP for fifteen years, and then as a consultant and expert witness in photography-related matters. He is the author of four books about the business of photography. Today, his interest in photography is limited to shooting subjects of his choice, and exhibiting and selling prints.

Victor S. Perlman is general counsel to the American Society of Media Photographers, Inc. He has also served on the boards of the Copyright Clearance Center and the Philadelphia Volunteer Lawyers for the Arts. His writing has appeared in *Communication Arts* and *Popular Photography*, and he is the co-author of *Licensing Photography*. He frequently testifies in Congressional hearings and proceedings held by the U.S. Copyright Office.

———————————— • ————————————

EVERY BUSINESS DAY PHOTOGRAPHERS HAVE A NEED TO COMMUNICATE TRANS-actional information to their prospects and clients. It might be the information in an estimate, the agreement expressed in a confirmation, or the verification of a delivery of photographs. Regardless of the nature of the communications, records of them are important, especially when they set the terms, conditions, price, and license to use your work.

Timely communication is very important. You should begin to communicate the transactional details of an assignment, whether proposed or awarded,

immediately after your first contact with the prospective client. Too many photographers rely on their invoice to set the terms of their agreements. The danger of expressing your terms on the invoice is that it arrives *after* the work is done. If it contains any surprises which were not discussed prior to the work being done, it will be contestable and could be considered an attempt to impose a contract after the fact. In such a case, some or all of the invoice's terms would not be binding on the client.

Keep in mind that you always want to present your terms, fees, and so on, before the work is started. If a client has full access to your terms and other details prior to the work being started, and allows you to start and complete the work, it will be difficult for the client to protest. When a client is fully informed and lets you proceed with the work, it implies that a contract was in force and that the conduct of the client (in allowing the work to proceed) amounts to a consent to your previously presented stipulations, terms, conditions, and fees.

A contract is formed between parties when certain conditions exist. There must be an offer, an acceptance, and consideration. An estimate is an offer to perform work with certain stipulations. An acceptance could be a purchase order matching the estimate, an e-mail awarding you the work, a client-signed confirmation, or an oral OK on the telephone.

Oral acceptance can present a problem, if denied later. This is where consent by conduct, allowing you to do the work, can be a factor. Remember: Unless your stipulations were in the client's hands before the consent by conduct, you might not be able to enforce your stipulations. Do your paperwork in a timely fashion.

You should be aware that having the correct forms and releases is no guarantee that you will not be involved in a legal dispute. The purpose of correct paperwork is to avoid misunderstandings, to lessen the possibility of legal disputes, and to protect you and strengthen your position if they do happen.

The ASMP recommends incorporating these forms into your business workflow. We have outlined below the most commonly used business forms. Samples of these are provided in chapter 26. You will likely need to customize these forms for your business, but the essential ingredients are here along with tips on how to fill them out. The use of a terms and conditions template (outlined in chapter 24) on the back of your estimate, confirmation, delivery memo, and invoice is what makes these contractual agreements complete. Do not forget this important step.

THE ESTIMATE

An estimate is used to communicate the projected cost of the work to a prospective client. Additionally it should embody other important details. An estimate

is a description of the work to be done, the media usage allowed for the stated fee, and the terms and conditions that govern the transaction, performance, payment, and so on.

The estimate should be sent to the client prior to starting any work. Even in cases where an estimate is provided on the telephone, you should alert your client that you will be sending a written estimate confirming the telephone estimate.

E-mail is the most common way to deliver this form. Make sure your terms and conditions template is included as the last page of the PDF when sending this form.

THE ASSIGNMENT CONFIRMATION

After your estimate is received, negotiated, and approved, including an oral acceptance over the telephone, you should confirm the final details of the transaction. Having the client sign a copy of the estimate and return a copy to you may be sufficient. But sending a separate confirmation to the client that embodies the details of the transaction is even better. It may be the same form as your estimate but with a different heading, or a letter referring to the estimate and stating that the work will proceed under the details as embodied therein, and with a copy attached.

Again, the confirmation should be sent to the client prior to the start of the work, if it is to have maximum force in any dispute that might arise. Work that is properly estimated and confirmed prior to the start of work is the least likely to be contested later. The properly executed confirmation, more than any other document, is an "ounce of prevention."

E-mail is the most common way to deliver this form. Make sure your terms and conditions template is included as the last page of the PDF when sending this form.

THE CHANGE ORDER

This form is used to verify client approval for changes made during an assignment. Due to the circumstances of the project, a signed change order form may not be practical. Use oral or e-mail agreements when necessary and follow up with this form as soon as possible.

THE DELIVERY MEMO

When you ship or electronically deliver your images, you should include a delivery memo. It is like a packing slip, detailing the contents of the shipment and the information needed for the client to match the shipment of work with its specific project.

In this age of delivering digital files, it is critical to remind clients that

metadata and color profiles be preserved. This memo is also the place for you to remind your client where your responsibility ends in the production process.

Send your delivery memo as a document inside the folder holding the digital files. The client has to open the folder to open the files, giving you proof that the memo was received.

THE INVOICE

Everyone wants to get paid, and the invoice is the classic means of presenting your request for payment for services rendered.

Invoices usually end up in accounts receivable departments of companies, and therefore are not in files pertaining to assignments. This is another reason why the invoice is not the best place to present your terms and conditions and licensing of rights for the first time. There is no point in having them reside only in the accounting department's files. You need these terms to be in the project work file in the office of the assigning party.

Still, you should restate any stipulations on your estimate or confirmation on the invoice. This emphasizes the details and reinforces your position.

INDEMNIFICATION AGREEMENT

There are times in your work when a party you contract with has to take a risk. It might be a model being asked to sit on the edge of a roof of a tall building, or being asked to pose with a lion. In each of these situations, the photographer is at special risk. If the lion, trained as it might be, gets spooked and bites the model, or a gust of wind causes the model to lose balance and fall off the roof, you might be held liable for the damages.

Obviously, the best way to deal with risk is to insure for it. However, it is prudent to secure an indemnification agreement from those parties who might be at risk, while rendering services to you, on your shoot. We have included a sample indemnification agreement in our grouping of sample forms. This, like all agreements, will be influenced by state law and court decisions. Having this form reviewed by your attorney for its enforceability under your state laws is a good idea.

Keep in mind that you are responsible for injury to your employees, and you cannot be indemnified by them under law. You are supposed to carry worker's compensation insurance for this purpose. It would not be uncommon for an injured freelance assistant or model to claim that she was your employee if she signed such an indemnification agreement. If the authorities found her to be an employee, you would be liable, in spite of the agreement. Here is one case in which an independent contractor's agreement is in order.

Sample Forms

> *Put your name and contact information here. Logo is good to use for a professional look, but make sure your name, address, phone, email, and web site are clearly visible. You may also want to list your EIN or SSN number on this form— your client may need this number to process such things as a purchase order or payment.*

ESTIMATE

Date: *This estimate is valid for 90 days from the date of issue.*

Client:

Assignment Description: *Be as clear as possible to avoid misunderstandings. Make sure to include location, # of images to be produced, outline subject to be photographed, any special requirements of the job. Be as detailed as possible in this area. This is your place to shine and show the added value hiring you will bring to the client.*

Licensing Agreement: *Use precise language here—this is the actual license outlining the use the client is purchasing.*
Use the PLUS recommended terms and order for listing the licensing specifics.

- ***The Parties:*** *Licensor (photographer) and licensee (client) and the end user (if different than the client).*
- ***Media Permissions:*** *The central element of the license description. An accurate description of the media in/on which you will permit your client to use the image, and the extent to which your client may use your image in that media. This should include: media, distribution, placement, size, versions, quantity, duration, region, language, exclusivity.*
- ***Constraints:*** *In addition to listing the Media Permissions, also describe any limitations that further constrain your clients right to use the image within the stated media.*
- ***Requirements:*** *State any requirements or obligations that are placed on your client under the license. Examples include a Credit Line Requirement and the Credit Line Text.*
- ***Conditions:*** *State any additional terms and conditions applying to the license. We suggest the use of the ASMP terms and conditions copied onto the back of your estimate or invoice documents, or included as an additional page in electronic versions of those documents.*
- ***Image Information:*** *Quantity and description.*
- ***License Information:*** *It is often helpful to note the Transaction Date, the client's purchase order number and other relevant information on your invoice.*

Make sure the licensing language used for a specific assignment is consistent on all forms.
All other rights, including but not limited to self-promotion usage, reserved.

Fees: *Some photographers separate out their Creative and Licensing Fees, some combine them. Review the ASMP paperwork share to get ideas and pick a system that works best for you. For help in calculating your fees, see the ASMP Licensing Guide.*

Expenses: *Some photographers prepare estimates only showing the client one number with fees and expenses combined. There is no right or wrong here, but it is critical that you methodically list and calculate the expenses even if that document is for your internal use only.*

This section will include, but is not limited to:

- *Equipment rental*
- *Digital processing fee*
- *Proofs or web gallery*
- *Retouching*
- *Master digital file*
- *Repurposed digital files*
- *Prints*
- *Archiving*
- *CD or DVD burning*
- *FTP*
- *Assistants*
- *Models*
- *Casting director*

- *Wardrobe, prop or food stylist*
- *Hair or make-up artist*
- *Location scout*
- *Carpenter*
- *Set designer*
- *Permits*
- *Hotels*
- *Airfare*
- *Mileage, tolls, parking*
- *Car rental*
- *Customs and carnets*
- *Gratuities*

- *Meals*
- *Tips*
- *Messengers or shipping*
- *Props—purchased or rented*
- *Backgrounds*
- *Location rental*
- *Wardrobe*
- *Catering*
- *Trailer rental*
- *Misc. supplies (e.g., tape, bulbs, gels)*

All expense estimates are subject to normal trade variance of 10 percent. *This percentage can and should be changed to match your experience and practice.*

Subtotal: *This is the creative fee, licensing fee and expenses combined.*

Sales Tax: *Put the sales tax here, if applicable, as required by your state. If you do not know, talk to your accountant.*

Total: *This is the creative fee, licensing fee and expenses combined.*

Subject to the terms and conditions attached hereof.

Most estimates are now delivered electronically. It is suggested that you use a multiple-page PDF when delivering forms to your clients and utilize the last page for your boilerplate terms and conditions.

> *Put your name and contact information here. Logo is good to use for a professional look, but make sure your name, address, phone, email, and web site are clearly visible. You may also want to list your EIN or SSN number on this form— your client may need this number to process such things as a purchase order or payment.*

ASSIGNMENT CONFIRMATION

Date:

Client:

Assignment Description: *Be as clear as possible to avoid misunderstandings. Make sure to include location, # of images to be produced, outline subject to be photographed, any special requirements of the job. Be as detailed as possible in this area. This is your place to shine and show the added value hiring you will bring to the client.*

Date(s) of Assignment:

Licensing Agreement: *Use precise language here—this is the actual license outlining the use the client is purchasing.*
Use the PLUS recommended terms and order for listing the licensing specifics.
- *The Parties: Licensor (photographer) and licensee (client) and the end user (if different than the client).*
- *Media Permissions: The central element of the license description. An accurate description of the media in/on which you will permit your client to use the image, and the extent to which your client may use your image in that media. This should include: media, distribution, placement, size, versions, quantity, duration, region, language, exclusivity.*
- *Constraints: In addition to listing the Media Permissions, also describe any limitations that further constrain your clients right to use the image within the stated media.*
- *Requirements: State any requirements or obligations that are placed on your client under the license. Examples include a Credit Line Requirement and the Credit Line Text.*
- *Conditions: State any additional terms and conditions applying to the license. We suggest the use of the ASMP terms and conditions copied onto the back of your estimate or invoice documents, or included as an additional page in electronic versions of those documents.*
- *Image Information: Quantity and description.*
- *License Information: It is often helpful to note the Transaction Date, the client's purchase order number and other relevant information on your invoice.*
Make sure the licensing language used for a specific assignment is consistent on all forms.
All other rights, including but not limited to self-promotion usage, reserved.

Fees: *Some photographers separate out their Creative and Licensing Fees, some combine them. Review the ASMP paperwork share to get ideas and pick a system that works best for you. For help in calculating your fees, see the ASMP Licensing Guide.*

Expenses: *Some photographers prepare estimates only showing the client one number with fees and expenses combined. There is no right or wrong here, but it is critical that you methodically list and calculate the expenses even if that document is for your internal use only.*

This section will include, but is not limited to:

• *Equipment rental*	• *Wardrobe, prop or*	• *Meals*
• *Digital processing fee*	*food stylist*	• *Tips*
• *Proofs or web gallery*	• *Hair or make-up artist*	• *Messengers or shipping*
• *Retouching*	• *Location scout*	• *Props—purchased*
• *Master digital file*	• *Carpenter*	*or rented*
• *Repurposed digital files*	• *Set designer*	• *Backgrounds*
• *Prints*	• *Permits*	• *Location rental*
• *Archiving*	• *Hotels*	• *Wardrobe*
• *CD or DVD burning*	• *Airfare*	• *Catering*
• *FTP*	• *Mileage, tolls, parking*	• *Trailer rental*
• *Assistants*	• *Car rental*	• *Misc. supplies*
• *Models*	• *Customs and carnets*	*(e.g., tape, bulbs, gels)*
• *Casting director*	• *Gratuities*	

All expense estimates are subject to normal trade variance of 10 percent. *This percentage can and should be changed to match your experience and practice.*

Subtotal: *This is the creative fee, licensing fee and expenses combined.*

Sales Tax: *Put the sales tax here, if applicable, as required by your state. If you do not know, talk to your accountant.*

Total:

Deposit: *Most photographers set some sort of deposit policy, such as; jobs over a certain dollar amount require a deposit, or all jobs require a 30% deposit, or all first time clients require a 50% deposit. At a minimum it is important to get all large expenses (e.g. talent, stylists, props, etc.) covered by an advance.*

Balance Due: *Set a policy and put it in your paperwork. The two most common policies are "Balance due in 30 days" or "Balance due upon receipt of images."*

This confirms the details of the assignment.

CLIENT

SIGNATURE

DATE

Subject to the terms and conditions attached hereof.

Most confirmations are now delivered electronically. It is suggested that you use a multiple-page PDF when delivering forms to your clients and utilize the last page for your boilerplate terms and conditions.

CHANGE ORDER FORM

Date:

Client:

Job Number/Purchase Order:

Assignment Description: *Prior to starting an assignment, prepare an electronic version of this change order form with the agreed upon job description in this space.*

Description of Change(s): *Be as detailed as possible carefully describing the nature and the reason for the change. For example, Per clients request, photographer will take four variations, rather than the estimated three, of the conference room meeting set-up.*

Additional Fees:

Additional Expenses:

This confirms acceptance of the outlined changes in this assignment.

CLIENT

SIGNATURE

DATE

Subject to the License, Terms and Conditions of the Assignment Confirmation and/or Estimate.

Put your name and contact information here.
Logo is good to use for a professional look, but make sure
your name, address, phone, email, and web site are clearly visible.

D E L I V E R Y M E M O

Delivered to:

Date Delivered:

Delivered Items: *Quantity and media*

Delivered Via: *Messenger, USPS, Fed-Ex, FTP*

Delivered Files Associated with this Memo: *List specific file names and any other relevant information.*

PLEASE NOTE—Digital File Information:
This is where you should indicate the following:
- *color profile used*
- *importance of maintaining the embedded profile*
- *qualifier for where your responsibility ends in the reproduction process*
- *any other necessary specifics for professional file handling*

These files contain metadata for identifying and tracking purposes. Files without metadata are at increased risk of unauthorized use. To protect your interests, do not remove or alter the embedded metadata. *We recommend this statement be used on all your delivery memos and that you, at a minimum, embed your copyright and contact information in all files before delivery.*

Licensing Agreement for the delivered files: *Use precise language here—this is the actual license outlining the use the client is purchasing.*
Use the PLUS recommended terms and order for listing the licensing specifics.
- ***The Parties:*** *Licensor (photographer) and licensee (client) and the end user (if different than the client).*
- ***Media Permissions:*** *The central element of the license description. An accurate description of the media in/on which you will permit your client to use the image, and the extent to which your client may use your image in that media. This should include: media, distribution, placement, size, versions, quantity, duration, region, language, exclusivity.*
- ***Constraints:*** *In addition to listing the Media Permissions, also describe any limitations that further constrain your clients right to use the image within the stated media.*
- ***Requirements:*** *State any requirements or obligations that are placed on your client under the license. Examples include a Credit Line Requirement and the Credit Line Text.*
- ***Conditions:*** *State any additional terms and conditions applying to the license. We suggest the use of the ASMP terms and conditions copied onto the back of your estimate or invoice documents, or included as an additional page in electronic versions of those documents.*

- *Image Information:* Quantity and description.
- *License Information:* It is often helpful to note the Transaction Date, the client's purchase order number and other relevant information on your invoice.

Make sure the licensing language used for a specific assignment is consistent on all forms.

Subject to the terms and conditions attached hereof.

Most delivery memos are now delivered electronically. It is suggested that you use a multiple-page PDF when delivering forms to your clients and utilize the last page for your boilerplate terms and conditions.

Put your name and contact information here. Logo is good to use for a professional look, but make sure your name, address, phone, email, and web site are clearly visible. You may also want to list your EIN or SSN number on this form— your client may need this number to process such things as a purchase order or payment.

INVOICE

Date:

Client:

Job Number/Purchase Order:

Assignment Description: *Be as clear as possible to avoid misunderstandings. Make sure to include location, # of images to be produced, outline subject to be photographed, any special requirements of the job. Be as detailed as possible in this area.*

Licensing Agreement: The following usage license will be granted upon payment in full of this invoice. *Use precise language here—this is the actual license outlining the use the client is purchasing.*
Use the PLUS recommended terms and order for listing the licensing specifics.
- *The Parties: Licensor (photographer) and licensee (client) and the end user (if different than the client).*
- *Media Permissions: The central element of the license description. An accurate description of the media in/on which you will permit your client to use the image, and the extent to which your client may use your image in that media. This should include: media, distribution, placement, size, versions, quantity, duration, region, language, exclusivity.*
- *Constraints: In addition to listing the Media Permissions, also describe any limitations that further constrain your clients right to use the image within the stated media.*
- *Requirements: State any requirements or obligations that are placed on your client under the license. Examples include a Credit Line Requirement and the Credit Line Text.*
- *Conditions: State any additional terms and conditions applying to the license. We suggest the use of the ASMP terms and conditions copied onto the back of your estimate or invoice documents, or included as an additional page in electronic versions of those documents.*
- *Image Information: Quantity and description.*
- *License Information: It is often helpful to note the Transaction Date, the client's purchase order number and other relevant information on your invoice.*
Make sure the licensing language used for a specific assignment is consistent on all forms.
All other rights, including but not limited to self-promotion usage, reserved.

Fees: *Some photographers separate out their Creative and Licensing Fees, some combine them. Review the ASMP paperwork share to get ideas and pick a system that works best for you. For help in calculating your fees, see the ASMP Licensing Guide.*

Expenses: *The formatting of the expenses on your invoice should match the formatting on your estimate.*

This section will include, but is not limited to:

• *Equipment rental*	• *Wardrobe, prop or*	• *Meals*
• *Digital processing fee*	*food stylist*	• *Tips*
• *Proofs or web gallery*	• *Hair or make-up artist*	• *Messengers or shipping*
• *Retouching*	• *Location scout*	• *Props—purchased*
• *Master digital file*	• *Carpenter*	*or rented*
• *Repurposed digital files*	• *Set designer*	• *Backgrounds*
• *Prints*	• *Permits*	• *Location rental*
• *Archiving*	• *Hotels*	• *Wardrobe*
• *CD or DVD burning*	• *Airfare*	• *Catering*
• *FTP*	• *Mileage, tolls, parking*	• *Trailer rental*
• *Assistants*	• *Car rental*	• *Misc. supplies*
• *Models*	• *Customs and carnets*	*(e.g., tape, bulbs, gels)*
• *Casting director*	• *Gratuities*	

Subtotal: *This is the creative fee, licensing fee and expenses combined.*

Sales Tax: *Put the sales tax here, if applicable, as required by your state. If you do not know, talk to your accountant.*

Total:

Less Deposit Paid: *Most photographers set some sort of deposit policy, such as; jobs over a certain dollar amount require a deposit, or all jobs require a 30% deposit, or all first time clients require a 50% deposit.*

Balance Due: *Set a policy and put it in your paperwork. The two most common policies are "Balance due in 30 days" or "Balance due upon receipt of images."*

Subject to the terms and conditions attached hereof.

Many invoices are now delivered electronically. It is suggested that you use a multiple-page PDF when delivering forms to your clients and utilize the last page for your boilerplate terms and conditions.

INDEMNIFICATION AGREEMENT

(MODEL) hereby agrees to protect, defend, indemnify, and hold harmless *(PHOTOGRAPHER)* from and against any and all claims, losses, liabilities, settlements, expenses, and damages, including legal fees and costs (all referred to collectively as "Claims"), which *(PHOTOGRAPHER)* may suffer or to which *(he/she/it)* may be subjected for any reason, even if attributable to negligence on the part of *(PHOTOGRAPHER)* or any other entity, arising out of or related to any act, omission, or occurrence in connection with the creation, production, or use of any image or the performance of any service relating to this Agreement or its subject matter. This provision shall apply to Claims of every sort and nature, whether based on tort, strict liability, personal injury, property damage, contract, defamation, privacy rights, publicity rights, copyrights, or otherwise. *(MODEL's)* obligations under this provision shall survive the performance, termination, or cancellation of this Agreement.

DATE

NAME

ADDRESS

WITNESS

ADDRESS

Terms and Conditions for Your Business Paperwork

by Richard Weisgrau and Victor S. Perlman

The following text was adapted for use in *ASMP Professional Business Practices in Photography* from the Terms and Conditions module published by the American Society of Media Photographers at *www.asmp.org/t&c*. The online resource provides members a customizable system to create their own terms and conditions template.

A CRITICAL PART OF YOUR FORM AGREEMENTS, AFTER THE SPECIFIC DETAILS of the work, price, and rights, will be the terms and conditions that you use to govern the transaction. There are many possible combinations of these elements, depending on the nature of the work. You should customize your terms and conditions, depending on your own needs in general or specifically.

You should understand these terms, when to apply them, and what options are available. If you are not sure, get competent advice. If you are still in doubt as to whether a term applies, it is better to include it than to exclude it. Outlined here are the terms and conditions that are normally found on the reverse side of your estimate, confirmation, and invoice.

TERMS AND CONDITIONS

[1] **Definition:** "Image(s)" means all visual representations furnished to Client by Photographer, whether captured, delivered, or stored in photographic, magnetic, optical, electronic, or any other media. Unless otherwise specified on the front of this document, Photographer may deliver, and Client agrees to accept, Images encoded in an industry-standard data format that Photographer may select, at a resolution that Photographer determines will be suitable to the subject matter of each Image and the reproduction technology and uses for which the Image is licensed. It is Client's responsibility to verify that the

digital data (including color profile, if provided) is suitable for reproduction of the expected quality and color accuracy, and that all necessary steps are taken to ensure correct reproduction. If the data are not deemed suitable, Photographer's sole obligation will be to replace or repair the data, but in no event will Photographer be liable for poor reproduction quality, delays, or consequential damages. Unless otherwise specifically provided elsewhere in this document, Photographer has no obligation to retain or archive any of the Images after they have been delivered to Client. Client is responsible for sending an authorized representative to the assignment or for having an authorized representative review the images remotely during the assignment. If no review is made during the assignment, Client is obligated to accept Photographer's judgment as to the acceptability of the Images.

Are you supplying images in some form? If so, use provision [1] in all your paperwork. If you are not certain which type of media you will be delivering, use language that covers both conventional film and digital.

[2] **Rights:** All Images and rights relating to them, including copyright and ownership rights in the media in which the Images are stored, remain the sole and exclusive property of Photographer. Unless otherwise specifically provided elsewhere in this document, any grant of rights is limited to a term of one (1) year from the date hereof and to usage in print (conventional nonelectronic and nondigital) media in North America. Unless otherwise specifically provided elsewhere in this document, no image licensed for use on a cover of a publication may be used for promotional or advertising purposes without the express permission of Photographer and the payment of additional fees. No rights are transferred to Client unless and until Photographer has received payment in full. The parties agree that any usage of any Image without the prior permission of Photographer will be invoiced at three times Photographer's customary fee for such usage. Client agrees to provide Photographer with three copies of each published use of each Image not later than sixty (60) days after the date of first publication of each use. If any Image is being published only in an electronic medium, Client agrees to provide Photographer with an electronic tearsheet, such as a PDF facsimile or URL of the published use of each such photograph, within fifteen (15) days after the date of first publication of each use. Unless otherwise specifically provided elsewhere in this document, all usage rights are limited to print media, and no digital usages of any kind are permitted. This prohibition includes any rights or privileges that may be claimed under §201(c) of the Copyright Act of 1976 or any similar provision of any applicable law. Digital files may contain copyright and other information embedded in the

header of the image file or elsewhere; removing and/or altering such information is strictly prohibited and constitutes violation of the Copyright Act. All fees and expenses payable under this agreement are required irrespective of whether Client makes actual use of the Images or the licenses to use them. Unless specifically provided elsewhere in this document, no reprographic, reprint, republication or other secondary reproduction usages may be made, and usage rights are granted only for one-time, English-language North American editorial print editions of the publication listed on the front of this document and six-month searchable archive use on the Web site of that publication.

Term [2] establishes that you retain ownership to: (1) the tangible images (prints, disks, transparencies, etc.) and (2) the copyright to the images.

This term sets defaults on the use of the images, if you do not specify other limits in the usage specifications on the front side of the document, to: (1) a maximum of one year, (2) conventional print usage, and (3) North America only. Where editorial uses are permitted, it also excludes uses of cover shots for promotional and advertising purposes unless you are paid additional fees. Note that it grants a license only upon your receipt of payment in full. Furthermore,, it prohibits digital uses, unless you specify elsewhere (presumably on the front) that digital uses are being licensed.

You should be aware that the provision specifying a tripling of your customary fee for unauthorized use may not be enforceable in court. However, it may help in negotiations, and its presence in documents like these is a common practice.

[3] Return and Removal of Images: Client assumes insurer's liability (a) to indemnify Photographer for loss, damage, or misuse of any Images, and (b) to return all Images prepaid and fully insured, safe and undamaged, by bonded messenger, air freight, or registered mail. Unless the right to archive Images has been specifically granted by Photographer on the front of this document, Client agrees to remove and return or destroy all digital copies of all Images. All Images shall be returned, and all digital files created by or on behalf of Client containing any Images shall be delivered to Photographer, deleted or destroyed, within thirty (30) days after the later of: (1) the final licensed use as provided in this document, and (2) if not used, within thirty (30) days after the date of the expiration of the license. Failure to return Images on time will result in loss to Photographer due to his resulting inability to license such Images. Client therefore agrees to pay a holding fee of five dollars and fifty cents ($5.50) per day from the return date until the day on which the Images are actually received by Photographer. Client assumes full liability for its principals, employees, agents, affiliates, successors, and assigns (including without limitation independent contractors, messengers, and freelance researchers) for

any loss, damage, delay in returning or deleting, failure to return, or misuse of the Images.

Use term [3] if you want to hold your client responsible to return your images in good condition, and to return or delete all digital files, and to do so in a reasonable period of time.

This term places responsibility on the client for:

1. protecting your interest for any loss, damage, or misuse of the images;

2. returning the images by specified means, including the destruction of digital files;

3. returning the images or destroying digital files by specified deadlines; and

4. any losses, misuse, and so on by any party receiving the images from the client.

[4] Loss or Damage: Reimbursement by Client for loss or damage of each original photographic transparency or film negative ("Original[s]") shall be in the amount of one thousand five hundred dollars ($1,500), or such other amount if a different amount is set forth next to the lost or damaged item on the reverse side or attached schedule. Reimbursement for loss or damage of each nondigital duplicate image shall be in the amount of two hundred dollars ($200). Reimbursement for loss or damage of each digital file shall be in the amount of two hundred dollars ($200). Reimbursement by Client for loss or damage of each item other than as specified above shall be in the amount set forth next to the item on the reverse side or attached schedule. Photographer and Client agree that said amount represents the fair and reasonable value of each item, and that Photographer would not sell all rights to such item for less than said amount. Client understands that each Original is unique and does not have an exact duplicate, and may be impossible to replace or recreate. Client also understands that its acceptance of the stipulated value of the Images is a material consideration in Photographer's acceptance of the terms and prices in this agreement.

Use term [4] if you want to set a default for the value of your work in case it is lost or damaged. However, be sure to complete the required schedule if it applies.

This term sets the frequently used $1,500 value per item for your original transparencies and negatives, unless you specify otherwise on a separate list. The values of nonoriginal items, including digital files, are set to a default figure of $200 unless they are otherwise specified on an attached schedule. Note: If you are routinely supplying dupes, scans on disk or tape, and so on, you should include the value of such items in the clause. Keep in mind that any declared value, $1,500 or otherwise,

must be reasonable and provable if it is to be accepted by a court. Also note that courts are generally hesitant to enforce stipulated damage provisions. You should feel free to use whatever value you think is appropriate in place of either of the figures that appear in this section.

[5] Photo Credit: All published usages of Images will be accompanied by written credit to Photographer or copyright notice as specified on the reverse side. If no placement of a credit or copyright notice is specified on the reverse side, no credit or notice is required. If a credit is required but not actually provided, Client agrees that the amount of the invoiced fee will be subject to a three-times multiple as reasonable compensation to Photographer for the lost value of the credit line.

Use term [5] if you are requesting a copyright credit line with your images.

This term requires that a credit line be given as stated on the front of the form and in the place specified (note that you have to specify those requirements). No credit is required if no placement is specified. It also provides that, if a credit is required but is not actually provided, the invoice will be subject to a three-times multiple. As with all multipliers, you need to understand that this provision may not prove to be legally enforceable, but there is at least one case in which it was, and at a minimum it is valuable as a negotiating chip.

Note: If you are doing work in applications where credit lines are not normally given, you can leave the placement blank or remove the term from your form by unchecking the box. Copyright credit is not required to retain your copyright but is desired and has specific advantages if used. As a rule of thumb, in practice, credits are typically given for the types of uses that generally do not require model releases, and vice versa; however, there are probably almost as many exceptions as there are examples that follow the rule, so you should always try to negotiate for a photo credit.

Term [6] outlines whether any alterations of the images you supply to the client are permitted.

Here are three options.

No alternations permitted, use option 1.

[6–Option 1] Alterations: Client will not make or permit any alterations, including but not limited to additions, subtractions, or adaptations in respect of the Images, alone or with any other material, including making digital scans unless specifically permitted on the reverse side.

Minor alterations permitted, use option 2. Minor alteration includes cropping or other adjustments typically required for reproduction but not any other

alterations. Note: Some applications for images, such as advertising, require that images be altered. It would seem necessary to give the client permission to make such alterations, provided that you are protected from any consequences of the alteration under term [7].

[6–Option 2] Alterations: Client may not make or permit any alterations, including but not limited to additions, subtractions, or adaptations in respect of the Images, alone or with any other material, including making digital scans unless specifically permitted on the reverse side, except that cropping and alterations of contrast, brightness, and color balance, consistent with reproduction needs, may be made.

Any alterations permitted, use option 3. If you use this option, be certain that you have gotten signatures on model releases that specifically allow such alterations.

[6–Option 3] Alterations: Client may make or permit any alterations, including but not limited to additions, subtractions, or adaptations in respect of the Images alone or with any other material, including making digital scans, subject to the provisions as stated in [7] below.

[7] Indemnification: Client will indemnify and defend Photographer against all claims, liability, damages, costs, and expenses, including reasonable legal fees and expenses, arising out of the creation or any use of any Images or arising out of use of or relating to any materials furnished by Client. Unless delivered to Client by Photographer, no model or property release exists, and it is Client's responsibility to obtain the necessary permissions for usages that require any model or property releases not delivered by Photographer. It is Client's sole responsibility to determine whether any model or property releases delivered by Photographer are suitable for Client's purposes. Photographer's liability for all claims shall not exceed in any event the total amount paid under this invoice.

Use term [7] in all your paperwork. This protects you if the images are used in an application requiring a release or license, and you have not supplied any, and for images altered by the client. It also establishes that there is no release or other permission unless you have supplied it.

[8] Assumption of Risk: Client assumes full risk of loss or damage to or arising from materials furnished by Client and warrants that said materials are adequately insured against such loss, damage, or liability.

Use term [8] if your client is supplying props or other items for the shoot. This term is intended to transfer responsibility for any client-supplied materials, props, and so on during the assignment. The principle is meant to transfer the bailee responsibility you have for another's property while it is in your care, as well as to protect you from any unforeseeable problems that may arise out of the use of such property. It is not a substitute for insurance (which you should always carry), but it is an added safeguard to protect your interest.

[9] Transfer and Assignment: Client may not assign or transfer this agreement or any rights granted under it. This agreement binds Client and inures to the benefit of Photographer, as well as their respective principals, employees, agents, and affiliates, heirs, legal representatives, successors, and assigns. Client and its principals, employees, agents, and affiliates are jointly and severally liable for the performance of all payments and other obligations hereunder. No amendment or waiver of any terms is binding unless set forth in writing and signed by the parties. However, the invoice may reflect, and Client is bound by, Client's oral authorizations for additional Images, fees, and expenses that could not be confirmed in writing because of insufficient time or other practical considerations. This agreement incorporates by reference the Copyright Act of 1976, as amended. It also incorporates by reference those provisions of Article 2 of the Uniform Commercial Code that do not conflict with any specific provisions of this agreement; to the extent that any provision of this agreement may be in direct, indirect, or partial conflict with any provision of the Uniform Commercial Code, the terms of this agreement shall prevail. To the maximum extent permitted by law, the parties intend that this agreement shall not be governed by or subject to the UCITA of any state. Photographer is an independent contractor and not an employee. If Photographer is deemed under any law to be an employee of Client, and if the Images are therefore considered works made for hire under the U.S. Copyright Act, Client hereby transfers the copyright to all such Images to Photographer. Client agrees to execute any documents reasonably requested by Photographer to accomplish, expedite, or implement such transfer.

There is no question: You should use term [9] in all your paperwork. This term prevents the client from assigning responsibility for the agreement to another party. It also limits changes to the agreement to those made in writing and signed by both parties, unless they are made by the client during the assignment. Finally it specifies the application of certain laws to the agreement, as a means of reinforcing the agreement's strength and of interpreting the agreement in your best interest.

[10] Disputes: Except as provided in [11] below, any dispute regarding this agreement shall, at Photographer's sole discretion, either: (1) be arbitrated in (*list your city and state*), under rules of the American Arbitration Association and the laws of (*list your state*); provided, however, that irrespective of any specific provision in the rules of the American Arbitration Association, the parties are not required to use the services of arbitrators participating in the American Arbitration Association or to pay the arbitrators in accordance with the fee schedules specified in those rules. Judgment on the arbitration award may be entered in any court having jurisdiction. Any dispute involving (*check with your local small claims court to find out the maximum amount of its jurisdiction and put that amount here*) or less may be submitted without arbitration to any court having jurisdiction thereof. Or, (2) be adjudicated in (*list your city and state*), under the laws of the United States and/or of (*list your state*). (3) In the event of a dispute, Client shall pay all court costs, Photographer's reasonable legal fees, and expenses, and legal interest on any award or judgment in favor of Photographer.

Use term [10] in all your paperwork. This provision ensures that disputes are resolved in the most economical manner and gives you the option of deciding whether to have disputes resolved through arbitration or litigation. Make sure to insert the required small claims maximum and geographic information.

[11] Federal Jurisdiction: Client hereby expressly consents to the jurisdiction of the Federal courts with respect to claims by Photographer under the Copyright Act of 1976, as amended, including subsidiary and related claims.

Use term [11] in all your paperwork. It states what the law provides and lets you avoid any question about jurisdiction over copyright disputes.

[12] Overtime: In the event a shoot extends beyond eight (8) consecutive hours, Photographer may charge for such excess time of assistants and freelance staff at the rate of 1½ times their hourly rates.

Use term [12] if you pay freelance and staff overtime and you want to ensure this cost is the client's responsibility.

[13] Reshoots: Client will be charged 100 percent fee and expenses for any reshoot required by Client. For any reshoot required because of any reason outside the control of Client, specifically including but not limited to acts of God, nature, war, terrorism, civil disturbance, or the fault of a third party,

Photographer will charge no additional fee, and Client will pay all expenses. If Photographer charges for special contingency insurance and is paid in full for the shoot, Client will not be charged for any expenses covered by insurance. A list of exclusions from such insurance will be provided on request.

The charges for a reshoot are established in term [13]. If the reshoot is required by the client, it sets 100 percent of the original fee and expenses as the payment. It requires payment of expenses only, when a reshoot is required because of the act of a third party or an act of God. It also provides that no expenses covered by insurance will be charged to the client if it has paid a fee for the coverage. Note: This clause does not absolve you from having to reshoot at your own expense if your negligence is the cause of a reshoot. You should consider deleting the statements about insurance if you do not make such contingency insurance available to your clients.

[14] Assignment Cancellations and Postponements: Cancellations: Client is responsible for payment of all expenses incurred up to the time of cancellation of the assignment, plus 50 percent of Photographer's fee; however, if notice of cancellation is given less than two (2) business days before the shoot date, Client will be charged 100 percent fee. Postponements: Unless otherwise agreed in writing, Client will be charged a 100 percent fee if postponement of the assignment occurs after Photographer has departed for location, and 50 percent fee if postponement occurs before departure to location. Fees for cancellations and postponements will apply irrespective of the reasons for them, specifically including but not limited to weather conditions, acts of God, nature, war, terrorism, civil disturbance, and the fault of a third party.

Term [14] sets up a cancellation policy and speaks clearly for itself.

Smooth Sailing: Avoiding Business Conflicts

by Jay Asquini

Jay Asquini is a former member of the Michigan chapter of the American Society of Media Photographers. He has been a successful corporate photographer who has also served as a national director, secretary, treasurer, and vice president of the ASMP. *www.jayasquini.com.*

———————————— • ————————————

I'M IN THE PHOTOGRAPHY BUSINESS TO HAVE FUN MAKING PHOTOGRAPHS. I dislike business conflicts as much as the next photographer. So I made a special effort to run my business in a way that prevents many conflicts before they arise.

I began by describing my business in legal terms. I used the ASMP forms as my starting point, then built up from there so my forms describe precisely how I do business. This is written in "legalese" on the reverse of all the forms we use.

Actually we have printed only one "base" form, which lists the terms and conditions on the back. On the front of this form, we imprint our estimate, assignment confirmation, change order, delivery memo, or invoice. On the front side of each of these, I begin with a plain-English summary of the big issues. For instance, our estimate and assignment confirmation forms carry this message:

> In order to provide you with the best service and support at reasonable prices, we do not sell our Photograph(s). We license their use. So the fee quoted is especially dependent on (1) payment of the invoice in full, (2) using the Photograph(s) only as indicated, and (3) protecting them with proper copyright notification.

In my sales efforts, I'm careful to explain why we do the things we do in terms the customer will appreciate. With new customers, I include a letter describing our services, which begins, "In this day of budget refinements and austerity programs, our aim is to produce the best images backed by the best pricing and service possible." It goes on to explain the virtues of pricing by usage, the advantages of our archiving system and other ways we consciously try to keep the client's costs down.

Both this letter and the lead statement in our estimate and assignment confirmation forms place money—not ego or creativity—at the fulcrum point of our discussions. They allow me to say things like, "Sure, we could do it that way. It's only money." You would be surprised how quickly they realize it's their money I'm talking about and how eager they are to learn about ways to save some, such as by paying for specific usage instead of buyouts.

In order to quote a job or to complete one, we have another form that prompts us to ask all the who, what, where, when, how, and why questions. Only after I know the answers to all these can I price and complete an assignment with confidence.

Establishing a price and getting it can be another tricky area. When pricing, I consider these three things: our cost of doing business, the profit margin we hope to maintain, and the value of our product or service to our customer.

It doesn't take long to calculate the cost of doing business—or to add a profit margin—but it is a worthwhile exercise. Try it. You'll never again grope for a response when a potential customer asks, "Why so much?"

Factoring in a dollar amount for the value of our work to our customer— commonly known as the creative or licensing fee—is slightly more nebulous. It begins with understanding our ability and need as photographers to be paid for "what we know instead of just what we do," as a very successful doctor friend of mine says—and does.

My next step is to prepare an assignment confirmation form, which states all the parameters of the project. I list everything as specifically as possible so the customer can see whether I have covered her needs, and we can both easily determine whether and when changes occur. Then I make sure I get a signature of approval before I begin, which happens with ease in this day of e-mail and digital signatures. I simply say, "Here's my copy of the assignment confirmation. Just sign your approval of it at the bottom so we can begin."

Incidentally, I have never had a customer refuse to sign when we are on location or in the studio and the job is pending. There is too much momentum for him not to do so at this time. Still, I know that the day will come when one won't sign and I will turn away smiling, knowing my system saved me from getting caught in a bad deal.

Finally, when we get an assignment, there are still two key things to remember to sail smoothly along. First, we must complete the job as we describe it. Second, we must note any deviations from those tight parameters we carefully drafted in our assignment confirmation form. We let our customers know as early as possible that if they need six versions of each product shot we will have to charge more, since our price was based on creating only the photos they asked for and specified in their comprehensive sketch (which we were careful to mention in our agreement with them).

But, if they need to have six versions of each, no problem. We can keep on shooting with their approval and the use of our change order form. Underlying these practices is the ingredient that makes businesses flourish: salesmanship. Salesmanship is using an approach or response that protects the integrity of your business while offering solutions to the customer. Photographers often overlook this ingredient, believing their work or creativity will carry them through. This might be true in a few instances, but the majority of us need it every step of the way.

Keep in mind that conflicts in business generally arise from two sources: intent or misunderstanding. Our paperwork helps weed out those who would intentionally mislead us into conflict. Our salesmanship and plain-English explanations of how and why our business operates eliminate most misunderstandings, so I can concentrate on making photographs.

SECTION 6
Releases

"If you have any intention of using an image for commercial purposes, you have to have a release."

—Steve Grubman

Why You Need Releases

This material was created by the combined efforts of various ASMP staff members including Peter Dyson, Victor S. Perlman, Peter Skinner, and Richard Weisgrau.

A RELEASE IS A WRITTEN AGREEMENT BETWEEN YOU AND THE PERSON YOU ARE photographing, or the person who owns the property you are photographing. The purpose of the release is to protect you from any future lawsuits the person might file for claims such as defamation and invasion of privacy.

A model release says the person being photographed has given consent to be photographed and to the use of the images you capture. It doesn't just apply to professional models or situations where people know they are posing for photos. You should seek to get a signed model release any time that your photos contain recognizable images of people, unless you are certain that you will never want to use them for anything other than editorial purposes.

A property release says that the owner of a certain property, such as a pet or a building, has given you consent to take and use images of the property. You don't need one for public property, such as government buildings (although you may run into problems just from photographing them, for security reasons). But for images of private property—and particularly of objects that are closely identified with specific people—you are safer if you get a release.

The releases you obtain should be saved forever and should be linked in some way with the photographs to which they relate. You can expect to be asked to produce them whenever you license an image, and you will need them if you ever have to defend yourself in court.

THE RIGHT OF PRIVACY

Although the laws of the fifty states vary, all states recognize that individuals have a right to be left alone in their daily lives and that harm (in the form of embarrassment, scorn, or loss of status) can result if that right is violated.

However, the right of privacy is not absolute. In particular, the courts

have long held that news reporting and social, political, and economic commentary—the things the First Amendment was designed to protect—are more valuable to society than an individual's right to be left alone. Therefore, images that are part of the public colloquy about events have usually been exempt from privacy lawsuits. In contrast, the courts have generally held that making money is distinctly less valuable to society than the right to be left alone.

Thus privacy issues typically arise when an image is used for purposes of trade or advertising. That is, it's not the picture, but how it is used that determines the need for a release. For instance, an image that is printed in a newspaper, shown in an exhibition or reproduced in a book might well be immune from a privacy suit. But the commercial sale of coffee mugs or T-shirts with the same image would probably not enjoy such protection. An advertisement almost certainly would not be immune.

Therefore if you are on an advertising assignment, you will need to collect releases from every person in your shots. News assignments are a little trickier. You are always better off if you have permission to photograph your subjects and can prove it. But it's not always possible to get permission and, in the United States, you can report the news without it. Lacking a release, however, you are limited in how you can license the image later on.

These days, even editorial clients are requiring releases—and releases using their specific forms—with more and more frequency, so you need to check the terms of your agreements with your clients and stock houses to see what is required.

THE RIGHT OF PUBLICITY

In an increasing number of states (California in particular), a famous individual has an additional "right of publicity": the right to control how her fame can be exploited for commercial purposes. Unlike rights of privacy, which die with the persons to whom they belong, rights of publicity survive their owners and can be passed along for generations. Rights of publicity also tend to be more specific in their prohibitions than rights of privacy.

For photographers and their clients, the right of publicity can become a problem when people become celebrities after you have taken their picture. It can especially be a problem with crowd scenes.

DEFAMATION

A defamation lawsuit alleges that a person has been portrayed falsely or maliciously in such a way as to damage her reputation. (The term "defamation" includes both slander, which is spoken, and libel, which is published in some tangible medium.) The falsity may be direct, such as by compositing several

images to depict a scene that did not happen, or indirect, such as advertising a rehabilitation clinic with a picture of someone who has never been a patient there. As always, there is a distinction between commercial use and editorial use, with commercial uses being held to stricter standards of truthfulness.

PROPERTY OWNERS' RIGHTS

Privacy and defamation cannot apply to objects (although defamation can apply to business entities). Things such as cars, buildings, statuary, costumes, and animals don't have legal rights. But the people who are closely associated with those objects do have rights and could claim that your photo of their property has caused harm. This is a tricky area of law, with few precedents to guide us. Property releases are discussed in more detail in chapter 29. In general, though, we advocate following the cautious rule, "When in doubt, try to get a release."

WHY WE TAKE THIS SERIOUSLY

Most of the time, you take your pictures, everybody gets paid, and that's the end of it. Once in a while, though, things can go very wrong.

An article in the *Los Angeles Times* for February 1, 2005, describes how Nestlé got slapped with a $15 million jury award because it used a model's picture without taking care of the paperwork. In this case, there was no blame on the photographer; rather, the client (Nestlé) was accused of failing to pay all the fees that were specified in the model's contract. But the size of the verdict shows that juries do take models' rights very seriously.

The passage of time doesn't necessarily reduce your risk. In the November 22, 1999, edition of the *New York Observer*, an article relates that Peter Beard was threatened with a lawsuit for a photo he'd taken a dozen years earlier. In 1987, Beard had photographed a 17-year-old girl near Lake Rudolph in Kenya. But by 1997, that girl had moved to Los Angeles, where she was waiting tables and looking for work as a model. A New York friend called to tell her that a SoHo gallery was selling her picture for thousands of dollars. She reacted by hiring a lawyer and demanding $50,000 plus 15 percent of Beard's sales. (It appears that the matter was settled out of court, so we don't know what really happened.)

What's in a Release?

This material was created by the combined efforts of various ASMP staff members including Peter Dyson, Victor S. Perlman, Peter Skinner, and Richard Weisgrau.

At its heart, every release says the same things:

1. I have given you permission to take pictures of me and use them for commercial purposes.
2. In exchange, I have gotten something of value.

Along with the subject's signature and a date, these two statements would be enough to constitute a bare-bones, but entirely legal, contract. Law students are taught that a contract records a "meeting of the minds" and, to be complete, must contain three elements: an offer, an acceptance, and a consideration.

OFFER

Often the subject is offering to give you permission, along with a promise not to complain about things later on. Most of the words in the release are there to describe exactly what the subject is willing to permit and not complain about.

In some cases, such as when you are working with professional models, you are offering to pay the model for her services. Granting the permissions in the release is one of the conditions that must be met before you will make payment.

ACCEPTANCE

When you are using unpaid subjects, your behavior (your making or using the photos, or accepting the signed release) indicates your acceptance. When you are paying your subjects, their signatures show that the offer was accepted.

Our recommended releases have space to write the subject's address and to place a witness's name. These are not legal requirements, however. If there are

no witnesses and the subject declines to give an address, or gives you only an e-mail address, the signed release is still a contract.

It is always good to have witnesses, of course. And it is useful to get the subject's address. For one thing, you may want to contact the subject later on. For another, you want to make it clear that the John Smith who signed your release is the same John Smith whose photo you took.

CONSIDERATION

A contract is complete only if value is exchanged. Consideration is the legal term for whatever your subject has gotten in return for the permission. It could be money; it could be tangible goods; it could be a promise to do something in the future, such as use your best efforts to get the photo published and thus increase your subject's renown. But it has to be something that has value, at least in your subject's eyes.

None of our releases say what the consideration actually is, but they all say that it exists and has value. Again, the subject's signature is an acknowledgement of the value.

When you are shooting in the field, it can be awkward to approach people and ask them to sign a release. But it becomes less awkward if you offer something tangible, yet tasteful—we often recommend handing out business cards and offering to mail a print from the shoot. Not only might this engender some good will, but it could lead to future business. It is important, of course, that you actually follow through on this commitment or the good will is lost.

FORMAL LANGUAGE

The releases that we recommend are a bit longer and more formal sounding than the bare-bones statements above. There are a couple of reasons why.

By spelling out the nature of the permission in great detail, the release makes it harder for the subject to claim that he didn't intend to grant quite so much permission.

The use of formal language alerts your subject that this is serious stuff and can't be lightly repudiated. In court, this would help reinforce the fact that the subject really did intend to give consent.

On the other hand, too much legalistic wording might scare your subject into refusing to sign. You have to strike a balance. That is why we have included samples of four general-purpose releases, ranging from the adult and child versions, which detail everything in formal language, to the pocket version that summarizes the deal in less than 100 words.

The sample releases in this book are designed to be all-purpose, and so they call for a very broad grant of permission. If your subject raises an objection

to signing a release with broad language, you can counter by offering to write a restriction into the document. Adding a restriction actually makes the release stronger, legally speaking, than a general release; the addition shows that your subject understood the document well enough to want a change and that a real negotiation of terms took place. Besides, in practical terms, your subject's cooperation is always your best defense against lawsuits.

USING PLAIN LANGUAGE

There are no magic formulas; the words in a contract mean what they say. If you add a restriction to a standard release, it's best not to get fancy with the language. Just write, in plain English and as exactly as you can, what you and your subject have agreed.

COMPETENCE

Not everyone is legally able to make a contract. Signers have to be able to understand the consequences of their acts. That means they must be of legal age and of sound mind. Minors who sign a release can repudiate it when they become adults, or their parents can repudiate it for them. In general, the legal age for entering into valid contracts is eighteen, though younger persons can, in certain circumstances, get a court order that makes them legal adults.

The "sound mind" requirement can be tricky. Crazy people can seem quite sane, and neither senility nor mental retardation are necessarily obvious in a brief conversation. Just as you need a parent's signature on a minor's model release, you need a guardian's or conservator's signature on a release for a legally incompetent person.

ILLEGALITY

The courts won't enforce a contract for illegal activity or one that is contrary to public purpose. For instance, in some circles, a few dollars' worth of hashish might be welcomed as the "consideration" element of your release—but a court of law isn't likely to see it that way. And if your pictures are used for blackmail, a model release is likely to be treated as evidence of conspiracy, not permission.

Property Releases

by Richard Weisgrau and Victor S. Perlman

Richard (Dick) Weisgrau's career in photography spanned more than forty years. During that time he worked as a professional photographer for twenty years. He was an ASMP member for fifteen of those years. After that he served as executive director of ASMP for fifteen years, and then as a consultant and expert witness in photography-related matters. He is the author of four books about the business of photography. Today, his interest in photography is limited to shooting subjects of his choice, and exhibiting and selling prints.

Victor S. Perlman is general counsel to the American Society of Media Photographers, Inc. He has also served on the boards of the Copyright Clearance Center and the Philadelphia Volunteer Lawyers for the Arts. His writing has appeared in *Communication Arts* and *Popular Photography*, and he is the co-author of Licensing Photography. He frequently testifies in Congressional hearings and proceedings held by the U.S. Copyright Office.

———————————— • ————————————

THE WHOLE SUBJECT OF PROPERTY RELEASES IS FILLED WITH URBAN LEGEND, assumption, and myth, along with a bit of actual law. As you know, using a person's likeness for trade or advertising purposes requires a model release. That is because a person has a reputation to protect, a right of privacy, and (in some states) a right of publicity. Property has none of these rights. So why should you go to the trouble to get a release?

It's a good question but one that requires a complicated answer. The ASMP has never seen a statute or a legal case that requires a release for property. The recommendation that you get one is based upon two legal theories.

Below, we use a house as the property in question. Remember that the

theories can apply to property other than real estate, such as pets, cars, works of art, and other personal property.

ASSOCIATION

The first theory is that a person's identity might be connected to the property. Take a picture of a house and use it in an article about drug users, and the owner might get angry enough to sue. Why? Because everyone on the block knows whose house it is, and since the house is not actually connected with drugs, the image was used out of context and paints the owner in a bad light. If the owner sees the use of the image as defamation of character, a lawsuit might be the response.

CONVERSION

The second theory is that there is an offense called "conversion," which means that you used another's property to your own personal gain without the owner's permission. It is a bit like copyright infringement, which covers intangible property, except this covers tangible property. If I rent out your house while you are away without your permission, I have converted it to my personal gain. That is conversion. The question is this: Is it conversion if I rent out a picture of your house for an advertisement without your permission? The picture of your house is not your tangible property. Is the photo of the house the equivalent of the house (at least for these purposes)? We know of no case that has ever settled those kinds of questions. The ASMP advises that property releases be acquired whenever possible because we don't want to see you be the test case.

FUTURE-PROOFING

What if you get the release to use a photo of a house, and then ownership changes hands? Is the release still binding? We would say probably yes, as you got it from the proper owner at the time. If ownership changes, that proper owner is (at least theoretically) obligated to tell the prospective new owner of the permission he gave you before the sale is made, so the prospective buyer can decide whether he wants to purchase under that condition. Does this mean that a new owner won't sue you? It certainly does not mean that. What it means is that you have a defense, if you are sued. The courts will sort it out. The problem is that there is no case law on these situations, so the courts will have to make it up as they go along. That is the most expensive kind of litigation there is—fighting over how to apply law when it has not been applied before.

If you want to make sure that your release will protect you in spite of changes in ownership, you have to do whatever is required by the law of the

state in which the property is located to have the release "run with the land." While that varies from state to state, typically it means that the release should:

1. State that it binds the owner and his heirs, successors, and assigns.
2. Be signed in front of a notary public and contain the sort of legal "acknowledgment" that notaries typically sign and seal ("On this ___ day of _____, 20___, before me, a Notary Public for the State of _____, the undersigned officer, personally appeared _____, known or satisfactorily proven to me to be the person whose name is subscribed to the foregoing instrument, and acknowledged that he executed the same for the purposes therein contained. In Witness Whereof, I have hereunto set my hand and notarial seal . . .")
3. Be recorded in the same place where you would record a deed to that property.

Just having the release state that it "binds the owner and his heirs, successors, and assigns" will, as a practical matter, probably be enough to convince most subsequent owners to go away, and might even be enough to protect you in a lawsuit. That is why you will find this language as the last sentence in our sample property release form in chapter 34.

Special Considerations for the 21st Century

This material was created by the combined efforts of various ASMP staff members including Peter Dyson, Victor S. Perlman, Peter Skinner, and Richard Weisgrau.

IN RECENT YEARS, TWO CHANGES HAVE COME TO PASS, ONE TECHNICAL AND THE other social. Both require special care in the wording of your releases.

DIGITAL MANIPULATION

It used to be said that "the camera cannot lie." No one says that Photoshop can't lie, however. Nowadays it is routine to alter colors, morph shapes, and assemble scenes by compositing portions that were separately shot. Your release should state that the subject gives permission for this to occur:

> I hereby release Photographer from any liability by virtue of any blurring, distortion, alteration, optical illusion, or use in composite form, whether intentional or otherwise, that may occur or be produced in the taking of such photographs or in any subsequent processing of them.

We've included a version of the above language in our general adult and minor model releases, because some level of manipulation has become a normal aspect of advertising photography. But that's pretty broad language: It allows every conceivable digital effect. Depending on the model's concerns (and the client's needs, of course), you may need to accept certain limits on the digital reworking that may be done. For instance:

> However, this compositing or distortion shall be done only by Photographer or by persons working under the direct supervision of Photographer, and it

will be limited to images and image components that are photographed on the same day.

If you need the "however" part and you are using a preprinted release, you can handwrite the extra sentence, and both you and the model can initial and date the change.

There's nothing magical about this particular set of limits. If you and the model have reached a different agreement on what may and may not be done, you should write it down in plain language. If it's a short statement, you can write directly on the release. If it's long, write it on the back or on a separate sheet of paper, and put a note on the front that refers to the extra material. (Get the model to sign the extended statement and initial the note.) That way, the deal is recorded and there's less chance that you will later be accused of doing what you promised not to do.

SENSITIVE USES

There are certain subjects with which many people may not want to be associated. These subjects are typically related to sex, religion, politics, and health. In some cases, appearing in the "wrong" ad campaign can spell ruin for a model's career. For those reasons, if you are going to use a photograph for any purpose that some people may find discomforting, offensive, or even distasteful, you should make sure that your release specifically authorizes that use. Since that kind of permission is by nature specific, having a general authorization to use images for "sensitive uses" would probably not be effective.

Instead, when needed you should insert language similar to the following, on an as-needed, case-by-case basis, filling in the blanks and changing words like "suffer" to fit your particular situation:

I understand that the pictures of me will be used in public-service advertisements to promote AIDS awareness. Knowing that such advertisements may intentionally or unintentionally give rise to the impression that I suffer from this disease, I nevertheless consent to this use.

Your licensing agreements should contain language that disallows using your photos for any sensitive subjects except those specifically identified. You would then grant such permission only where you have a model release that covers that use.

Trademarks

This material was created by the combined efforts of various ASMP staff members including Peter Dyson, Victor S. Perlman, Peter Skinner, and Richard Weisgrau.

A TRADEMARK IS A DISTINCTIVE MARK (WHICH CAN INCLUDE WORDS, NAMES, symbols, designs, combinations of them, etc.) that a manufacturer attaches to its goods as a symbol of authenticity, to distinguish its goods from those of others. They are often accompanied by a symbol like ™ or, if they have been registered at the federal level, ®. To be valid, marks must be actually used in trade and can be lost through lack of use. Registration is not required for validity, at either the state or federal level.

Marks can also be used in connection with services as well as goods and can consist of building designs, packaging, and so on. Trade names are similar. Registration of marks requires that specific categories of goods and services be identified in the registration, and the registration protects the mark only for those classes of uses. Use of things like words and images that have been trademarked is prohibited only if the use would be likely to confuse someone as to the origin or authenticity of a product. Descriptive or noncommercial uses of trademarks, names, and so on may be permitted under the doctrine of fair use.

Q *Can I take photographs showing buildings that are registered trademarks?*
A As long as you are making the photograph from a public vantage point, you have the right to go ahead and shoot.

Q *What can I do with photographs that show trademarks, logos, or buildings, or props that are themselves registered trademarks?*
A Generally such photographs should be safe for editorial uses. You should make sure, however, that you specifically point out in your paperwork that you do not have any releases or permissions. If possible, have the

client indemnify you against any claims arising out of his use of the photograph. Remember that violations of third-parties' rights come primarily from use of the photograph, not the photograph itself, and you have no control over that use once you have agreed to license it.

COMMERCIAL USE

When you get to commercial use, things become a lot trickier, and no answer can apply in the abstract—it will always come down to all of the details of the usage, including what the usage looked like. Let's assume the buildings have trademarked material on them, such as names or logos, or may even be registered as trademarks themselves. Not every use of a trademark is a trademark use, as strange as that sounds. What it means is that just because a trademark appears in a photograph, use of the photograph may not violate the rights of the trademark owners.

Trademarks started out, not as property rights, but as a form of consumer protection to keep the public from being confused as to the source of a product or service. So if you have a photograph of Ford corporate headquarters and use it in a brochure for, let's say, DuPont, you have probably created the impression in the public's mind that there is some affiliation between or endorsement of the two companies, and/or their products by the other. A reader might well assume that the two companies are related, or that Ford cars use DuPont paints or plastics, and so on. This would most probably violate Ford's trademark rights.

On the other hand, if you had the same photograph in a brochure for the Detroit Chamber of Commerce, most people would probably assume that the only relationship between the two is that Ford is located in (or near) Detroit and that the chamber's function is to boost business in the Detroit area. That does not seem likely to violate Ford's rights.

The same is true for trademarked props. A still-life showing writing paper and a Mont Blanc pen would probably be fine to use on a brochure for a law firm or literary agency but seems likely to cause problems in an ad campaign for Crane stationery. If you took a photograph of a Harley-Davidson motorcycle and sold it as an uncaptioned poster, the chances are that it would be legal. If you added the Harley-Davidson bar-and-shield logo to a corner of the poster, most people looking at it would probably believe that the poster was an officially produced or licensed product of Harley-Davidson, and you would probably be liable for trademark infringement.

Ideas for Getting Signatures

This material was created by the combined efforts of various ASMP staff members including Peter Dyson, Victor S. Perlman, Peter Skinner, and Richard Weisgrau.

EXPERIENCED MODELS ARE FAMILIAR WITH MODEL RELEASES (PERHAPS MORE familiar than you are) and will expect your request to sign the papers. Others may be surprised by such a request, and you may need to do some explaining or even some bargaining to get their signatures. There are no sure-fire techniques that work every time, but we offer a few strategies in the spirit of information sharing.

Elsewhere we note that it is often useful to give out your business card and offer to send a print if the subject will sign your release. And we suggest using the "pocket" release for shooting in the field—it's short and unthreatening.

IT'S FOR STOCK

A lot of times people will ask how you intend to use their picture. The more specific you can make your answer, the more likely that they will sign your release. Except, of course, you often don't know all the possible uses. But you can say that you are shooting "for stock" and explain what that means. If you work with a stock agency, tell your subjects its name and Web address. Tell them that the images may or may not ever be licensed, that you find out when and where the photos are used only after the fact. It can't hurt to add that you get but a small fraction of the license fee.

THE CELEBRITY RELEASE

If you photograph performing artists and celebrities for purely editorial projects, you don't need a release. However, you do need consent for any commercial use—and that includes self-promotion, such as showing the images on your Web site or in your portfolio. Rare is the artist who will sign a broad

model release, though. A bit of creativity is called for. Here is an example from Timothy H. Wright, of the Wright Studio:

> I have had the opportunity to photograph several music artists this past year for major music magazines. These have been editorial assignments; the artists have already agreed to be interviewed and want their photos to accompany the articles. Everybody is agreeable to the use of the photos, and the magazine and the artist do not require or desire me to interject a model-release issue.
>
> I introduced a 'celebrity release' on one of the assignments and secured a signature from the artist. I modified a basic model release to specify the publication and that initial usage, and added a usage for me to use the photos in my own self-promotion. I intentionally did not include a broad unlimited release, believing that it would be rejected by any artist's management.

KEEPING TRACK

It is not enough to get the signature on the release. You also have to be able to produce the signed paper when it is required. It will be required if you ever have to defend yourself against accusations of wrongdoing. In addition, many licensors insist on getting a copy of the release along with a copy of the photo, because they might someday have to defend themselves. You need a reliable filing system.

Here's a tip from Baltimore photographer Ed Ross that could make your system work better:

> After any shooting session in which I use a model I have used previously or might use again, I make thumbnails of all the images and print them on the bottom or back of the release, or on separate pages which I attach to the release. That way, if I shoot the model again and have a second release, I can quickly see which images are covered by which release.

Frequently Asked Questions about Releases

This material was created by the combined efforts of various ASMP staff members including Peter Dyson, Victor S. Perlman, Peter Skinner, and Richard Weisgrau.

GENERAL ISSUES

Q *How do I know when I need a model release?*

A The answer to this question can be reached by asking a series of questions about the subject and the use of the photograph. A model release is needed from each person whose likeness appears in a photograph that is used for advertising or trade (business) purposes when the person is identifiable. Look at the photograph and the person(s) in it, and ask these questions:

1. Could the person in the photograph be recognized by anyone? Be warned: It is very easy for a person to show in court that he or she is recognizable.

If the answer to question No. 1 is no, then you do not need a release.

2. Is the photograph to be used for an advertisement? (In law, "advertisement" is broadly defined.)
3. Is the photograph going to be used for commercial business purposes, like a brochure, calendar, poster, Web site, or other use that is intended to enhance a business interest?

If the answers to question No. 2 and question No. 3 are both no, then you do not need a release. Otherwise, the answer is that you do need a model release.

Q *What is the legal age for signing releases?*

A Eighteen is generally the legal age across the United States. However, it is an individual state determination, and we do not have the legal stats on each state. If you want to know the answer for any state, we suggest that you call the state attorney general, state solicitor's office, or whatever your state calls its legal arm. You can also call a qualified local attorney.

A safe course is to use the ASMP's recommended release forms, found in chapter 34. You are well protected because we use the words "of full age," which covers you in any state. ("Full age" and "legal age" mean the same thing in legal jargon. "Full" allows you to keep the word "legal" off the paper. Some folks fear the word legal when they see it on paper.)

When the subject is not of legal age, you must get the signature of at least one parent or legal guardian on the release. Getting the signatures of both parents is better, so that one cannot seek to rescind the consent of the other.

Q *What are the differences between having a photograph appear in an ad and in a magazine's editorial pages?*

A The two differences are the need for model releases (see the answer to the first question) and money. Generally, photographs used for advertising are worth substantially more money to everyone involved than photographs used for editorial purposes.

Q *If I photograph a large group of people and plan to sell the picture, would I need model releases from every person?*

A If you just want to sell fine art prints or even posters, you should be OK without releases. If you license the picture for use in a book, you should be OK without any releases as long as you don't allow the publisher to put the photo on the cover of the book or use it in promotional materials.

But if you put it on coffee mugs or allow its use in any way that would be considered purposes of trade or advertising, you are probably going to be liable for the invasion someone's right of privacy unless you have gotten releases from every person who is recognizable in the photo. A bank once made a photo of about 300 of its own employees standing in one of its lobbies. When the picture ran in an ad campaign, some of the employees sued the bank and won.

Q *If I photograph a clown in the circus and the picture appears in a magazine, can the clown sue me for depicting his trade dress without permission?*

A If the photo appears as an editorial illustration, rather than an advertisement, he could sue you but he probably would not win. Just like trademarks, trade dress can be shown in photographs as long as the use does not create confusion in the mind of the public as to the origin or ownership of the trade dress and the usage doesn't damage the value of the trade dress.

"Trade dress" is like a trademark, in that it is unique or distinctive and helps to create a business identity for the clown. (The term is actually quite broad; the feminine shape of a Coke bottle is protected as trade dress.)

PROPERTY RELEASES

Q *How do I know when I need a property release?*

A The answer to this question can be reached by asking a series of questions about the subject and use of the photograph. A property release is advisable and may be needed from each property owner whose property appears in a photograph that is used for advertising or trade (business) purposes when the property owner is clearly identifiable by the property. (Note that the owner can be a corporation as well as an individual.)

Look at the photograph and the property in it, and ask these questions:

1. Could the owner of the property in the photograph be identified by anyone just by looking at the photograph of the property?

If the answer to question No. 1 is no, then you do not need a release.

2. Is the photograph to be used for an advertisement? (In law, "advertisement" is very broadly defined.)
3. Is the photograph going to be used for commercial purposes, like a brochure, calendar, poster, Web site, or other use that is intended to enhance a business interest?

If the answers to question No. 2 and question No. 3 are both no, then you do not need a release. Otherwise, you do need a release.

When doing this analysis, remember that a property can include, or even be, a trademark. Depending on the details, use of another's trademark without permission may be a violation or dilution of the mark. For example, if you photograph a building with the logo of the ASMP on it, you have to have permission to use it for advertising or trade purposes because the logo is the property of the ASMP. What about the building

the logo is displayed on? This is a more complicated question. To learn more about trademarks and related marks, see chapter 31.

Q *Can a property owner prevent me from taking pictures of his building, car, and so on from the outside? From the inside?*

A If you are taking the picture from a public place, and the subject is visible from that place, the owner does not have a legal right to prevent you from making photographs. The answer is different if you are taking the picture inside (or on) private property. There, the owner gets to make the rules, and if he says no photos, then you can't take photos.

PRIVACY AND LIBEL

Q *Am I legally permitted to photograph strangers in public places? Are city and state parks considered public places?*

A Yes, you can photograph strangers in public places, unless you do it to such an extent and in such a way that you become a harasser or nuisance to the public.

City and state parks are generally public places. Figuring out what is or isn't a public place is usually easy but not always. If the public is allowed free and unrestricted access to a place—like streets, sidewalks, and public parks—it is probably a public place (although parts of sidewalks and what appear to be public parks may be privately owned). Once you go indoors, you are probably no longer in a public place, and some person or entity can probably make the rules, including restrictions on making photographs.

Note that even in public places, police officers have broad powers to protect the public from possible harm and to enforce the local ordinances. If a cop tells you to stop, you'd better obey promptly and defer the arguments until after you've checked with a lawyer.

Q *If I photograph a man doing something silly such as slipping on a banana peel and the picture appears in a newspaper, can he sue me for holding him up to ridicule?*

A In the areas of defamation, libel, and so on, truth is almost always a good defense. Assuming the photo is not staged or manipulated—that is, that it is a true and accurate image of what really happened, and assuming it is used for editorial purposes and not trade or advertising, the photograph by itself will probably not be a source of liability. However, if the newspaper decides to do something like run it with a headline that says, "King of the Klutzes" and an embarrassing or humiliating story, there

could easily be a successful lawsuit. The liability, though, would belong to the publisher of the newspaper, not the photographer, although the photographer would probably be stuck having to defend him- or herself in the suit. Even worse, the photographer may have signed an agreement with the publisher in which he promised to indemnify the publisher. In that case, the photographer would be stuck with all of the costs and liabilities, even though the fault would be the publisher's.

Q *If I photograph a crowd at a baseball stadium and it's published, but the boss of one of the people in the audience recognizes him as an employee who called in sick that day and fires him, can he sue me for causing him to lose his job?*

A If it is published as an editorial photo, not as part of an ad or for other trade purposes, he would be unlikely to win such a suit.

Q *If I take a picture of a seedy neighborhood and a magazine editor writes a caption describing it as a red light district, can I be sued for defamation by someone shown in the picture?*

A Yes, which is why your paperwork with the magazine has to make it clear that there is no model release (if there is none). Ideally, the magazine should agree to indemnify the photographer against any damage from publishing the picture, since the magazine is the one that controls the use of the photo, and it is the use—not the photograph—that creates the liability. Unfortunately for photographers, in today's world, that seldom happens.

Q *When does the right of privacy protect someone from having his picture taken?*

A When a person has taken steps that would give rise to a reasonable expectation of privacy, they will likely be able to claim this right. If you go into a room with closed doors and window shades pulled down, you would probably have a reasonable expectation of privacy, and someone putting a fiber-optic lens under the door and taking your picture would probably be liable for invading your privacy. If you are sitting at a window table in a restaurant, you are probably fair game.

Q *If I stand outside a store and take a picture for publication of someone inside, either through the door or store window, is that a violation of some sort?*

A Probably not. Standing in a store with glass windows and doors is not a situation that would give a reasonable expectation of privacy.

Q *What are the rules about photographing nudes?*

A This is a huge and volatile topic. First, let's assume we're talking about subjects who are legally competent adults. Let's also assume that you are taking the photographs with the models' knowledge and permission, and that they have given you valid model releases. The language of the release covers both privacy and defamation issues, so you should be covered on that score.

That leaves the question of whether the photos are obscene. If they are, you could be charged with violating state and/or local obscenity laws. What is obscene? The U.S. Supreme Court has struggled with this question. Justice Potter Stewart characterized it as "trying to define what may be indefinable." The court's guidelines, if you can really call them that, are hardly more than the instinctive reactions of the people in the street:

> (a) whether "the average person, applying contemporary community standards," would find that the work, taken as a whole, appeals to the prurient interest . . . (b) whether the work depicts or describes, in a patently offensive way, sexual conduct specifically defined by applicable state law; and (c) whether the work, taken as a whole, lacks serious literary, political or scientific value.

The kicker is the "community standards" part, especially in an Internet era. Not long ago, a San Francisco couple running an Web site found themselves indicted for violating obscenity laws in Tennessee, and the community standards in those two communities are presumably quite different.

Q *If I photograph my young children in the bathtub and send the film out for processing, could the processor turn the film over to the police? Could I be prosecuted for child pornography?*

A This area is a real hornet's nest of emotions and political sensitivity. Yes, the processor could and might turn the film over to the police, and yes, you could be prosecuted for child pornography. You wouldn't necessarily be convicted, but the whole process would be enough to ruin or at least severely damage your life and reputation. Just ask some of the photographers to whom this has happened.

There are occasional reports of overzealous lab employees inappropriately blowing the whistle over photographs no more offensive than the classic naked baby on a bearskin rug. These days, you are better off using digital cameras and printing your own photos than using a lab where unclothed children are in the picture.

Sample Releases

THESE FORMS ARE ALSO AVAILABLE ONLINE AT *www.asmp.org/releases*.

ADULT MODEL RELEASE

Use this for commercial shoots with professional models. There is an optional clause for sensitive uses.

MODEL RELEASE FOR A MINOR CHILD

This is almost identical to the release for adults, except the child's parent or guardian signs it. (One parent is sufficient, but get both parents to sign if you can.) There is an optional clause for sensitive uses.

SIMPLIFIED PERMISSION FOR PHOTOGRAPHY

A shorter version of the general release, this form is adequate if the use of the images is restricted to "safe" contexts and straightforward applications.

POCKET PERMISSION FOR PHOTOGRAPHY

A very short document, this is useful for spontaneous encounters with members of the public.

PERMISSION FOR PHOTOGRAPHY OF PROPERTY

Use this to record the property owner's consent for photos of places, pets, automobiles, works of art and so on.

RELEASES IN OTHER LANGUAGES

All of our releases are in English, which is fully acceptable in the courts of the United States and Canada. In other countries, you cannot assume that English will be acceptable, and you are very likely to encounter resistance to signing a document unless it's in the correct language. Even in North America there are

many people who don't read English. These people may be more willing to sign a release if it's in their own language.

Fortunately, Getty Images has translated its standard release into nine languages and has graciously made these versions freely available on this page. The languages are: U.S. English, U.K. English, German, French (two versions), Spanish, Italian, Portuguese, Japanese, and Chinese.

Please be aware that the ASMP has not conducted a legal review of these documents and does not officially endorse their use. Getty has designed its releases to protect Getty and its contributing photographers—but if their interests are not identical to yours, they are probably fairly similar. Besides, any release is likely to be better than none.

ADULT MODEL RELEASE

In consideration of my engagement as a model, and for other good and valuable consideration herein acknowledged as received, I hereby grant the following rights and permissions to _____ ("Photographer"), his/her heirs, legal representatives, and assigns, those for whom Photographer is acting, and those acting with his/her authority and permission. They have the irrevocable, perpetual and unrestricted right and permission to take, use, re-use, publish, and republish photographic portraits or pictures of me or in which I may be included, in whole or in part, or composite or distorted in character or form, without restriction as to changes or alterations, in conjunction with my own or a fictitious name, or reproductions thereof in color or otherwise, made through any medium at his/her studios or elsewhere, and in any and all media now or hereafter known, specifically including but not limited to print media and distribution over the internet for illustration, promotion, art, editorial, advertising, trade, or any other purpose whatsoever. I specifically consent to the digital compositing or distortion of the portraits or pictures, including without restriction any changes or alterations as to color, size, shape, perspective, context, foreground or background. I also consent to the use of any published matter in conjunction with such photographs. I hereby waive any right that I may have to inspect or approve the finished product or products and the advertising copy or other matter that may be used in connection them or the use to which they may be applied. I hereby release, discharge, and agree to hold harmless Photographer, his/her heirs, legal representatives, and assigns, and all persons acting under his/her permission or authority or those for whom he/she is acting, from any liability by virtue of any blurring, distortion, alteration, optical illusion, or use in composite form, whether intentional or otherwise, that may occur or be produced in the taking of such photographs or in any subsequent processing of them, as well as any publication of them, including without limitation any claims for libel or violation of any right of publicity or privacy. I hereby warrant that I am of full age and have the right to contract in my own name. I have read the above authorization, release, and agreement, prior to its execution, and I am fully familiar with the contents of this document. This document shall be binding upon me and my heirs, legal representatives, and assigns.

X _____ (SEAL)
SIGNATURE

NAME

ADDRESS (Line 1)

ADDRESS (Line 2)

DATE

X _____
WITNESS

ADDRESS (Line 1)

ADDRESS (Line 2)

MODEL RELEASE FOR A MINOR CHILD

In consideration of the engagement as a model of the minor named below, and for other good and valuable consideration that I acknowledge as having received, I hereby grant the following rights and permissions to _____ ("Photographer"), his/her legal representatives and assigns, those for whom Photographer is acting, and those acting with his/her authority and permission. They have the absolute right and permission to take, use, reuse, publish, and republish photographic portraits or pictures of the minor or in which the minor may be included, in whole or in part, or composite or distorted in character or form, without restriction as to changes or alterations from time to time, in conjunction with the minor's own or a fictitious name, or reproductions of such photographs in color or otherwise, made through any medium at Photographer's studios or elsewhere, and in any and all media now or hereafter known, including the internet, for art, advertising, trade, or any other purpose whatsoever. I also consent to the use of any published matter in conjunction with such photographs. I specifically consent to the digital compositing or distortion of the portraits or pictures, including without restriction any changes or alterations as to color, size, shape, perspective, context, foreground or background. I waive any right that I or the minor may have to inspect or approve any finished product or products or the advertising copy or printed matter that may be used in connection such photographs or the use to which it may be applied. I release, discharge, and agree to hold harmless and defend Photographer, his/her legal representatives or assigns, and all persons acting under his/her permission or authority or those for whom he/she is acting, from any liability by virtue of any reason in connection with the making and use of such photographs, including blurring, distortion, alteration, optical illusion, or use in composite form, whether intentional or otherwise, that may occur or be produced in the taking of said picture or in any subsequent processing thereof, as well as any publication of them, including without limitation any claims for libel or violation of any right of publicity or privacy. I hereby warrant that I am a legal competent adult and a parent or legally appointed guardian of the minor, and that I have every right to contract for the minor in the above regard. I state further that I have read the above authorization, release, and agreement, prior to its execution, and that I am fully familiar with the contents of it. This release shall be binding upon the minor and me, and our respective heirs, legal representatives, and assigns.

X _____ (SEAL)
FATHER, MOTHER OR LEGAL GUARDIAN

X _____
FATHER, MOTHER OR LEGAL GUARDIAN

X _____
MINOR'S SIGNATURE (if 14 or older)

MINOR'S NAME

ADDRESS (Line 1)

ADDRESS (Line 2)

DATE

X _____
WITNESS

ADDRESS (Line 1)

ADDRESS (Line 2)

SIMPLIFIED PERMISSION FOR PHOTOGRAPHY

For valuable consideration received, I grant to _____ ("Photographer") the absolute and irrevocable right and unrestricted permission concerning any photographs that he/she has taken or may take of me or in which I may be included with others, to use, reuse, publish, and republish the photographs in whole or in part, individually or in connection with other material, in any and all media now or hereafter known, including the internet, and for any purpose whatsoever, specifically including illustration, promotion, art, editorial, advertising, and trade, without restriction as to alteration; and to use my name in connection with any use if he/she so chooses. I release and discharge Photographer from any and all claims and demands that may arise out of or in connection with the use of the photographs, including without limitation any and all claims for libel or violation of any right of publicity or privacy. This authorization and release shall also inure to the benefit of the heirs, legal representatives, licensees, and assigns of Photographer, as well as the person(s) for whom he/she took the photographs. I am a legally competent adult and have the right to contract in my own name. I have read this document and fully understand its contents. This release shall be binding upon me and my heirs, legal representatives, and assigns.

X _____ (SEAL)
SIGNATURE

NAME

ADDRESS (Line 1)

ADDRESS (Line 2)

DATE

X _____
WITNESS

ADDRESS (Line 1)

ADDRESS (Line 2)

POCKET PERMISSION FOR PHOTOGRAPHY

For valuable consideration received, I grant to _____
("Photographer") and his/her legal representatives and assigns, the irrevocable and
unrestricted right to use and publish photographs of me, or in which I may be included,
for editorial, trade, advertising, and any other purpose and in any manner and medium;
and to alter and composite the same without restriction and without my inspection
or approval. I hereby release Photographer and his/her legal representatives and
assigns from all claims and liability relating to said photographs.

X _____ (SEAL)
SIGNATURE

NAME

ADDRESS (Line 1)

ADDRESS (Line 2)

DATE

X _____
IF MINOR, SIGNATURE OF PARENT/GUARDIAN

X _____
WITNESS

PERMISSION FOR PHOTOGRAPHY OF PROPERTY

For good and valuable consideration herein acknowledged as received, the undersigned, being the legal owner of, or having the right to permit the taking and use of photographs of, certain property designated as _____, does irrevocably grant to _____ ("Photographer"), his/her heirs, legal representatives, agents, and assigns the full perpetual rights to take and use such photographs in advertising, trade, or for any purpose. The undersigned also consents to the use of any printed matter in conjunction therewith. The undersigned hereby waives any right that he/she/it may have to inspect or approve the finished product or products, or the advertising copy or other published matter that may be used in connection therewith, or the use to which it may be applied. The undersigned hereby releases, discharges, and agrees to save harmless and defend Photographer, his/her heirs, legal representatives, and assigns, and all persons acting under his/her permission or authority, or those for whom he/she is acting, from any liability by virtue of any blurring, distortion, alteration, optical illusion, or use in composite form, whether intentional or otherwise, that may occur or be produced in the taking of said picture or in any subsequent processing thereof, as well as any publication thereof, even though it may subject the undersigned, his/her/its heirs, representatives, successors, and assigns, to ridicule, scandal, reproach, scorn, and indignity. The undersigned hereby warrants that he/she is a legally competent adult and has every right to contract in his/her own name in the above regard. The undersigned states further that he/she has read the above authorization, release, and agreement, prior to its execution, and that he/she is fully familiar with the contents thereof. If the undersigned is signing as an agent or employee of a firm or corporation, the undersigned warrants that he/she is fully authorized to do so. This release shall be binding upon the undersigned and his/her/its heirs, legal representatives, successors, and assigns.

X _____ (SEAL)
SIGNATURE

NAME

ADDRESS (Line 1)

ADDRESS (Line 2)

DATE

X _____
WITNESS

ADDRESS (Line 1)

ADDRESS (Line 2)

Professional Services

"The advice and expertise provided
by accountants, attorneys, and other
professionals help ensure that the business
side of photography is also in focus."
—Allen Rabinowitz

Your Professional Team

ATTORNEY, ACCOUNTANT, ESTATE PLANNER, AND INSURANCE AGENT

by Allen Rabinowitz

Allen Rabinowitz, an Atlanta-based writer, has been writing for many years on photography and other visual communications topics.

————————————— • —————————————

PHOTOGRAPHERS RELY ON THE HELP OF SUCH PEOPLE AS ASSISTANTS, CAMERA and digital technicians, prop makers, and stylists to guarantee that their images are on the money; the advice and expertise provided by attorneys, accountants, and other professionals help ensure that the business side of photography is also in focus. Whether for a particular problem or a long-term relationship, such professional service providers can make an important difference in the financial health and security of a business.

Choosing the right professional service provider for a particular need is a crucial decision that should be made with care. This chapter will outline the factors that should go into such a decision, as well as some personal actions that can help control the cost of these services.

ATTORNEY

Whether it's for help in writing or reviewing a contract, or representation in resolving a dispute, photographers depend on the advice and assistance of an attorney. Although a photographer might be a skilled negotiator, there will be times when an attorney's training is invaluable. In dispute resolution, the general rule is this: If a business problem exists, the best possible result can be achieved with the assistance of a knowledgeable, effective attorney. The

attorney can advise you about the parameters of the law, what might represent a reasonable settlement, and how to use leverage in terms of your legal position to extract a higher settlement. If your attempt to arrive at a businesslike solution to the problem fails and legal action is required, you are less likely to have prejudiced your case, and your attorney can better handle it having been in on it from the start.

Identifying the specific legal situation for which an attorney's talents and knowledge are most needed is the first step in choosing one. If, for example, you encounter a constant series of problems relating to copyright infringement, someone with that particular expertise should be sought. Just as an art director wouldn't consider a tabletop specialist to shoot fashion photos, neither would a photographer hire a tax attorney to handle a problem involving copyright.

Most people, however, prefer to have an attorney who is knowledgeable about them, is familiar with how their business is conducted, and, most important, is someone whom they can go to with a variety of legal problems. The most important criteria are feeling comfortable with the attorney, trusting in her expertise and judgment, and feeling confident that if the problem lies outside the attorney's area of expertise, referrals to attorneys with that specialized knowledge and experience can be provided.

Whether the attorney is a sole practitioner, with a small firm, or part of a large, multifaceted firm should not make a difference. Be aware, however, you're not hiring a firm, but, rather, an individual attorney. The support that the attorney has within the firm may be a consideration in some instances, such as in the context of complex litigation or a transaction requiring tax, pension, and corporate law expertise. But in most situations, the individual attorney's own professional qualifications and expertise should be the main consideration. The ASMP can refer a member's attorney to specialists for consultations and advice.

Word of mouth is usually a good first step in finding an appropriate attorney.

Inquiring among friends and colleagues, as well as reps and clients, can often lead to an attorney with a good understanding of the workings of the photo business. Another good method is to ask attorneys in the community to recommend an attorney with the desired specialized knowledge. If you need to learn more about an attorney you're considering retaining, the legal directories published by Martindale-Hubbell (*www.martindale.com*) are a good resource.

These directories list such information about attorneys as where they went to school, associations and professional societies they belong to, and articles they've published. The directories grade attorneys on the basis of technical skills and ethics. Seek attorneys rated A–V; that is, an "A" in technical skills and a "V" for very high ethics.

At a preliminary, get-acquainted meeting, the attorney should be asked certain questions. Whether the meeting is to hire that attorney on a one-time basis for a specific case or to establish a long-term relationship, it's important to clarify such issues as:

- The scope of the work.
- The hourly rate as well as the rates of the other attorneys who may be involved and lend assistance.
- The billing cycle for service, whether it is monthly, quarterly, or whatever suits both parties.
- What costs and disbursements the client will be responsible for, and the need for them to be itemized on the bill.
- Requiring that the bills be specific to the tasks performed, the amount of time spent on each task, the specific attorney or legal assistant performing each task, and the hourly rate associated with each segment of work.

Defining who is responsible for expenses becomes especially critical during litigation.

Since costs may be substantial during the course of litigation, whether the photographer will be responsible for them as they're incurred (and billed on an agreed-upon basis), or the attorney will be advancing these costs to be paid out of any settlement or judgment, needs to be ironed out in advance.

If the attorney is working on a contingency basis, where the fees are paid out of a final judgment or settlement, this needs to be clarified in advance and set forth in writing so there's no ambiguity or uncertainty later. Though attorneys usually receive one-third of the settlement or judgment in contingency agreements, this percentage may vary depending on the case and the risk being taken.

After the initial meeting, a retainer agreement spelling out the terms of the relationship should be drawn up. If an attorney refuses to do so, it's advisable to go elsewhere. It should be understood from the beginning of the relationship that the attorney will be billing for any time spent handling legal affairs. This means that even the shortest phone conversation will be reflected in the bill. If you are working on a tight budget, that should be made clear to the attorney, and authorize a limited number of hours to be spent on the case. You can also request to be periodically informed about the amount of time being spent on the case and to receive a weekly accounting. You might consider placing a cap on the upper limit of expenditures on the case.

Undertaking litigation can be an expensive proposition with a substantial investment in legal fees. Litigation is extremely time-consuming, especially if the photographer is the defendant in a case. In the context of litigation,

request that the attorney prepare a projected litigation budget, and monitor how closely it is followed.

There are, however, alternatives to going to court. First, determine whether the situation or dollar amount in question warrants the investment in attorney's fees.

In disputes with a low dollar value, small claims court is often a viable option. Many states will put a dollar-amount ceiling on such proceedings, so the photographer must check with the individual state about that amount. For a minimal filing fee, it's possible to get a quick hearing on the dispute, usually within a matter of weeks rather than months. Although attorneys are not required for such hearings, if the photographer is incorporated, the particular state law might require representation by legal counsel. Remember, however, that small claims courts have no jurisdiction in matters of federal law, such as copyright.

In certain disputes, consideration should be paid to arbitration or mediation. In arbitration, both parties present their side of the dispute and the arbitrator makes a decision on how it should be resolved. In some situations, that decision is binding and final; in others, the arbitrator's decision is preliminary and can be challenged in court.

In mediation, by contrast, an outside party helps the parties negotiate a solution to the problem but does not make any independent determinations as to what the solution should be. The mediator's role is that of a facilitator, not a decision maker. In both cases, a person who is knowledgeable about the law, though not necessarily an attorney or judge, will perform the services of a mediator or arbitrator. Usually these routes are taken when both sides have reached an impasse in their discussions but choose to have an independent party help them resolve the issue without having to go to the expense and trouble of court proceedings. Arbitration might be specified in a contract as a method of resolving any dispute under that contract. Organizations such as the American Arbitration Association have established procedures and can make people available to arbitrate disputes. Mediation, too, can be a remedy provided for in a contract. But before agreeing to binding arbitration in a contract, consult with an attorney about the pros and cons of doing so.

Including a binding arbitration provision in a contract may serve the photographer's interests in some situations. But in others, such as copyright infringement, a binding arbitration provision will remove access to the courts where more effective remedies may be available.

Whether attorneys should be present at mediation is up to the disputing parties. If both sides believe they can reach agreement better without their attorneys, they can be excluded. At arbitration, counsel generally represents both sides.

When should one method be chosen over another? If a good relationship existed with the party in dispute, mediation might be preferable. A good-faith approach to the situation is required from both parties, and they must genuinely desire to reach an amenable resolution.

In arbitration, the situation has usually reached a point where the parties cannot amicably resolve their dispute and require an outside party to make a decision. Be aware, however, that many arbitrators tend to reach a middle ground where both sides receive something from the decision. If a winner-gets-all victory is desired, then litigation should be pursued.

Along with being unbiased, the arbitrator needs to be someone mutually acceptable to the parties. Though not necessarily an attorney, the arbitrator should be someone with training in dispute resolution who has an understanding of what the applicable legal precedents are in order to arrive at an equitable solution. It may make sense to choose someone who does not possess detailed knowledge of the photo business, as that person will not have preconceived ideas about who might be in the right and can reach a decision based on the merits of the case.

ESTATE PLANNING

Estate planning is not a topic that comes frequently or easily to people's minds. Although many photographers put a lot of time, thought, and energy into growing their businesses, few devote much consideration to what will become of those businesses after they pass away. Failure to do adequate estate planning during your lifetime, however, could mean a wealth of problems for your heirs rather than the kind of financial security you'd prefer as a legacy.

Early in a photographer's career it would be wise to put together a team of professionals that could advise him on the timing and the steps to take in estate planning. This team is usually composed of an attorney, accountant (CPA), and life underwriter (CLU, CFP).

Like other owners of small businesses, photographers' estates usually consist of more than just property, cash, and securities. Along with equipment, a stock photography library, and possibly a studio, the business itself is an asset, along with the good name and goodwill garnered through the years. In order to have survivors benefit, care must be taken to prepare the proper documentation.

Probate laws vary from state to state, but some basic rules should be followed. Prime among them is drafting a will and/or trusts that contain detailed language about the disposition of the estate. Where the estate includes a closely held business, these documents give the executors, personal representatives, or trustees the power to deal effectively with the property.

Failure to include detailed language enabling the executor or trustee to make such changes in the structure of the business, such as buying and selling assets, could handcuff the estate. In most states, an executor might have to get the court's permission to perform such duties as continuing the business, selling off assets, or making other changes. The first step to ensuring a trouble-free estate is enlisting the aid of an attorney who is competent and experienced in the area. Along with referrals from friends, colleagues, and clients, the Martindale-Hubbell directory, which lists attorneys along with their educational background and specialties, is an important source. Look for experience in estate planning, estate administration, probate, trusts, and estates. As mentioned before, an attorney rated "A" in technical skills, and "V" for very high ethics is one to seriously consider.

At a preliminary meeting to discuss the relationship, inquire about how the attorney charges for services. Without being asked, the attorney may not volunteer this information or make it clear at the first meeting. Estate planning services is one area where people truly get what they pay for. When it's done right, you and your family are better off, even if these services cost more than you think they should. In the past, attorneys wrote wills as loss leaders, hoping to make bigger fees administering the estate. They would charge for estate administration based on the worth of the estate, rather than on the basis of the work performed. The approach today is moving toward billing on the basis of time spent for both planning and administration. Though you may feel you're paying too much up front, your surviving spouse and children will usually end up paying considerably less.

At a preliminary meeting with the attorney, the following details should be spelled out:

- How fees will be calculated, including whether payment will be on the basis of time spent on the planning and administration of the estate.
- Which attorney at the firm will be working on the file and what the hourly rates are. You should not have to pay a partner's fee if a junior associate, for instance, is assigned to your estate.
- If billing is to be on a time basis, then a ceiling might be imposed on the fees.

More likely, the law firm will present an estimated informal range of fees that similar services have cost for others. Realize that such figures might not necessarily apply in every case.

Although a number of books and software programs claim to allow you to write your own will without an attorney's assistance, using them is not in your

best interest. Like the client who owns a state-of-the-art camera and doesn't use a professional for a job, the photographer who writes his own will is letting an amateur take the place of a professional, with a similar outcome in quality. These programs and books are designed for universal usage, meaning there's little chance they can work well for any one particular application. The photographer who writes his own will runs the risk of creating problems that will cause heirs to pay more to straighten them out than the up-front cost of legal advice would have been.

Dealing with trust and estate documents is an exercise in using precise and proper language. By writing your own will, you're leaving the door open to have your words misinterpreted or applied in conflicting ways by someone else reading the document.

Additionally, your sense of what a word means may be quite different from what courts have traditionally held it to mean.

One of the major bequests a photographer makes to heirs is the copyright to a career's worth of images. Under current copyright law, these rights are good for seventy years beyond the photographer's life in most cases. If you've taken the proper steps to protect these copyrights, there should be no problem with their transfer to heirs or beneficiaries. However, if you've been negligent, your heirs will inherit nothing but problems. Internal organization is the key to a successful transfer. Since your surviving spouse or executor will have to go into your office and make sense of what's been left behind, you can leave a blueprint that helps everyone. If the images are well organized and filed, and copyright records are clearly placed on a computer database, life will be easier and more financially productive for the estate and its beneficiaries. Will and trust documents should make provisions for professional management of these images and their rights. Having some kind of agent in place or at least arranged for in the will or trust will maximize revenue for heirs. Choosing an executor (sometimes called a personal representative) is one of the most important decisions in estate planning. Along with trustees, such overseers of an estate are collectively referred to as fiduciaries and are held to the highest standard of behavior imposed by law with a mandate to act in the best interests of the estate and/or its beneficiaries. They cannot act in their own interest and may be barred from acting in the face of any possible conflicts of interest.

If such potential conflicts of interest exist—if, for example, another photographer may be named as executor—the documents must deal with how that will be handled. If, for instance, a surviving partner/executor wants to buy out the other's interest in the business from the estate, the terms and rules for that need to be spelled out.

A prime candidate for a fiduciary position is someone you trust and who

might also be familiar with the photo business. It's not uncommon, however, to have two executors, one being a close family member, such as a spouse or child, and the other someone who brings expertise to the table. A professional executor, such as a bank or trust company, might be chosen to manage the estate. In selecting such a fiduciary, choose one experienced in handling estates holding small or closely held businesses. The executor's term of responsibility usually lasts one to three years, after which the responsibility for handling assets, if they haven't all gone to the ultimate beneficiaries, usually goes to the trustees.

When setting up the documents, it's important to give the estate's management as much flexibility as possible and to specify the powers fiduciaries should have. If you have specific ideas about how your photos should be used, these instructions need to be written into the documents. However, this should be done in a way that neither handcuffs nor restricts the management of these images, since it can't be predicted how future developments might affect the images or their best use.

The document may contain language referred to as "precatory," meaning it expresses an intention or wish but is not legally binding or enforceable. Alternatively, these intentions can be left out of the will but communicated in the form of a letter of guidance to whoever will handle the stock. Some photographers may choose to leave their stock library in the form of a charitable bequest to a university, museum, or other nonprofit organization. When this is done, the recipient should handle the images as it would a cash bequest and work with the photographer and his or her attorney ahead of time to make sure it gets the gift in a way it wants.

It's wise to periodically review the will or trust documents, especially if there's been a significant change, such as an altering of the tax laws, a difference in the family situation (such as marriage, divorce, or the birth of a child), a revision of the copyright laws or modification of the structure of the business. As the will or trust is altered to reflect these new realities, you should also review any other relevant financial documents to see how these might affect the estate plan.

Business Tip: Don't Carry Too Much Debt! Many businesses make the mistake of trying to carry too much debt, reasoning that any debt is simply an added operating cost. Overlooked is the fact that repaying debt eats into your profit. The more money you owe, the more you will have to earn, often just to maintain your financial status quo.

As an example, a studio owner might add another $1,500 a month to overhead by borrowing to buy expensive new equipment and rationalize the added burden by claiming that another day's billing will take care of it.

Actually, the studio will have to generate $1,500 extra profit each month, something very different from simply billing an extra $1,500, to meet that extra debt. If your net profit is 33 percent, you will need to bill an additional $4,500 to meet a $1,500 monthly loan payment.

An experienced studio owner who has seen how too much debt can cripple a business offers this advice:

- Be aware that operating expenses and repaying debt are not the same thing.
- Average the revenues of your business over at least three or four months—preferably a year—to determine how much debt you can safely carry. Don't base the business's debt-carrying capability on one good month's revenues.
- If you find you're overextended, rather than trying to get bigger to pay down the debt, go the other way and cut down on expenses. Invariably there will be costs that can be cut.
- Before incurring more debt, carefully weigh your financial situation to determine whether your business will really benefit as a result. How long will it take to recover the costs of the equipment you are financing? Ask yourself: Is this extra debt really worth it?
- Above all, keep reminding yourself that extra debt comes out of your profit.

ACCOUNTANT

Often the difference between photographers' success and failure is not aesthetic taste or visual talents but rather how they conduct their business. To best deal with the myriad of rules involved in state, local, and federal tax laws, the expertise of a certified public accountant is a necessity. The choice of an accountant who is also a well-versed business advisor can mean the difference between a prosperous studio and one where the photographer spends more time dealing with the taxman than creating quality images.

The best place to start the search for an accountant is with colleagues or business associates. Word of mouth is usually a good indicator of whether an accountant has done a good job in helping other shooters get their financial houses in order. In addition, stylists, designers, and other self-employed craftspeople might be able to suggest possible accountants.

When choosing an accountant, be particularly concerned that candidates for the job have industry experience, particularly in the sales tax area. Since

these complicated laws vary from state to state, most accountants are not familiar with the sales tax implications relative to photographers and the rendering of photographic services. If the accountant doesn't possess photo-industry experience, however, inquire whether she has a background in art or art-related fields. The candidate should be familiar with some of the terminology, and, at the very least, have service businesses as clients. If she has only dealt with such businesses as doctors, manufacturers, or nonprofit organizations, look elsewhere.

When interviewing a potential accountant, ask whether she is aware of mark-up procedures, billing procedures, and studio systems and controls. Ask whether the accountant has knowledge in:

- State sales tax and payment procedures.
- Payment procedures to freelancers or employees and the distinction between independent contractors and employees. The IRS provides guidelines for contractors/employees, but your accountant should be aware of state interpretations too.
- Terminology and knowledge of the component parts that go into a job, such as props, wardrobe, stylists, and so on.

The accountant should also be asked about how she bills and what other services will be rendered along with the customary service of preparing an annual tax return. Chief among these services should be tax planning and the preparation of an annual financial statement.

The annual financial statement, generally done on an accrual basis as opposed to the cash basis for the tax return, is a critical tool in tracking business. Not only can it be used in obtaining loans to help the studio grow, but it can also be used to compare the studio's financial performance against industry models.

A successful annual financial statement will show or track:

- Growth in revenue.
- Whether expenses are increasing or decreasing as a function of revenue.
- Whether too much is being spent in a particular area.
- Whether the company is building net worth and the capability to expand.
- How much income was truly earned on an annual basis.

The financial statement doesn't need to be a tight, formal document, but it should be written down, scrutinized, and analyzed from year to year. This statement can also help you and the accountant prepare a reasonable budget that enables the studio to grow.

In general, the accountant should be called on for tax and financial information and advice, but not such activities as payroll. If there are two or more employees, that task may be best handled by an outside payroll service. These companies produce payroll checks, do quarterly payroll tax returns, prepare W-2 forms, and take care of deposits with the appropriate regulatory agencies.

Tax planning is another key service provided by an accountant. The successful photographer/accountant team will have the tax situation well in hand in advance of deadlines, rather than being in a flurry of activity at the beginning of April.

A knowledgeable accountant will schedule a planning meeting with you about nine months into a year, at which time you'll discuss what needs to be done before year's end to reduce any huge tax burden. In addition to this meeting, you should meet with your accountant at the end of the year to prepare the tax return and annual financial statement and budget for the subsequent year. Additionally, any time a major financial decision needs to be made, meet with your accountant, or at least discuss it over the phone.

You can help the accountant and save on billing by keeping accurate records and preparing relevant information. Summarize monthly cash receipts by category, listing how much was collected in photo fees versus the job expenses billed out and sales tax.

At the end of the year, prepare a list of open accounts receivable and open accounts payable.

Having the appropriate paperwork in order can help both you and your accountant. Make a concerted effort to organize such documents as:

- All disbursements: All paid invoices should be on file.
- All payments to independent freelancers.
- Petty cash files: All items over $25 need to be documented.

In the case of independent freelancers, be especially wary. There are times when a part-time worker, such as an assistant, might be considered an employee rather than an independent contractor. Instead of just issuing a 1099 form at the end of the year (if the person was paid more than $600), you may need to take out withholding and contribute payroll taxes for that individual.

A general rule of thumb is that if you control the destiny of an individual (tell him or her when to come in, when to leave, provide tools of the trade, and give direction during the day), that person is an employee and not a freelancer. Since there are penalties when someone deemed an employee is treated as a freelancer, consult with your tax advisor on dealing with that situation.

Sales tax, as mentioned earlier, often provides photographers with their biggest tax headaches. In order to better deal with the situation, keep the following general rules in mind:

- Although sales tax rules vary from state to state, most of the time, sales tax is imposed on the full amount of a billing, not just the photo fee or expenses.
- If a client tells you that he or she's not supposed to pay sales tax, obtain either a resale certificate and/or an exemption certificate from the client.
- Generally, out-of-state services are nontaxable if billed and rendered out of state. (If, for example, a New York photographer does a job in California for a company in that state, the photographer does not have to charge New York sales tax; but the company might have to pay a California use tax.)
- Labor, facility, and equipment costs are generally nontaxable. Job expenses such as wardrobe, sets, and film are generally exempt if bought for resale. You must present a certificate to the vendor stating that the material will be sold or will be part of a job billed to a client.

It is up to you to have the correct sales tax information. If you're doing a job out of town, consult your accountant on the sales tax rules that apply in that locale.

Getting audited by the Internal Revenue Service is a situation that people dread. If such a notice comes, the first thing you should do is not panic. The second is to call your accountant and prepare for the audit. Generally, the IRS notice will pertain to a particular area, such as expenses. It's rare for the IRS to question an entire return. Focus on the area in question and pull out all documentation and review the return. Although you might be able to personally deal with the IRS in some matters, you might feel more comfortable with your accountant on hand. The key to a successful audit is doing the necessary homework and not walking into it unprepared.

A professional who is authorized to represent taxpayers before the IRS should accompany you to the audit. Tax attorneys and CPAs are automatically entitled to provide such representation, while other tax preparers, unless they've received special designation, cannot. If the situation becomes serious or if a significant amount of money is involved, seek an attorney who specializes in tax law. An accountant is not allowed to represent a client in tax court.

If you and your accountant have worked together to produce a sensible business plan and manner of tackling any tax problems, these audits will not be the "encounters from hell" that photographers experience in their worst nightmares.

What about Sales Tax? If there is a subject both complex and complicated, it's the state-run sales taxes. There are differences from state to state on how much and under what circumstances sales tax should be charged. Overall, state sales tax laws are very confusing, but it is an area within which potentially lurks a large liability for the photographer. Many photographers can tell horror stories of being confronted with large tax bills for not collecting sales tax—in their state or in others they've done business in. Usually they found themselves in this predicament through misunderstanding the state's tax codes, not trying to avoid the tax. Here are some basic steps you should take regarding sales tax:

- Ask an accountant with which authority you should register your business and get your sales tax registration number.
- Obtain that authority's guidelines on sales tax. Clarify any matter you're unsure about.
- Generally charge sales tax on the full amount of an invoice.
- If resale exemptions apply, make sure you get a copy of the client's resale certificate.
- If you are doing business in other states, or have a rep in another state, get professional advice on your sales tax liability.
- If you have any doubts about sales tax matters, seek professional advice immediately.

That way you will be taking steps to avoid any surprise, and probably costly tax bills.

INSURANCE

Unfortunately, for insurance purposes, most of what goes into the job description of "photographer" touches on almost every exclusion in every existing business insurance policy. Whether shooting from helicopters or on boats, going out of the country or even out of state, the things photographers do in the course of a working day put them in a problematic area for acquiring the basic insurance coverage their businesses need.

Finding a source of insurance is a hard task. The first step is finding an insurance broker who can handle all needs. But because of the way the insurance industry is structured, brokers and/or agents either fall in the life-and-health area, or in the category of property and casualty. Since a broker who deals in disability, for example, may not know much about health or professional

coverage, find specialists in the different insurance categories to arrange for coverage.

Like most buyers of insurance, photographers don't know what they're buying until there's a loss; and if they haven't properly prepared, by then it's too late. A self-employed person should carry the following coverage at a minimum:

- Health
- Disability
- Nonowned and hired auto liability
- Workers' compensation
- General liability (especially if your business is not incorporated)
- Umbrella liability.

Life insurance is not mandatory, but this type of coverage is recommended for photographers who have a family depending upon them for income and to cover any indebtedness. While most photographers will take out insurance on their cameras, few stop to consider the importance of having coverage in the previous six areas. If $20,000 in equipment is lost, for example, at least you're aware of what's gone. But those other areas contain the potential for catastrophic loss. If something should go wrong and you don't have adequate insurance protection, the resulting claims might wipe you out financially.

Disability insurance is an area that often presents difficulty. Insurance companies prefer not to issue a disability policy to self-employed individuals because it's difficult for the company to tell whether that person will work again, since many self-employed people work out of their homes.

Therefore, many self-employed people receive poor definitions of the meaning of "disabled." Where an insurance company might offer a doctor or an attorney a disability policy that pays for the entire benefit period (usually up to age sixty-five) regardless of whether that individual can teach or do something else, photographers would probably receive a policy offering benefits for two years if they could not perform their occupation, and thereafter if they could not secure any gainful employment. The ASMP disability policy has a five-year own occupation definition.

In addition, since disability is based on age and occupation, you may end up paying more per $100 of coverage than a same-age attorney or doctor because insurance companies have determined that a photographer has much more of a chance of becoming disabled.

What can be done in this and other instances? The best bet is to find an agent who has an understanding of the photo business. Such a person can then

attempt to find a company that will write a disability policy that takes your career situation into consideration.

Workers' compensation is another area where special notice should be taken. Although you may think hiring freelancers, such as assistants, frees you from needing to purchase workers' compensation coverage, in fact, the definition of what constitutes an employee is solely up to an individual state's workers' compensation board.

In some cases, a person hired for just one day may be defined as an employee. If a freelancer were to get injured in the course of an assignment where he or she was told by you what time to report to work, and what to do on the job, and you supplied all the materials necessary to do the job, the workers' compensation board may rule that the person was an employee. In that case, if you do not have sufficient workers' compensation coverage, the results could be financially disastrous.

There are several factors by which you can feel reasonably comfortable that a freelancer will not be defined as an employee:

- If the person is incorporated, and performs the service for parties other than you.
- If the person provides a certificate of insurance to show that he has worker's compensation insurance.

Workers' compensation is paid based on payroll, and all employees must be covered by such insurance. You or your broker should check the workers' compensation laws in any state in which you plan to hire people to work for you, to determine who needs to be covered as an employee and whether a separate policy is needed for another state.

Health insurance is another area where the self-employed usually have great difficulty obtaining appropriate coverage. When exploring health insurance programs, inquire how long the carrier has been in business. Try to go with an established company—one that will be there if medical problems arise. If the company goes under and you are left uninsured, it could turn into a financial disaster.

Consider a qualified high-deductible health plan that allows you to make contributions to a health savings account. A limited policy with a low deductible is another option to investigate. In general, people tend to get better value for their dollar with a high deductible, in which the coverage addresses catastrophic matters.

There are several pitfalls to be avoided when getting health insurance. Make sure any policy is noncancelable in case the carrier decides to drop its

health coverage program. (Note: A noncancelable policy isn't guaranteed to be noncancelable. The carrier might opt to cancel all such policies in a state. But, more likely, the insurance companies might sell all such policies to another carrier.) Also, in a number of self-insured programs, the company retains the right to exclude coverage if it finds that claims are running too high in any particular area. Stay away from such a policy.

If health insurance benefits are extended to employees, realize the obligation you're taking on yourself. If the program is not administered properly, problems might lead to expensive lawsuits. There are tax benefits to an employer-sponsored health insurance program, but another legitimate option is giving employees a lump sum of money to acquire their own health insurance.

Photographers (and, in reality, most others) have difficulty understanding commercial general liability insurance coverage. It protects your legal liability against lawsuits for bodily injury or property damage that occur within the United States or Canada to other people or other people's property but does not cover any of your property. It also excludes other people's property in your care, custody, or control. Things like props, sets, and wardrobes fall into this category. You should have bailee or inland marine coverage for this exposure.

Other important exclusions in all liability policies include, but are not limited to:

- People eligible for disability benefits under a state statute
- People considered to be employees covered under workers' compensation
- Anything having to do with an automobile, aircraft, or watercraft
- Claims resulting from improper models releases, invasion of privacy, infringement of copyright or trademark, infringement of patent, libel, or slander
- Anything having to do with pollution
- Any international act
- Discrimination, sexual harassment, and wrongful termination
- Claims by someone other than an employee to recover damages paid to or sought from a former or existing employee.

Listed below are additional coverages to be considered in addition to general liability, workers' compensation, nonowned, and hired automobile liability:

- Statutory disability benefits
- Owned automobile

- Third-party property damage liability—for damage to locations in your care, custody, or control
- Bailee, which protects you for property damage to other people's property and/or props, sets, and wardrobe that are in your care, custody or control
- Rental equipment coverage
- Fire damage legal liability for your space as an endorsement to the policy
- Employment practices liability
- Employee dishonesty
- Errors and omissions in case of intellectual property rights infringement
- Foreign liability (outside the United States and Canada)
- Nonowned aircraft
- Nonowned watercraft
- Group travel accident
- Still photographers production package policy
- Monies and securities
- Animal mortality
- Weather
- Political risk and confiscation
- Umbrella liability.

Since general liability excludes any benefits paid by workers' compensation, you may benefit by purchasing a workers' compensation policy before general liability. You may incorporate to gain some protection from general liability claims, but you can't protect personal assets against failure to have workers' compensation.

Nonowned and hired auto insurance, while it excludes your own vehicle, is also important coverage to have. This will cover you for vehicular accidents caused by others in your employ driving their own cars or for accidents caused by rental cars under their control. The insurance does not cover physical damage to the car being driven but, rather, bodily injury or property damage to other people's property.

[In addition to coverage required for most businesses, investigate policies relating to situations specific to photography; see chapter 37.]

Insuring a stock library presents a unique problem. Although $1,500 is usually given as the value of an image, if you tried insuring every photo in your stock library at that amount, the premium for coverage would be enormous. Although people might insure their homes for large sums, few choose to do that for their stock photo library.

There are several ways to determine a fair value for a stock library for insurance purposes:

- Figure out the sales value of the entire collection, divide by the number of images, and come up with a price per image.
- Determine the value of time and expense it would take to recreate the library, divide by the number of images, and come up with a value per image.
- Hire a qualified photograph appraiser to assess the value. Experts recognized by the courts could serve this purpose.

Though figuring out insurance policies is often a time-consuming and confusing task, making the effort to obtain the best possible coverage will help you in the event of any major problems.

Preserving Your Visual Legacy

ESTATE PLANNING FOR PHOTOGRAPHERS

by Aaron D. Schindler

Schindler, a former photo agent turned financial advisor, specializes in providing investments and disability, life, and long-term care insurance to photographers. Managing Director, Wealth Advisory Group LLC, (212) 261-1897, *aschindler@wagroupllc.com*.

———————————•———————————

The following text was adapted for use in *ASMP Professional Business Practices in Photography* from an article originally published in the *ASMP Bulletin*, assigned and edited by Jill Waterman.

ABOVE AND BEYOND CONSIDERATIONS ABOUT THE INITIAL FEE FOR THEIR WORK, all photographers need to consider the potential future income stream or legacy of an image. Whether generated through stock or print sales, an annuitized royalty stream has the potential to finance retirement and send grandchildren to college even after you are gone.

Early estate planning can help maximize the value of your collection while you are alive and minimize a potential tax burden to your beneficiaries after your death. Below I offer specific estate planning tips for an orderly and tax-efficient transfer of your assets to your chosen beneficiaries.

ESTATE TAX EXEMPTIONS

The good news is that, as of 2005, the first $1.5 million of your estate is exempt from federal estate tax, and by 2009 that exemption is scheduled to reach $3.5

million. In 2010, the tax is scheduled to be repealed completely. However, in 2011, Congress is scheduled to substantially reduce the exemption. If you're likely to live beyond 2010 and believe that your estate will grow substantially, the sooner you begin planning the better. Otherwise your family could pay as much as 55 percent in estate taxes and your legacy could fall into the wrong hands.

DIFFERENT OBJECTIVES, DIFFERENT VALUATIONS

Especially if you are appraising a collection for insurance, sale or, in some cases, gifting to a nonprofit institution, you will most likely want to achieve the highest valuation possible. Of course valuation is not something you "choose": it's generally what a willing buyer and willing seller would agree on.

Charitable giving, such as leaving your collection to a nonprofit museum, can greatly reduce income and estate taxes. For estate tax purposes, the fair market value of a charitable gift from the estate of a deceased person is directly deductible when determining the value of a taxable estate. Assuming that a nonprofit organization will accept your collection, the additional benefit of this type of charitable giving could be the preservation and enhancement of your visual legacy.

If, however, you were valuing the collection to gift or bequeath to family members or to a for-profit institution, you would want a lower valuation to ease an estate tax burden if the estate is worth more than the estate tax exemption.

If you have a large estate but its total value falls below the estate tax exemption, you might want to achieve a "step-up" in value for your imagery to maximize the cost basis at which the beneficiary will inherit your collection. Except for year 2010, the law says that beneficiaries will inherit assets stepped-up to their market value at date of death or six months after date of death.

For example, if you inherit a photograph worth $10,000 at date of death and sell it for $11,000, you will only pay taxes on the $1,000 profit. The higher the stepped-up cost basis, the lower the potential ordinary or long-term income taxes when you sell an inherited asset.

GIFTING STRATEGIES

Another strategy for reducing your estate is to make annual gifts. For photographers who run their own stock photo library business, one strategy suggested by Joel Hecker, a prominent attorney working with photographers on copyright and estate planning issues, is to annually gift shares of the business to a family member, thereby slowly moving the archive out of the estate while you are alive. Currently you can gift up to $11,000 per year, per person, tax-free with the limit rising to $12,000 in 2006.

CHARITABLE TRUSTS AND FLPS

ENSURE INCOME WHILE LIVING AND REDUCE ESTATE VALUATION

The Charitable Remainder Trust, Charitable Lead Trust, and Family Limited Partnership (FLP) are vehicles that could provide different solutions such as income generation and tax deductions while you're alive and/or the reduction of estate taxes at death. When analyzing these potential solutions, you should weigh the tax benefits against how much control of your collection you are willing to cede upon transfer or gifting of assets into a trust or partnership, both during your life and after death. These solutions are typically useful if you have a large estate and should be implemented by an estate attorney who has experience working with art and other collectibles.

LIFE INSURANCE TRUST: A POPULAR TOOL FOR REPLENISHING WEALTH

Life insurance is a popular estate-planning vehicle for replenishing wealth lost to estate taxes or replacing the value of an asset that has been gifted to a charity. A cash payout from life insurance can also provide liquidity, particularly if your estate consists of illiquid assets such as your photography collection.

The typical photographer's estate consists of a home, qualified retirement account, and photo collection. If an estate is valued at $2.5 million and the estate tax exclusion is $1.5 million, the resulting tax is $460,000, which the family might be forced to raise by selling off assets. Life insurance, particularly if placed in an Irrevocable Life Insurance Trust (ILIT), could provide this liquidity.

A life insurance payout is typically included in the decedent's estate, assuming he or she was the owner of the policy. If you place life insurance in an ILIT, you can avoid subjecting the policy proceeds to estate taxes. Keep in mind, however, that by placing the policy in an ILIT, you cede control over the policy during your lifetime.

APPRAISING YOUR ARCHIVE

A formal appraisal is a comprehensive document that should set the value of the collection and clearly spell out the methodologies of valuation. A valuation is typically based on a solid record of sales history. Keep in mind that appraisal methodologies can vary greatly and are as much art as science.

For more information on appraisals, please consult "The Power of Valuation" by Ethan G. Salwen in the fall 2005 issue of the *ASMP Bulletin*.

ESTATE PLANNING DOCUMENTS

Most estate planners recommend that you execute the documents below when planning for the future: a testamentary will, a living will, a durable power of attorney, and an inventory list of your assets.

While you can create your own will using software, I strongly suggest that you work with a qualified attorney. If you miss one step in creating a will, such as having signature witnesses, the will could be null and void. Additionally, your estate documents should be stored in a secure place that is known and accessible by your beneficiaries, such as a safety deposit box or with your attorney. I also recommend scanning your estate documents both for accessibility and preservation.

LAST WILL AND TESTAMENT

Working with an attorney, you should draft a will, along with a list of assets, to provide clear instructions regarding the distribution of those assets to your beneficiaries. Even if you believe that your estate is not sufficiently valued to warrant estate planning, a will can provide a smooth transfer of your assets and prevent infighting or legal disputes among family members.

LIVING WILL

A living will is a legal document that states your medical wishes if you are unable to speak for yourself if you become medically incapacitated. The recent fight over Terri Schiavo's fate was a very public reminder of the importance of drafting a living will. Because she didn't leave a written directive regarding her health care, she left her family in confusion and controversy.

DURABLE POWER OF ATTORNEY

A durable power of attorney gives you (the principal) an opportunity to authorize an agent (usually a trusted family member or friend) to make legal decisions when you are no longer able to do so yourself, typically for financial and health reasons.

ASSET INVENTORY LIST

It is extremely important to create and regularly update a list of your assets, including real estate, bank and investment accounts, stock and bond certificates, imagery, and other collectibles. This list should include account numbers, plus names and phone numbers of your account managers.

You should also keep a separate inventory list of your photography collection that includes only those images that you deem valuable. You could even label "nonmarketable" images as "family" or "reference" to indicate that they

should not be included in your estate valuation. If the IRS values each image at 50 cents and you have one million images, the value of your collection could total $500,000. Too many images could generate an estate tax.

If you fail to inventory your assets, your beneficiaries may spend countless hours and dollars trying to track them.

You should consult with a professional appraiser, estate attorney, and tax advisor prior to implementing any estate planning. Planning ahead can allow you to control the distribution of your life's work, help you build a visual and financial legacy for future generations, and ease the burden of income and estate taxes.

Aaron Schindler
Managing Director
Wealth Advisory Group LLC
355 Lexington Avenue, 9th Floor
New York, NY 10017
Ph. 212 261 1897
Cell. 917 715 2233
Fax. 646 349 1455
aschindler@wagroupllc.com

ASMP Prosurance

A PLAN DESIGNED SPECIFICALLY FOR THE PROFESSIONAL PHOTOGRAPHER

by Scott Taylor

Scott Taylor graduated magna cum laude from New York University in 1982 with a bachelor of science in finance and accounting. He is a member of Phi Alpha Kappa and Beta Alpha Psi. He earned his Juris Doctor degree from St. John's University in 1987 and was admitted to the New York State Bar in the same year. Scott is currently President of the insurance brokerage Taylor & Taylor Associates Inc., which specializes in insurance for still photographers and companies in the entertainment industry.

———————————— • ————————————

ARRANGING INSURANCE PROTECTION FOR A STILL PHOTO SHOOT IS AS ESSENtial as organizing the proper crew, securing adequate locations and renting equipment. A well thought out insurance program will help to protect your shoot from the financial consequences of damage to or destruction of raw film, exposed film or digital imagery; damages as a result of faulty stock, faulty cameras, faulty lenses or faulty processing; replacing stolen or damaged property as well as defending covered lawsuits.

Purchasing insurance is similar in theory to purchasing a car. You start out with a very basic stripped down model to which various options can be added such as a navigation system, DVD car theater system, sun roof, etc. The added options improve the quality of the car you end up buying. Insurance is similar in that you start out with a very basic policy that excludes many types of losses. A variety of endorsements can be purchased that can improve upon the protection that you are ultimately afforded.

This chapter provides a brief overview of the various types of insurance coverage available under the ASMP Prosurance program.

OFFICE CONTENTS

Covers business personal property that is situated *within your office* such as furniture, computer equipment, copy machines, fax machines, and improvements and betterments.

MISCELLANEOUS EQUIPMENT

Protects your cameras, lighting, computer equipment outside of your office, and darkroom equipment against fire, theft, water damage, breakage, earthquake and much more. Coverage is worldwide and on a replacement cost basis for owned equipment. This differs from some policies that exclude coverage for theft from unattended vehicles, earthquake, that are limited to the United States and Canada or only provide coverage on a depreciated basis.

The ASMP Prosurance policy automatically includes a $35,000 limit for rented equipment including Hired Automobile Physical Damage (see below). This limit recognizes the growing trend to rent versus own equipment and the high cost of digital systems. The valuation for rented equipment is legal liability and actual cash value for hired vehicles. The standard deductible is $500 but a $1,000 option is available.

HIRED AUTOMOBILE PHYSICAL DAMAGE

Protects against physical damage to rental cars with a limit of $35,000 for any one vehicle subject to a $500 deductible. Coverage is worldwide. (This coverage is included as part of the rented camera equipment section of the policy. One limit applies for both vehicle physical damage and/or rented camera equipment.)

NEGATIVE FILM & FAULTY STOCK, CAMERA & PROCESSING ($15,000 LIMIT)

This coverage pays for expenses to re-shoot the job due to lost, stolen, damaged film or digital imagery and/or film rendered unusable as a result of laboratory processing errors and/or camera malfunction. Coverage is designed to cover a current job and you must actually re-shoot the job in order to collect under this policy section. This important coverage is provided on a worldwide basis. Losses resulting from operator error are not covered. The standard deductible is $500.

Imagine that your camera bag were to be stolen after a shoot. The loss suffered would be greater than just the value of your actual camera equipment as you may have also lost exposed film and/or a digital storage device. If your

camera were to malfunction you might lose some or all of the images from the shoot or they may be unusable. These are a couple examples of claims that would be covered under this section of the policy. Please note: This coverage section does not cover stock photography or the liquidated damage amount of $1,500 per image.

PROPS, SETS & WARDROBE ($25,000 LIMIT)
Protects you for damage to or theft of other people's property that is in your care, custody or control and is a part of your photographic set. There is a $10,000 sublimit for jewelry, furs, fine arts, antiques, precious metals and objects of art. The standard deductible is $500.

EXTRA EXPENSE ($10,000 LIMIT)
Covers the additional expense incurred to complete your photo shoot should your cameras, props, sets, and wardrobe and/or location sustain direct damage from a covered loss. Coverage has been extended to include mechanical breakdown of cameras, generators and computerized systems to control cameras. The standard deductible is $500.

THIRD PARTY PROPERTY DAMAGE ($1,000,000 LIMIT)
Protects against unforeseeable damage to a location in your care, custody, and control while the location is being used temporarily as part of a photographic set. The standard limit is $1,000,000 and the standard deductible is $500.

BUSINESS INTERRUPTION
Covers the actual loss sustained for up to twelve months as a result of direct damage to the premises listed in your policy by a loss from an insured peril.

PORTFOLIO AND CASE ($2,000 LIMIT)
This coverage protects the cost to reproduce prints, slides, chromes, tear sheets, etc. The basic policy provides up to $40 per image if your portfolio were to be destroyed, lost or stolen. Coverage is worldwide. Note: This coverage section does not include stock photography. The standard deductible is $500.

MONEY & SECURITIES ($10,000 LIMIT ON PREMISES / $2,500 LIMIT OFF PREMISES)
Covers loss of money and securities resulting directly from theft, disappearance or destruction.

GENERAL LIABILITY ($1,000,000 LIMIT)

Protects you for your legal liability against lawsuits for bodily injury or property damage that occurs within the United States and Canada. (Note: There is limited worldwide liability coverage.) One of the important aspects of this coverage is that it affords coverage both on your premises and locations within the policy territory. Listed below are some of the important coverage exclusions.

- Injury to people deemed to be covered by a Workers' Compensation Statute
- Benefits payable under a statutory disability statute
- Anything having to do with the use, loading or unloading of an automobile, watercraft, or aircraft
- Damage to other people's property in your care, custody or control
- Claims resulting from an improper model release, invasion of privacy, infringement of copyright or trademark, infringement of patents, or libel or slander if you are in the business of advertising, publishing, broadcasting or telecasting
- Claims arising outside of the United States or Canada
- Anything having to do with pollution
- Any intentional act
- Wrongful termination, discrimination, or sexual harassment

An important benefit of the ASMP Prosurance program: No charge for standard certificates of insurance.

NON-OWNED AND HIRED AUTOMOBILE LIABILITY ($1,000,000 LIMIT)

Protects an employer for bodily injury or property damage claims that arise from use of a hired, borrowed, or rented vehicle. This coverage will respond only after the policy insuring the vehicle involved in the accident has paid its limit. Please note there is no coverage for a person who drives their own vehicle on your behalf. Coverage is limited to the United States and Canada.

ERRORS AND OMISSIONS LIABILITY ($1,000,000 LIMIT)

For those members who meet the eligibility guidelines and complete an application, coverage can be extended to include copyright infringement claims as a result of errors and omissions. An important policy enhancement for this type of coverage is that the defense costs are in addition to the policy limit. (*This is an optional coverage and subject to an additional premium.*)

LOSS PAYEE AND ADDITIONAL INSURED

A Loss Payee is a person or organization that has a financial interest in the property given or leased to you and for which you have agreed to provide the insurance. By adding a Loss Payee endorsement, both signatures are needed on a claim check in order to cash the check. The loss payee thereby maintains control of the insurance claim proceeds.

An Additional Insured endorsement extends your liability policy to cover another person or organization for bodily injury and/or property damage claims resulting from your negligence. Since the insurance carrier is now protecting more than one business or individual, there may be an added premium for this coverage.

OPTIONAL COVERAGE AVAILABLE

- Workers' Compensation and Employers Liability
- Statutory Disability Benefits (Statutory States: New York, New Jersey, California, Rhode Island, Puerto Rico, and Hawaii)
- Foreign Commercial General Liability, Foreign Non-owned, and Hired Automobile Liability, Foreign Voluntary Workers' Compensation
- Employee Dishonesty
- Employment Practices Liability
- Business Automobile for owned vehicles
- Umbrella Liability
- Non-owned and Hired Watercraft Liability and/or Physical Damage
- Non-owned and Hired Aviation Liability and/or Physical Damage
- Animal Mortality
- Pollution Liability
- Cast Coverage for key models
- Plate Glass
- Pension Plan Liability
- Boiler and Machinery
- Disability Income
- Health Insurance and Dental Insurance
- Accidental Death and Dismemberment
- Life Insurance
- Long Term Care Coverage

WORKERS' COMPENSATION

There is a general misconception that Workers' Compensation would not be required when hiring a "freelancer" or "independent contractor" to assist on a photo shoot because these individuals only work for you once in a while and taxes are not being withheld. I suggest the following is the truth:

- You are not withholding taxes because you believe these people to be "freelance."
- The Internal Revenue Service and the Workers' Compensation Board are two different administrative agencies.
- You can legally have an employee for a day.
- The courts will go to great lengths to protect an employee's Workers' Compensation benefits. For example, a written agreement between an employer and employee where the employee signs away his rights to Workers' Compensation benefits will not be upheld.
- Workers' Compensation benefits are generally determined by the state in which an employee is hired. The state legislature sets the structure of these benefits and there is no jury to award damages for pain and suffering. Therefore, it is far cheaper for an insurance company to pay the state mandated Workers' Compensation benefits than to pay the same claim under the Commercial General Liability coverage which could include an amount for pain and suffering. This is one reason why a Commercial General Liability insurance carrier will determine if they are able to categorize a claimant as an employee.

It is our recommendation that every photographer that hires an employee, freelancer or independent contractor should carry Workers' Compensation including Employers Liability. It does not matter whether the person you hire works for one day or for a full year. A Workers' Compensation policy will protect you for the state mandated benefits in the event this individual were to be injured while working for you.

Each state has statutes that define the mandatory benefits available to an injured worker and generally this will include medical expenses and a portion of income lost as a result of injuries suffered while working for you. The Employers Liability coverage will protect you for claims brought by someone other than an employee to recover for damages paid or sought from a former or existing employee. If an injury were to occur and you did not purchase Workers' Compensation coverage, you would become personally responsible for this benefit and you would subject your business to potential state fines. Failure to provide Workers' Compensation is one instance in which the courts will pierce the corporate veil (shield) and the shareholders will remain personally liable.

Workers' Compensation coverage is made available in many states by means of State Insurance Funds. Policies provided through these Funds might include a premium discount for favorable loss (claims) experience; however, a major disadvantage is that they only provide benefits of the state in which they are located. In contrast, policies offered by the private insurance carriers will usually provide benefits for all states except those in which they are not

licensed as well as the five monopolistic states of Ohio, West Virginia, North Dakota, Wyoming, and Washington. Therefore, coverage would not apply for employees hired in these states. Workers' Compensation coverage in the five monopolistic states may only be purchased from the sponsored plans in each state.

It is also important to note that you should not hire children in violation of the conditions of their working papers. When a child is hired in violation of their working papers and becomes injured on the job, the standard policy will only pay a single Workers' Compensation benefit. Some states will require that a multiple benefit be paid. The difference between the standard compensation benefit and the penalized benefit is the responsibility of the employer.

This chapter outlines the highlights of the ASMP Prosurance policy. It is not intended to replace or supersede any of the terms and/or conditions of the policy. Please refer to the actual policy for an exact determination of coverage.

Is Your Assistant an Independent Contractor or an Employee?

by Mark Tucker

Mark Tucker is a commercial photographer specializing in lifestyle and portraits for advertising. His work has been featured in *Communication Arts*, *Print* and *Photo Design*. Mark lives and works in Nashville, Tennessee. *www.marktucker.com*

———————————— • ————————————

THIS IS A DILEMMA THAT CONTINUES TO CONFRONT SMALL BUSINESSES. Historically commercial photographers have regarded freelance assistants as independent contractors. At the end of the year, if the assistant has earned more than a certain amount (at this writing $600) the photographer sends the assistant a 1099 Form. From that point on, the assistant takes care of paying taxes.

But the issue is clouded, and photographers are advised to treat this matter carefully. There have been attempts to have the relevant laws changed, and this may yet happen. After all, it is not just photographers who are affected.

The laws concerning independent contractors or employees vary from state to state, but the following twenty common-law factors might help photographers determine their assistants' status. If any one of these suggests an employer/employee relationship, you probably should treat the situation as such.

1. **Instructions.** Has the employer retained the right to require the worker to comply with instructions regarding when, where, and how the work is to be performed?
2. **Training.** Has the right to provide training with regard to methods of performing work been retained by the employer?

3. **Integration.** After determining the scope and function of the employer's business, see whether the services of the worker are merged into it.

4. **Services rendered personally.** Does the employer require the worker to perform the work personally? Or does the worker have the right to hire a substitute without consulting the employer?

5. **Hiring, supervising, and paying assistants.** Hiring, supervising, and paying wages of assistants usually shows control over all individuals on a job.

6. **A continuing relationship.** This usually indicates an employer/employee relationship, even though the arrangement holds that the services are part-time; that is, they are to be performed at frequently recurring but irregular intervals (such as the employee being on call, or whenever work is available).

7. **Set hours of work.** When an employer establishes set hours of work, this indicates control because it prevents workers from being "masters of their own time," which is a right of an independent contractor.

8. **Full-time required.** This restricts workers from doing other work. On the other hand, independent contractors are free to work when and for whom they choose. However, "full-time" does not necessarily mean an eight-hour day, five days a week—the definition may vary with the intent of the parties and the nature of the work.

9. **Doing work on employer premises.** This kind of arrangement implies control by the employer because the worker is physically under the employer's direction and supervision. However, there is also control when an employer has the right to direct a person to travel a designated route, or to work at specified places at certain times.

10. **Order or sequence set.** The employer has control if he retains the right to set patterns of work for employees.

11. **Oral or written reports.** These indicate control because workers are compelled to account for their actions.

12. **Method of payment.** Payment by the hour, week, or month usually indicates an employer/employee relationship—while payment by the job or on a straight commission basis signals that the worker may be an independent contractor.

13. **Payment of business or travel expenses.** If an employer pays a worker's expenses, the worker is usually an employee; the employer retains the right to control a worker's activities in order to control expenses.

14. **Furnishing tools and materials.** If an employer furnishes tools and materials, this indicates an employer/employee relationship. The employer can control the tools the worker uses and, to some extent, in what order.

There are numerous exceptions, however; for example, carpenters, auto mechanics, barbers, and the like, who often furnish their own tools.

15. **Significant investment.** Investment by the worker in facilities used to perform work for another may tend to establish the worker as an independent contractor. Lack of investment, however, may indicate the worker's dependence on the employer and that an employer/employee relationship exists.

16. **Working for more than one firm.** Generally this is evidence of an independent contractor status. However, it is possible for a person to work for a number of firms and be an employee of one or all of them.

17. **Making services available to the general public.** Individuals who make their services available to the general public are usually independent contractors. Some tests are:

- Do they have an office or place of business?
- Do they hire?
- Are they listed in the business section and/or yellow pages?
- Do they advertise in newspapers, trade journals, radio, and the like?
- Do they run their own business, or act in a managerial capacity for another firm?

18. **Right to discharge.** This strongly indicates an employer/employee relationship. Control is implicit in the power to discharge. An independent contractor normally cannot be fired except for failure to produce results, per his or her contract.

19. **Right (of worker) to terminate**. An employee generally has the right to resign at any time without incurring any liability; by contrast, an independent contractor agrees to complete a specific job and is responsible for its satisfactory completion or incurs legal liability for a failure to complete.

20. **Realization of profit or loss.** Persons who can realize a profit or loss as a result of their services are generally independent contractors; and persons who cannot are generally employees.

INDEPENDENT CONTRACTOR AGREEMENT

AGREEMENT entered into as of the _____ day of _____ 20____, between _____ located at _____ (hereinafter referred to as the "Photographer") and _____ , located at _____ (hereinafter referred to as the "Contractor").

The Parties hereto agree as follows:

1. Services to be Rendered. The Contractor agrees to perform the following services for the Photographer

2. Schedule. The Contractor shall complete the services pursuant to the following schedule:

3. Fee and Expenses. The Contractor shall be paid as follows:
 The Photographer shall reimburse the Contractor only for the listed expenses.

4. Payment. Payment shall be made as follows:_____

5. Condition precedent to Agreement. Contractor does not consider himself eligible for nor has any intention to, and will not, apply for unemployment or worker's compensation benefits in a claim against the Photographer.

6. Relationship of Parties. Both parties agree that the Contractor is an independent contractor. This Agreement is not an employment agreement, nor does it constitute a joint venture or partnership between the Photographer and Contractor. Nothing contained herein shall be construed to be inconsistent with this independent contractor relationship.

7. Proprietary Rights. The proprietary rights in any work produced in conjunction with this Agreement shall be vested solely and exclusively in the Photographer.

8. Miscellany. This Agreement constitutes the entire agreement between the parties. Its terms can be modified only by an instrument in writing signed by both parties, except that oral authorizations of additional fees and expenses shall be permitted if necessary to speed the progress of work. This Agreement shall be binding on the parties, their heirs, successors, assigns, and personal representatives. A waiver of a breach of any of the provisions of this Agreement shall not be construed as a continuing waiver of other breaches of the same or other provisions hereof. This Agreement shall be governed by the laws of the State of _____.

IN WITNESS WHEREOF, the parties hereto have signed this as of the date first set forth above.

PHOTOGRAPHER CONTRACTOR

This form produced and recommended by ASMP. ASMP does not take the position that this form, by itself, will create an independent contractor relationship or prevent the establishment of an employer-employee relationship.

Guidelines for Assistants

by Pamela Kruzic

Pamela Kruzic is an ASMP associate. She currently works with Creative Eye/ Mira for her stock work and is a member of Stock Artists Alliance. She is based outside of Knoxville, Tennessee, and still enjoys the challenges of freelance assistant work.

———————————— • ————————————

WORKING WITH AN EXPERIENCED, PROFESSIONAL, COMMERCIAL PHOTOGRA- pher can be both exhilarating and exasperating. If I had to pick one thing that it takes to succeed as an assistant, it would be an unequivocal dedication to the successful completion of the project. You will receive none of the credit, except possibly from the photographer who recognizes and praises your contribution. The rewarding experience is the intrinsic satisfaction associated with taking part in the creative process and helping to overcome and resolve the numerous problems encountered in a photo shoot. At the end of the day, you may be dirty, tired, wired, scraped, pinched, and punchy. On the other hand, some projects may be so low-key and enjoyable that getting paid seems a little pecu- liar. One day it is setting up for forklifts and backhoes, the next it is wedding cakes and ribbons, or celebrities and CEOs. It is this type of variety that makes each day a new and exciting adventure.

There is one aspect to be aware of when working with a photographer for the first time. Initially your every move will be watched. It may seem that he is finding fault with everything you do and the way you do it. Don't defend or argue. This usually originates from the fact that the photographer is watching to see that his very expensive equipment is being handled properly and also try- ing to help you do your job better. Once he is comfortable with your capability, this will subside.

Another aspect to be aware of is that the photographer is under a great deal of stress. He carries the responsibility for the project's success. The more professional photographers are less likely to allow pressures to affect the treatment of their team, but it can happen. Not that anyone should accept verbal abuse, but if you are spoken to sharply or abruptly at times, it may be from pressures that you are not aware of. Just move on. Hurt feelings, grudges, and anger just get in the way of your concentration.

An assistant may be able to avert some problems by simply noting and interpreting small details in the photographer's actions. For example: If the photographer walks across the room to set down his drink instead of next to the shooting area, then obviously don't set your drink in the shooting area. On the other hand, just because the photographer gives a lens cap a toss into the camera case, this is not permission for the assistant to do the same. Just use common sense and pay attention.

Remember: An assistant is a part of a team, a tool that the photographer uses to achieve his vision. You are not there to talk about yourself. That was done when the photographer hired you. No chattiness with clients, art directors, or the like. Common courtesy and pleasantries are fine, but remember that your purpose is to be there for the photographer and to do everything within your power to help him attain the artistic goal and not to interfere with a smooth shoot.

ATTITUDE/ATTRIBUTES

Above all else, an assistant must have a positive attitude, including a sincere desire to be there, a willingness to learn, and enthusiasm for the project.

Be a listener; be flexible, efficient, and punctual; be able to follow instructions; be aware of what is going on; be motivated and show initiative. You must be able to swallow your pride—it is not a question of "if you will catch it," just when. Whether it is your fault or not, you might as well get over it and move forward.

Anticipate what is going on, what will be needed next. Figure out what is threatening to go wrong and prevent it from happening. Remember good manners and be politically correct. Also important is compatibility. Try to be amiable: Sometimes it works, sometimes it doesn't.

COMMUNICATION

Try to get an understanding of what is expected of you. Each photographer has different requirements and expectations. Talk to him; build a relationship.

Know when to speak and when to be silent. Chattiness is deadly. Most likely you will miss something important if your lips are flapping. Be aware that sometimes you will be listening between the lines, to subtleties.

Don't assume. If you're not sure, ask. Better to ask and feel stupid than not to ask and be stupid—and possibly destructive. Be discreet: If you need to let the photographer know that something isn't right, don't announce it to the whole set. There is a time and a place for everything; figure out when and where that is. A good photographer is alert to his team and will usually be able to recognize that you need to tell him something.

PREPAREDNESS/TOOLS

Wear the proper clothing for the job, and ask beforehand. Also, ask about the nature of the job. Some of the tools you should have in your kit are a Sharpie pen, a watch, a fanny pack, a small pad for notes/instructions, a survival tool, Band-Aids, aspirin, and, for emergencies, some cash ($20–40), and a quick snack and water.

A more advanced kit might include: a small flashlight, various tapes (black photo, white, double-sided), a plug-in electrical circuit tester, work gloves, dual timers/clock for timing Polaroids, and various hand tools.

The A.S.H.: This is an *Adjustable Sense of Humor* that can be set to fit each photographer's personality. Don't forget to bring it.

SAFETY

Think. Don't run around impulsively. Move carefully and decisively. Protect equipment from theft and damage. Use downtime to repair, organize, restock, check cords, and clean up the set. Protect against trip hazards, such as cords, stands, or wires. There are certain ways to set up stands and hang cords. Your carelessness could be quite expensive to the photographer.

SKILLS/TECHNICAL

Be alert to what is happening or is not happening with the equipment. Be attentive to sync cords, recycle times, strobes firing, gels, reflectors, stands, and props. Watch that slaves don't get blocked. Notice where gear comes from and put it back in the same place, the same way. Keep equipment clean and organized. Put things back in cases instead of around the set so they are less likely to get lost.

Never touch the camera unless instructed to do so. For 35mm, check that the shutter speed is not too fast for sync. For medium/large format, pull the dark slide, check that the sync cord is connected. Make sure the f-stop and shutter speed are correct for the film being used. Be able to load various formats of film.

Cameras differ, and a photographer will likely review any peculiarities of his equipment. If you have to be taught, however, don't expect to be paid a full rate. Count shots and be ready for roll changes. Put roll numbers on the film and keep the Polaroids in one place.

While digital photography makes some of these tasks obsolete, most are still applicable with adaptation. Digital equipment is constantly changing. The savvy assistant needs to keep up with the latest digital cameras and skills. [For more information, see chapter 42 on digital technicians.]

Whether film or digital, keep track of exposures and pertinent technical data, model releases, as well as other materials used, as required, by the photographer. Make sure all cameras are unloaded at the end of the shoot.

BUSINESS

Keep track of all receipts and reimbursable expenses to include with the invoice—mileage, tips, and similar expenses—and make sure they are legible.

Have your invoice ready to present at end of the shoot. Include on the invoice the following: client name, shoot date, your address, telephone number, and Social Security number. (Some photographers will ask to have your invoice mailed or faxed to them within a specific time frame. Omission of this information will delay your payment.)

Practice confidentiality when it comes to clients and photographers. Gossip is for busybodies, not professional assistants.

Ask for the photographer's business card. It helps to have contact information (for a variety of reasons) and can give you ideas when you begin to look at designing your own stationery.

FINALLY

This is vital: Always remember that you were hired by the photographer to assist. You were not hired to promote yourself, tell the client how you would do a shot, or discuss money matters around the client or the art director.

Digital Business Essentials

"In a business environment that is becoming more challenging by the month, every advantage you can leverage is important. Understanding the principles of digital asset management will help you to increase your efficiency."

—Peter Krogh

Digital Asset Management

by Peter Krogh

Peter Krogh is the author of *The DAM Book* (O'Reilly, 2005), the most widely used reference on collection management for photographers. He has been a professional photographer for more than twenty-five years and sits on the ASMP's Board of Directors. Peter lectures and consults worldwide. He is an alpha tester for Adobe imaging software and is part of the prestigious Microsoft Icons of Imaging program. He lives outside Washington, D.C., with his wife and two daughters.

———————————— • ————————————

DIGITAL ASSET MANAGEMENT (DAM) IS A TERM THAT REFERS TO EVERYTHING one does with image files from the point of capture onward. This includes transferring, renaming, attaching metadata, rating, adjusting, proofing, backing up, archiving, and more. Understanding the principles of sound DAM practices will help you design a workflow that is secure and efficient, and can help you increase profitability in the world of digital photography.

As professional photographers, there are a couple of functions of your DAM practice that are going to be most important. The prime directive, to borrow from *Star Trek*, is to make sure you don't lose the files. If the images can't be delivered, you can't be paid. So the first thing a professional photographer needs to do is to evaluate the risk points in file handling and develop an adequate system to protect against these hazards.

The second most important function of the DAM system for the pro is to create an efficient workflow, so that jobs can be delivered profitably. If you are spending twice the time (or more) that your competitors do to get jobs out the door, you will be at a significant competitive disadvantage. In a business environment that is becoming more challenging by the month, every advantage

you can leverage is important. Understanding the principles of digital asset management will help increase your efficiency.

A good understanding of DAM can also help the pro photographer find images in the collection, and to combine them in new and valuable ways. Because a photographer's collection can be brought together as a large body of work, the photographer can find and group images efficiently. As both the technological and business landscape change, it becomes even more important to mine your collection for new sources of revenue.

Developing a DAM system will be an ongoing process. As your understanding of the tools improves (and as the tools themselves improve), you'll be able to do more. Start with the prime directive (don't lose the photos) and move forward from there. Don't try to do everything at once, as it can make the process overwhelming and lead to paralysis. Let's take a look at some of the tools and principles, and see how to come up with a plan of action.

USE DAM SOFTWARE

Asset management will be best done by making use of DAM software. While you can do lots of the necessary functions by looking through folders of images and keeping a pencil and paper handy, that's going to be frustrating and inefficient. DAM software is designed to help you with these tasks.

As this chapter is being written, there are a number of packages of DAM software on the market. Many of them provide similar functionality, with the main differences lying mostly in the form of user interface. I strongly suggest that you download trial versions of the software so that you see which has the features you like, with acceptable performance, and a user interface you can understand. Here are a few guides as to how to compare software.

Cataloging software is the kind of program you'll be looking for. This type of software keeps a database record of all your images, and can show them to you even if you are not currently connected to the storage device. Catalog software helps preserve the images because it knows what photos are supposed to be in the collection. This is essential information to have in the event of some kind of problem with the storage hardware.

A comprehensive catalog system can help you streamline the work you do to your images from card to delivery. And because the catalog can help you bring widely scattered images together, it can assist you as you work to extract new value from your existing collection.

Browsers are a type of software that lets you look through folders of images. While they can be helpful in finding images and may include the capacity to do lots of work to the pictures, they don't provide the kind of total information about a collection that catalog software does. And if the images are gone

for some reason (you're away from the studio, say, or the hard drive crashes), a browser will be of no help at all.

Cataloging software and browsing software may also have the ability to adjust your images, in addition to helping to organize them. In most cases, these adjustments will be done by reinterpreting the image as it gets opened, rather than by actually changing the image as Photoshop does. This nondestructive adjustment is called parametric image editing (PIE), since it changes the photo by changing the rendering parameters.

The most interesting area of growth in collection management is occurring where cataloging software is combined with a parametric image editor. We can call this cataloging PIEware. In these programs, you can sort and manage your images in the same program that lets you adjust them. At the time of this writing, there are two cataloging PIEware programs on the market, Apple's Aperture and Adobe Photoshop Lightroom. Although neither can claim to be the best catalog software on the market, they both do a reasonable job with these functions. Look for this to be an area of rapid growth. Listed below are some current software offerings, by type:

- **Browsers**
 - Adobe Bridge
 - Photo Mechanic
 - Google Picasa
 - BreezeBrowser
- **Catalog software**
 - iView MediaPro
 - Microsoft Expression Media
 - idImager
 - iMatch
 - ACDSee
- **Cataloging PIEware**
 - Apple Aperture
 - Adobe Lightroom

PROTECTING THE IMAGES

While digital imaging can offer the ability to protect your photographs in ways unimaginable in the film world, it can also lead to the loss of images in brand new ways. Theft of a laptop, hard drive crash, virus, or user error can all wipe out large number of images in a fraction of a second. As part of your image handling, you need to anticipate problems and make allowance for these hazards.

While we photographers don't think of ourselves as IT professionals, in the digital world that's exactly what we are. We can take some of the accepted IT rules and apply them to our DAM system. Perhaps the most useful concept in image preservation is the 3-2-1 rule. To be fully protected, you should have three copies of any file (that's three different devices, not three copies on the same device), two different media types (like hard drive and DVD, for instance), and one should be stored off-site. If you can adhere to this rule, your images will be extremely well-protected.

While it's pretty feasible for most people to implement the 3-2-1 rule for images that have been worked and archived, it's a little more difficult if you are working on location. I strongly suggest that you work with a program that allows you to download multiple copies of the file, so that the backups are made the first time you mount the card on your computer. For very valuable shoots, it makes sense to create a write-once copy of the files (like a DVD or Blu-ray disk), but that may not always be possible. If you can't get the files onto a second media type right away, at least make sure you have the images in three places right away.

Once the images have been archived, you will still need to do periodic checks of the files to make sure that everything is still there, and that the files themselves are fine. Most catalog software can help you check to see that all images are sitting in the archive where you expect them to be (at this writing, the cataloging PIEware applications seem to be less capable in this regard). You should also use disk utilities to check on the general health of your storage media. You should do periodic checks of both the volume structure (kind of like the table of contents of the disk) as well as media checks (the capability of the media itself to be read correctly).

In addition to disk utilities, we will be seeing a growth in programs that can comb through an entire drive looking for files that have problems. Keep an eye out for this functionality as you evaluate how you store your image files.

Once we can be reasonably sure that the images won't be lost due to some catastrophic failure, we need to think about how to make sure they are not lost to confusion. Perhaps the most important principle here is to always know which is the primary version of your image, and which is a backup. Using good DAM practice for wrangling your image files can help you not confuse the primary and the backup version of the files.

GOOD DAM PRACTICE AIDS WORKFLOW

Designing a good workflow is a challenge for all photographers as they go digital. We experiment with different software, devices, and work order. By understanding the principles of DAM, a photographer can standardize work order for maximum efficiency, security, and repeatability.

Once the photographer understands the ecosystem for collection management, it becomes easier to get a handle on all the tools and how to put them together most efficiently. While there may be no "right" way to do things, there certainly are some methods that are more efficient than others.

Listed below are the steps I use in my own workflow, in the order I generally do them.

- Renaming image files
- Backing up
- Applying bulk metadata (creator information and subject information)
- Rating for quality
- Custom adjustment of images
- Cataloging
- Archiving
- Creating proofs
- Creating master files
- Cataloging and archiving master files
- Data validation

Taking steps out of order can result in the loss or duplication of work. Once you understand why a particular work order is more efficient, it becomes a natural and obvious workflow for the photographer. By settling on a standardized work order, you speed your jobs through the workflow and are less likely to make mistakes.

There's another benefit to understanding DAM and standardization of workflow—it lets you hire people to help with the work. If you can't say with certainty how you want the work done, it's pretty difficult to trust someone else to do it for you. Once the production routine is standardized, you can offload some of the production to an assistant, and you can get back to shooting, or building your business, or spending time doing something that is not work.

MAKING IMAGES DISCOVERABLE

The preceding sections have dealt with the medicine part of DAM—protecting from loss and protecting your time. Now let's talk about the candy. Creating a comprehensive DAM system lets you get the most out of your images, both personally and professionally. By using comprehensive DAM techniques, you can have access to your images in ways that are unimaginable in the film world, and you can do some interesting things with those pictures.

You can use some simple techniques to make it easy to find images when you want them, and to group them with other images in interesting and valuable

ways. There are a couple of different kinds of metadata that can be used in a comprehensive manner across your entire collection. You can cross-reference this metadata to make finding images easy. Let's take a look at some of the tools we have available.

Several kinds of automatically created metadata can be collected by cataloging software. These include the date the image was created, the file format, and the camera used. This makes it easy to find images with any of these attributes without having to group the images by folder.

Of course you can also assign keywords to the files—descriptions of the subject matter that is in the photographs. By assigning the keyword "landscape" to appropriate images, you can collect and view all landscape images easily, despite the fact that they may be scattered among many folders across several different hard drives.

The IPTC file information standard also has several fields where you can make note of the location of the photograph. This includes the country, city, state, and location where the photo was taken. Most DAM software will collect this information in a hierarchical form so that the location is a subset of the city (if appropriate), which in turn is a subset of the state, which is a subset of the country. By organizing information in this manner, it becomes relatively easy to find images taken in a particular location, even if they were shot at different times for different projects.

Any cataloging software worth using will also have the ability to create some kind of user-defined collections. You can think of these as little piles of slides that have been grouped together for some reason. This could be a broad grouping like "all my architectural photos" or a narrow one like "images to send for stock request of kids eating ice cream." These collections are where the real power of cataloging software lies, since they enable the photographer to group images in valuable ways that are appropriate to the body of work.

Once you get accustomed to using the collection tools, you can start to mine your collection for valuable groups of images and to bring them together for output. If you're putting a portfolio together, you can group and refine your photos to help create the most compelling presentation of your work. If you've been shooting a particular subject matter on an ongoing basis, you can collect those images for a custom Web site, book proposal, or stock sales effort.

Using catalog software enables photographers to think of and see their photographs as a body of work, rather than simply as a collection of individual pictures. As you think about how you can bring value to the marketplace, having your image collection easily available can give you new ideas on how to use the photographs and make those new uses economical.

Beyond the important economic value, having access to your images can provide you with a richer artistic relationship with your photos. Most of us became photographers because we love the photographic image. The demands of professional photography often force the personal use and enjoyment of photography to take a back seat to day-to-day production concerns. By using proper DAM techniques, you can unlock the personal artistic value of your images and get to spend more time with them.

A WORD ON LIABILITY

While DAM practices can offer a lot of protection for the images, I advise most photographers to avoid charging a specific DAM or archiving fee in their production charges. Once you charge a client for anything related to long-term storage of images, you open yourself to some liability in a number of ways.

Most obviously, if you have charged a client for archiving, you may be financially responsible if the images are lost through some kind of unexpected event. In the case where the images would be costly to reproduce, this could be a significant financial risk for the photographer.

Additionally a client who is charged for archiving may feel as though the images should be available at a moment's notice. This may include, for instance, the expectation that the photographer would be able to provide the images at any time, with little or no prior warning.

In my photography business, I charge for capture and processing but only charge for retrieval of older images—never for archiving them. I make clear in my paperwork that the client is responsible for archiving the photos once they have been delivered. I do archive them and expect to keep them forever, but I do not offer any sort of claim that I will do so; the liability is just too great. (I do charge for retrieval of previously delivered images and find that I do this several times a year. Clients who need this service are generally only too happy to pay a modest charge for redelivery of legacy images.)

CONCLUSION

Collection management is a fast-moving part of the digital photography puzzle. The software and the hardware are changing at a pretty fast clip, as companies work to provide the best solutions. While there's no one-size-fits-all solution, nor a single program that does everything, it's getting easier all the time.

Managing a collection of digital images is like managing a film archive in some ways and is very different in others. It's up to the individual photographer to understand the pitfalls and the opportunities, and to create an affordable solution that works for his or her business. At the moment, that means understanding the components of a digital archive and how to use them

to create a secure and efficient system. Of course, this is not so different from what professional photographers have always had to do—understanding the technical needs to bring their creative works to market.

As you are putting your system together, it will be necessary to do some study and some testing. And while it may be a bit frustrating at first, be aware that good DAM practice can unlock the power of your photography and give you access to your photographs in ways that could only be dreamed of a few short years ago.

RESOURCES

- *The DAM Book*, by Peter Krogh (O'Reilly, 2005).
- The DAM Forum, *www.theDAMbook.com*.
- White paper of nondestructive imaging, *www.adobe.com/digitalimag/pdfs/non_destructive_imaging.pdf*.

Universal Photographic Digital Imaging Guidelines (UPDIG)

QUICK GUIDE, VERSION 3.0

Principal author: Richard Anderson. Technical editor: Michael Stewart. Additional editing: Greg Smith. Contributors: Andre Cornellier, Bob Croxford, Dennis Dunbar, Robert Edwards, Ken Fleisher, George Fulton, Judy Herrmann, Reed Hoffmann, Peter Krogh, Bob Marchant, Sam Merrell, Alan Newman, Michelle Alvarado Novak, Betsy Reid, David Riecks, Stanley Rowin, Jeff Sedlik, Greg Smith, Ulrik Södergren, Tamra Stallings, Eddie Tapp, Mike Upstone.

———————— • ————————

This document, prepared by the UPDIG working group, represents the industry consensus as of September 2007. Because digital production standards and best practices continue to evolve, we recommend checking *www.updig.org* for updates and supplements.

THESE TWELVE GUIDELINES AIM TO CLARIFY THE ISSUES AFFECTING ACCURATE reproduction and management of digital image files. Although they largely reflect a photographer's perspective, anyone working with digital images should find them useful. The guidelines have three primary goals:

- Digital images should look the same as they transfer between devices, platforms, and vendors.
- Digital images should be prepared in the correct resolution, at the correct size, for the device(s) on which they will be viewed or printed.
- Digital images should have metadata embedded that conforms to the IPTC standards, thereby making the images searchable, providing usage and contact information, and stating their creators or copyright owners.

Extensive details on each of these guidelines are available online at *www.updig.org*.

1. ICC COLOR MANAGEMENT

ICC profile-based color management defines color information in standard terms necessary for the proper reproduction of images. Devices such as monitors, printers, scanners, and, ideally, cameras should be profiled. Working and output spaces, such as Adobe RGB, sRGB, SWOP CMYK, and so on, should be embedded and preserved when opening files.

2. MONITOR CALIBRATION

Monitors should be calibrated and profiled with a hardware device. Visual calibration is not adequate for professional image editing. An accurate visual representation of the image is extremely important to the imaging process. Calibration standards range from:

- Gamma: 1.8 to 2.2
- White point: 5000–6500K
- Brightness levels: 80cd/m² to 140 cd/m²

As a general calibration guideline, use gamma 2.2 and 6500K for both Windows and Mac. A white point of 5000–5500K is a common recommendation for offset printing. Brightness levels are set in relation to the room's ambient lighting.

A calibrated and profiled monitor, in conjunction with good print profiles, will allow you to "soft-proof" the intended output. A daylight (5000K/D50) light source at correct brightness is necessary to visually match monitor to print.

3. COLOR SPACE

Camera settings for color space are critical when shooting TIFF or JPEG files. Color space for RAW files does not need to be set in the camera because it can be set in postproduction. Choosing a large-gamut space such as Adobe RGB (1998), ECI-RGB, or ProPhoto RGB is better for image editing, while shooting in a narrow-gamut space such as sRGB is convenient if images do not require color correction or editing, or if the images are intended for Web or sRGB lab prints. One consideration: A wide-gamut space can always be converted to a narrow space such as sRGB, but a narrow-gamut space converted to a wide space will not recapture the extra gamut.

Offset printing requires the CMYK color space, a very different color space from the RGB color space produced by digital cameras. CMYK conversions

are best when done by someone with knowledge of the specific press and paper type. Simple mode conversions in Photoshop are not recommended.

Photo lab prints usually require the sRGB color space. However, some labs may have a specific color profile either for embedding in the file or for use in soft-proofing.

4. FILE FORMATS

The best quality comes from shooting and editing in a RAW file format. The advantages of RAW file formats are: choosing color space when the file is processed; greater bit depth; ability to adjust white balance, saturation, exposure (to a degree), and tonal characteristics; adjustable noise reduction; and correction for lens aberrations—all in a nondestructive way. RAW files may be processed in a variety of software, from the camera maker's own to many third-party products, and even by using the built-in RAW processing of Apple and Windows operating systems. Converting RAW files to DNG format is considered by many to be an excellent method for archiving RAW files. DNG is a more universal file format than camera-specific RAW formats like NEF or CR2.

File formats include: lossy compression types such as JPEG; lossless compression types such as LZW, PSD, and most RAW file formats; and uncompressed types such as standard TIFFs. For the Web, use JPEG. For printing, uncompressed TIFF is often preferred, although high-quality JPEGs (level 10–12] can be visually indistinguishable from TIFFs and some printers prefer their smaller file size.

5. NAMING FILES

To avoid problems with files that will be transferred across computing platforms, name them with only the letters of the Latin alphabet (A–Z, a–z), numbers, hyphens, and underscores. Do not use punctuation or symbols. Keep the full name to thirty-one characters or less, including the three-letter extension. Use file names that will not be duplicated. Multiple files with the same name cause problems for computers and people alike. Including the numeric date and the photographer's name is an excellent method for creating unique names.

6. RESOLUTION

Resolution of digital images is described either by pixel dimensions (width and height) for screen use or by physical size and resolution. Image resolution is expressed as pixels per inch (ppi), pixels per centimeter (ppc), or pixels per millimeter (ppm). Resolution should always be specified in output size. Here are recommendations for common uses:

- Inkjet prints: 180 to 360 ppi.
- Continuous-tone printing: 240–400 ppi.
- Offset: 300 ppi is often specified, but resolutions of 1.3 to 2 times the halftone screen ruling are considered safe. This means 195 ppi–300 ppi for a 150-line screen. Newspapers are usually printed with 85-line screens, so 170 ppi is sufficient.

7. SHARPENING

Capture sharpening is required to compensate for the loss of detail that occurs during any digital capture process. TIFF and JPEG capture allows for sharpening in-camera or during postproduction. RAW files are sharpened in postproduction. Images should not be heavily sharpened early in the image-editing process.

Process sharpening counters the loss of detail in the reproduction process. It is done after color- and tone-correction, retouching, image sizing, and so on. The goal is an image that is acceptably sharp for viewing at its current size, but never over-sharpened.

Output sharpening is specific to the final output size and the output system (printing device, paper, ink, etc.) and is applied only as a final step before output. It is important to communicate whether output sharpening has been applied when images files are delivered.

8. METADATA

IPTC, IPTC Core Schema, and PLUS are the current standards for embedding metadata in image files. Embedded metadata should include creator and copyright information as well as searchable keywords and license information. Including useful and relevant information in metadata adds value to the image.

9. FILE DELIVERY

Digital image files may be delivered on a variety of removable media, including hard drives, CD-Rs or DVD-Rs. Do not use adhesive labels on optical media, since they may separate and damage an optical drive. Printing directly on inkjet-writable or LightScribe media CD-Rs or DVD-Rs is a good way to provide information such as your copyright, usage license, file lists, and disclaimers. For speed and convenience, electronic delivery by FTP or e-mail may be used. All image files should have embedded metadata. (In the case of proprietary RAW files, the safest route is to have the metadata included in a sidecar file.) Image file delivery should include ReadMe (see footnote) files.

It is important to provide a ReadMe file in either PDF, HTML, or TXT format with all files that you deliver for output. Such files should specify image

size(s), color space(s), the copyright owner's contact information, any licenses granted, and, if certain rights are being withheld, the words "other uses, reproduction, or distribution are specifically prohibited." The ReadMe file should also include disclaimers noting that recipients are responsible for following an ICC-based color management workflow.

10. GUIDE PRINTS AND PROOFS

Guide prints and proofs can serve as a valuable reference point for digital files, especially if the recipient is unknown or the output profile is generic. Creating guide prints and proofs that accurately represent offset CMYK printing requires knowledge of printer profiles and color management. The method in which the guide print was produced should be clearly conveyed.

11. ARCHIVING

It is important to address the issue of who will archive digital image files. Basic decisions include what kinds of files will be archived and how the archives will be protected from format obsolescence and media failure.

12. DIGITAL IMAGE WORKFLOW

No single workflow suits all photographers or all clients. A good digital workflow is the most efficient and automated way to get the job done. It should satisfy the clients' needs, embed necessary information (metadata), embed color profiles, and automate the archiving and backup of files. A good workflow saves time and protects against both loss of images and loss of work done to the images. There are many software options to choose from when you are constructing a digital workflow. New programs that aim to be all-in-one solutions are constantly being introduced. You will need to test to see which programs, or combination of programs, give you the efficiency, speed, and quality.

Digital Technicians

DIGITAL TECHNICIANS AND DIGITALLY SAVVY ASSISTANTS OFFER CRITICAL SUPPORT SERVICES

by Ethan G. Salwen

Ethan G. Salwen is an independent writer and photographer currently based in Buenos Aires, Argentina. In addition to covering Latin American cultures, Salwen writes extensively about technical, artistic, and marketing aspects of photography. He is a regular contributor to the *ASMP Bulletin*, *The Picture Professional*, *Rangefinder*, and *After Capture*. *www.ethansalwen.com*.

———————————— • ————————————

The following text was adapted for use in *ASMP Professional Business Practices in Photography* from an article originally published in the *ASMP Bulletin*, assigned and edited by Jill Waterman.

Baltimore-based photographer Richard Anderson knows a great deal about digital photography. He has employed an all-digital workflow for more than four years, he dedicates time each day to studying digital developments, and he represents the ASMP in an industry initiative to create standard digital guidelines (*www.updig.org*). However, Anderson still relies heavily on the support of three digitally savvy assistants. At the same time that Anderson needs digital assistance, he also provides digital consulting services to colleagues who are less knowledgeable than he is.

Anderson represents a new reality of digital photography: Photographers need extra help to accomplish many tasks in their heavy digital workflows, and they constantly need to update their skills to stay abreast of developments

in the digital realm. At the same time, these photographers are in an excellent position to help other photographers—and to make good money in the process.

THE EVOLVING DIGITAL LANDSCAPE

While the digital imaging revolution has left all photographers scratching their heads about some aspect of the new technology, the evolving landscape of digital photography has also created new opportunities. One intriguing niche generated by the digital-based workflow is the emergence of the digital technician—a new breed of professional who is ready to step in and provide a wide variety of critical support services for the photographer.

New York-based photographer and digital technician Von Thomas has clearly seen the advantage to offering digital support services. An early convert to digital with a background in computer technology, Thomas began serving as a digital tech in 2003, when the demand for such tradespersons was first emerging in earnest.

Thomas's initial success in this field enabled him to open Digital Tech NYC, a company that provides equipment and technicians for high-end shoots. "I'm still a shooting photographer," says Thomas. "But while the shooting competition remains fierce, the need for highly qualified digital techs and related services is only growing."

Using the most advanced digital techs has become an unavoidable necessity for photographers working on high-end shoots that require digital capture backs, on-site computers, and on-location file management, manipulation, and delivery. Many seasoned pros—struggling with the constantly shifting digital learning curve—simply couldn't meet their clients' needs without this degree of support. And the need for digital techs is not simply the result of digitally deficient photographers. Just as it is impossible for a single photographer to position all his own lights on a large shoot, even the most technically savvy photographers are compelled to call on the services of digital techs.

THE POWER OF DIGITAL ASSISTANTS

In today's imaging landscape, rapidly improving digital SLRs are sufficient to handle the majority of jobs, and few photographers require the services of the most highly skilled digital technicians like Thomas. Yet many smaller scale DSLR shooters can benefit from digital assistance. From understanding how to set custom white balances to downloading and batch-processing thousands of raw captures, photographers need timely, competent digital help. The right digital assistant can help a photographer overcome the time-consuming digital

workflow issues. By improving customer service and giving the photographer time to focus on the creative and marketing aspects of their business, digital assistants can be the key for photographers to keep their businesses viable.

For this reason, digitally savvy photography assistants are quickly becoming the professional photographer's secret weapon for thriving in the digital age. Unlike full-blown digital techs, these assistants might have only one or two areas of digital expertise. The seasoned pro's job is to find a digital assistant best suited to a particular need and determine how to best employ his or her skills. Those seeking to work as a digital assistant should clearly identify the commercial and professional value of their individual skill sets.

DIGITAL TECHS AND ASSISTANTS DEFINE

"Digital implies everything to everybody, but it means nothing to anyone," says New York-based photographer Joseph Cartright. One of the problems facing photographers in the digital age is a lack of universal language and a clear understanding—by all parties involved in the digital workflow—of exactly who needs which help with what services. This confusion of language extends to a specific definition of exactly what services a digital technician can provide. Terms such as "digital technician," "digital assistant," "digital imaging specialist," and "digital capture technician" don't have strict definitions.

The vast amount of technical specialization continually ushered in by digital photography assures that no one can know it all. A skilled digital tech may have extensive expertise in two types of capture software but might not know much about a third. Inversely, a freshly graduated photography student might not pass muster as a digital tech, but he or she might have a high aptitude for the intricacies of color management or workflow automation—skill areas that still baffle a number of successful pros.

In general the term "digital technician" refers to the most technically savvy operators of medium- and large-format digital capture devices, such as systems manufactured by Leaf and Phase One. These experts know how to smoothly bridge the gap between a client's needs and a photographer's skills and style. Most importantly, they know how to handle, with a cool head, any technical problems that arise during a shoot.

High-end digital techs have an amazing degree of computer expertise, in-depth knowledge of multiple digital camera systems, and a strong background in image file management and preparation for client delivery. They sometimes provide rentals of their own equipment, and they can always procure the right equipment for any job due to close working relationships with local rental houses. These techs are constantly educating themselves, keeping abreast of

new developments in the field, and they have the capacity to educate the photographers who are their clients. They can save thousands of dollars on an assignment by increasing workflow efficiency and averting disasters.

However, the majority of self-identified digital technicians have a much narrower skill set than this. Many digital technicians—even those with certification—are conversant with only a limited range of equipment in specific and consistent workflow scenarios. "When it comes to digital technicians," says Thomas, "what separates the men from the boys is the depth of the tech's knowledge, and the tech's ability to problem-solve and to anticipate a photographer's needs."

THE 21ST-CENTURY PHOTOGRAPHY ASSISTANT

Perhaps one of the least-acknowledged consequences of the digital revolution is the shifting role of photo assistants. Until very recently the primary assets photographers sought in their assistants were a can-do attitude, the aptitude and desire to succeed in photography, and the ability to work long, hard hours. But these days, the digital skills an assistant brings to the table make that person much more valuable (or a far greater liability), and it also shifts the nature of the assistant-pro relationship.

"There was a time when you could hire an assistant right out of photo school who really knew his stuff," says Richard Anderson. But he points out that photography schools have only recently begun to teach digital photography adequately. "Because schools weren't teaching digital well enough, photographers couldn't find assistants who were digitally savvy," Anderson adds. "This created an opening for digital technicians."

While the need for high-end digital techs has risen, so has the need for all photo assistants to increase and actively market their digital capabilities.

"In one sense, any person who helps a photographer with *any* aspect of the photographer's digital workflow is effectively a digital assistant," says Peter Krogh, Baltimore-based photographer and author of the highly-acclaimed *The DAM Book: Digital Asset Management for Photographers*. "While he might not be considered a digital tech, anyone doing any kind of real work on the computer—downloading, backing up, adding metadata, and so on—is in a powerful position to increase efficiency or promote disaster," explains Krogh. "And this requires a whole new level of trust, as well as more clearly defined working relationships."

"In digital photography, a little knowledge can be a dangerous thing," says Joseph Cartright. "The more you know, the more you realize how little you know." Therefore, Cartright suggests that photographers and assistants should

clearly identify their own strengths and weaknesses. "This makes photographers better suited to assess and hire the most appropriate person for the job at hand," he says. "And it allows techs and assistants to better market their skills."

EXTRA EARNINGS

When digital technicians first emerged in the industry, there was a great opportunity for these savvy assistants to maximize their incomes as digital techs. A highly skilled digital tech can earn between 50 and 100 percent more than an average photo assistant, with day rates running from $500 to $1,000, compared with the $250 to $400 for a more traditional photo assistant. While the best digital techs are well worth their day rates, it's important to note that having a little digital knowledge—even the ability to run one particular medium format capture system—does not suddenly make an assistant worthy of such high fees.

In many respects the golden opportunity of turning basic digital expertise into big bucks has already passed. About the time Thomas went into business, pressure was increasing for professionals to transition to digital capture. Many of these pros needed a digital tech to help handle the job and cope with a steep learning curve. At that time competent digital technicians were few and far between, so high fees were easily obtained by the best.

Now, as digital capture has all but replaced "traditional" capture methods, added pressure is placed on assistants to be digitally competent to earn standard compensation. In short, expanding one's digital skills may not always translate into an increased day rate. However, the assistant with the most digital knowhow will definitely be the most employable. And high-end digital techs will continue to command higher incomes and better opportunities than peers with more limited skill sets or less-focused digital ambitions.

FLEXIBILITY: THE ULTIMATE TOOL

While creative and professional flexibility has long been the hallmark of successful photographers, the workflow and business challenges of digital photography have increased the need for fluid adaptability. The simple truth is that the steep learning curve that accompanies the digital revolution is not going to level out anytime soon. Photographers cannot simply expect to master digital photography and go back to business as usual. After clearly identifying their electronic imaging needs, photographers must now turn to an ever-increasing numbers of individuals—digital technicians, digital assistants, and other pros available for consulting—who can help them forge ahead and thrive in the digital age.

The Economics of Digital Assistance. "Every photographer is drowning in production work," says Peter Krogh, photographer and digital workflow expert. "The problem," he explains, "is that the nature of digital photography has increased a photographer's responsibility for postproduction work that, until recently, was handled by professional photo labs." In order to cope with this workload, even the savviest photographers must turn to digital techs and assistants (and even other pros) to help them, both to learn and execute the time-intensive aspects of digital imaging.

Unfortunately too many photographers think of digital assistance as an added expense they cannot afford. But the simple truth is that regardless of a project's complexity, for photographers to succeed in today's marketplace they must allocate to digital techs and assistants the funds previously directed to the labs. However, many photographers have been slow to appropriately charge for digital production services. "Digital photography has changed the economics of photography," says Krogh. "And photographers must realize that they need to bill clients to adequately compensate them for the time they spend to accomplish digital tasks."

In predigital days, if a job required two on-site assistants, a photographer wouldn't think twice about quoting this expense to a client. In the digital days, photographers need to increase their awareness of specific digital costs—from paying for the services of an on-site digital tech to hiring a postproduction digital assistant to prepare hundreds of files. And photographers need to pass these expenses along in a way that makes them transparent to clients.

CRITICAL SKILLS

Marketing

"**We live in a world of marketing.** There is so much noise out there, how do you get someone to listen to you, how do you break into that noise?"
—Barbara Bordnick

7 Steps to an Effective (and Doable) Marketing Plan

by Leslie Burns-Dell'Acqua

Leslie launched the oddly named Burns Auto Parts in September 1999, continuing her career of helping creatives make a living doing what they love. In addition to her consulting work, Leslie has written many photo business book chapters and articles, and her own photo biz book, as well as lectured to creative groups across the United States. She also produces the monthly Creative Lube podcast and the Super Premium blog.

———————————•———————————

These days, Americans are inundated with marketing almost 24/7. According to a 2005 article from *USAToday.com,* it's estimated that the average consumer gets hit with between 3,500 and 5,000 marketing messages per day. For most of your targets, it's even more difficult to cut through the clutter because these people work in the communications industries—either in advertising or publishing or in corporate communications departments. They are the hardest nuts to crack in some ways because they, of all people, understand how good marketing works. They can be judgmental when they get poorly designed pieces, are exposed to sloppy marketing, or, worst of all, get lied to.

It takes much more than one contact with a potential client, no matter how fabulous a contact, to get in that potential client's head. I've read sources that say it takes five, eight, or even ten points of contact before a potential client (customer) even recognizes that he has heard the company name before, and I can tell you from experience that even when someone is looking for a photographer, the names and images quickly become blurs for the most part unless the contact is consistent and regular.

Unfortunately, you can't just call up a target (a potential client) every day for ten days and expect to get a project. Yes, you will probably break through the clutter and the target will probably recognize your name, but not in a good way. You'll be that annoying photographer who just won't stop calling! That's called stalking. Besides, data show that people are more likely to remember a product/service name if they receive it repeatedly via multiple media, not just over and over in one. So it is far better if you make a plan to cover repeated points of contact through multiple media.

Now I don't think photographers are best served by writing highly technical marketing plans. Instead I think a modified one which emphasizes goals, targeting, tools, budget, and scheduling will give most photographers the guidance they need without bogging them down with technical business "mumbo jumbo" (like market segmentation and SWOT analyses for each category) that makes most photographers' eyes glaze over faster than a beauty queen's at an astrophysics convention.

So here are the steps to produce a good working plan with a minimum amount of hoo-hah and a maximum amount of effectiveness.

STEP ONE

You need to do one thing before you actually write out your plan and that is to write your marketing statement. I prefer to call this your vision/marketing statement (VMS) because it should, first and foremost, speak of your individual vision. It is your vision, your way of seeing, that really differentiates your business from that of every other photographer and it is the *most important factor* in appealing to clients. Also if you are the only photographer who shoots a certain way, you can charge a much higher creative fee. That's simple supply and demand. Besides, you became a photographer because you love to shoot and want to do it your way, not just be some tech-head who clicks the shutter while someone else does all the creating, right? The ideal is to get paid for your vision, and that will never happen unless you choose to base your business on your vision and market it that way.

There are many examples of marketing statements available on the Internet or in books. I think you should ignore them. More often than not, they are chock-full of useless marketing buzzwords that don't really say anything: "[. . .] maximizing the client's profit potential and implied position in the consumer marketplace" or "partnering with clients in advertising, corporate, and editorial arenas." Blech. You will be much better served by writing something honest and in your own voice.

The VMS questionnaire will help you find the information you need to write your own VMS. It's entirely possible that after you answer those questions, you'll pretty much have your VMS. What the answers will reveal is the

V M S Q U E S T I O N N A I R E

Leslie Burns-Dell'Acqua

The following questions are designed to help you find a verbal method for describing your vision. Don't over-think—answer them honestly and make sure they resonate with your own individual Truth. Don't worry about being judged or sounding crazy—honesty in marketing goes a long way with persuading clients. You must tell your own story. How else can your business be any different and thus valuable to your market?

What do you love to shoot?

How do you love to shoot it/them? Maybe you love to shoot in existing/natural light or maybe you love highly-produced environments...or what about your approach, etc?

What do you bring to a project? Think about things like a sense of humor or conceptual thinking or connecting with your models, etc.

Who are your dream clients? Be very specific and list at least 5, like "American Express" or "New York Times Magazine" or "Apple."

Why did you become a photographer? What was the first spark that lit the fire?

List 5 words that describe your work (like "ethereal" or "hyper-real" or "clean" etc.).

List 5 words that describe you (like "energetic" or "intense" or "funny").

What makes working with you different from working with any other photographer out there?

truth about who you are and how you see. Another thing you can do is to ask other people what they think your images say. Do they say, "fun and exciting," or "illustrative," or "challenging," or what? Sometimes getting that outside perspective can be very helpful. Often a creative person has a hard time taking a step back so that he can find the right words to describe the work. Getting an outside opinion can help with this.

Here's an example of a good vision/marketing statement:

Jeffrey Jacobs shoots architecture and architectural/design products. His approach is transformative, making the mundane appear stunning and the well-designed quite literally awesome. Jeffrey can find the right angle to reveal the artistry of the designer's work, be that a large structure or a product detail. When the production matters, Jeffrey is the man to turn to. He can produce a shoot with more tools and tricks than anyone could envision, but he also knows when natural light and "simple" is the best choice. From scout to finish, Jeffrey Jacobs is the photographer to reveal your work. *[www.jeffreyjacobsphoto.com]*

The VMS serves as the foundation of everything you put out to the public—every marketing tool you use will be held up to the VMS to see whether it is on- or off-brand. If Jeffrey wanted to send a print promo that was totally goofy, with a photo resembling a snapshot, that would go against what he most wants his business to be. More importantly for his marketing, it would contradict the image he wants to project to his targets. He wants his clients to think, "serious, revealing architecture-related imagery = Jeffrey Jacobs Photography."

So it is important to take some time to figure out and write down your own Vision/Marketing Statement. It will help you to frame your thoughts when it comes time to develop your marketing materials and help to remind you when you "forget" your direction.

STEP TWO

Make a list of your business goals for the next year, next two years, and next five years. While your plan will actually be for one year, listing longer term goals will help you take steps and plan for future achievement.

Be clear, and remember that goals should be specific, measurable, and achievable.

Some examples of goals:

- I will bill (gross) ≥ $250K in 2008.
- In 2008, I will work with at least one new national-caliber client like American Express or Fidelity Investments.

- By 2010, I will increase my gross billings by 50 percent over 2007's numbers.
- In 2008–09, Bob Smith Photography will make at least 750 sales calls (phone) per year.

Some examples of things that sound like goals but aren't really:

- I will be more successful.
- I will work on better projects.
- Bob Smith Photography will get more notice from nonlocal clients.

Notice that the second set was vague; what is "successful," and how do you define "better projects?" Make the goals clear and concise, and define them fully.

STEP THREE

Describe your general target categories. For example, you may wish to target financial services companies and their advertising agencies or national business magazines. For your plan, you just need general categories of potential clients—your specific list doesn't need to be laid out on your marketing plan.

By the way, your specific list should be made up of those potential clients you have discovered using the system described in the marketing lecture. To reiterate that system:

Get a folder of some sort and keep it handy all the time. Whenever you see an ad or an image in a magazine that you wish you had shot, put it in the folder. Be selective—don't put in things you could have shot but rather things you really want to have shot. Don't let little things like the fact that the client was Nike or some other big company spook you. If you would have given your eyeteeth to have made that image, in it goes. The work needs to be your kind of work, work that your vision would be great for, but if it matches up, in it goes.

After a while, you'll have a few items in your folder. Take the items and use your list service to research them (or go look them up using sources in the library). For example, if you had an ad for American Express, go online or use a list service (like ADBASE or Agency Access) and find out who the agency is (or agencies are) that do work for AMEX. Check for its in-house creative department too. And check listings under graphic design firms. You may end up with three or four companies to target from that one ad. Repeat this for all the items in your folder. The resulting list will be your A-list. These are the clients you want the most and will spend the most effort targeting.

STEP FOUR

Define your overall annual marketing budget. This number can be anything you want it to be, but I suggest making it at least 5 percent of your previous year's gross billings to as much as 10 percent of your desired billings for the year this plan will be in effect. More is, of course, better. Going cheap on your marketing budget will not provide you with the resources you need to build your business.

Remember to refigure your cost of doing business numbers for the year (and change your fees as needed) with this marketing budget in mind.

STEP FIVE

Make a list of potential marketing tools. Some of these you pretty much must use (a good Web site is absolutely necessary), some you can pick and choose (print ads/sourcebook ads), depending on your budget. List everything you can think of, even if you think you might not need it for now. It will be good for you to keep thinking of options, even those you might not use until some future date.

Here are some of the most popular marketing tools for photographers (in no particular order):

- *Portfolio*—your "book," and it needs to be filled with the best of your work; you need at least two copies
- *Web site*—the electronic "version" of your book (but not exactly the same images as your book!) and at least as important as your physical portfolio, arguably more so
- *Print mailers/promotional items (postcards, etc.)*—calendars, postcards, posters, tri-fold brochures, coffee mugs, you name it, if it can be printed and sent to potential clients, it fits in this category
- *E-promos*—everything from an image with a link to extensive newsletters to online games
- *Print sourcebooks*—Workbook, Black Book, AltPick, and others: buying ads in these used to be a great way to reach clients, now, not so much, but there are some new options with potential
- *Online sourcebooks/portals*—the online versions of the print books, these are a great place to spend your marketing money
- *Other print or online ads*—like in *Communication Arts* or *Archive,* or their sites, or other sites your targets go to
- *Personal selling*—phone calls, meetings, lunches, and so on, these are still some of the best methods of reaching your targets; you just can't beat connecting on a personal level

- *Competitions—Communication Arts* photo annual, PDNs, and various awards can be extremely helpful in getting you recognized even though the chances of getting in aren't too good

There are, of course, other things you can include as marketing tools, as many things as you can think of and more that you probably never would, but there are at least two more that need to be on everyone's lists: media releases and networking.

Media releases, also known as "press releases," are technically public relations, but I have always seen PR as a subcategory of marketing. One good blurb in the right publication can get you more notice than a bucket of ads and mailers. And yet photographers rarely send them. They're surprisingly easy to do. Better yet, get a good writer to compose these for you. There are many examples of the style available online. Just keep a list of anything and everything you do that could even vaguely be of interest to your targets. For example, if you shoot a project for a national company, note it for your PR. Or if you get any sort of award, note that. Even if you shoot for a tiny local company but produce really fantastic work on the project, note that. Hire a new studio manager? Note it. Stuff you think is boring or just not special may be of interest to your targets. Read some of the blurbs on PDNonline—boring to us but great for the photographer who gets his or her name there—and that's all from PR.

Networking is another area where photographers could improve. Photographers are generally a solitary bunch who need to get out more. Networking will serve the double function of getting a photographer out and building relationships that will improve business. While going to the ASMP meetings is absolutely great for your business, don't forget to go to meetings for your *target* groups. AIGA meetings are a fantastic place to get creative stimulation and to meet targets; its members are all designers. If you shoot architecture, go to AIA meetings. Events? Chamber of Commerce meetings. And so on. It is particularly effective for local clients, but it can be done in other geographic areas as well—like going to a national AIA conference if you are an architectural shooter or Art Directors Club events in New York City for advertising, design/corporate, and editorial photographers.

STEP SIX

Apply your budget to your tools and apply time guidelines. Once you have your budget and you have an idea of what tools you might use, you need to plan how much you are going to put into using the tools. That means assigning budgets for each of your tools. It also is a good time to decide which tools will get repeated and how often throughout the year.

From: Leslie Burns-Dell'Acqua <leslie@burnsautoparts.com>
Subject: Release: New Photo Business Book by Leslie Burns-Dell'Acqua
Date: August 14, 2006 9:45:40 AM PDT
To: XXXXX

For immediate release, contact info follows release

New Photo Business Book by Leslie Burns-Dell'Acqua

Burns Auto Parts–Consultants is proud to announce the release of *Business Basics for the Successful Commercial Photographer: or how to use your left brain, too.* Written by BAP owner and internationally known consultant Leslie Burns-Dell'Acqua, *Business Basics for the Successful Commercial Photographer* is a small book geared to students and emerging photographers who, like so many pros, are not always getting much information about the business side of the photo business in their coursework. This book will fill in a lot of those blanks, introducing issues like copyright, marketing, paperwork, business entity types, and more. While it does not explore these topics in depth, it does give readers the basics and points them to other sources for more information.

When asked about her reasons for writing the book, Ms. Burns-Dell'Acqua said, "My goal was to get the basic information to as many people as I could, thus planting the seeds for positive, effective, life-long professional business practices rather than forcing newer photographers either to read dense business tomes or just wing it when it comes to their businesses."

The book is published via Lulu.com--a new way of approaching publishing. "I decided to use Lulu.com rather than traditional publishers to control the process more," said Ms. Burns-Dell'Acqua, continuing "I could write what I wanted in a style that probably wouldn't be acceptable to a traditional publisher but one which will resonate with students and emerging pro photographers. And the process has been great."

Business Basics for the Successful Commercial Photographer: or how to use your left brain, too. is available from Lulu.com at http://www.lulu.com/content/347372 (preview pages available) in both print and downloadable forms.

Leslie Burns-Dell'Acqua is the owner of Burns Auto Parts–Consultants, a business & marketing consultancy for creative professionals, particularly commercial photographers. Based in San Diego, CA, Ms. Burns-Dell'Acqua has developed a sizable following via her online "Manuals," regular column in *Picture* magazine, and innumerable professional photographer forum postings. Known for her straight-shooting style, she encourages positive change in creative businesses around the globe. For more information, go to burnsautoparts.com.

Leslie Burns-Dell'Acqua
Creative/Marketing Consultant
www.burnsautoparts.com
4311 Post Road San Diego, CA 92117 USA
619.961.5882

For some tools, this is easy—it's a once-a-year event with a set price. If you buy an ad in Workbook, you're going to produce that ad once a year and it will entail that cost (plus your designer's fees). But a *www.Workbook.com* online portfolio is changeable and should be "refreshed" at least once a year (two to three times is better); so it will have its annual cost, but the actions connected will occur two to three times.

Mailers may be sent out at any interval you choose (though I suggest between four and six a year) and e-promos can vary in their scheduling, too. Their costs will certainly vary as well, depending on materials and/or complexity.

So, for example, you could end up with a list like this (total annual marketing budget, $14,000):

- Portfolio: $1,500 budget for three copies
- Web site: $5,000 budget (new design and hosting); update quarterly
- Print mailers/materials: $3,000 budget for four postcard mailers (including list service subscription and postage) to go out about every three months, and one folded card for thank-you notes, and so on
- E-promos: $1,000 for six times per year using e-mail service
- Print sourcebooks: (none this year)
- Other print/Web ads: (none this year)
- Online sourcebooks: $2,000 for *www.Workbook.com*, update in six months (two times a year); $300 for *www.AltPick.com*, update every four months (three times a year)
- Personal selling and networking: $700 for meals, networking (meeting fees), miscellaneous; fifteen calls/week and as many meetings as I can get
- Media releases: $0 (self-written and e-mailed), quarterly
- Competition entry fees: $500

STEP SEVEN

Convert timeline guidelines to specific dates. After you flesh out your plan to the point of selecting your tools and assigning budgets and general timelines, you should put in actual dates. For instance, the print mailers in the example above would have mailing dates of March 15, June 15, September 15, and January 7 for four times in one year (while avoiding the downtimes of August summer vacations and the holidays). Or your new portfolios could have a due date of February 12 and your new *www.Workbook.com* portfolio could be due March 1 and refreshed on September 1.

Select whatever dates you feel are achievable; but do select dates and write them down on your plan.

Now would be a good time to go ahead and take those dates and "pencil"

them into your calendar—whatever calendar system you use. For the items that require significant action, like getting new portfolios, set up a rough production schedule, working backward from the penciled-in dates. Write down the tasks you need to achieve these goals, and transfer them into your calendar, too.

Remember the example goal listed earlier of making 750 phone sales calls in a calendar year? You can break items like this down and transfer it to your calendar, as well. Three calls a day = 15 calls a week = 750 calls a year (with two weeks off); schedule it however you think you are most likely to really get the tasks done.

That's it. These are the guts of your marketing plan. You have goals, a budget, and a schedule. There are marketing things for you to be doing throughout the year and, as you break down these different events into their subtasks (like getting the mailers designed, printed, and labeled), you will find you have marketing tasks to do every week. This will help keep you at your marketing on a regular basis and that consistency will prove very lucrative in the long run.

WHAT'S THE USE?

Lots of creative people look at a marketing plan with everything they need to do and throw up their hands, saying, "What's the use? Why do I have to do all this? I just want to make art!" Well, that's a nice idea, to make art all day. But unfortunately no one is going to pay you to do that unless you market, first and always.

It does seem like a lot to do, but taken in little chunks over time, it's really not the mountain it first seems. You should spend between 10 and 20 percent of your working time doing marketing tasks. For a 40-hour week (and yes, you should strive to work about 40 hours a week), that's between four and eight hours, and for maximum efficiency you should break those hours down into much smaller chunks of time (thirty minutes here, an hour there at the most). Those are very achievable goals—doing thirty minutes of marketing Monday afternoon, an hour on Tuesday, and so on. Also much of the work is creative, albeit differently creative than a lot of your work. For example, working with a designer to create a promo campaign is a great series of creative events. Shooting the images is part of it, but pretty much the whole process is creative at least on some level, up to printing out labels and mailing the things, of course.

Regardless, the payoff is worth the effort. To make your living doing the art you love—how great is that?

Web Sites

by Leslie Burns-Dell'Acqua

The following text was adapted for use in *ASMP Professional Business Practices in Photography* from a chapter originally published in *Business Basics for the Successful Commercial Photographer* (2006).

You cannot overstate the importance of a good Web site in a photographer's business. Note that I said "good Web site." This importance is perhaps made more evident by the fact that the number of physical portfolios brought in by agencies for review for specific projects has dropped significantly in the recent past. When asked (in a 2005 survey) how many portfolios these photography buyers used to bring in for a project (before Web sites really hit), 74 percent said six to twenty-nine books (with 13 percent more saying twenty-six to forty-nine), depending on the project. Now, the buyers bring in only zero to five (52 percent) when they bother to call in print books at all. In almost every case, each individual respondent said that the number had dropped for him/her—for example, if he had brought in six to twenty-nine portfolios for a project, he now only brings in six to fourteen or even less. And those numbers are dropping every day.

At the very least, buyers will often select the first cut for any potential project based on Web sites alone. They may review a large number of sites, but at best they'll only call in a couple of physical books.

This clearly means that if your Web site doesn't win, neither will your business. The days of photographers building their own sites and having them be effective are pretty much in the past (with very rare exceptions).

Your site needs to be of a certain quality to hold the interest of most worthwhile potential clients. As in all parts of your marketing mix, there are some basic standards to keep in mind when it comes to your site—things like branding, design, and ease of use. There are a rather surprising number of

photographers' Web sites out there that are an affront to the eye and the ear, or are so complicated or poorly designed that they may as well have no site at all. I see them every day. Buyers see them too, and loathe them.

When asked (as an open-ended question—meaning they could answer whatever they want—no prompts), "What's the worst thing a photographer can do with her Web site?," many buyers mentioned things like complicated navigation, bad programming, forcing users to log in or to click copyright agreements, and top of the list, bad images.

So the first "rule" is that you should hire a professional to do your site. The initial design and programming should be done by someone who specializes in this sort of work—you are a photographer, not a designer, and not a programmer. Photographers have a tendency to try and do everything themselves, but this is the wrong place for that. Hire a pro and get it done right.

That being said, I suggest working with your designer with this goal in mind—to create a clean, simple site that loads quickly, shows your work well, and that you can easily maintain and update. The ability to self-update your site is important and you should really learn what you need to know to do that. That way there is no easy excuse for not keeping it fresh and interesting to your buyers.

These days there are also template-based options like *www.bludomain.com* or custom packages like those offered by *www.Livebooks.com*. The sites they produce are clean and image-centric. Clients love their simplicity, clean design, and navigation—they get to see the work, and the sites are all about the work. These are good options that can save you lots of money over getting your site designed from scratch. Livebooks, in particular, has an outstanding back-end that makes it dead-easy to make changes and update images. Livebooks has done lots of research to keep its products not only effective but actually liked by photography buyers.

The second "rule": It's about the images, so you need to show only your best stuff. Just like in your print book, you need to show the work you want to get, not the work you have gotten. Think about the future and your Vision Marketing Statement (see chapter 43, 7 Steps to an Effective and Doable Marketing Plan). Your Web site is your main tool for communicating your VMS to your targets. If you start trying to show what you think some imaginary potential clients might possibly want to see, you'll end up trying to show lots of things other than only what you do best, uniquely, and what makes you a valuable service provider.

Show clean images, not tearsheets, and if there is a significant difference between your "personal" work and the other images you are showing on your site, you are not being honest about your work and you're not honoring your

VMS. I don't even like "personal" categories on Web sites but prefer personal work to be integrated into the body of images shown. Your personal work will usually be the best examples of your true vision, and those images should be related to the other work you are showing on your site, in your book, and in every marketing piece you put out there.

WHAT WORKS? WHAT DOESN'T?

I've reviewed more Web sites than I could count. Between that experience and my talks with art buyers and other creative services buyers, what works and what doesn't becomes pretty clear. If you already have a Web site, this information should help you re-evaluate its effectiveness. If you don't have one, you can start off on the right foot.

Generally speaking, forget about the fancy Flash-animated intro. These are particularly disliked if there is no "skip" button, but generally they are seen as more intrusive than entertaining. I say, dump 'em.

In the past I advocated not using Flash at all for photographer sites. However, the technology is much better now and Flash rarely causes any sort of problem. On the other hand, contrary to some claims, it does not provide any real protection against someone using your images illegally (i.e., downloading the image from your site). Frankly you shouldn't spend too much time being worried about that. Register your copyright and go after offenders, but don't put protection above reaching out to your best targets.

If you are concerned about losing potential clients because you have a Flash site, have an alternate, simple HTML version of your site clearly available from the main page. For now, this will also help those clients who are using iPhones and other less Flash-happy alternatives to view sites.

Music is not a great idea on photo sites unless there is an obvious "off" or "mute" button. Remember, many of your buyers work in open cubicle environments so sound can be a big problem in the workplace. Also, you may love Snoop Dogg, but your potential client may hate rap music—so why run the risk of offending? I've seen more than one person click off a site in disgust because of the music.

I know, you are trying to create a "user experience" where the images and sound work together, but hey, your buyers aren't going to care in most cases. They care most about the quality of your images, your creative vision. They also care about doing their work without having their fellow workers complaining about the noise.

Oh, and speaking of sound, the "amusing" noises like shutter sounds on mouse clicks should be dumped. Today. How original do you think it is to use a shutter or auto-drive sound in the first place? It's been done to death and now

is pretty much considered the mark of a lower end photographer. You want to increase your perceived value at all times.

The best sites are often very simple. Remember, you are not selling design or music or Web sites, you are selling your vision. If the images aren't easy to see or are overshadowed by the site design, you're shooting yourself in the foot.

When it comes to navigation, the most popular and effective sites are user-directed; that is, the navigation is controlled by the user, not forced by the site. "Slideshows," in which the order and the timing are uncontrollable by the user, are the least effective and most disliked. Thumbnails or at least smaller images that a user can click on to see a larger version are OK. But the best navigation device is some sort of static, clickable arrows that lead from one image to another. This way the user doesn't even have to move the mouse to click for the next image. "Keep it simple" is a good mantra for navigation questions. You want your targets to see your work, after all.

The categories for the images, if you choose to categorize, can present some problems. Remember: These are busy people who just want to see the work. So depending on your work, you can either not categorize at all or use specific and clear titles that fit your work (and, hopefully, only your work). Still, using terms may pose a linguistic problem in that a person who reads "still life" has a mental expectation as to what she is going to see. If the material in that category does not match that expectation, the user gets a sense of being "lied" to, and that is not good.

DID I MENTION "RULE" 2?

Your potential clients are all creatives or at least people who are so intimately involved in the creative industries that they can and will see past all the bells and whistles to the quality of your work. You can't hide bad work with a fantastic site. As the old saying goes, you can't put lipstick on that pig. If your site is fabulous but your work isn't strong enough, well, it won't succeed.

Thus the work you show should be first and foremost your best work, it needs to show your vision, and it needs to be consistent with all your other marketing pieces. Remember, this is your online *portfolio*. If you wouldn't put the work in your physical book, why are you putting it online? Issues of sequencing may become more fluid because of the nature of a Web site, but image selection should still be clearly the work which best shows your vision.

As for how many images to show, there is a greater variation on the Web than in physical books (where I like to keep it below twenty-five pages). Still, you don't need to show everything you've ever done. It is much better to have fewer but very strong images than many "good enough" images. If you feel like you have too few images that are powerful enough to show, you need to shoot

more. Having said that, I think around forty to seventy images is a good range for a Web site. Some can go higher, but once you get past one hundred, it's really getting too big for most people to go through. Instead, take the extra images and rotate them in periodically. That way your viewers will get rewarded with new images when they repeatedly view your site.

Keeping the total number down has a second benefit—you can tease viewers into contacting you for more. If they like what they see but need to see more for a potential project, you get to talk with them because they will call or e-mail for more. Personal contact is your greatest selling opportunity. Always.

As a Web site is a part of your entire marketing mix, it is important for it to match your other marketing materials. Most importantly the images on your site should reflect the same vision as the images in your physical book. It is not good to have your book called in by a potential client because of what she saw on your site, and then send a book that is totally different. Buyers complain about that all the time, and it's the kiss of death for a future relationship. I like some overlap in the images seen on the Web site and in the physical book, but with some "new" images for the buyer to see as well. The general rule I use is no more than 50 percent overlap between book and Web—if you have thirty images in your book (on fewer than twenty-five pages, thank you very much) then no more than fifteen of those images should be on your site.

CONTACT INFO, PLEASE!

The most important thing to keep in mind is, always make it easy for your targets to hire you. That means besides making it simple for your potential clients to see your work, you need to make sure it is easy for them to contact you. I have seen a surprising number of Web sites that lack basic contact info. You must have, easily available, the following: your name, your e-mail address (with a clickable link), and your phone number. Including your street address is not a bad idea either. This can be done as a separate page with your full contact information, including your complete street address and any other potential contact points—with a link to that page on every page. Besides just being easy to contact, providing full information has an additional benefit: Buyers do searches based on location so if you have your location on your site, they will be able to find you (even well-programmed Flash sites can be SEO-friendly, which is another reason to have it professionally made).

OTHER BITS AND PIECES

I personally like sites with a biography page of some sort. It humanizes you. Sometimes information in your bio will "connect" with potential clients and they'll give you a shot where they might not otherwise. Don't make it too long,

though, and keep it related to your professional life. It may be fine to write "Bob Smith lives in Del Mar, California, with his wife and two kids," but don't go on to say, "Bob's wife, Samantha, is a real estate professional who knits in her spare time" or "Bob likes to golf with his eldest son on the weekends and watch his daughter play soccer." Remember, potential clients are busy people and you don't want to waste their time. Of course, if you shoot golf products, then mention playing it (even with your son) because that shows your passion for your subject. But otherwise, skip the family shout-outs (and that definitely includes family photos).

You can list some of your clients in your biography or have a separate client list. I tend to prefer the latter, and in simple list format. Again you don't need to include every single client you've ever worked with, but do make sure to list those with good name recognition. Clients often ask me if they should put agencies or end-clients on their lists. I think you should list both. Some potential clients will be impressed to see that you worked with Nike, while others will be more impressed you did that work for Wieden+Kennedy. And don't skimp on the publication titles if you've done editorial work. People are impressed that you've shot for *Business Week* or *Hemispheres*.

Speaking of writing, as a photographer's Web site is obviously a mostly visual thing, sometimes words get short shrift. While a site shouldn't get too wordy (less *is* more), the words that are on the site need to be grammatically correct, spelled correctly, and the writing should be good. As most photographers are visually oriented, I suggest hiring a good copywriter. At the very least, hire a good proofreader. Language errors can make a surprising difference to potential clients. Misspellings and grammar faults make you look unprofessional. A copywriter or a proofreader won't cost you very much, but she can make a big difference in your perceived value.

A "BONUS" MARKETING OPPORTUNITY

As I mentioned earlier, you want to keep your Web site easily updateable. This is important not only because it should be constantly and consistently reflective of your vision, but updating the Web site also provides you with additional marketing opportunities. Each time you update your site, you should contact your clients and targets, to let them know what's new. Whether you do this via a postcard or an e-mail, it's another point of contact that will help keep your name in their heads. You can also send out press releases announcing the "new Web site" or "new material" or "new images available for viewing." Thus, you can get at least one more point of contact with your targets that you may not have had, simply by doing an update.

OTHER DETAILS

One quick note about image size: One of the best things you can do for your Web site is to make the images as large as you can without making the user scroll. This is a technical thing, and another reason to hire a pro to do your site. Targets love to see the work without having to squint (thus big), but they hate having to scroll. As many end-clients are using laptops, you want to be sure that your Web site either fits the smaller screens or re-sizes automatically to fit them.

And on the topic of SEO (Search Engine Optimization), I've had several long debates with people about this. For some photographers it is really important. If the buyer—such as an architect, a bride, or an editor—is hiring based on location, they are using Google more and more. If you are shooting weddings in Cincinnati, it's important for you to rank high for a search like "photographer, wedding, Cincinnati, Ohio."

It is less important for advertising photographers, but a few gigs might come your way . . . maybe. Instead, they will use places like *www.Workbook.com* (No. 1 in my surveys, every time, by the way), *www.AltPick.com*, and ASMP's Find a Photographer to find someone new for a project. They'll only use Google if they remember the photographer's name but can't find his or her contact info in their files or if the budget is low. So if your Web site is not optimized for the search engines, it's not going to significantly impact your business.

Lastly, more and more photographers have photoblogs, but they are just starting to link them to their business Web sites. Buyers generally like to see a photoblog. It gives them something new to see every time (just about) they visit the site, and they equate the photoblog with your personal work so they feel like they are getting to see more of what is inside of you, creatively. Having a photoblog can increase repeat visits from targets, and that is one of the best ways to get business. They're also good for you creatively because having a photoblog sort of forces you to shoot more, if only to have something to post.

And if you are expanding into video, the photoblog may be a good way of testing the waters by putting the video there or a link to YouTube (or whatever). The photoblog space tends to be more open to experimental work so new technical forays fit here nicely. However, if you are considering having a downloadable PDF portfolio available to your potential buyers online, I would put that link someplace more obvious—on the main site, that is.

Of course, with technology changing at such a rapid pace, many of the technical issues of today will not be around in short order, and others will arise. But no matter what the technology, it will always be about the images, so make them your best.

Web Site Success Case Study

by Blake Discher

Blake Discher specializes in people photography for editorial, advertising, and corporate clients. He's always made use of the latest imaging technologies, and somewhere along the way he began to dabble with an old Commodore computer. He created an Internet presence very early on and expanded his knowledge to search engine optimization. Through leveraging his knowledge of photography and the workings of the Internet, Blake continues to be in demand by Fortune 500 companies worldwide.

———————————— • ————————————

My Web site is a critical tool in my marketing toolbox. I was an early adopter, and back then the purpose of my site was to save the almost $50 in express shipping costs I incurred when a potential client asked to be sent my portfolio for review.

I had about twenty-five images on the site, sorted under the headings "people" and "places," the two areas I specialized in at the time. So in essence, the site took on a "passive" role in my marketing; I had to direct clients and potential clients to the site in order for my work to be seen.

Fast-forward to today and my Web site has taken on an entirely different role. My site is now a critical part of my marketing and sales efforts. And thanks to the search engines, about 65 percent of my new clients each year come from the Internet.

A search engine makes it extremely easy for a photo buyer to locate a photographer in virtually any market in the world. By entering the search phrase "[market] photographer" (where market is the city in which the photograph is to be taken), a great many photographers will be listed for consideration. You can also optimize for a type of photography or a type and geographic

combination—for example, "editorial photographer" or "Detroit editorial photographer."

My site is optimized, or "tweaked," for the phrase "Detroit photographer." By optimized, I mean that during the design phase of the site's development, steps were taken to craft the content in such a way that was very search-engine friendly. This is referred to as search engine optimization, or SEO.

I quickly moved to the number one position in Google when someone would search for "Detroit photographer." That was an early goal and one that I still work very hard to maintain.

Because the criteria that the search engines use to rank a Web site is constantly changing, and the search engines do not share that criteria with the public, staying number one is constant work and beyond the scope of this article. Well, almost.

The search engines have always strived to return relevant results. Their algorithms have changed and evolved over the years. In fact, they are now changing them about every three or four months. Throughout the years however, one ranking criteria has not changed—namely, their reliance on text on a Web page. This must be human-readable text. The text should describe what you do and provide information about your business.

Search engine optimization is a cat-and-mouse game. As Web masters figure out what the search engines want and attempt to manipulate their pages (by means that are not always honorable), the search engines alter their algorithms. You're best served, in the long term, by having what's called "relevant body copy" about your business on your home page.

Granted, it's a balance between having a site with pleasing aesthetics and one that is optimized for the search engines, but if done properly those trade-offs are minimal. Plan your site's design with an eye toward incorporating content the search engines regard as relevant. It is possible to bridge the gap between the desire to have a visually appealing site and the need to rank highly for the terms your potential clients use to find a photographer such as yourself.

Once your site is "live" on the Internet, it will likely be the least expensive, hardest working, portion of your total marketing plan. And the results it generates are measurable; it keeps working for you twenty-four hours a day, seven days a week. And as you continue to grow your business with better clients and better work, don't forget to update and improve your site with fresh content.

Your Web site can do for you what mine did for me. I am staying busy in one of the most economically challenged cities in the country.

Web Site Usability Considerations

by Blake Discher

JUST ABOUT EVERY PHOTOGRAPHER HAS A WEB SITE. BY NOW, YOU'VE MADE the design decisions that give your site its "look and feel." The two most important considerations you may not have given much thought to are, one, your site's visibility in Google and Yahoo search results; and two, your Web site's usability. In this article we'll focus on the usability aspect of Web site design.

Listed below are a few items to consider when either designing your new site or redesigning your existing site.

COMMUNICATE YOUR MESSAGE CLEARLY

Today's photographic buyers and art directors allocate minimal time to initial Web site visits. Their primary goal is to locate a photographer (or two, or three) who "fits the job." So you must quickly convince them that spending some time on your Web site is worthwhile.

PROVIDE INFORMATION YOUR POTENTIAL CLIENT WANTS

Photo buyers must be able to easily (and quickly) determine whether your sample images and capabilities meet their needs, and why they should do business with you. What can you offer that your competitors do not? What differentiates you from the other photographers they're considering? Is it your style? Your experience? Get your message out right up front, or make it easy for them to get to this sort of information within your site.

OFFER INTUITIVE, SIMPLE NAVIGATION AND PLEASING, CONSISTENT PAGE DESIGN

Remember your reader. She will learn the "flow" of your Web site if you provide consistent, predictable navigation methods and content that shares design

elements from page to page throughout the site. Provide "quick links" that serve as easily accessed shortcuts to the paths that you believe people will want to follow most often, such as your portfolios. Don't bury important links in body copy. And be sure to use a pleasing color palette.

Equally important, don't have links that only appear when a portion of a photograph is rolled over with a mouse. Studies have shown that a person arriving at your Web site from a search engine query will click the "back" button if they don't find what they came for after eight seconds.

CONTENT, CONTENT, CONTENT

I can't stress it enough. We all show pictures on our Web sites. Don't forget to "introduce yourself" to your Web site visitor. Share some personal information with him. These days we're getting less and less "face time" with potential clients, so you need to let your Web site do your selling. We all shoot great pictures. Here are a few things you could write about on your site: your working style, your clients (don't go overboard here), your experience, or what you do when you're not working. Maybe your last great assignment; here's where a blog can be a useful tool but only if it matches the look and feel of the rest of your site.

Now you have plenty of ideas to get you thinking about your Internet presence. Look at other photographers' sites and put yourself in the position of a first-time visitor. What did you or didn't you like about the site? Was it easy to move around in? Was your experience a good one? Or did the site's Flash animation require you to roll over the beautiful model's eye for the "portfolio" link? You get the idea, now go work on your studio's Web site!

Art Directors Voice Their Do's and Don'ts

by Elyse Weissberg

Elyse Weissberg was a representative and creative consultant for photographers. She was a much-respected voice in the industry through her writing and lecturing on marketing for photographers. Her book, *Successful Self-Promotion for Photographers, Expose Yourself Properly*, is a valuable resource for any professional photographer.

———————— • ————————

IN A NATIONAL SURVEY, I ASKED ART DIRECTORS TO LIST THEIR "DO'S" AND "Don'ts" when working with photographers.

Here are some suggestions:

Do

- Include promotional pieces with your work to reinforce who you are.
- Keep things flowing on the shoot (the meter is always running).
- Be easygoing and have a sense of humor. Show enterprise. Many times the assignment is obvious—but when a photographer can go beyond what's expected and surprise me with an original visual solution, I will go back to him again.

Don't

- Be disorganized. It interferes with my shoot.
- Show little interest in the job, as mundane as it may be.
- Have a messy studio.

- Give me a reason a picture won't work—before the picture has been made. I can't print excuses.
- Call me as a follow-up to a mailer. If I am interested, I'll call you.
- Call me just because we have landed a new tobacco account to tell me you have shot cigarettes. That does not interest me. What I am seeking is vision.
- Feel you need to tell me how difficult each shot was as I am looking at your book. If I am interested, I will ask.
- Think you have to show tearsheets.
- Call an associate of mine and tell him/her I recommended you if I didn't.
- Leave lengthy solicitations on my phone mail.

To sum up, an art director had this to say: "Hiring photographers is the result of how well a combination of things impresses me—the book, the photographer or rep's personality, and the knowledge each has about how to get things done from several different angles. For a photographer to get more business from me, it depends on how smooth the first shoot went, how the images looked, and how the photographer followed up after the images were delivered."

Qualifying Clients. Before you drop off your portfolio or send a direct mail piece, you should research the client to ensure that you are targeting the right person. How do you find out who is working on what and how photographers are chosen? Ask! Here is a list of questions to use when qualifying potential clients:

- Do you use photography? (Stock or assignment?)
- How often do you shoot? (Two times a month, four times a month?)
- Are you the person who makes the final decision about hiring a photographer?
- (a) Referring to photography as a category, do you use still life photography? (People, kids, location, fashion, etc.?) (b) Referring to photography as a style, do you prefer an editorial style of shooting?
- Do you use a graphic style?
- Do you make appointments or do you prefer portfolio drop-offs?

Keep your conversations short; time is precious and often these people will not be able to stay on the phone as long as you might like. Sometimes, you

will get answers only to the first three questions. But remember: You are not trying to make friends. The call is to gather information. If you get the feeling that it is not a good time for the person to talk, get off the phone quickly and gracefully.

Briefly going over the information gathered previously to show them that you have done your homework is a good idea too.

Once you have qualified a client, go after him or her. Try for an appointment or drop off your portfolio and send promotion. Don't stop. This process may take a while. It will probably be a combination of these and other efforts that will get your portfolio called in, leading to a job.

Reps and Marketing Assistants and Consultants, Oh My!

by Leslie Burns-Dell'Acqua

The following text was adapted for use in *ASMP Professional Business Practices in Photography* from a chapter originally published in *Business Basics for the Successful Commercial Photographer* (2006).

MARKETING IS A LOT OF WORK. IT'S A LOT MORE THAN MANY PHOTOGRAPHERS first think and, when they realize how much they will have to do, more than a few will balk. Darn it, you just want to shoot and get paid for it. Most photographers at one time or another have exactly those same feelings, and they often lead to this thought: "Get a rep! My rep will take care of all that stuff, and I'll be free to shoot and get paid!"

Unfortunately, like most things, the rep-photographer relationship isn't quite that simple. In fact, a rep may not be the best solution to your needs. There are other options, such as marketing assistants and consultants. Let's look at each of these marketing helpers for a better understanding.

THE REP

Each and every rep out there does a variety of things for her talent. Every rep builds relationships with (potential) clients, but beyond that the roles can vary dramatically. Some reps only do that, arranging meetings, schmoozing, building lists (which, by the way, are usually the property of the rep, not the photographer), while others develop complete marketing plans, come up with advertising strategies, and participate in designing mailers and ads. Some do the estimating and invoicing, but others just tell their talent that the fees should be X dollars for a specific project and leave the shooter to do the rest. Some work as producers (casting, arranging crew, etc.), while others expect their talent to

handle the details. In addition, some expect to receive as much as 35 percent of the fees for their services, though around 25 percent is more usual, and that's not always directly related to what they do for you—that is, a rep who does "everything" might want 25 percent while one who only builds relationships and suggests fees might expect 30 percent. Each rep has his own way of doing business. You need to find the right one for you.

Some rep firms will only handle one or two talents, while others may have a whole bevy of talent, including some who share your specialty and/or general style. So what does that mean for you, the creative person? It means you had better know what you want before you go looking for a rep.

If you just "want more business," then you should re-evaluate your needs to be more specific—you might be able to do that yourself once you determine your real goals (for example, maybe you just need to be a bit more organized). But if you want someone to work with you to build your client base, provide expert advice on a variety of business-related subjects (contracts, usage, fee structures, marketing, and the like), to help define your best market, to get your book to the right people, and to (most importantly for their cost) negotiate better fees, then maybe you should seek out a rep.

Getting a rep is not unlike trying to get a new client. You will have to convince the rep that you are worth his effort. Talent isn't the only thing (though it is obviously important); you have to convince this person that you know how to do your job—both creatively and business-wise.

"But," you may be thinking, "that's why I want a rep—to do that business kind of stuff!" Yes, but no rep is going to touch you if you don't show some sign of at least understanding the business side of your business. You're still going to have to work, to hold up your end of the bargain, and if you don't have a clue what that involves, a rep is not going to be interested. No rep is going to want to handle a photographer who doesn't understand the importance of deadlines, how to work with a client, and at least the basics of marketing.

A rep usually wants to work with an established talent—one who has a decent track record. A rep's reputation is as fragile as your own, maybe even more so—if you drop the ball on a project, you only hurt yourself. But if you work with a rep and drop the ball, you make him look bad and threaten the relationship between that client (at least—pray they don't talk to others in the business) and the rep, and all of his talent. Reps want to prevent that from ever happening. It makes good business sense for them to be picky.

Before you start looking for a rep, look at what you are doing now and make a list of what works and where you think you need help. Then make a separate list of your goals. Lastly, make a list of what you expect out of a rep. These lists will give you a good idea of your needs and will help in the actual rep search.

The rep/creative relationship is very much like a marriage: It had better be based on trust and good communication or it will fail. It is, in its own way, an intimate relationship. You wouldn't marry someone you had only known for two days, and you shouldn't get involved with a rep without taking the time to get to know him. It needs to be a match.

When you start looking for a rep, you can check out professional organizations like the Society of Photographers and Artists Representatives (SPAR) (but many reps who do not live in New York City are not members), AIGA, GAG, and the ASMP. Art buyers are another good source—they work with reps regularly and can tell you whom they like (and, maybe more importantly, whom they don't).

Once you have a list of potential reps, contact them. I suggest an intro e-mail or sending a promo piece, either with a personal note expressing an interest having this person represent you and sharing some information about your success to this point. In either case, ask the rep how she would like to be approached. Offer to send your book or your promo pieces from the past year, for example. You can try to call, but reps tend to be a busy lot and returning your call will not generally be a priority. You want to impress a rep in the same way you would want to impress a potential client, maybe even more so. And, most importantly, don't be discouraged if you don't get an immediate response. Reps, if they're any good, are busy people—so you must be persistent but understanding. You will not get a rep in a week or two; it could take months or even years, depending on where you are in your career and where they are in theirs. So market to them just the way you would to one of your A-list targets. Once you have someone who is interested in repping you, you need to get to know that person (or firm). Do you have similar goals? Attitudes? Are you comfortable talking with him? Do some more research on the potential rep—how is his reputation? Ask buyers you know for input. And importantly, do you like the way he looks and acts? That last question isn't as shallow as it seems. Your rep will often be your "face" for clients. If you don't think he presents himself in a manner you're comfortable with, then find someone else. A good rep is a great thing and a bad one can kill you, business-wise. Art buyers have said that they won't work with someone, even though his work was perfect for a project, because the rep was too unpleasant to deal with. Sad, but true.

Once you've found someone you're comfortable with, you'll need to negotiate what your roles will be. You need to have a complete understanding of what you will need to do, and your rep will have to know specifically what is expected of her. Who will take care of promotions/marketing? And who will pay for what? How many portfolios will your rep need? What are the financial goals? Who will decide on advertising in sourcebooks and make all the arrangements? Who will do the estimating? Billing? Collections? Producing? And what

about the rep's fees—what percentage will she get for house accounts? Non-house? And, what about if one of you decides to leave the relationship—who is obligated to pay what and for how long? All of these questions (and others) need to be answered before the relationship starts—and they should be defined in writing—in a contract. This protects both you and your rep. Just like a marriage, you both are going into the relationship with the best of intentions, but things can happen which might sour it. The contract will keep things tidy if there are any bumps along the road or if, heaven forbid, you need to end the relationship.

SPOUSES AS REPS, STUDIO MANAGERS, OR MARKETING ASSISTANTS

Many creatives think that their spouse would be the perfect rep (or studio manager, or whatever) for them. While there are exceptions, this is generally not a good idea. The spouse relationship has its own pressures and issues and, when combined with the business relationship, it is extremely hard to keep things separate. For example, it can take many months for a rep to do anything financially positive for a talent. If the rep is intimately aware of the home mortgage being due and child care cost and the like, she cannot effectively focus on what needs to be done for the long-term good of the talent. Instead, with an understandable but mistaken focus on the "now," she will often settle for less, just to get "something." In addition, if you have issues with your rep, and she is your spouse, it is extremely hard to address those issues without affecting your personal relationship. And who wants that? Lastly, if your spouse is not a professional rep, she will probably not negotiate the kinds of fees a "real" rep would. So in the end, you are not saving money but rather losing it. These issues hold true for having your spouse as your marketing assistant or studio manager too.

Regardless of who she is, your relationship with your rep is extremely important. Take the time to do your research, know what you want and need, and find your match. Then have patience while the rep does her job and builds relationships for you. In the end, if you've taken the time and done your part as well, it can be one of the best relationships you've ever had.

MARKETING ASSISTANTS

If, after you've looked at your list of needs, you determine that a rep may be too much or something that you cannot get right away but you still need help, there is a great alternative: the marketing assistant.

If you want someone to take care of all the "business crap" like labeling postcards and making calls, a marketing assistant can definitely be a good

addition to your company. The MA is often a part-time employee. I tell my clients to consider getting a junior or senior college student for this position. They'll need the experience, and they'll be cheaper than hiring someone out of school.

Unlike a rep who should be a full partner (or even your boss) when it comes to your marketing, a marketing assistant is definitely a step down the food chain. This is someone who can take care of many of your tasks, with the exception of things like personal meetings/portfolio shows, which you should do yourself.

A good MA will update the database and research targets for you, even making suggestions for potential targets and bringing ideas for new methods and tools to the table. This is one of the reasons hiring a student can be so beneficial to you both—the fresh ideas of youth.

A talented MA can easily grow into a full-time studio manager as your business grows. This can be a great long-term relationship. In fact, that's how I got into the business, as a studio manager who also did some marketing, until I got enough experience to become a studio manager/marketing rep (then, eventually, I launched my own repping company and took on additional talent). I spent many years in that studio manager/marketing rep role and the relationship is one that I still treasure.

CONSULTANTS

I don't think I could explain the roles of a consultant any better than Judy Herrmann did on the ASMPproAdvice listserv (*www.asmp.org/community/proadvice.php*) in April 2006.

> A good consultant can evaluate your work, assemble a strong, unified portfolio and marketing campaign, and help you map out a plan to achieve your goals.
>
> Once I've defined where I am and what I'm trying to achieve, I'd talk to some photographers about which consultants they've worked with and what their experiences have been. In particular, I'd try to find out if the consultant they've worked with has helped them effectively in the areas that you feel you need help in. Talk to the consultants that come the most highly recommended about their backgrounds and experiences and weigh how those experiences fit with what you need.
>
> If your first and foremost problem is that your work is stale, then you need a creative coach—someone that'll get you to shoot better images. If your work isn't commercial enough, then you might need a consultant that has a stronger advertising or commercial art background who can help you

revamp your style to something that's more viable. If the problem isn't your work, but rather your marketing materials or presentation, then you might need a consultant whose experience comes from the buying and selling sides of the business rather than the creative development side.

Finally, a consultant is someone that you bare your heart, soul and checking account balance to. They know more about your business than ANYone. They know about your fears, your insecurities, your self doubts, and anxieties. You have to feel like you can trust them. You have to feel confident enough in their advice to follow it even when it's something you've never done before or thought of doing or think will work. If you get the teeniest wiggly feeling in your gut when you talk to these people—if you feel that they're there to sell you on their services or to stroke their own ego or to do anything other than put their heart and soul into really thinking about what you need and what's best for you—run.

There are some great consultants out there. There are also a few slime balls. But mostly, there are people who have certain areas of expertise and certain areas that they aren't as strong in. Ultimately you just want to find the right match for you—someone who knows and has experience about where you're coming from, where you want to go and how you can best get there.

OTHER OPTIONS

There are also companies that will take care of a lot of your marketing "crap." For example, *www.Wiselephant.com* will design your site, print promos, e-mail promos, and even make the dreaded follow-up calls for you. List services like *www.AgencyAccess.com* or *www.Adbase.com* have integrated e-mailing services that combine their lists with distribution and tracking software so you can do all your e-promos in one step. Lost Luggage (*www.lostluggage.com*) also does more than provide you with the cases and outer trappings of your print portfolios; they offer other design services. Using any of these services, or a combination of providers, will help to get your marketing under control and will also help to keep it all on-brand.

Of course, you can get a lot of these same services "bundled" from your own designers. Design firms often handle both print and electronic design and some even have moved into offering e-mail blast management as well.

However, the big issue for all these choices is cost. That's something you're going to have to figure out for yourself—is it worth paying for? When you do the math, though, don't forget to figure your time and your exasperation factor into the calculations. I recently had a client who was spending hours each week working on fixing his Web site. Every time he wanted to add an image, it was a programming nightmare. And to top it off, he didn't understand some of the

rendering issues the Web generates and so his site looked terrible on certain browsers. Why was he doing it? He thought he was saving money over hiring the work out in some form. In fact, he was losing money on it—between the hours he spent, the ineffectiveness of the product, and the frustration over it all, "saving" that money by not hiring it out had cost him thousands. In other words, if you are being blocked by the effort of doing your marketing, it will probably be cost-effective for you to hire someone, at some level, to help you out.

SAMPLE CONTRACT BETWEEN PHOTOGRAPHER AND REPRESENTATIVE

AGREEMENT made this _____ day of _____ (year) _____,
by and between [Photographer's name and address] (hereinafter referred to as
"Photographer") and [Representative name and address] (hereinafter referred to as
"Representative"). The parties agree as follows:

1. Definition of terms

 As used for the purposes of this agreement:

 (a) The term "Active Account" is defined as follows: An account is an active
 account when it generates assignments currently; it is either a product worked on,
 an art director worked with, or the original individual buyer for whom assignments
 have been initiated. An account may be a single order or a continuing campaign.
 An active account must consist of assignments initiated or assignments done
 within a period of (six) (twelve) months.

 Upon the initiation of an assignment of any sort, oral or written, that constitutes
 an order for work, an account becomes active.

 (b) The term "House Account" is defined as follows: A house account is an
 active account reserved to the Photographer or to the studio, from which the
 Representative is restricted in service of solicitation and on which the Representative
 does not receive commission, but with specified conditions may receive partial
 commission. When full commission is given the account is no longer a house account.

 (c) The term "Library Account" refers to a general assignment which is
 undertaken on the basis of payment per picture use, where the pictures are to
 be paid for by the client for current use and are intended to be used and paid
 for by the client in the future, as well. A library account assignment represents
 an income source which extends in to the future and which, therefore, generates
 future commissions for the representative.

 (d) The term "Stock" is defined as follows: Stock refers to photographs taken
 either independently or on assignment on which publication or use rights revert
 to or are retained by Photographer or the studio after use or rejection of the
 original stock. Stock rights belong solely to Photographer or the studio.

2. Representative shall use his or her best efforts to solicit assignments, contracts,
 and other work for the Photographer.

 (a) Representative shall work in the following geographic territory: _____

 (b) Representative shall represent the Photographer in the following fields of work:

3. During the term of this agreement, Representative agrees not to represent any
 other photographer [Option: any photographer other than those enumerated on
 an attachment to this Agreement] without the written consent of Photographer.
 Photographer shall not use one or more other representatives in the territory
 and the field(s) described above without first obtaining the written consent of
 the Representative.

4. The following are house accounts:

 a. _____

 b. _____

 c. _____

 d. _____

 At any time hereafter, if Photographer is solely responsible for obtaining an
 account, said account shall become a house account.

5. Representative's commissions shall be as follows:
 a. Advertising _____
 b. Stock _____
 c. House Accounts _____
 d. Library Accounts _____
 d. Editorial _____

6. Commission shall be calculated against the net photographic fee; i.e., the photographic fee exclusive of expenses chargeable to the client. In the event that a "flat fee" shall be set, the net photographic fee shall be that remaining after actual expenses directly relating to the specific job have been deducted.

7. Representative's claim to commissions shall arise when the Representative obtains a new assignment from an active account, subject, however, to Photographer's acceptance and completion of the assignment. Representative shall have no claim to commissions if for any reason Photographer refuses an assignment or if, after accepting it, Photographer does not complete the assignment.

8. Representative shall pay his or her own expenses, including telephone, entertainment, delivery, and general business expenses.

9. Billing shall be made in accordance with subparagraph [specify (a) or (b)] below. In the event an election is not made, subparagraph (a) shall be deemed to have been adopted.
 (a) Photographer shall be responsible for all billing, shall be named in all purchase orders, and shall provide Representative with monthly statements, or copies of all bills rendered, for accounts Representative has serviced. Upon reasonable demand, Representative shall have the right to examine Photographer's bills and receipts for accounts Representative has serviced. Payment to Representative shall be made within 10 days of receipt of moneys.
 (b) Representative shall be responsible for all billing and for all purchase orders on accounts for which he is responsible, and shall provide Photographer with monthly statements, or copies of all bills, for all accounts which Representative has serviced. Photographer shall be named in all billing. Payment to Photographer shall be made upon receipt of moneys. Upon reasonable demand, Photographer shall have the right to examine the Representative's purchase orders, bills, and receipts on all accounts Representative has or is servicing for the Photographer.

10. Both Photographer and Representative warrant that each has now in effect, and agrees to maintain during the term of this agreement, personal liability insurance with coverage in the amount of at least $100,000.

11. The relationship between Photographer and Representative shall be that of independent contractors, and nothing contained herein shall constitute this arrangement a joint venture or partnership.

12. Photographer retains the right to refuse any assignment obtained by the Representative.

13. Photographer shall not be bound by any representations or statements made by Representative unless Representative is specifically authorized by Photographer to make such statements or representations.

14. Photographer agrees to provide Representative with samples of work, to replace same as they deteriorate, and to provide a reasonable amount of fresh work from time to time.

15. Representative shall not acquire any rights in any of Photographer's work, and shall return any and all of said work on Photographer's demand.

16. This agreement shall terminate 30 days after receipt of written notice of termination given by either party, subject to the provisions of paragraph 17.

17. Termination

 (a) Upon termination, Representative shall receive commissions from all active accounts as provided for under this agreement for a period of ____ months; however, on library accounts Representative shall receive commissions for a further period of ____ months. Representative shall be entitled to no other or further commissions, or remuneration of any kind.

 [Alternative]: Upon termination, Representative shall receive commissions from all active accounts as provided for under this agreement for a period of ____ months. After this agreement has been in effect for ____ months, the period for such commissions shall be extended by an additional ____ months [optional: and commissions will also be paid on house accounts at the reduced rate of ____ percent for ____ months]. On library accounts, Representative shall receive commissions for ____ months. Representative shall be entitled to no other or further commissions or remuneration of any kind.

 (b) If Representative is replaced with a new representative, notwithstanding paragraph 17(a) above, at any time after termination the parties shall have the option to mutually agree in writing as follows: Upon the effective date of an agreement between Photographer and a new representative. Representative shall receive half commission. Such Entitlement shall last for the period from the effective date of Photographer's agreement with the new representative until the final date for termination compensation as provided above in this agreement. Such mutual agreement between Photographer and Representative shall specify those accounts from which Representative shall be entitled to receive half commission. In the event of such mutual agreement, Photographer shall provide in the agreement with the new representative that all such specified accounts shall be serviced by the new representative for the duration of Representative's payment period. In the event of such mutual agreement, Representative shall not be entitled to any other or further commissions or remuneration of any kind.

 (c) Notwithstanding paragraphs 17(a) and (b) above, at any time after termination the parties may mutually agree in writing to provide for a cash settlement which shall discharge all obligations and duties owed to each other under this agreement. Under this cash settlement procedure, Representative shall relinquish all rights to any future commissions payable under this agreement.

 (d) In the event Representative shall have been responsible for billing under paragraph 9(b), upon termination Representative shall supply Photographer on demand with copies of all outstanding purchase orders and bills.

 (e) Upon termination, either party shall have the right to notify third parties of the termination of this arrangement.

18. Any controversy or claim arising out of or related to this contract or the breach thereof shall be settled by arbitration before a single arbitrator in the City and Sate in which it has been executed in accordance with the rules of the American Arbitration Association or, at the election of both parties, in accordance with the rules then obtaining before the local Joint Ethics Committee, if any. In either instance, the award rendered may be entered in any court having jurisdiction thereof.

19. This agreement is personal to the parties and is not assignable by either party, unless the assignment is to a corporation in which the assignor is and remains the majority stockholder. This agreement shall be binding upon and shall inure to the benefit of the respective heirs, legal representatives, successors, and assigns of Representative or Photographer.

20. This agreement constitutes the entire understanding between the parties and no modifications shall be of any force and effect unless made in writing and signed by the parties hereto.

21. Notice shall be given to Photographer at _____

and notice shall be given to Representative at _____

Notice shall be deemed received on the date of personal delivery thereof, or two days after the date of mailing such notice by U.S. Mail.

22. Both parties agree to execute and deliver such further documents as may be necessary or desirable to effectuate the purposes of this agreement.

23. This agreement shall be governed by the laws of the State of _____

Photographer: _____

Representative: _____

Date: _____

City and State: _____

Sample Notice of Termination
Under Paragraph 16

To: Chris Representative

Please be advised that I am giving you notice of termination of our agreement of _____ (date), and that thirty days after your receipt of this notice our agreement is terminated.

Unless we enter a further agreement providing for termination payments to you under paragraph 17(b) or 17(c) you will be paid in accordance with paragraph 17(a).

At the end of thirty days, please return to my studio all my art work which you now have.

[Since you have been doing the billing, please turn over to me within 30 days copies of all outstanding purchase orders and bills.]

(Pat Photographer)

Sample Agreement
Under Paragraph 17(b)

_____ (date),

To: Pat Photographer

I understand that our agreement of _____ (date), (was) (will be) terminated on _____ (date), which is thirty days after my receipt of notification of termination from you.

I further understand you have entered into an agreement with another representative, (Mr.) (Ms.) _____ and that (he) (she) will start working as your representative on _____, (year)_____.

In consideration of my release herewith of all claims which I may have against you on account of commissions or otherwise, you agree to pay me half commission from _____ (date), until _____ (date), on the following accounts:

1. _____

2. _____

3. _____

I also understand that you have arranged to have your new representative service these accounts during the above period.

If this letter sets forth your understanding, please sign below and return the signed carbon to me.

By your signature you will acknowledge receiving copies of the following bills and purchase orders which had been made by me on your behalf:

1. _____
2. _____
3. _____

Sincerely yours,

(Chris Representative)

Accepted and Agreed to this _____ day of _____ (date)

(Pat Photographer)

Sample Agreement
Under Paragraph 17(c)

To: Pat Photographer

I have your notice of termination of _____ (date)

In accordance with Paragraph 17(c) of our agreement of _____ (date), I hereby release and discharge you from all claims which I now have under that agreement, in consideration of your payment to me of $_____, receipt of which I hereby acknowledge.

Sincerely yours,

(Chris Representative)

Accepted and Agreed to this _____ (date)

(Pat Photographer)

Reinventing Yourself

by Elyse Weissberg

When was the last time you took a hard look at your portfolio? Do the images in your book best represent the style you are currently shooting? Is it well edited? Does the presentation look current? Is it positioned toward the type of assignments you want to shoot? If you answered "no" to one of these questions, then it is time to reinvent your portfolio. Your competition means business. They are not "making do" with their portfolio, so neither should you. Although pricing may be a factor in choosing a photographer, it is your portfolio that often makes the final hiring decision.

Do the images in your book best represent the style you are currently shooting?

Ask yourself: Does your photography have a specific style? Although you may be a generalist (shooting still life, people, and location), there should be a concise style to your photography. That style should be carried across into your portfolio presentation, promotion, and company identity. Having one "look" for your total package will position you and your company in the way you want to be thought of.

Is it well edited? As you know, bad self-editing can weaken a portfolio. Make sure the pictures in your book are your strongest "photographic" images—as opposed to images you like for personal reasons. A portfolio with "mixed styles" may be confusing. Many photographers do shoot different styles (depending on the client and subject matter). The best way to present a variety of images in your portfolio is to support each style with five to six strong images. That will show the viewer that you are well versed in each area. Another common mistake is having too many pieces in the book. A good number of pieces for a general book ranges between fifteen and twenty-five images.

Does the presentation look current? If your portfolio has had the same look for the past three to five years, then you should think about making some changes. The changes do not have to be drastic. Adding new images—whether

they be test shots or personal work—can bring more of your point of view to the portfolio. Take chances. Don't try to second-guess what you think clients may want to see. Go with beautiful, well-lit photography. Isn't that why you became a photographer in the first place?

Most art directors are bothered by the little care some photographers take with the "upkeep" of their portfolio. Portfolios that are falling apart, and those with worn boards and badly scratched plastic pages and plastic sleeves do not look professional. Your portfolio needs constant maintenance.

Is your portfolio positioned toward the type of assignments you want to shoot?

Looking through magazines, annual reports, and other visual material in search of "I wish I had shot that" images will help you to define your market. I ask photographers whom I consult with to keep a file like this. It helps them to see how their potential clients are using photography and shows them the types of ads that are being produced. Then ask yourself whether the images in your portfolio relate to the way your potential clients are shooting. If they don't, it's time to shoot some tests. Use the materials that you have collected to inspire you to create your own new images.

Ten New Year's Resolutions for Self-Promotion

1. Call all the clients you worked with and wish them a "Happy New Year." Then tell them you are looking forward to working with them next year.

2. Look through your portfolio and edit out those "filler" images. Less is more; keep your strongest pictures in the book.

3. Keep your portfolio looking fresh. Replace those worn mats, damaged laminations, and scratched plastic sleeves.

4. Create an identity for yourself. This can be accomplished with a creative logo that best represents your style of photography.

5. Design a new promotion piece. Create a fresh look for your mailer or leave-behind.

6. Plan a promotional strategy for the next year, even if it is on a minimal scale, such as sending a promotional card to all your past clients on a quarterly basis. This will help your clients remember you.

7. Send out or drop off your book to one new client a week. Be proactive!

8. Make an effort to get more editorial work. The rates are low, but the credit lines are good exposure.

9. Make a wish list. Keep it a manageable size. Choose five new clients with whom you want to work and go after them.

10. Keep a positive attitude. Remember: Your talents are both needed and valuable.

Negotiating

"Everything you do has value. You don't just
drop your price or raise your price for no
reason."

—Chase Jarvis

Negotiating Principles

by Michal Heron and David MacTavish

Michal Heron is a freelance photographer working on assignment for editorial and corporate clients. She is the author of several books, including *Digital Stock Photography: How to Shoot and Sell*, and *Creative Careers in Photography* and is co-author of *Pricing Photography*. A former board member of the ASMP, Heron has appeared on numerous panels relating to the photography industry, including the Maine Photo Workshop. She divides her time between New York City and the Catskill Mountains of New York state.

David MacTavish was a Chicago location and aerial photographer for twenty-five years and the ASMP national president from 1988 to 1991, the ASMP national board director, and Chicago-Midwest Chapter president. He has lectured internationally about copyright and photographers' business issues. MacTavish now represents photographers and other creative people with matters of copyright and other intellectual property through his firm, the Law Office of David MacTavish. He can be contacted at *david@mactavish-law.com*.

———————————— • ————————————

The following text was adapted for use in *ASMP Professional Business Practices in Photography* from a chapter originally published in *Pricing Photography, The Complete Guide to Assignment and Stock Prices* by Michal Heron and David MacTavish (2002), published by Allworth Press. In addition to this chapter on negotiating principles, *Pricing Photography* covers in detail how to determine your pricing structure and includes extensive stock and assignment pricing charts. *www.allworth.com*.

NEGOTIATION IS AN ART. IT IS ALSO AN ESSENTIAL SKILL IN BUSINESS. ANY PHOtography business, whether assignment or stock, will founder without a good flow of income derived from the successful negotiating of prices.

The keys to a flourishing photography business are good photography, knowing what price to charge, and being able to negotiate to get that price.

Picking a figure out of a price list may seem the easy answer to a client's request for a price quote. But a price-list price can't possibly offset the intimidation you'll feel from a client who pretends to faint or who barks "You're charging what?" if you don't truly and fully understand why you've selected that price.

At that moment, your adrenaline starts flowing, and fear takes over. Without the information to back it up, your price, if plucked from a list, becomes a mere straw in the wind. Only a firm grasp of the economics of your own business (including your bottom line as outlined in chapter 2) and of skill in using negotiating techniques will make you comfortable answering that client's confrontational question calmly and from a position of strength.

Strength comes from understanding and believing that the figure you've quoted is a reasonable one. It comes from being able to articulate why you've quoted that price and from knowing your bottom line.

The first step in building that negotiating strength is to break the chains of stereotypical attitudes.

ATTITUDES TOWARD NEGOTIATION

Negotiating may be photographers' least favorite aspect of the business—and their single greatest weakness. Often, we are our own worst enemies when it comes to dealing with money. A combination of myth and misconception intrudes on our ability to require a fair price for our work.

A fortunate few are born with a natural skill at negotiating. They like the challenge and the excitement that comes with making a successful deal. As surprising as it may seem, negotiation is second nature to them.

But the majority of us must learn how to negotiate. With time and training anyone can become an effective negotiator. It's done by practicing technique and by summoning courage.

The first step is to throw off the yoke of misconception that holds us back from acting in our own best interests. Some of us work with the naïve belief that our talent will be recognized automatically and justly rewarded. Also, we may buy into the following myths:

- It is undignified for a creative person to talk about money.
- We may appear pushy, materialistic, or greedy by holding out for a fair price.
- Our worth is measured by the amount the client is willing to offer (the client must know how much we're worth).
- If we don't accept this deal, the buyer will never call again.

Fear is the culprit here—fear of what a client might think of you, fear of taking risks, fear that paralyzes. The effects of fear are far reaching. They get in the way of clarity, preventing you from asking the right questions and from getting the information you need to quote an accurate price.

WHERE DID THESE ATTITUDES ORIGINATE?

It has not been routine in our culture to negotiate prices for consumer goods. Historically, we have been more likely to accept and pay a ticket price than to assume we could bargain. In addition, a few arrogant or unpleasant photographers have made negotiating a dirty word. But there are many fainthearted photographers who by their lack of courage have done equal damage to the climate for negotiating. By this attitude, clients have been led to believe that they can dictate photography fees, sometimes to a level below what it costs to run a business. These photographers have accepted the underlying message that we can't sell our work if we dare to question what buyers offer.

Successful, amicable negotiations occur every day in the photography business. To learn the tactics necessary to emulate these transactions, we must first shed old habits.

CHANGING ATTITUDES

To change the attitude, face the attitude. A first step in taking the risks necessary to becoming a good negotiator is to change the way we view the world of negotiating. Consider that reality is the opposite of the myths listed earlier in this chapter. Consider that:

- It is fair and reasonable to charge enough to earn a living.
- It's possible to explain why you must charge a certain price in a dignified, professional manner.
- Charging a fair price is a way of showing respect for your photography.
- Self-confidence is not incompatible with creativity.
- It is not reasonable for buyers to expect to use photographs for whatever price they want to pay, no matter how low.
- You are not personally responsible for the survival of the client's project.
- A love of photography doesn't require you to subsidize everyone who asks.
- It is possible to say "no" courteously to buyers and still have them call you again.

If you are still having trouble justifying your right to a fair price, consider an enlightened self-interest approach. Getting a good fee allows you to improve your service to the client. It allows you to invest in new equipment, spend time

and money on testing film, filters, or lighting, and to experiment with new creative approaches. Explain to your client why you need to maintain a fee structure that allows for investment in research and development and how it benefits them. But, make sure you believe it first.

ROLE-PLAYING

In order to feel comfortable making your negotiating points to a buyer, some photographers role-play a buyer/seller situation with each other. It is a technique some stock agencies use to train new sales people. The "buyer" writes down a type of photographic usage, the top price the client's company is willing to pay, and the low price that is buyer's goal. The "photographer" writes down the lowest acceptable price as well as the highest price that seems even remotely possible for the usage—the dream fee.

They begin discussions. When an agreement is reached, the winner is the one who came closest to his or her goal price. It is a great, entertaining technique for polishing the rough edges of negotiating.

Role-playing as a technique for learning to negotiate should not be dismissed lightly. It is enormously valuable and can break down the stage fright one may encounter when talking with a client. Actually, I have had more stage fright when role-playing with my photographer friends than with many clients. I found I was concerned about my colleagues' respect and good opinion of me and sometimes clutched for an answer. After all, with clients it was only money! But that uneasiness of role-playing with friends was a valuable lesson and paid dividends when it came to real negotiating situations. If you are new to the business and don't have many photographer contacts, join organizations like the American Society of Media Photographers (*www.asmp.org*).

Once you have polished your negotiating conversations through role-playing, keep in mind that while your practice sessions may give you courage, your presentation style must be polished as well.

Be vigilant when negotiating—given half a chance, photographers needlessly tend to sell themselves short. With clients, your tone should be pleasant and accommodating—holding absolutely firm when they can't meet your bottom price, but standing your ground all in a cordial manner.

The reasons? It's a better negotiating tactic to be pleasant. But the more important reason is that this is your world, this is how you spend your days, and these are your clients. They sometimes become friends. Why not make the time and process enjoyable? Being contentious won't add any joy to the day, license any more photographs, or land any more assignments.

STARTING OUT

If you are new to the business, you may, as you read this book, be wincing at every reference to "experience" and wondering how you'll get it. As a new photographer, you can use all the techniques we mention, simply modified to your circumstances. If you are looking for assignment work, you have probably done some assisting for established photographers. When working for another photographer, learn all you can from the experienced pro's business habits and negotiating style. If you haven't assisted, try to connect with some experienced photographers through trade organizations. These contacts may also shed light on the stock business.

If it seems more difficult to take the plunge with stock pricing, remember that it doesn't hurt to be honest with a client. In some cases you may even let the client know you are new to the business, but do so with this caution in mind: If the client wants to use your photograph, it has value, no less value for the client's purpose than if you'd been in business for twenty years.

Even as a newcomer, you shouldn't give your work away. You may consider a slight break for volume, or a slight percentage off (10–15 percent, tops) and let the client know why: "I am breaking in and want tearsheets for my portfolio, which is why I can give you a better price." Always negotiate a trade when you adjust your price, and put on your invoice that the discounted price must be accompanied by *xx* number of tearsheets or reprints, per your discussion. But use this technique *only* if you are really being pressed on price. A client may simply like your photography and pay a standard fee. So don't rush to assume your clients know how green you feel. Playing the novice card is only for the rare, tight pinch.

NEGOTIATING STRATEGIES

Becoming a good negotiator takes practice, a knowledge of the business (so you can educate clients), and confidence in yourself. Lack of courage is what limits most photographers.

The goal and measure of a successful negotiation are clarity, a fair price, and a return client. You need clarity to avoid the confusion and misunderstanding that breeds conflict, a fair price so you can stay in business, and a repeat client because that's how you continue to prosper. The ideal is that both you and your client are happy with the outcome of a negotiation.

You may say, "What's to negotiate? The buyer has a price and a budget in mind. That's what the buyer will pay, and I can simply take it or leave it." Wrong. Every time you discuss price or assignment specifications, it is a negotiation. The only question is how successful the outcome is for you.

There are six basic steps that take place in every negotiation, whether handled in ten minutes or over a period of days, and they are crucial to the process.

NEGOTIATING STEPS

- **Establishing rapport** is the first step in any contact with a client. It may seem self-evident, but start with a friendly, welcoming tone. Find some common ground—the weather, the holidays, recent events. Next, express your interest in the client's project. You may think it's obvious that you are pleased by the call. Not so. Say it. Show interest in the company, in the client's publication, and in this particular request.

 If you set a good tone, the caller will enjoy the exchange and remember that it is pleasant to work with you. Removing a little stress from the day will stand you in good stead.

 Learn to read the mood of the client through voice inflection or body language. When a client is busy and not inclined to small talk, pick up the clue. Stay cordial, but conclude in a quick, professional manner. However, don't let a buyer rush you into a price quotation before you get the facts. It's perfectly legitimate, and to the client's benefit, to ask for time to give thoughtful attention to figuring a price.

- **Gathering information** is the critical step. Ask about usage. You must know where, how big, for how long, how many times, and for what purpose the picture will be used. Make clear that you can't quote without this information, and explain why. Let your clients know that price depends on usage, size, and many other factors. Make the point that by being very specific with usage you may be able to give them a better price.

 When quoting an assignment, explain that it's not only usage that affects the fee but the complexity of the shoot and pre- and post-production logistics as well.

 In stock, the fee can also depend on which of your photographs they are considering—one produced under normal conditions or one involving high model costs, travel expenses, or other costs which will affect the price.

- **Educating the client.** When you are dealing with a knowledgeable long-time client or with a new one who clearly knows the ropes, you may not have to do any educating. But if you suspect that the buyer is new to the field or inexperienced in the area you're discussing, then it will help if you clarify industry standards as the groundwork to negotiating.

 One sign of inexperience (or an experienced but tough negotiator)

may be a reluctance or inability to give you information about the project, particularly about usage. "Just tell me how much—I'm not sure how we'll use it," is a giveaway. It's more likely to stem from inexperience than duplicity, but it still creates an impossible negotiating atmosphere, for you at least.

Explain that it is industry standard to price by usage as well as by your cost to produce. Let such clients know that it works to their advantage to limit the rights they need. Explain that vague, sweeping, all-encompassing usage can be more costly. If your clients aren't sure about future uses, create a range of fees for additional usage to help them in planning. Indicate that potential future rights, negotiated now, will be lower than if they come back to you in a few years. Say something like, "We could create a package deal for you with any future uses for posters rated at $*xxx* and brochures at $*yyy*." This approach relates to assignment usage rights as well as to stock fees.

It is vital that you focus everyone's attention on the disparity between the enormous cost of media placement and the cost of photography. Doing so reminds your clients of an obvious fact they may wish to ignore, and it helps reduce any insecurities you may feel about asking for a fair deal. After all, it's the image-maker that provides the emotional resonance of the advertiser's message; you deserve a fair share for that contribution.

When negotiating assignments, pay very special attention to any request for work for hire, all rights, or buyouts from any client. Use the reasons listed above for limiting rights for the sake of controlling the client's costs. It's enough to say here that buyouts should be avoided like the plague, since, when you give away all rights, you are dramatically limiting your future earnings by killing off residual usage from the assignment client as well as potential stock use.

Here's another red flag that may indicate inexperience in assigning photography: "We need the Pittsfield facility photographed, and it's a one-day job. No, the Corporate Communications VP will be out of town. No, we don't have the plant manager's phone. He'll show you around when you get there." Let these potential clients know why vague, free-floating arrangements can cause expensive assignment problems and that part of helping them get the best price is to avoid disasters in the making.

When informing an inexperienced client, handle it in a subtle, friendly manner. List the factors that affect a stock price or assignment fee.

In order not to appear condescending or didactic, use the phrase, "As I'm sure you understand . . ." to preface your comments. This lets you present information in a way that helps inexperienced clients relax and possibly save face, so that they can hear your information in a neutral environment.

Why might you be dealing with inexperienced people? In today's fluctuating economy, many advertising agencies, corporate communications departments, and editorial art departments have eliminated various levels of support positions. An overworked art director or photo editor may even use a trainee or secretarial assistant to do groundwork. You are helping yourself when you help the caller become informed.

Don't hesitate to give objective backup to your position by referring an inexperienced client to this and other books or sources. (It might be wise to do this—if you can—before pricing comes up.) It's easy to say, "If you don't have copies, you might find some of the ASMP publications useful. They provide a good background on what we're discussing. . . ."

Understanding on the part of both sides makes the process work. While you are educating the client, don't forget about the overhead factors that must be a real, if silent, part of every negotiation. You *don't* bring it into a discussion as a whining complaint, "I can't afford to license at that price or I'd go out of business." Rather, use it as a reminder to yourself that you have to cover your overhead in order to continue to provide quality images. If it's necessary to mention this factor, do it in a positive way, to underscore your persistence in holding firm to a price: "I'd love to help you with a lower price, but given the extraordinary costs of materials and overhead, it isn't practical for me to go any lower."

- **Quoting the price.** Though basic approaches still apply, the actual discussion of numbers is where stock and assignment price negotiations will differ.

 When negotiating stock prices, you are usually discussing a specific picture. The buyer will use the photograph, or not, based on how closely the perceived value to the client matches the reproduction fee you quote.

 However, assignment pricing is complicated by many factors, including costs of preproduction planning, props, models, crew, rental fees, location fees, travel time, creative fee, and photography expenses, such as film and processing.

 In pricing either area of the business, stick with the principles:

 - Get the information.
 - Don't be rushed into a quote.

- Quote a range (to leave some leeway for movement).
- Have a bottom line.

You must guard against taking the shortsighted attitude, "Good for me if I can just cover my overhead, plus a little extra, and save the client. Why not?" This viewpoint continues to cost photographers—from the amount of money they can put in their pocket to the amount of money they will be able to make in the future. Why? Clients use previous production budgets to calculate current and future budgets. Many art buyers have said that once the account executives and clients have gotten accustomed to getting good, usable photography at the fire-sale prices that have prevailed for the past few years, it's almost impossible to increase budgets for future productions. So whether it makes sense or not, art directors are given smaller and smaller budgets to work with and are still told, "Make it happen! Find a photographer to do it for less." And the downward spiral continues. As long as there's no resistance from photographers, pragmatic buyers will continue to squeeze more from the overall budget (at your expense) to cover the ever-increasing cost of media space.

- **Closing the deal** is an aspect of negotiating that some photographers let slide. It can cause messy repercussions through misunderstanding. Once you have negotiated a fee, make sure it is clearly understood by both parties. For stock usage, ask the buyers if they will be sending a purchase order. Assignments often include complex and detailed estimates as part of the negotiating process. In addition to asking the clients to sign-off on your final estimate and to provide you with a purchase order, send your own follow-up memo confirming specific aspects of the assignment, such as who handles what—researching locations, booking models, making travel arrangements, and so forth.

 Note that the exact license of usage rights must be spelled out in your invoice both for stock and assignments. At this stage you are merely summarizing what you will be billing for later.

- **Following up.** Letting a client know that you are interested in the outcome of an assignment or the results of a stock usage is important. On an assignment, call shortly after the finished work has been received to see if the client is as pleased as you were with the photographs. Check in again later, once the materials are printed. Use that as an opportunity to request tearsheets. Ask about the success of the project, learn how others in the corporation viewed the work, and possibly find out about future plans.

 Following up is a way of letting your clients know that you value the relationship with them, that you are serious about your work, and that

their success is important to your satisfaction with the job; you don't just take the money and run.

VALUE OF PHOTOGRAPHS

Photographs have value to users only to the degree that they solve a visual problem for them, whether it's illustrating a magazine article or advertising a product. The amount they will pay to assign a shoot or to reproduce a stock photograph depends on what they perceive as the value of that particular photograph to their project.

The value of a stock photograph or assignment, to you, is much more complex. There are economic, aesthetic, and emotional components that sometimes cloud the pricing issue. Photographers may hesitate to charge enough for a stock photograph they especially like, not wanting to risk having their price turned down.

Assignment photographers may be tempted by the opportunity to shoot in an exotic location and may dramatically lower their fee in the mistaken belief that they shouldn't be well paid for something they love to do or that the only way to secure the job is to charge little. Take a cool-headed look at the economic value of your photography. When quoting an assignment, understand that any special equipment, techniques, or skills you have to offer add value that affects the fee. You are charging for your creative and technical abilities, not just your time.

In stock, you can and should place greater value on some photographs than on others. Measure your photographs, and price them based on their cost to produce and on their unique quality—not only on the client's intended use or ability to pay.

NEGOTIATING CONVERSATIONS

Having absorbed these principles of negotiation, you must now believe; believe that you have the right and the ability to negotiate a fair price. Once you are a believer, it's simply a matter of expressing these negotiating methods in your own style. No matter what words you choose, remember to communicate the following:

- You want to help the client, to work it out, to conclude a deal.
- You understand the client's problems.
- You hope the client understands your situation.
- You are disappointed when you can't reach an agreement.
- You hope that there will be another opportunity to help the client out.

Your tone is accommodating. A polite but firm manner must be shown when you have reached your bottom price. Regardless of how you really feel about the negotiation, you must project an earnest desire to solve the client's problem. In fact, you do want to conclude a deal, and you are disappointed when you can't answer the buyer's needs. Not only is an accommodating attitude smart negotiating, but it usually has the additional merit of being true.

NEGOTIATING IN HARD TIMES

Price cutting is not the answer to a tight economy. It's easy to say, because it's true, that to get work in a tough climate you must be better, more original, and more creative than the next photographer. It certainly helps. However, in assignment work personal attributes are valuable to a client as well. Being perceived as someone who is easy to work with will give you an edge, perhaps even over a very creative but arrogant hot shot. Competence and dependability are highly valued, especially when money is in short supply. Make sure you let clients know your ability to meet deadlines and solve problems. Buyers may be less likely to take risks during hard times, so promote your dependability, along with your creativity quotient.

Finally, remember that negotiation is not at odds with the creative aspects of photography. Believe it or not, there are many photographers who are good photographers, skilled negotiators, and nice people.

Summary: Steps in Negotiation

- *Establishing rapport:* Create a friendly climate for doing business. Open or respond in a pleasant manner. Express interest in the project. Set the tone as professional and cordial.
- *Gathering information:* Whether you are negotiating an assignment or a stock reproduction fee, it is critical to get enough information before beginning a pricing discussion. Find out the usage: for what purpose, where, how big, for how long, how many times, and so on.
- *Educating the client:* This may be necessary when you suspect that the buyer is new to the field. Before quoting a price, make sure that the client is aware of industry standards. In a concise, polite way, set out the factors that affect a stock price or assignment fee.
- *Quoting the price:* Do not talk money until you have all the information available about usage and production requirements. Do not be rushed. Assignment estimates can be complicated—you need time to give a responsible quote. If possible, find out the client's budget before you answer the query, "What do you charge?" Quote a price range to

encourage the client's response. Know your bottom line, the figure below which it's not worth making a deal.

- *Closing the deal:* When you have agreed upon a fee, expenses, and a production budget, make sure everything you have negotiated is clearly understood. Request a purchase order. Confirm in writing, by fax if necessary, by sending your own estimate form and a memo confirming your understanding of all the details of an assignment.

- *Following up:* Checking in with clients, particularly after you've turned in an assignment, is a useful way to let them know that you value the relationship and are serious about your work. You can request tearsheets, ask about the success of the project, learn how others in the corporation viewed the work, and find out about future plans.

Negotiating the Assignment Deal

by Richard Weisgrau

Richard (Dick) Weisgrau's career in photography spanned more than forty years. During that time he worked as a professional photographer for twenty years. He was an ASMP member for fifteen of those years. After that he served as executive director of the ASMP for fifteen years, and then as a consultant and expert witness in photography-related matters. He is the author of four books about the business of photography. Today, his interest in photography is limited to shooting subjects of his choice, and exhibiting and selling prints.

———————————•———————————

The following text was adapted for use in *ASMP Professional Business Practices in Photography* from a chapter originally published in *The Photographer's Guide to Negotiating* (2005), published by Allworth Press. In addition to this chapter on negotiating the assignment deal, this book covers the strategies and tactics of negotiating, details on negotiating stock photography fees, and outlines steps for negotiating contracts and purchases. *www.allworth.com.*

OF ALL THE NEGOTIATING CHALLENGES A PHOTOGRAPHER ENCOUNTERS, negotiating an assignment deal is usually the most difficult. I am not saying it is difficult by nature. I am saying that the negotiation of an assignment deal is more difficult when compared with negotiating a stock photography sale. I say this because you are negotiating a price for something that does not exist at the time of the negotiation. You are negotiating for the opportunity to create something. Unlike a stock photography sale or the purchase of a camera, the assignment's tangible product, the images, exist only as concepts—until after the work is done and the photographs are made. In other words, the buyer does not know exactly what she is buying.

INTANGIBLE FEARS

Take a moment to think about buying stock shares in a company. You are buying a piece of paper that has an assigned value on the day you buy it. This value is based upon many factors, including the emotion-driven, fickle stock markets of the world. You could pay $100 per share for a stock on a Monday, and it could drop in value by 50 percent by Friday. While you hope that your research into the company whose stock you bought will protect your investment, you realize that factors beyond your control can affect the value of any stock shares that you buy. One major factor is the performance of the company issuing the stock.

An assignment's outcome depends, in the first place, upon the performance of the photographer. A complex assignment may also depend upon the performance of several other people under the photographer's control: Assistants, stylists, models, set and location preparers, and others might be involved in making the assignment a success. The buyer is taking a risk based upon your company's performance.

PERFORMANCE ISSUES

Place yourself in a buyer's shoes for moment. You are selecting the photographer to make images for a $50,000 regional advertising campaign for a lawncare service. Lawn care is seasonal. Advertising has to be properly timed for the selling season. Media space has to be reserved, and lots of work has to be done before the first ad appears. Much of that work has to be done in advance of the photography, because the images to be made will depend on layout and copywriting considerations. Now you know why photographers are called last. The fact is that the creative agency and its client are going through a process that ends up with the photography being taken near the end of the project. That fact increases pressure on the buyer and can make him very concerned about the outcome.

The buyer's concerns are meeting the deadline for the photography, and achieving hassle-free and acceptable quality of service in addition to excellent photographs. Add to that list the fact that the buyer needs it all done within budget, because no one likes to go back and ask a boss or client for more money: It is not good for job security or client retention. Your buyers worry about staying within the budget. The performance issues are timely delivery, quality of service and photographs, and budget.

Tactical commitment—that is, offering proof that you can meet all the performance demands of the work to be done—is a natural fit for dealing with performance issues. It should be included as part of your sales pitch in any attempt to secure an assignment when the client is not aware, by personal

experience, of your ability to perform. Remember, every photographer seeking the assignment will show a client list and a number of tear sheets to prove his capability. However, those things do not speak to performance in a totally convincing manner. Who knows what horrors were encountered in the photography phase before the job went to print and produced those nice tear sheets? The tear sheets and client list do not indicate whether the job was done within budget and on time. They do not indicate whether any reshooting was required. They don't tell whether extensive work had to be done on the photographs to correct problems. They only show what the final ad looked like. Of course, your portfolio photographs will speak to your proficiency and artistry as a photographer, but consider this: All buyers know your portfolio contains the ten to twenty best shots you have taken in the past few years. They know your portfolio does not contain any work that was less than optimum for a buyer's eyes.

A list of satisfied clients with contacts and phone numbers is a great testimony to your performance. The mere fact that you offer such a list demonstrates that you have confidence in your performance. Confidence is contagious—help your client catch it. Deal with performance issues head on and set her mind more at ease than your competition will. When you do this, you will have positioned yourself for a successful negotiation of the remaining bargaining issues.

Finally, it never hurts to replay your message about your performance capability. While not being a broken record, mentioning your commitment to performance at critical stages when dealing with the value issues can only help you in the client's mind.

VALUE ISSUES

In addition to the performance issues mentioned above, you need to focus on value issues. The three main value issues in an assignment negotiation are time, usage, and materials. Time influences the fee for you and your support personnel. Usage is the copyright rights required to permit the client to use the photographs. Materials involve the expenses and costs (including your overhead) related to the job. Every assignment has these three components.

TIME

You have undoubtedly heard the saying "Time is money." In business that is a true equation. Another thing is true about time. It is the only thing you are sure to eventually and permanently run out of, and that makes it extremely valuable. You charge a fee for your time. That fee is negotiable, as it should be. Your negotiating success will set the value of your time. It's that simple when

it comes to time you are selling. But there is another aspect when it comes to the value of time in a negotiation. Some time is more valuable than other time. Let me explain.

There are some days in everyone's working schedule when the workload is lighter than other times. If you can shift workload from one time to another, it can mean that your earnings will increase. An example of this concept follows.

You are called to provide a quote on an assignment that the buyer wants to shoot on a certain day—let's say a Tuesday. It happens that you are already committed to shoot on that Tuesday. That means you lose the job unless you can shift the day on which one of the jobs is shot. It is difficult, and perhaps unwise, to postpone scheduled work. Clients generally do not like to change schedules, and doing it to shoot another job for a different client is like telling the original client that her work is not as important to you. A more successful approach would be to time-shift the work of the client who is offering the new job. Shifting the time will allow you to make money that you would otherwise not receive. You might consider proposing a discounted fee if the job being offered can be shifted to a different day. This does not mean that you should discount the overhead or materials. That would be like throwing away your money. Time-shifting is all about getting money that you might otherwise not receive.

Time-shifting tends to come into play on smaller, routine jobs. Big productions usually have to be planned well in advance, so they are normally scheduled for available days. Less complicated jobs, like a facility shoot for a brochure or a product shot for a small ad, are more likely candidates for time shifting. These jobs don't usually require lots of time calculating the price. You routinely know what you charge for them. So you can give a price early and quickly.

Offering a time-shift discount is simple to do. You discount the time by any amount you feel is worth giving up to get the extra revenues. You put your price on the table with a condition. You might say it this way: "Normally I would charge $1,000 for this job, but if you can shift it from Tuesday to another day, I can do it for $900. I am so jammed up on Tuesday that it's worth it to me discount my price to shift the work. In fact, if it can't be shifted from Tuesday, I'd better pass on it. I can't ask my other client to postpone. I don't want to inconvenience them. What do you say? What other day do you want me to shoot the job?"

You have just offered a conditional discount as an incentive, and you have reinforced your commitment to the welfare of your clients by not inconveniencing one with a change of shooting date. Buyers like discounts, and they like suppliers who protect their interest. You have provided a practical

advantage in a discount and a psychological advantage in shaping the client's positive impression of you.

COPYRIGHT DEMANDS

Rule number one in negotiating is that you cannot negotiate the terms of something that you do not understand. Many photographers have a very difficult time when it comes to negotiating copyright rights with a client, because they have an inadequate knowledge of the subject. Consequently they have trouble developing alternatives to the client's demands. See Section 2 of this book for detailed information on understanding copyright.

There has been a long contest between photographers and clients over the ownership of rights. The clients have the economic clout to freeze the photographers out—they hold the purse strings. If you want some of the purse's contents, you have to either comply with their wishes or be uniquely desirable for the specific assignment. Most assignments do not require unique talent. A competitor of equal talent, who is willing to surrender more rights for the same fee as you offer, is more likely to get the job. One way to deal with such a situation is by taking a different approach from those of your competitors who concede the ownership of rights without negotiating.

You can differentiate yourself by dealing with the needs of clients rather than their wants. You do that by avoiding the use of the word "copyright" during a negotiation. Instead, determine how your clients will use the photographs. Once you have an understanding of the required usage, you can offer a proposal to license the rights to meet the usage needs. The word "rights" is a red flag in a negotiation. People fight over "rights" because it is a psychologically charged word. Rights are hard to come by and are defended at any cost. But clients and photographers have no reason to fight over usage. We use things every day that we don't care about keeping forever. When you ask what rights the client wants, you are generally going to get an answer like "all rights." But when you ask how the images will be used, you generally get a list of uses.

RIGHTS AND MARKET SEGMENTS

In the advertising market, the common demand from buyers is for the copyright or an exclusive grant of all rights. Advertisers usually want all rights to the images you shoot, in order to protect the perception of their products and services. In the corporate market, the buyers will most often want the copyright or an exclusive grant of all rights to those images that identify the company or its processes. These are usually called "proprietary images." In the editorial market, the buyer usually wants limited rights. The exceptions would be prestigious magazines that want copyright or an exclusive grant of all rights

only for photographs used on the cover of the magazine, since the cover is its flag in the trade—as precious as a logo is to the corporate buyer, and the product or service identity is to an advertiser.

ALL RIGHTS AND BUY OUTS

Buyers of photography often use the words "all rights" and "buy out" to indicate that they want unrestricted use of the photograph(s) that they are commissioning. Buyers can also mean that they want the exclusive use in addition to unrestricted use. While "buy out" is not a legal term, "all rights" is an imprecise legal term—as in the phrase "all rights reserved" that often accompanies copyright notices on creative works. You should avoid the use of the term "buy out" because it is subject to various interpretations in the trade. "All rights" means exactly all (each and every) rights that exist. Granted exclusively and without termination, "all rights" is the same thing as providing a copyright transfer.

If you limit the period of time that the client will own "all rights" or "all rights exclusively," you are retaining the copyright while giving the buyer the right to exercise all the copyright rights for a specified period of time. Granting a time-limited transfer of "all rights" is better than making a transfer of copyright, because it keeps ownership in your hands for the long run.

COUNTERING ALL-RIGHTS DEMANDS

Clients often ask for all rights or a buy out for very specific reasons. Understanding them is helpful in trying to fashion usage alternatives to meet the clients' needs. Let's look at a few of the reasons and your possible counterproposals.

- Corporate image and proprietary information are very valuable. Companies want to protect both. They do not want their product or service associated with anything negative. They do not want their personnel's images used in any way that might be even remotely unflattering to the individual or company. These things have happened to companies, and they want to guard against it. Having "all rights" is a way to protect their interests. You can offer the client "sole and exclusive usage rights," which means you will never allow any other party to use those assignment images.
- Liability is another concern. Clients who buy substantial amounts of photography are aware that there can be lawsuits for lost or damaged original photographs. They do not want to defend a lawsuit for such a loss, especially when they paid to have the photographs produced in the first place. You can offer to hold them harmless for any loss or damage. If there is loss or damage, it is the clients' money that is lost, because they paid for the production of the images.

- Clients prefer to make as much use as they want (not need), and "all rights" gives them that right. Again, we all want as much as we can get for our money. You can give them all rights for a limited period of time. It is the rare image that is usable for more than a few years. Have a lower price for a time-limited exclusive than for a perpetual exclusive. That way you have given a discount for a decrease in what they are demanding from you.

- Clients often want to avoid negotiating any future usage, because once they are committed to a photograph they cannot change easily or cost-effectively. Their fear is that you will hold them up for an unrealistic fee for that future usage because you will have the power. You can offer to set the fees for any reuse as part of the deal that you are currently making. A percentage of the creation fee is usually appropriate. That eliminates future negotiations and settles matters while the power is balanced during the current, original negotiation.

USAGE AND VALUE

In its simplest form, usage can be divided into four basic categories: limited, unlimited, exclusive, and nonexclusive. The categories can be put into real-world terms easily by using the magazine marketplace as an example.

Upper-tier magazines such as *Time*, *Newsweek*, and *Business Week* require some exclusive categories of rights. For a cover, they insist upon exclusive rights for any purpose and for all time. That is "unlimited exclusive." For inside use, they insist upon exclusive use for a limited period of time, but they make additional payment for additional editorial uses after the period of exclusivity. That is an example of exclusive rights limited by time and specific use. These magazines generally pay three to four times the inside, full-page space rate for the cover. So the difference between all rights exclusivity and specific-use exclusivity for a limited period of time is a 300- to 400-percent increase. Using a similar approach, you can formulate a percentage increase for different levels of rights in advertising and corporate negotiations.

Lower-tier magazines, on the other hand, will usually want nonexclusive rights limited to one use in one issue of the magazine. This limited, nonexclusive use will not command a high fee, when compared with the cover of an upper-tier magazine. However, when a publisher wants to run your images on a nonexclusive basis but in several issues of one magazine, or in different magazines, the value increases.

To better understand how to establish relative values around the four categories—limited, unlimited, exclusive, and nonexclusive—you must understand the parameters of the terms. "Exclusive" means that the person to whom you grant the rights can use those rights, but no one else can. You can

assign all rights or any number of rights exclusively. For example, you could assign print-media rights on an exclusive basis, so no one else can use the image in print media. "Limited" means that there are restrictions on the use. What restrictions might there be? Time, number of copies printed, and region are good examples. Obviously the opposite terms, "nonexclusive" and "unlimited," have opposite parameters. Regardless of the parameters, the concept is that the more you buy the more it costs.

FEE NEGOTIATIONS

Negotiating your fee is always the hardest task in a selling situation because assignment photographers do not have, and have never had, an industry-wide pricing method as there is in stock photography. It is impossible to price creativity by formula, and your total price includes your production and overhead costs, plus your creativity and usage fees. You can isolate the production costs and know your overhead, but how do you put a price tag on the creativity that you bring to any job? You can't—at least you can't do it before the job is done. After it is over, you know, or at least have a good feel for, the level of creative energy that went into the work, but can you really put a price tag on it? I don't think so, and neither can your prospect or client. But each of you knows that some jobs require more creativity than others. For example, a studio photograph of a teacup and saucer on a plain white background requires craftsmanship, but how much creativity does it take? Some, but not as much as shooting a snowmobile crashing through a snow mound in a winter mountain setting.

The fact is that much work that photographers do requires careful craftsmanship, but it doesn't tax the photographer creatively. While most photographers will try to be more creative than the client's job specifications call for, there is often little room to introduce highly creative thinking into an assignment, because either time or circumstances do not allow it. This means that you have to distinguish between what I call the "bread-and-butter" jobs and the "champagne" jobs. Most businesses run on bread-and-butter jobs, and they get a real boost in monetary and psychic income from the occasional "champagne" job. The first thing you have to distinguish before you offer or negotiate your fee is which kind of job you are being considered for. You will have more competition for the bread-and-butter job, and that means that you have to be more conservative in pricing it.

FEE SETTING

Decide your fee on the basis of the level of experience, capability, and creative talent that the job really requires, and how much better you are than your competition when it comes to the kind of photograph you are being asked to

make. If your price is questioned or challenged, use those factors to sell the fee. Remember, "there is no such thing as a free lunch." TINSTAAFL!

> **TINSTAAFL.** This mnemonic device helps you to remember the fact that There Is No Such Thing As A Free Lunch. In business, you get what you pay for and you pay for what you get.

You can point to other assignments of a similar nature—whether done for the same client or a different one—to demonstrate that you received a fee similar to the one you are quoting for the present job. It is your responsibility to justify your fee. Do it with facts and common sense. Quality includes completing the job on time, within the estimated price, and in a creative manner. That is what you are pricing. Anyone can deliver a photograph that meets the prospect's basic needs, but you are going to deliver a photograph that meets the prospect's wants. This is more about selling than about negotiation. It is a good time to be a "broken record." Be direct and confident. Reassert that your fee is reasonable.

ASKING ABOUT THE FEE

If your client cannot accept your fee offer, then try asking a question like "Based upon your experience, what do you think the fee should be?" If the client's answer is close to yours, you can compromise. If it is not, you have a problem, and you have to ask the client if he really wants to work with you specifically. You cannot cut your fee by a substantial amount. If you do, you have told the client that you were just trying to exploit him with your first offer. The job cannot be worth $5,000 when you present it and $4,000 the next minute. That is like saying that you padded the estimate by 25 percent. Do you want to work with people who pad their estimates to you?

No matter what people preach to you, there is no such thing as the right fee. If anyone knew the correct fee for photographic assignments, she would be indispensable, famous, and wealthy. Fee negotiation requires balancing interests: yours, your clients', and, in the case of an ad agency or design firm, their client. Your fee has to reflect the value of the photograph to the client while preserving the value of what you bring to the job. Value is relative to the experience, creativity, capability, and reliability that you bring to the job, and it is relative to other costs the client will incur in the project. When a company is doing a million-dollar media buy for ads, it is not looking for the cheapest photography around. That would diminish the return on the advertising investment. Keep that in mind. Tell clients that, if they want to maximize their client's investment, the best way they can do it is by maximizing the quality of

the photography. And that means you are the right person for the job, and the right person costs more than the wrong person.

Always keep in mind when closing a sale that what you do has value. If it did not, the client would not be trying to buy it. You know the value of your services. The client might not agree with you. If you can develop a good rapport with clients, you might be able to get them to share their insights into the value of a job with you. That is not easily done, and it usually requires that you have some kind of ongoing relationship with the clients. But your value increases along with your rapport with the person. When a client convincingly tells you that she wants you to do the work but that the fee cannot be more than a given amount, you have achieved some level of rapport. You have convinced the client of your value and gotten the admission that she cannot afford your price. It is up to you to decide whether to meet her needs. Maybe you can do it with a reasonable rationale for lowering your price. Reasons like, "I want to show you what I can do" or "Because you are such a good client" are acceptable reasons to lower a fee but not to take a loss. Some differences of opinion cannot be resolved. Sometimes you have to say no. Remember, no one ever went out of business by saying no to a bad deal. Many people have gone out of business by saying yes to bad deals. Stay out of the latter group. Know your value and don't work for less, unless you are sure that it is a one-time step to achieving greater value in the future.

THE BOTTOM LINE

You must have a bottom line when it comes to fees. That bottom line should be based upon the costs of operating your business. Every day you work on assignments, you have to earn a certain minimum fee just to stay in business. When a job doesn't measure up to that level, you ought to pass on it. If it does, you have a reason to take it.

OPTIONS PACKAGE

Over the years, I learned that almost any fee I placed on the table was going to be too high in the client's mind. If a client accepted my proposed fee without any discussion, I knew that I had priced the work too low. I hated that feeling. Fortunately, I managed to avoid that experience and find a way to focus fee negotiations quickly and usually in my favor. You and your client have positions on a fee and on rights. That sets up a negotiating range—with your position on fee at the top end of the range and her position at the bottom of the range, and vice versa when it comes to rights. When negotiating the rights and fee positions, you first agree on the rights and then on the appropriate fee for those rights. You normally end up somewhere in between the two starting positions.

I developed a way to set up a negotiating range that made my job easier. I combined the fee/rights package into one position, and then I proposed three alternative packages. Each package had its own specific fee and set of rights. In other words, I would offer a menu with three options. By doing that, I pushed the negotiation toward considering my negotiating range rather than that set up by my client's. The three options offered a range of rights and fees that went from my wants to my needs, and a range of rights that were similarly arranged.

AN OPTIONS EXAMPLE

Your client is asking for all rights exclusively and in perpetuity, and has indicated a budget and willingness to pay $10,000 plus expenses. The images are for an annual report. Many of the images will be generic and will have value as stock photography. Some of the images will be proprietary, and you will have to protect them from use by anyone other than your client. It will take five days on location to shoot and another five days for travel and pre- and postproduction. Ten days work for $10,000. That figures to be $1,000 per day. The rate you normally charge for this kind of job is $3,000 per day when you have to surrender all the rights. That means you want a $30,000 fee to fulfill the client's wants. Note we are talking about "wants," not needs.

You know that most annual report images will not be used for more than one year. There are some exceptions to this. For example, executive portraits might be reused for the next year's annual report. They also will likely be used whenever the client needs an executive portrait to send out. You also know that some of the photographs are likely to end up in a corporate brochure within the next two years, because annual-report photographs often make good filler material in brochures. This means that the client's needs are one year of use in the annual report, collateral use of the images for two years, and continuing use of the executive portraits.

The client's negotiating range is between the wanted all rights and the needed annual report and collateral rights, plus liberal permission to use the executive portraits. Your usual fee for all rights is beyond the client's budget, and you are not inclined to accept half your normal rate for any all-rights deal. The executive portraits are proprietary. Companies don't want to lose control over their executive's portraits. Too many of them have shown up accompanying unflattering magazine articles because the photographers licensed them for editorial use without care for the client's possible concerns. You can live without those types of sales because you want to keep this client and get repeat business that could be worth a lot more than a few editorial stock fees.

Now you consider your negotiating range. You will grant all rights for

$30,000 or annual report rights with protection of the client's proprietary interests for $10,000, your bottom line. You have a $20,000 spread. That is a very wide range. Now you make the strategic decision and set a goal to sell all rights exclusively to the client for a period of two years and to give a perpetual exclusive rights license for use of the proprietary images for a fee of $20,000. That package meets the client's needs and the most important wants—namely, to use the images in next year's annual report and in collateral uses for the usual two years.

When you present your offer to the client, you put all three packages on the table. In doing so, you have rejected her offer of $10,000 for all rights and priced it well above the budget, and you have created compromise with your bottom-line offer. You have avoided rejecting the client's offer out of hand by making your refusal more subtly through a higher fee for the all-rights demand. At the same time, you have set up an all-rights negotiating range between the client's offer and your proposed fee, in case all rights is the only acceptable license. More important, in between your proposed options is a compromise that fits the client's budget and meets her needs. From here on it is tactical bargaining. Your strategy has gone from the planning to the operational stage. Now you must engage in a negotiation—remembering everything that you have learned about tactics in this book.

You have also avoided trying to close a $20,000 spread between your and your client's wants. That would be an almost impossible task. You have taken control of the direction of the discussion, and now you must make your middle option appear fair and reasonable to your client. And why shouldn't it be? It moves beyond meeting needs but does not reach for the dead end of trying to settle wants.

A SAMPLE DIALOGUE

In my book, *The Real Business of Photography*, I incorporated several dialogues between a buyer (Pat Buyer) and a photographer (Happy Shooter). I have incorporated one of them here because it shows how parties might speak to each other and how the photographer's strategy works in practice. The dialogue begins after Happy has offered his estimate with three options to the client.

HAPPY: Hello, Pat. I wanted to check in to see if you have any questions about my estimate for the Slippery Snowmobile assignment. If you don't, I am ready to get started on the job.

PAT: I did look at it, and I have a few concerns that I do not have about the other two estimates I have for the job.

HAPPY: Let me resolve your concerns. What are they?

PAT: The option for different fees and rights is not what I expected. The other photographers just quoted the "buy out" that I asked for. When I compared their prices to yours for that deal, your fee was the highest.

HAPPY: I'm not surprised that I am the highest because my work is so well suited to your needs. I believe that is what got us together in the first place. I do my homework very carefully when I look for a client. I took the time to examine the fit between you and me before I even promoted myself to you. I was sure that you would see that I was particularly suited to do the Slippery Snowmobile work. It's that "particularly suited" that makes me cost a bit more than my competitors on this one. Getting those action shots you need out in the cold snow banks of Colorado requires skill and experience like mine. I don't know how the other bidders are on this job, but I'm certain that I can do it better than they can, and now I have to convince you of that. . . .

PAT: (interrupting): The fact still remains that you are higher priced. How can I justify that to the account executive and the client?

HAPPY: Ask them if they have Ford mechanics tune up their BMWs. Just kidding. I wouldn't try to justify it. Instead, I'd suggest that you suggest that my option two presents your client with a near-perfect deal. They get all the rights they really need, and they don't pay for something they want but don't need. Look, they get three years of exclusive, unlimited use, and they don't pay for a lifetime of use that won't be needed because of model changes.

PAT: The continuing use is not the issue. The client does not want the images ever being used by another party. They have a fear that someday they will see one of their snowmobiles in a magazine story titled something like "Snowmobiles—Cripplers or Killers." They just want to be sure that something awful doesn't happen.

HAPPY: Very understandable. I can solve that problem one of two ways. I can agree in writing to never license the photographs to anyone for any reason. I don't use advertising photos of products as stock photography. Or I can give them the copyright transfer for the same price as option two, if they agree to pay for any additional years of usage beyond three at the same yearly rate. How's that sound?

PAT: I think that they'll buy the transfer with a guarantee of additional payment for extended usage. But the price for your option two is still too high compared to the other photographers. So you have to come down.

HAPPY: I just effectively went from $50,000 to $30,000. I think $30,000 is a very fair price for guaranteeing that your images will never get into the wrong hands, and three years of unlimited and exclusive usage.

PAT: Yes, but the client changes models every two years, and that is the longest they will pay for usage.

HAPPY: Well in that case, option one would have sufficed for their needs. It gives them the two years they need with exclusive use.

PAT: Yes, but it doesn't give them the copyright.

HAPPY: I think I can solve our problem, but first I need to know what I am competing against. There is no point in my doing so, if I am simply going to be asked to drop my price at the end to match someone else's. I need to get a certain amount for a job like this, because the job is worth it and I am worth it. I can't let my competition determine my value. What's your bottom line on the fee for the job? You must have one.

PAT: I've got a budget of $35,000 for the whole thing—fees, expenses, etc. I can't even think about asking for more because the account executive is not about to jeopardize our relationship with Slippery when we can get an acceptable result from a photographer within the budget.

HAPPY: For $35,000 I can give you everything your client needs with the protection they think they need. I am asking you—if I can structure the deal in a way that does what I just said, will I get the job?

At this point the negotiation can go in one of two directions. The buyer either acknowledges that he or she wants to work with Happy, or indicates no preference for Happy over the other bidders. Let's look at each scenario.

SCENARIO 1

PAT: If you can meet my client's needs and eliminate the fear factor I spoke about for no more than $35,000 for everything, I can give you the job.

HAPPY: I can do it. I need a little time to come up with the right wording. Can I call you back in half an hour?

PAT: Sure. I'll wait for your call.

SCENARIO 2

PAT: Look, Happy, you are a good photographer, but I have to go with the lowest, qualified bidder to keep peace with the boss.

HAPPY: So where do I have to come in to get the job?

PAT: The low bid is $25,000 for the whole deal with fees and expenses.

HAPPY: I have to think about it. Can I call you back in half an hour?

PAT: Sure.

WORKING THE SCENARIOS

Now Happy has to get his mind in gear. He has the parameters for the "real" deal. The prospect's client wants maximum flexibility with exclusive use for the

product model's life span of two years. In both scenarios the budget constraint makes the upper price limit $35,000. In the second scenario there is a second constraint from a competitor's bid. Dealing with the first situation is easier than the second because Happy has no real competition. The prospect has already offered him the job, if he keeps his price below the $35,000 limit. In the second situation the prospect has introduced a new ally, Happy's competition. Now let's look at how to deal with each scenario separately.

Under Scenario 1, Happy has only to decide how to present his new offer to the prospect. His upper price limit is established. All he has to do is construct a reasonable proposal that meets the prospect's needs of all rights with exclusivity for two years. In the original estimate the expenses totaled $12,971. This leaves $22,029 for the creative production fee without exceeding the $35,000 price cap. Happy comes up with this rational basis for the new price proposal he will offer: a transfer of copyright for two years, allowing unlimited use for the two-year duration of the transfer for a fee of $22,000. He will satisfy his need to get paid for more than two years of usage by an additional payment condition. This means his price will be $34,791, just under the $35,000 cap set by the client. Under Happy's original estimate, option three was the closest to the new offer. It read: "Exclusive rights for one year allowing unlimited use for a period of one year from the date of first publication for a fee of $15,000. One additional year of usage would increase the fee to $25,000." It would have brought the entire job to a price of $37,791. Happy is underselling his original position by $3,000. But he has a method to his madness, which he will carefully construct in writing so he can read it to his prospect and then employ the same language in his confirmation letter.

A NEW OPTION

Here's a copy of his new offer:

> Transfer of the full title to copyright in the images taken as part of the assignment. No rights can or will be transferred to any other party except that Happy Shooter may use copies of the images and the advertising in which they appear for the promotion of his business interests, in any picture books or photography exhibits, and as art for display purposes. If the images are used for publication of any kind after two years from the date of initial publication in advertisements, Happy Shooter will be paid an additional fee of $5,000 per year of actual usage.

This offer gives the advertiser all the exclusive protection and the rights it needs for the two years of the product model's life. It also gives Happy the right to do one important thing with the images and the ads themselves: He can

use them to continue his niche marketing efforts, routinely sending copies of both to prospective clients. As soon as the advertising campaign hits the street, Happy will be sending a new promotion to the agencies and communications directors of other winter sports companies and off-road vehicle manufacturers. This promotional right is potentially worth many thousands of dollars more than he traded off to get the assignment. Happy has surely learned one thing: The photographer has to be looking down the road all the time. You are the only person who can guarantee your own successful future.

CALLING BACK

The next step is a call to Pat Buyer to present the deal. Since it meets Pat's price needs, and really offers Pat's client all it needs, it should fly without a problem. If it doesn't, Happy will have to negotiate to finesse the deal to a conclusion. He will do that by continually reasserting that the deal meets the client's needs. If Pat tries to force a better deal, Happy will remind her of the commitment that a $35,000 buyout would fly, and that she indicated that her client would not use the photos beyond the two-year period before the model change. One thing Happy won't do is to drop his rights position award, unless he gets the full amount of his original estimate. Happy has not lowered his price. He has obtained the value of his original price in a fee, plus an award of valuable rights. If he lowered his price, Happy would be telling Pat that his price always comes down for the asking. In that case, Pat will be sure to ask over and over again. A good deal is one in which items of equal value are exchanged. The successful photographer gets the maximum value obtainable for his or her work in every deal made.

Under Scenario 2, Happy must deal with a bigger challenge. The prospect has introduced the competition as a factor. The competition might or might not be real. It is not uncommon to cite competition to a photographer in an effort to keep the price of work down. Sometimes there is real competition in play, and other times there is not—it's just a tactic. The problem is that you never know which situation you are facing. The way to deal with the problem is to ignore it. You cannot solve the problem. You will never know for sure. Why should it matter? You submitted your proposal based upon your policies and pricing criteria. These are the underpinnings of your business. If you are ready to meet the competition's deal just as the competition proposed it, then your competitor is running your business. I assure you that your competitor will not run your business as well as you will.

This kind of situation calls for confidence on Happy's part. He has it be-cause he understands several things about the business process. The prospect asked him for an estimate like every other bidder contacted. But the prospect

pursued Happy's bid even though it was much higher than the competitive bid later quoted by the prospect. Why would a prospect pursue a $30,000 estimate when he claims to have a $25,000 estimate that provides all that is needed? The answer is simple. The prospect wants to work with Happy. If not, he would have just said, "Thank you, but we are giving the job to a photographer who has a much better price."

Armed with the positive belief and outlook that Pat Buyer wants to work with him on the Slippery Snowmobiles assignment, Happy plans his response to deal with Pat's attempt to get his price down. He constructs a statement of his reasons so he can be prepared to recite his position when he calls Pat back. That call might go like this:

HAPPY: I've thought about the competitive offer to do the job for $25,000, and I am sorry that I cannot even consider meeting it. I thought that would be the case when we were talking, but I wanted a chance to go back over my figures in case I had made a mistake. I didn't. My quoted prices are as competitive as I can be, and I know them to be in line with those of the other successful photographers in town. Maybe my competitor can do it for $25,000, but all that says to me is that he doesn't command proper professional fees or he is desperate. In either case, I think I don't want to be in his situation, so I have to stay with my price. But I did work out what I think is a fair deal which will allow you to save your client a few dollars while getting the best work available.

PAT: What's your best deal?

HAPPY: For a $35,000 maximum including fee and expenses, I will transfer the full title to copyright in the images. No rights can or will be transferred to any other party except that I may use copies of the images and the advertising in which they appear for the promotion of my business interests, in any picture books or photography exhibits, and as art for display purposes. If the images are used for publication of any kind after two years from the date of initial publication in advertisements, I am to be paid an additional fee of $5,000 per year. If there is any good collateral material to be produced to support the ads, I could cut back the fee a little bit more if I can get either a credit line for the photography and/or enough copies so I can use them to promote my business. That would be worth a couple of thousand dollars to me. On that basis I could knock the price down to $33,000.

PAT: You are still $8,000 higher than your competition.

HAPPY: Yes, I am, and I am going to stay $8,000 higher because that is a fair price from a professional who has proven to you before he ever met you

that he can deliver the work you need, when you need it, at a fair price. I don't know who my competitor is in this case, but I hope you do. You are talking about a competing photographer who seems to me to be too inexpensive for the kind of work involved. I am a frugal fellow, and I keep my operating expenses as low as I can without sacrificing quality of service. If I were charging this competitor's rates, I'd have to cut back in ways that would affect the outcome of the work. I can't do that and call myself a professional. I think you want to use me, or you wouldn't have asked me to estimate the job. Give me a shot at this. I'll try to make it up to you in the future with great value and service. Do I have the job?

At this point Happy had dropped his price based upon replacing one kind of value with another. The client's cash price went down and Happy's compensation will now include partial payment by virtue of a credit line and copies of the finished work product for his promotional use. These two items have a cash equivalent value to Happy. Pat is either going to give Happy the job or just stonewall. If she stonewalls Happy, the next move for Happy is to push the matter to a conclusion. In that case it becomes Pat's turn to make the hard decisions. Happy has already staked out his final offer of $33,000. He cannot and will not meet the competition's price in any event. If he did it would be like telling Pat that his original offer was an attempt to get an extra $8,000 for the work. That is not going to make Pat favorably inclined to use Happy in the future. Pat wants a professional photographer, not a huckster to service her needs. Happy has also turned a favorite buyer's ploy around on Pat. Buyers often ask photographers to cut the price on a current job with the prospect of being better treated on a future job. Happy played that classic move in reverse by offering greater value and service in the future. That greater value and service could be achieved by putting in extra hours on a future job or two without extra charge. It doesn't have to be by cutting a normal fee.

Let's assume that Pat is going to have one more go at Happy. Here's the dialogue.

PAT: Happy, your offer is better, but how can I justify spending $8,000 more to use you on this job?

HAPPY: I'd suggest that you explain the reality. Let's face it. If you wanted the $25,000 guy, you wouldn't be talking to me right now. In fact, we might not have ever gotten past the first few minutes of our previous conversation. You know he isn't your first choice, and I know that. Why? Might I speculate it is because you think I will do better work? Your client is going to spend several million dollars on advertising and collateral using the

photographs that you commission today. How can anyone risk having less-than-excellent images in a multi-million dollar ad campaign when $8,000 will assure success? If that isn't true, then I can give you the name of my assistant. He is trying to get started in the business. He'd probably do the job for $20,000, so you could save $13,000 over my estimate. I know you don't want to take that risk. Why take any risk? You have a $35,000 client-approved budget. My work comes with the assurance that the job will get done the way you and your client need it. Pat, I think you have to decide if you want to ride in a Ford or a BMW. Can I start planning the job?

Pat is now up against the wall she put you against. It is now her decision. You have given her food for thought. She decides and you live with the decision. She decides in Happy's favor.

THE FINALE

The negotiation will end in one of two ways: Either you reach agreement or you fail to do so. When you have reached an agreement, you should look over the notes you have been making throughout the process and summarize the items agreed upon. You have been keeping notes, haven't you? All good negotiators keep notes so that they can write up an agreement or complete a form agreement that embodies that which was agreed upon by the parties. After you confirm the details in the concluding review with the client, you will write up a confirmation and send or deliver it to her. The last thing that you want is for anyone's short memory to cause a subsequent disagreement over the terms that you originally agreed to. Confirming the agreed deal is the final and critical act of the negotiation. Be sure not to skip that important action.

If you failed to reach an agreement, express how sorry you are that things did not work out and confirm that you hope to be given another opportunity to work for the client on a future assignment. Then send her a letter saying the same thing so that she sees you mean it, and that you really are ready to come back and try again. Some people take failed negotiations to mean that the other party wants no part of them in the future. You should firmly dispel that thought if you want to build your clientele and bank account.

BE THOROUGH

There are no shortcuts in negotiating. You have to consider intangible fears like performance issues and value issues like time, copyright/usage, and fees. You will have to understand the value relationship between fees and usage. You will have to understand your client's positions and separate the wants from

the needs, so you can develop a range of alternatives around which to build a compromise. Never skip confirming your agreements unless you like to negotiate disputes (and if you do, maybe you ought to try law school). Always keep the door open when negotiations fail. Tomorrow might bring a better job with a better budget or relaxed demands. That may be the one you have been looking for so don't miss the opportunity to get a shot at it. Thoroughness is a key component of negotiating—before the fact when doing homework, during the discussions, and after the fact when wrapping up.

Negotiating Quick Tips and Telephone Cheat Sheet

by Blake Discher

NEGOTIATING QUICK-TIPS

These Guidelines Developed By Blake Discher

Before You Negotiate
1. SET LIMITS before negotiation, eliminates emotional outcomes
2. Know you have a PAUSE BUTTON

Four Main Keys to Creating a Win-Win Outcome
1. DON'T NARROW the negotiation down to one issue, instead…
2. ADD VALUE constantly, and…
3. Move conversation AWAY FROM PRICE, remember…
4. Your counterpart does not have same NEEDS AND WANTS as you, and…
5. Don't assume you know your counterpart's needs. ASK FOR CLARIFICATION.

Listen, Listen, Listen
1. GATHER INFORMATION, the person with most knowledge wins
2. If you must speak, ASK QUESTIONS
3. Be alert to NON-VERBAL CUES
4. Let counterpart TELL HER STORY FIRST
5. DO NOT INTERRUPT
6. DON'T GET EMOTIONAL
7. You CANNOT LISTEN and SPEAK at same time

Questions
1. For YES or NO—ask CLOSED ENDED questions
2. For DETAILS—ask OPEN ENDED questions
3. Ask SHORT and CLEAR questions, cover ONE SUBJECT at a time
4. DON'T INTERRUPT counterparts answers
5. ONE, TWO, THREE—pause before you speak

TELEPHONE "CHEAT SHEET"

This Form Developed By Blake Discher

Client Information

Client Name _____

Email _____

Address _____

City _____ State _____ Zip _____

Phone _____ Fax _____

Tracking Information

How did you hear of me? _____

Job Details

Has budget been established? (Get vibe from client!) _____

Shoot date and time _____

On site contact and phone _____

Usage requested_____

Deadline for materials to client _____

FedEx number_____

Job notes _____

Action Steps

Estimate sent on _____ How? _____

Shoot confirmed to on-site contact _____

Notes_____

Customer Service

"Formula for success: under promise
and over deliver."

—Tom Peters

Turning Projects into Relationships: Give Them an Experience

by Leslie Burns-Dell'Acqua

Leslie Burns-Dell'Acqua launched the oddly named Burns Auto Parts in September 1999, continuing her career of helping creatives make a living doing what they love. In addition to her consulting work, Leslie has written many photo business book chapters and articles, and her own photo biz book, as well as lectured to creative groups across the United States. She also produces the monthly Creative Lube podcast and the Super Premium blog.

———————————— • ————————————

The following text was adapted for use in *ASMP Professional Business Practices in Photography* from a chapter originally published in *Business Basics for the Successful Commercial Photographer* (2006).

WHILE COMPLETING PROJECTS IS THE PRIMARY PURPOSE OF YOUR BUSINESS, each assignment actually presents you with multiple opportunities to build your reputation and your relationships with clients. Photographers often underestimate the importance of "the show" in their businesses but, if you give clients great experiences along with great images, you will be more likely to get repeat business. That's important. It takes considerably more time, effort, and money to get a new client than to keep one you've already "won." Some sources say that it can be as much as five times more expensive to get a new client than to keep an old one. It's worth the effort.

Besides, it's not really that much effort. Planning a production is stressful on a certain level—there are so many details to remember—but planning to take care of the client can be the easiest and most fun part. Generally speaking, with new clients, think about what they would like and why they might be excited to work on the project with you, the photographer, beyond the creative part of the experience. Look for the "hook." Don't be afraid to ask questions about tastes like "Do you prefer sushi or pasta or red meat for lunch?" and "Who are some of your favorite bands?" Planning client "care and feeding" for a production is not unlike throwing a small party—you want to make everyone feel comfortable and impress on them how important they are to you.

ONE THING YOU *MUST* DO

If you do only one thing (and yes, you should do more) to court the clients on a shoot, it should be this: Give them a great lunch. If you can break and go to a fabulous restaurant, do that, but that's usually not going to happen. If not, bring in the best food you can and don't skimp on the extras. This doesn't mean that you have to hire a craft services company and have the whole thing catered at Hollywood-type levels, but do at least get carry-out from a good restaurant and order some extra hors d'oeuvre-type nibblies, too. If the budget permits, then sure, hire full catering and give the clients the "Hollywood treatment." Better to have too much good food than to save a buck in this situation.

Speaking of a buck, there is a big debate about billing food back to your client. I see both sides of the debate and will tell you my solution: Make sure you get paid for the food (with a mark-up), but bury the cost in your fees, until it gets to be too large of a number, then list it as a line item. Clients expect to see a line item for "craft services" or "meals" but, if it's a smaller budget project, giving the appearance of throwing in the food makes you look better in the client's eyes. It gets you a "Hey, what a nice guy—he bought lunch" response. On the larger budget projects, listing the cost plus mark-up as a line item in your production charges is not only fine, but expected. Don't forget, whichever way you do it, you do have to get paid your food costs plus a mark-up, just like any other item.

Regardless, feeding your client is worth more than its cost in good will. Sharing a meal is a very basic human connection activity. "Breaking bread" for business is a ritual going back thousands of years to the Roman Empire and beyond, and for good reason. Sharing food represents sharing life, on a certain level. Many cultures seal a deal by eating or at least drinking together. So providing a great lunch is a great way to begin building a trust-bond with your new client.

CREATURE COMFORTS, INSIDE

If you maintain a studio, there are things you should have for your clients to make them comfortable when they come for a shoot. You may be able to work in a spartan loft heated by a tiny space-heater in winter, and cooled by a fan and only survivable in your Speedo-like shorts in the summer. But if you're going to have clients in the place, that "starving artiste" aesthetic isn't going to cut it. Clients do not find freezing or sweating to be chic or fun.

So proper heating and cooling is absolutely necessary. Your clients work in climate-controlled offices (mostly) and end-clients do, too. They won't be prepared or happy to set foot in a studio in summer only to start sweating as they cross the threshold! When you're alone in your space you can cut off the heating or cooling as much as you can stand to save money, but crank it up before clients arrive.

Munchies and beverages should be available and offered, often. Even when you tell clients to "help themselves" to the fridge, often they will not feel comfortable doing that, especially on a first project with you. Bottled water (individual or from a 50-gallon cooler) is absolutely necessary, even if your tap water is directly connected to the Evian springs and tastes as pure as melted virginal snow. Coffee should be made and waiting when clients arrive in the morning, with plenty of sugar, Splenda, NutraSweet, and half-n-half (regular and nonfat) available. Soft drinks, a good selection, are needed because there is always one person who must drink Diet Pepsi (not Coke) with lemon or something, so if you have a choice available, clients won't get frustrated when you don't have their one odd request. While it's great to ask ahead of time whether there are any special requests from your clients, they will usually say, "No, nothing special" and then show up and want a "Tazo green tea, decaffeinated, in a ceramic mug with a butterfly on it." You can't cover every possibility, but you can give the impression that you have gone out of your way to try and make them comfortable.

Munchies like chips, nuts, M&Ms, fresh fruit and veggies are good to have spread around any place a client may sit or hang out. Don't forget to refill the dishes (a good job for an extra assistant) during the shoot. If the shoot starts in the morning, a selection of bagels, donuts, pastries and fruit is always appreciated. Juice, too.

NONFOOD ITEMS

A fast wireless Internet connection is pretty much expected these days. If a client has to jack-in, he is going to think you are running a cheap business. Make sure the system is both Mac- and PC-friendly as most end-clients use PCs these days, while your creative colleagues are usually Mac-ified. If you are worried about having an open system, dedicate a couple of logins for client use.

There is a lot of waiting at a shoot, especially for all the "extra" people who show up, like end-clients, copywriters, account executives, and so on. It's amazing who will come to a shoot sometimes—when all you really need is the art director and your crew. Anyway, they all need places to sit and things to amuse. These things can serve the double duty of keeping everyone happy while also subtly distracting the unnecessary-but-self-important folk from poking their noses and opinions into the actual shoot. Provide plenty of comfy chairs and tables, preferably near enough to the main studio floor to give them the impression of being a part of the action but far enough to keep them out of your way.

Toys are good to have around, too. I know of several photographers who have pinball and/or video game machines in their studios. Great ideas! A Wii and a large-screen TV will also work. And don't forget the tunes—have a selection of music available (music you like to work to), and let your clients pick out which of those disks or playlists to throw on. That lets them feel like they are a part of the event, and you don't get stuck working to Eminem if you hate his music.

Lastly, but so very importantly, have decent and *very* clean bathroom facilities available. I remember going to a photographer's studio with a bathroom that made a gas station look like an operating room. It was a nightmare. Double-check that you have plenty of paper towels, toilet paper, and the like in the bathroom before your clients arrive. And clean the toilet. It's a little thing, but it counts for more than you know, especially if your client group has women (not that men are pigs, but women are usually more sensitive to nasty toilets).

CREATURE COMFORTS, OUTSIDE

When you are shooting on location, there is a lot more variability in the potential amenities. Your location may be a fabulous hotel with outstanding food and comfy chairs, or you could be shooting in a canyon with snakes, tarantulas, and scorpions a stone's-throw away. Plan appropriately.

If you've got an outdoor location, rent an RV for the shoot. You'll need the space for models (if you have them) and styling, and it will give the clients a place to hang out, away from the elements. As always, include the cost in your estimate and invoice (plus mark-up). This isn't a luxury but a necessity. For example, I do terribly in the direct sun. Unless I'm lounging by a pool, the sun and I are not friends. If I had to be outside on a summer shoot, as a client, I would get extremely upset if some sort of cool shade was not provided. An RV will give you this, and a tent/awning of some sort with chairs outside is helpful, too. In the winter, the RV will provide a warm place for everyone. Think about

how you can make the people on the shoot as comfortable as possible, in the given conditions. You might have to suffer for your art; don't make the client join you.

For location shoots you should have what I call an "environmentally correct" first-aid kit. If you're shooting outside, have a bee sting kit in your standard first-aid kit, for example. If you're shooting in a remote location, survival items would be wise to pack, just in case. Take the time before the shoot to consider what sort of things might go wrong and prepare ahead of time for these possibilities. While you can't (and shouldn't) prepare for everything, if you cover the significantly possible, you could end up being a real hero to your client.

Lastly, for location shoots make sure you prepare and send detailed directions from the client's office to the shoot location (if it's local) or from the hotel to the location. Yes, we all know about MapQuest and GoogleMaps, but providing a map saves the client a few minutes. You could even lay it out on your letterhead, create a PDF, and thus send a branded set of directions and map. How cool!

SHOOT'S FINISHED, BUT YOU'RE NOT

After the shoot is completed, you need to deliver the images to your client. This gives you another opportunity to make a great impression. While in some cases you may be time-constrained into FTPing the image to your client, if you have the time to burn a disk, don't just throw it into an envelope and send it out. And if you shoot film, you need to get that to your client—take a few minutes to package it well.

There are all sorts of packaging possibilities for final delivery, whether you are shooting film or digital. In the case of digital, consider using *www.jewelboxing.com* packages (designers love them). You can do something branded to your business (always good) or something more project-specific (if you shot on a beach, maybe a tiki-designed box, for example). For film, depending on the format, you might wrap the box in a cheap inkjet print from the project. Be creative, but don't make it too complex (one of those Chinese puzzle boxes would not be a good idea as the client needs to get at the work without jumping through hoops).

If you can hand-deliver the final images, on disk or film, do it. That extra touch of service can turn into a mini-meeting. When I was a rep there were several times when the art director and I would look at the final images, and another AD would walk by and start talking about a project he had coming up!

Also, with final delivery you can include a "thank you" note and gift in the package. You have to be careful about the gift, because some businesses

have significant restrictions on the monetary value of gifts their employees can accept, but something is entirely appropriate. One photographer I know takes a shot of the whole crew—models, stylists, himself, and any client-type folk, on every project. He makes a great print, puts it in a nice frame, and includes it with the film/files to the AD. Clients love this! Or maybe the client remarked on how she loved the music at the shoot—put the playlist on an iPod shuffle (less than $80) for him (I'd save this for the more significant projects). Another photographer I know sends great T-shirts with his film/files. The T-shirts change every year, and ADs at his regular clients always want the latest version—but they have to work with him to get one!

One note about gifting like this. If you worked with an art buyer to get the project and an art director on the project, you need to gift them both. Don't slight the AB just because she wasn't the creative partner; this person was quite possibly the driving force to get you the gig in the first place! Also, often you'll be told to deliver to the AB and so she'll get the package (and the goodies)—but you want the AD to be thanked as well in that case.

This brings me to the last thing you need to do after projects, and it's something too few photographers do: follow up. After project is done and the clients have the images, wait a couple of days to a week and then make a call. You're calling to make sure the images were everything they needed, to see if there were any finished layouts with the images you could see and/or to find out when the project will run so you can see the work in its final form, if possible. Ask whether there were any problems, ask whether there is anything else you can do for them, ask whether they got your gifts (if they haven't sent a thank you), and then tell them how much you loved the whole process and that you look forward to working with them again soon.

If you didn't send a thank-you gift with the images, now is the time to send something, even if it is only a handwritten note without any other sort of gift.

BETWEEN PROJECTS

Once you've worked with someone, you have something in common with that person, and that commonality can be all you need to build a relationship. Take note of bits of info you learn doing the shoot, and keep those notes in your database with the person's contact info—birthdates, kids' names, pets, and so on. Send birthday cards or at least birthday e-mails. Remember special days for clients, and they'll remember you.

Likes and dislikes are good to note, too. Maybe a client loves old Cheap Trick tunes and you hear that the band is coming to town. Contact that client and tell him about the tour. Send an e-mail link about the tour. If you love the band, too, talk about going to the event and see whether this person wants to

go with you (or with you and your spouse or significant other, if you want to be clear it is not a date). Socialize outside of work and make friends with your clients. To this day I have some very good friends who were originally clients.

We like to work with people we like. Making friends with your clients will improve your chances of being considered for projects and will increase your rate of repeat business. You don't have to be deepest, closest friends, but just be friendly and enjoy your commonalities. It'll help your business, and it's good for your mental state to boot.

Now it may sound odd to talk about giving clients an experience and in the next breath talk about making friends with them. These things, though, aren't mutually exclusive. You can show people a great time and care about them, too. In fact, it becomes easier over time as you get to know your repeat clients.

Working *with* Clients

by Leslie Burns-Dell'Acqua

The following text was adapted for use in *ASMP Professional Business Practices in Photography* from a chapter originally published in *Business Basics for the Successful Commercial Photographer* (2006).

YES, THAT WORD "WITH" IS KIND OF IMPORTANT. THERE IS AN UNFORTUNATE truism for many freelance creatives that this is an us-versus-them business. It is, but only for those who make it so themselves. That is to say that if you choose to assume an adversarial relationship with your clients, it will be an adversarial one. But if you choose to be a collaborator, then, usually, barring that one-in-a-thousand pain-in-the-butt client who sees everyone as an adversary himself, you will build a positive and respectful working relationship.

This point is often overlooked or deliberately discarded, and it is one that could only serve to improve the industry: The client is *not* your enemy.

Make that your mantra.

To work *with* clients, as opposed to *for* clients, the first thing you need to remember is to respect yourself. You can't be your clients' equal in their eyes unless you are first their equal in your own. This is a lot harder for creatives than for most business people, but for what it's worth almost all freelancers and small businesspeople have this exact same feeling at some point.

Clients are your lifeblood. If you don't have clients, you don't have money and you are out of business. It is very easy to be sucked into treating them with awe if that's what you have in the back of your head. But here's the trick: You are their lifeblood, too. They will not stay in business if they don't have images. Yes, there are plenty of others who could provide them images, but if you have a real vision in your work, something that sets you apart from all the rest, then only you can provide them your kind of images. Also, even if your work isn't the most vision-based (yet), that doesn't mean

you're completely toast; there are other ways to stand out from the crowd. If you are easy to work with or send really fabulous thank-you gifts or have a great studio or, well, something, you will be the one they want to work with. Regardless, the point is to remember that this is a collaboration of equals—a symbiotic relationship.

Here's a little exercise to help you remember that what you do is just as important as any of your clients. Take a pen and paper, and write down everything you do for a project. List what you bring with you as well, like how you know how to light the ugliest widget so it looks like a million bucks or you know a great stylist or you have a friend who caters and is a great chef. Be honest, but be thorough. When you are done, honestly look at that list and put a check mark next to what you do better or more specially or more efficiently, and so on. I bet you have some check-marked items that you never even thought of before. These things are special parts of the value that you bring to any project (they are also things you might want to consider adding to some of your marketing materials).

Unfortunately, some creatives go too far in the other direction. We've all heard of the *prima donna* actor. Well, you can find that in the creative industries, as well. A few of the best-known photographers have reputations for being overly demanding and difficult, it's true, but among successful creatives, acting like some sort of creative god is actually quite rare. Most (by a huge margin) of the top-level photographers are actually kind and generous. They focus on collaborating with their clients and push back, but only to the betterment of the project, not the aggrandizement of their egos.

The majority of the egomaniacal creatives never become much of anything. Ego can easily become a significant negative. How many stories do you know about some actor who hits with a series or movie and then acts like he is a gift to the movie-going public, and then a year later, can't get a job? Why does this happen? Because the actor becomes too demanding and spends so much time talking and thinking about himself that he forgets to do the work at the level that got him there in the first place. He forgets to say "thank you" to the "little people" and bad-mouths the people who hire him. Before you know it, no one wants to work with him. This happens with photographers and other creatives too. Don't let it happen to you.

THE BENEFITS OF WORKING *WITH* YOUR CLIENTS

Once you start from a mental point of being equal with your clients, you'll find that it will become easier and easier to ask for what you need as well as hearing what your clients need. Clear, frank, up-front communication is the foundation to great relationships.

Open communication makes it much easier to deflect some of the common arguments that buyers try to use to get photographers to lower their prices. For example, a popular argument you may hear is "I wish I could make $2,500 a day! That's more than I make in two weeks!" When you know that your work is of value to them, you will have the confidence to respond that you do not make $2,500 every day and that, in fact, after self-employment taxes, health insurance, retirement, and all the other benefits that they have with their jobs that you must pay yourself, (and add in all the other costs of running a business), well, that $2,500 you will get for this one project won't go too far.

This is a form of educating your clients. Most of the people you will work with will have traditional jobs. They get paychecks and benefits and so their mindset about the numbers is completely different from your own. However, when you talk to them about just how expensive it is to be in business, that helps them to start to get their heads around your pricing. But to do that you need to be open and honest with your clients.

Additionally, when you feel confident in the value of your work you can tell your client that the images you will provide will not only be worth their price, you can bet that the client will actually want to relicense the work for additional use. And, you will have the confidence to prove that value to them. For example, let's say you are asked to shoot an ad that will run in a trade magazine six times. The total media buy for the six ads is $200,000, and each edition of the ad will reach 100,000 sets of targeted eyeballs, for 600,000 total. If you price the shoot fee at $2,000 and the usage fee at 4 percent of the media buy, the total fees for the project will be $10,000. When the client complains about the "high fees" you can tell him that your image will cost less than 1.7 cents per viewer. That's a bargain! Anyone who would charge less obviously doesn't value his work enough and that usually means a lower quality product.

Also, when you listen to and speak openly with your clients you will learn what they really need, which is quite often not what they originally say. For example, a client calls up and says they need a "buyout" and the budget is $5,000. This obviously isn't going to work at first glance. But if you tell the client that, flat out, you're not even going to get a shot at the project. However, if you tell her that you're concerned the end-client may be asking for much more than is needed, and, "what do they really need—not want, but need?" you open a dialogue. Often this will result in your client saying that they don't want to have to contact the photographer again later in order to do something else with the image. Again, tell them that you want to make sure you provide them with what they need "so let's figure out what that really is."

Sometimes you'll have to start from the other side, by asking specific questions like "Do they need usage outside of the metro area?" or "Do they envision

running the image on billboards?" or "Are they going to do Web ads or just use it on their site?" and the like. Every time they say "no" respond with something like "Well, that will help keep the fee down." This often helps the buyer see that you really are trying to work with them by being concerned about keeping the fee within budget. This builds trust, and with trust comes relationships.

And every business is built on relationships.

WHEN ALL ELSE FAILS

Most of the time, using open communication, asking questions, and listening to your clients will result in you getting the project or, at least, you not getting the project for the right reason (there was someone more perfect for the job), and you getting offered another project down the road. But sometimes, you just can't come to terms.

When you reach a point in the discussion where you know the project doesn't have the kind of fees you need to get or the client won't agree to your terms and conditions or whatever it is that lets you know it's not right, you have to walk away from it. This is one of the hardest things for a creative person to do, but it is a skill you must learn:

- Say "no." Really. Right now, out loud, say it.
- Say "no" again.
- Say "no" one more time, but this time, refuse to feel guilty while you are saying it.
- Keep practicing.

The above may seem silly, but saying "no" is actually a vital part of your business toolbox. You must learn to say "no" with grace but with commitment. If a client wants you to shoot a project but the fees are too low and you cannot negotiate a fair deal, you must say "no." This protects your business because once you work for a client for too little money, you will (almost) never be able to get more money for work of the same value. It also protects the industry because if a client has to call twenty photographers to find a low-baller to shoot something for a too low budget, that will take up too much time.

This point is particularly important when you run across that old saw, "If you do this project at this low rate now, we can promise that we'll give you five more projects like this!" or "We'll make up for it on our next project with you!"

Just say "no" to these lines. Always. You can try to negotiate by saying something like "Let's do this one at my usual rate, and that fifth project I'll do for half," but I have never seen that actually work.

Now when you say "no," you should try to do it, as I said, with grace. There is no reason to be nasty. Try things like "I really wish we could figure out a way to work together, but the numbers just aren't what my business needs them to be. If you get a budget increase, please give me a call as I'd love to shoot this," or "My business advisor [that's me, the author, by the way] has told me she'd beat me if I ever signed away my rights like this, so I'm afraid I'll have to take a pass on this project." In both cases you have made it clear that it is not you who is saying "no" but rather your business is. And you are saying "no" in such a way as to keep the lines of communication open.

Lastly, one of the hidden advantages to saying "no" to projects that aren't right for you, for whatever reason, is that you make yourself less available in the client's head. Now, normally I advocate making yourself as available as possible to clients, but in this case there is a subtle difference: You are available to them, they just have the impression that you are more selective and thus more valuable. Think about it in terms of dating—the men and women who appear more selective and less available are the ones more in demand and wanted. We've all experienced that from one side or the other. It's the old truth about wanting what we cannot have. And while this is totally in our heads, it's in your clients' heads, too, and you might as well use that to your advantage.

TO REVIEW

Firstly, take the time to remind yourself that you are your client's equal. You both bring things to the table. A project is not a gift that a client bestows upon you but rather something that needs to be done and done well. And by collaborating with your client, you can achieve that goal.

Secondly, try to work with your clients to make it possible to achieve your shared goal. Your clients want to work with you and you want to work with them; ask questions and listen to try and find a way to make that happen for everyone. As creative and business partners, rather than adversaries or unequal participants, you are much more likely to produce better work for that client and to build a long-term relationship with that client that will result in good things for everyone involved.

Lastly, if you can't get to a point where both you and your client are served by the project, its terms, and its budget, gracefully decline the project. It's the best thing you can do for your business (in that situation).

Sometimes, your client will even thank you for it, especially when they are aware that the budget was set too low (yes, that really does happen). Your saying "no" gives them ammo to go to their client and to get the budget increased. This helps them to set more reasonable budgets in the future and you will be remembered (positively) for that.

Managing Change

"It is not the strongest of the species that survives, nor the most intelligent: it is the one that is most adaptable to change."
—Charles Darwin

Value Your Work

AN EDUCATED PHOTOGRAPHER
IS YOUR BEST COMPETITION

by Emily Vickers

Emily Vickers is former director of education for the ASMP, creator of Strictly Business 1, currently partner in Mason Vickers Productions, LLC, providing worldwide production support to professional photographers.

—————————•—————————

The following text was adapted for use in *ASMP Professional Business Practices in Photography* from an article originally published in the *ASMP Bulletin*.

A VERY SUCCESSFUL CLOTHING STORE IN MANHATTAN ADVERTISES ITS DISCOUNT prices on designer clothing with the headline "An Educated Consumer is Our Best Customer."

I think of that line each time I hear a photographer say that he never shares his pricing procedures, or other information, with his assistants or competitors because he's convinced they will use that information to underbid him and get the job behind his back. Photographers who subscribe to this philosophy shortchange themselves and the profession they hope will sustain them over a life-long career.

I say, "An Educated Photographer is Your Best Competition."

Value is the basis of any successful business. Photographers who understand the worth of the service and product they supply to the communications industry are naturally better negotiators and more effective advocates for rights. Photographers who are aware of their value are less likely to underbid, low-ball, or otherwise compete unfairly. No one knowingly gives away diamonds for the

price of paste. The most important mission of the ASMP's education programming is to instill in photographers a solid sense of their personal worth and the true commercial value of their photographs. To fulfill this mission, we must overcome obstacles which lie at the very core of a freelance profession.

The dictionary definition of "freelance" is "one who acts independently without regard to party lines or deference to authority" and "one who pursues a profession without long-term contractual commitments to any one employer." This definition could describe any freelance profession, including law, medicine, and architecture. Any independent businessperson is a freelancer at heart, eschewing traditional employment for the freedom and personal identity of an autonomous career. But while other professions have evolved both in economic and social stature (surgeons were once moonlighting barbers), freelance photographers have gained neither the respect nor economic rewards that their contribution deserves.

Unfortunately some photographers have taken the virtues of independence and autonomy to unhealthy extremes of antipathy and unethical competition, undermining the efforts for collective advocacy which distinguish other professions. While competition exists in the ranks of every profession, in photography the battle is fought almost exclusively at the bottom line.

Unlike law, medicine, and architecture, ours is an "uncredentialed" profession. There are no licensing, peer-review, or board-certification requirements to fulfill in order to call oneself a professional photographer. All you need is a camera, a business card, and a portfolio to get into an art director's door and try to sell a buyer on your ability to do the job. This is both the appeal and the tragic flaw of our profession. We have no institutional accreditation or outside regulations to guarantee that professional photographers uphold standards of professional behavior and fair pricing. It is up to each of us to ensure that photography survives as a career from which we can make a dignified living and from which we can voluntarily retire, not be forced to leave because it is no longer profitable or enjoyable.

If photography is to evolve as a profession, we must recognize the value of our product and insist upon fair compensation. Indeed our prosperity revolves around a cycle of value. Photographers must make a collective commitment to maintaining that value. Collective action requires mutual trust. Trust is born of confidence, and confidence is a natural outgrowth of a belief in one's own value. If photographers can be educated to understand and argue for the true commercial value of their work, the entire profession will benefit.

Value can be taught. Viewed in relation to other costs and expenses involved in producing annual reports, magazine ads, brochures, direct-mail pieces, and multimedia shows, a relative commercial value for photographs can

be determined and defended using the cool, objective logic of apples-to-apples comparison. Advertising space rates, printing, paper, retouching, design, and mailing costs are available, through some research, for every project that involves photography. But while these costs have steadily climbed, photographers' fees have declined. Photographers must work to regain the ground they've surrendered. They must recognize their value and learn how to negotiate for it.

Education is not an isolated event; it is an ongoing process. It is not something you receive and tuck away but something you participate in and share. Our profession can thrive only in an atmosphere free of the unethical competition that breeds mistrust and paranoia—the cycle of devaluation that threatens our very ability to make a living. We need courage, leadership, and open communication if we are to keep competition where it belongs, between the covers of our portfolios, not at the ever-shrinking bottom line.

The Sky Is Falling, Grab Your Camera!

by Judy Herrmann

Judy Herrmann of Herrmann+Starke specializes in digital still life and lifestyle photography for advertising. Her work has appeared in *Lurzer's Archive*, *Graphis*, *Communication Arts*, the *HOW International Design Annual*, and *Pix Digital Annual*. She has been recognized as an Olympus Visionary since 2000. She lectures extensively about digital photography and offers consultations on building a successful photography career. She has served as national director, secretary, first and second vice president, and president of the American Society of Media Photographers.

———————•———————

IF YOU ASKED MOST ESTABLISHED PHOTOGRAPHERS ABOUT THE STATE OF THE industry, they'd tell you that we've been living through a time of disruptive change. Many use expressions like a "perfect storm" or "sea change." And they have a point.

In recent years the stock-licensing industry has transitioned from a diverse collection of boutique and niche agencies to a handful of mega-stockpiles that control the vast majority of the world's images. Digital capture has simultaneously increased the costs of doing business and lowered the bar of entry to our industry. Not only can photographers no longer define themselves by the equipment they use (our clients and subjects frequently own the same cameras that we do), but the ease of creating montages, slideshows, digital video, and interactive media at home on a personal computer, combined with the cultural movement away from print media toward interactive vehicles, means that the role of still imagery within the larger scheme of visual communication is shifting.

Our culture's traditional attitudes toward artists and the protection of copyright are also changing. The appropriation and use of imagery created by others without compensation to the original creator is rapidly becoming normalized, especially among the younger generation. As yesterday's students become today's photography buyers and legislators, they will lead the way to a very different earning paradigm for visual artists. As businesses shift their promotional dollars toward new media, the demand for images grows substantially—blogs, e-mail marketing campaigns, image-rich Web sites, video game and cell phone marketing—all of these vehicles call for enormous quantities of still and moving images. Yet the supply continues to outpace the demand. Improved Internet search capabilities make it easier than ever to get into the photography business as a part-time sideline, and we're seeing a tremendous influx of participants for whom any income generated from their photos is simply gravy.

The pundits all agree that technological change will continue at ever-increasing rates. Just look at the technological changes that have taken place in the last few decades. In 1980 no one had a personal computer—the IBM PC was launched in 1981 and the Apple Macintosh in 1984. In 1990 only twenty-one out of every 1,000 Americans had a cell phone. In 2000 the iPod didn't yet exist. The speed at which new technologies are both developed and adopted accelerates with each passing decade.

For most photographers, new and established, everything feels chaotic and out of control.

The dogmas of the quiet past are inadequate to the stormy present.

—Abraham Lincoln (1809–1865)

It seems that people always feel they live in times of excessive change and upheaval. The "good old days" are often only recognizable in hindsight. It's important to accept that change is a normal part of life. As early as 500 B.C. the Greek philosopher Heraclitus observed that "nothing is permanent but change," and in the late 1800s George Bernard Shaw noted, "Progress is impossible without change."

Change comes about in a variety of ways. It can be externally driven, coming from economic, political, technological, or social movements. It can be internally driven; frustration with your clients, career, lifestyle, income level, or environs can all spur change. Sometimes it's just part of the natural progression of life. The obvious transitions—from student to assistant or assistant to photographer—clearly leave people grappling with change, but these kinds of transitions are normal, even expected.

Transitional changes continue throughout one's career. The emerging photographer with few encumbrances gets older, gets married, gets a mortgage and must change to adapt to these larger responsibilities. The more established you become, the more you equate change with risk, and the harder it becomes to change. Often established photographers become trapped by their own success. Their revenues shrink as their work becomes dated and stale, yet they find themselves unable to take the risks necessary to grow creatively. Growing as an artist is one of the scariest, and most necessary, changes for photographers to make and it's one that never goes away. As Miles Davis once said, "If anybody wants to keep creating, they have to be about change."

All changes, even the most longed for, have their melancholy;
for what we leave behind us is a part of ourselves; we must die
to one life before we can enter another.

—Anatole France (1844–1924)

The different motivations for change—external forces, internal frustrations, and natural transitions—usually affect people differently. Externally driven change can be devastating; you're making good progress toward accomplishing your creative and financial goals when suddenly something changes and you either adapt or lose everything you've worked for.

The transition from film to digital capture forced many photographers to completely rethink their careers. Some photographers found these challenges invigorating and exciting. They embraced the new technology and used it to create new opportunities and new revenue streams. Some even changed their visual style or the subjects they specialized in shooting so they could more fully exploit the capabilities of this new medium.

For others the change was too much. Digital capture rendered nearly everything that established film photographers had invested in—equipment and expertise—virtually obsolete. It required them to develop new ways of thinking, new forms of problem solving, new skill sets, and new pricing models. For many it imposed a significantly different lifestyle, and I can recall more than one photographer complaining bitterly to me that they hadn't entered this field to become "computer jockeys." For many photographers, the emotional and financial investment in photography as they knew it was too great for them to tolerate adapting. Many of these photographers justified their inaction by arguing that digital wasn't "there yet" even as their revenues and client base dwindled.

Externally driven change often forces you to make tough decisions, especially if you were happy with the way things used to be. Accepting the fact

that the status quo is going away and won't come back is a crucial first step. Denying that externally driven change is real can lead to personal and professional crises. When you're dealing with externally driven change, the sooner you examine the full implications of those changes, the more time you have to make decisions and put your new plans in place.

For some adaptation becomes too painful—they don't want to remain in an industry that won't support how they've always done things. That's a valid decision, and when you're dealing with externally driven change one of the first questions you have to ask yourself is whether it's worth adapting to these new circumstances or whether you'll be happier doing something else with your life.

Internally driven change can be just as traumatic. For most people the key impetus for internally driven change is desperation. Deep-rooted and often long-term feelings of dissatisfaction in one's lifestyle, personal life, career, or finances can trigger strong feelings of inadequacy or a sense that you're wasting your life. Each day that passes seems as though it's lost forever. Panic sets in and even though you recognize that change is necessary, finding the wherewithal to force yourself to make these changes can seem impossible.

Transitional changes often blend external and internal forces. Luckily, the excitement of entering a new phase of your life can help offset the pressure of needing to change. Even so, people grappling with transitional changes frequently experience the same narrowing of choices involved in externally driven change, combined with the personal frustration and panic common to internally driven change.

Regardless of the motivating force at work, people grappling with change often experience a "treadmill effect" where they feel like they're running as fast as they can but going nowhere. They can't find the time to reflect, plan, or develop new skills. They're unable to see how they could improve upon their current practices. They feel an increasing need to "do something" but can't figure out what that should be. This results in a growing sense of failure, which just makes them run that same treadmill even faster. As a wise friend once told me, "Sometimes when you're facing a brick wall, you just have to put the car in reverse."

> *Chains of habit are too light to be felt until they are too heavy to be broken.*
>
> —Warren Buffett (b. 1930)

Change can be dramatic and immediate or slow but persistent. The first step to dealing with change is to force yourself to let go of the status quo. People

have a tendency to hold onto the familiar because it's, well, familiar. When the familiar fails to fulfill your needs, it's time to let it go. As the writer Alan Cohen notes, "It takes a lot of courage to release the familiar and seemingly secure, to embrace the new. But there is no real security in what is no longer meaningful." In truth, you'll find more security in learning how to manage change than in resisting it.

The challenge then becomes, what do I replace the familiar with? Oil baron J. Paul Getty once said, "In times of rapid change, experience could be your worst enemy." Experience combined with habit and fear can lead to paralysis. Fortunately since human beings have had to deal with change since the dawn of time, some very smart people have developed tools that will help.

First, it's useful to note the key factors for successfully managing change. At the top of that list is pressure. Changing is hard, and few people have the will to change without substantial pressure. When the pressure gets strong enough that you're ready to accept the need to change, the next step is to create a clear, articulated vision of what you're trying to accomplish. If you have employees, co-workers, or a boss, they must share this vision or they will sabotage all of your efforts.

Once you've outlined your vision, you need to gather the resources to make it happen. This might involve a financial investment, the development of new skills, the addition or replacement of employees, and/or collaboration with an expert who can provide needed services or training. Finally, to successfully change you must be fully committed to taking action. Talking about it won't accomplish anything. You must set aside the time and money necessary for fulfilling your plan.

Sometimes the situation is only a problem because it is looked at in a certain way. Looked at another way, the right course of action may be so obvious that the problem no longer exists.
—Edward de Bono (b. 1933)

Let's assume that you're already feeling the pressure to change. After all, that's probably why you're reading this chapter. So now you're faced with articulating a vision and mapping out a plan. This is where your creative problem-solving and strategic planning skills come into play. Start by using your creativity to examine the problem you're trying to solve from different perspectives. The more ideas you can come up with to improve your situation, the more likely you are to find ones that will work. As you're brainstorming, don't edit yourself—often the most stupid or far-fetched ideas serve to trigger the best solutions.

As you evaluate your list of ideas, you need to take into account your personal values, and the potential for life and career satisfaction that this plan would bring you—the factors that will help you achieve your goals and obstacles in your path.

> *It is not the strongest of the species that survives, nor the most intelligent: It is the one that is most adaptable to change.*
>
> —Charles Darwin (1809–1882)

Strategic planning shows us how opportunities lie in every challenge. It gives us tools to help us articulate our values, quantify the political, economic, social, and technological landscape, and analyze our strengths and weaknesses. At the end of the process, we've established goals, identified threats and opportunities, and built a plan that will enable us to meet our creative, financial, lifestyle, and career goals.

Developing a strategic plan lets us hone in on what's important and leave the chaos of the unknown behind. Regardless of the driving force behind the change, these tools help us become adaptable to change, to steer our careers and our lives in the direction that's most likely to satisfy our needs.

Building an effective strategic plan for your career takes a lot of soul-searching, research, and analysis. An examination of why you've decided to change will help you determine exactly what you need to change to improve your circumstances. You'll need to define exactly what improvements you're looking for and how you'll know that you've achieved them. Your goals must be S.M.A.R.T.: specific, measurable, attainable, realistic, and timely. Since your career goals need to reflect your personal values, this is a good time to examine other areas of your life to ensure that your efforts to change result in a life that you'll be happy leading.

Once you have your plan, you'll need to break it down into bite-sized, doable steps. Tasks that are left too large to handle in a single day will keep getting put off until you have more time. Break large tasks into four categories: to decide, to buy/errands to run, to contact or research, and to do or make. Each task should boil down to a series of actions that you can tick off of your list with minimal effort. If an item on your list still seems overwhelming, you haven't broken it down far enough.

Creating this kind of plan alone can be very challenging. Enlist the help of a friend, spouse, or consultant. Make sure that your planning partner is objective, knowledgeable, and realistic, that he or she will keep you focused and on track, and that he or she doesn't have any vested interests that will get in the way of helping you accomplish your goals.

Knowledge is power.

—Francis Bacon (1561–1626)

As you go through this process, stay informed! In the early 1900s philosopher and psychologist John Dewey wrote, "Since changes are going on anyway, the great thing is to learn enough about them so that we will be able to lay hold of them and turn them in the direction of our desires." This is where your trade associations, peer network, and community really come into play. Don't just pay attention to what's going on in your own backyard or your own niche. Pay attention to what's going on in the world around you.

Watch the innovators. Diffusion of innovation theory teaches that innovators initiate trends, which are picked up by early adapters. The early adapters make the trend more user-friendly, and then the mainstream follows. By the time the mainstream catches on, the trend is already dying and the innovators are onto the next big thing. Being an innovator can be painful—they don't call it "the bleeding edge" for nothing. By paying attention to the innovators, though, you can jump in early enough to profit from the mainstream adoption of the trend and be ready to move onto the next wave before it hits.

Figure out what's special about the services you offer. Why should someone hire you? What value do you bring that no one else offers? Keep in mind that focusing on price just lowers everyone's earning potential. Do that and you'll enter the race to see who can stay poorest the longest. A true competitive edge comes from understanding your clients, defining your markets, and offering services that your clients need, want, and are willing to pay for. To accomplish this, you have to learn as much as you can about your prospective clients and markets. You must also examine your offerings with a cold, critical eye to see exactly how your services measure up.

Let your clients help you. Talk to them, find out what problems they're trying to solve. Don't just look for new relationships; explore how you can use your skills to expand the relationships you already have. Concentrate on finding better ways to meet client needs in the segments that you're most interested in serving. Find the areas where your clients' fears, needs, and desires intersect with your skills. Focus on areas you feel passionately about and where you have an advantage over competitors.

One change leaves the way open for the introduction of others.

—Niccolò Machiavelli (1469–1527)

In his blog, David Wolf, advisor to technology, media, entertainment, and telecommunications industries in the Asia Pacific region, wrote, ". . . filmmakers

have been pulling their hair out over technology destroying cinema since the introduction of talkies, but here we are, eight decades after the introduction of sound, sixty years since the introduction of television, and thirty years since the first VCRs began landing in homes, and each one of these 'horrible' developments with their big negative downsides has only brought more opportunities to filmmakers and more revenues to Hollywood."

Recognize that experts, pundits, gurus, and industry analysts frequently predict a doomsday scenario that doesn't come to pass in exactly the way they describe. Use the experts to gain a larger understanding of the forces at work, but rely on your own insights and creative problem-solving skills to navigate a path that will enable you to fulfill your goals.

> *Plus ça change, plus c'est la même chose. (The more things*
> *change, the more they are the same)*
> —Alphonse Karr (French journalist and author, 1808–1890)

As you look at managing change, cut through the chaos by focusing on what stays the same. When I first entered the business, postcard mailers and a physical portfolio were de rigueur. Now, it's all about e-mail blasts and Web sites. The vehicles have changed, but the key messages and goals haven't. You must still reach the decision-maker. You must still show images that are appropriate to your target audience's needs. You must still use every interaction with your prospects and clients to show the value that you bring to the table.

Basic business truths also rarely change. No matter what else happens in this world, I guarantee that you can't lose money and make it up in volume. To be a successful businessperson, you have to understand profitability. You have to know the difference between investing, and wasting time and money. You must also find ways to buy yourself the time to invest in the skill-development and marketing necessary to land the jobs that will further your goals.

Recognize that you can't change everything overnight. As you look to change your policies, practices, client base, or market, take a two-pronged approach that allows you to maintain income while transitioning into new areas. As you change your business, you may be able to take some clients with you, but trying to radically change client behavior, expectations, or needs often results in the client finding another photographer. As you're making the transition, use new policies, portfolios, pricing strategies, or business models with new clients. Wait until you can afford to lose an old client before introducing him to your new business paradigm.

Focus on keeping what still works and only letting go of what's no longer viable—don't throw the baby out with the bathwater.

Desperation is sometimes as powerful an inspirer as genius.
—Benjamin Disraeli (1804–1881)

The status quo will not remain, that I can guarantee. "This, too, shall pass" applies equally to good times and bad. Change may mean the end of the world as you know it, but it doesn't have to mean the end of the world. The biggest obstacles to change are often psychological: fear of the unknown, stress over things beyond your control, anger at being in this predicament, guilt over decisions that have affected your family, colleagues, or employees. Dwelling on these feelings can crush your confidence and leave you paralyzed, depressed, and indecisive.

Instead recognize that change brings new opportunities. Use change as a tool for greatness. Let it inspire you; let it fuel your determination to succeed. Turn fear into a galvanizing and positive force. Don't let it paralyze you; instead use its power to inspire you to genius. Take advantage of the tools that others have already developed for you. Creative problem-solving and strategic planning tools informed by your understanding of yourself and the world around you will enable you to adapt to whatever changes come your way.

It's a bad plan that admits to no modification.
—Publilius Syrus (1st century B.C.)

Just as circumstances change, your plans, goals, dreams, and desires will also change over time. Plan, but hold your plans loosely. Revisit your plans often, and modify them as necessary. The old proverb, "He who fails to plan, plans to fail," must be tempered by the observation that sticking rigidly to a plan that no longer serves your needs will lead you directly to a place that you no longer want to be.

This above all, to thine own self be true.
—William Shakespeare (1564–1616)

As you grapple with change and the fear and stress that it brings, always keep in mind why you're doing this. Tom Guidera, a former ASMP national director whom I met at the ASMP's first Strictly Business program, once told me that the best piece of business advice he ever got was "Never pay too much for money." Adapting to change is hard! And if you're going to do it, make sure that your efforts result in a career and lifestyle that will make you happy.

This is your life—it's the only one you've got. Don't waste it pursuing other people's ideas of what's important. Don't let your own preconceived notions of

who you are and what you do limit your ability to see how your many skills can be applied in innovative, satisfying ways that will let you build the life you want. As you look at building or rebuilding your career, get back to what really drives you. Refocus on where your passion lies. Determine what compromises you are and are not willing to make. Armed with that knowledge, you'll be able to build and implement a plan that will help you meet your creative and financial goals as you adapt to change.

Glossary of Industry Terms

SELECTED TERMS FROM THE PLUS PICTURE LICENSING GLOSSARY

The PLUS Picture Licensing Glossary is the result of an international collaborative effort between all industries engaged in creating, distributing, and using images. The goal is to provide standardized definitions for all terms used in image licensing and other communications related to image rights. Terms and definitions included in the Glossary were drafted and approved by participating associations and stakeholders representing the interests of photographers, illustrators, artist representatives, designers, advertising agencies, publishers, museums, libraries, and educational institutions.

The PLUS Glossary is the foundation of a comprehensive system of standards developed by the nonprofit PLUS Coalition for use in communicating and managing image rights. More than 2,000 registered Standards Reviewers participated in the development of the PLUS Glossary and other PLUS standards. The ASMP is a founding member of the PLUS Coalition and encourages you to learn more about this important organization at *www.useplus.org*.

To access the full Glossary including more than 1,500 industry-standard terms and definitions, visit the PLUS Web site at *www.useplus.org*, where you will find a free searchable online version.

KEY TO THE USE OF THE GLOSSARY

To use the Glossary, look up any term in alphabetical order. The elements of each listing are described in detail below. Where a term's definition varies based upon the context in which the term is used, there will be multiple listings for that term, each indicating a different "facet" (context) of the term. Where a term is used in several formats (hyphenated, abbreviated, etc.), each such "variation" will be separately listed in alphabetical order within the Glossary, and each term record will provide a listing of all variations on the term. PLUS

identifies each term with a PLUS Glossary ID ("PGID"). These ID codes may be used in place of the actual terms, to allow precise communication. The PGID codes will also facilitate worldwide, multilingual use after the Glossary is translated. The first four digits of the PGID indicate the term number. The 5th and 6th digit indicate the facet number, and the 7th and 8th digit indicate the variation number. The final four digits indicate the Glossary version number, an essential reference, as definitions may be revised in future editions by industry consensus. PLUS also applies a "Usability Rank" to many terms. In ranking terms, PLUS does not recommend or discourage any business practice. Rather, PLUS applies a rank of "Cautioned" or "Discouraged" to terms that are ambiguous, outdated or otherwise often result in misunderstandings. In such instances, PLUS provides a "Preferred Term" designed to facilitate the clearest possible communication.

This material © 2006 PLUS Coalition, Inc. Reproduced with permission of the PLUS Coalition. The terms listed in this book are part of the glossary developed and approved by the PLUS Coalition.

THE PICTURE LICENSING GLOSSARY VERSION 1.0. First Published in the United States of America by PLUS Coalition, Inc., 50 North Hill Ave., Suite 302, Pasadena, CA 91001 USA; Toll-free: 866.669.7587; Telephone: 626.405.8100; *www.usePLUS.org*. First Edition 2006. Printed in the USA. ISBN 978-1-4303-0115-8

ACKNOWLEDGEMENTS. This Picture Licensing Glossary is the result of an unprecedented collaborative effort in the image-licensing industries. Hundreds of volunteers from more than a dozen professions in more than ten countries contributed many thousands of hours to reviewing, discussing, and revising the terms, phrases, definitions, and supplementary information contained in this publication. The PLUS Coalition thanks all those who so generously shared their knowledge and expertise. The PLUS Glossary editors dedicated months and years to reviewing proposed terms and definitions, and to making revisions based upon industry consensus.

Advertising [1628-00-00-0100]. The activity of attracting public attention to a product, idea, or business using announcements in print, broadcast or electronic media. *info:* In most cases advertising is clearly different from editorial content and is paid for by an advertiser, who controls its appearance and content. This distinguishes it from public relations content, which can be edited by a media outlet and is inserted without payment. *ex: Advertising is one element in an overall marketing strategy.*

Advertorial [1081-00-00-0100]. Paid advertising or public relations created and designed (often by the staff of a magazine or other media in which it appears) to resemble editorial material. *info:* The publication reproducing

the advertorial typically receives an insertion fee or enters a barter arrangement and receives in-kind goods or services. The publication may also offer advertorial insertions as incentives to advertisers who purchase a certain amount of advertising. By law in some countries, an advertorial page must be marked advertisement. *ex: The advertorial was on page five of the September issue.* *plural:* Advertorials. *preferred term:* Advertisement. *usability:* Caution.

Aerial Photography [1341-00-00-0100]. Images created with the visual impression of no physical connection to the Earth's surface, usually from an aircraft, building rooftop, or cherry picker. *ex: Aerial photography shows a bird's-eye view of the ground.*

Agency [4200-00-00-0100]. A company authorized to act for another company or individual within the scope of an assignment or project. *ex: The agency commissioned the photographs on behalf of its client.* *plural:* Agencies.

Agent [1570-00-00-0100]. A party authorized to act for or in place of another. *info:* The scope of an agent's authorization is typically limited by contract. *ex: My agent is a brilliant negotiator, watching out for my bottom-line interests.* *plural:* Agents. *preferred term:* Representative. *usability:* Caution.

Agreement [1573-00-00-0100]. The act of two or more people or entities uniting to express a common and mutual purpose, and/or the writing that is evidence of their common and mutual purpose. *info:* An agreement must have the elements of: offer, acceptance, consideration. It involves terms and conditions that two or more parties agree to, rather than something that might be only arranged or understood. *ex: Our agreement states the delivery date and each of our responsibilities.* *plural:* Agreements. *preferred term:* Contract. *usability:* Caution.

All Media [1229-00-00-0100]. Licensing language granting use in all types of communication. *info:* May be limited by time, geography, size, or restrictions, but meaning can be unclear. *ex: The license includes usage in all media.* *preferred term:* Unlimited Use. *usability:* Caution.

All Reproduction Rights [4530-00-00-0100]. Denotes right to create unlimited copies, without restriction on media, size, placement, or distribution unless otherwise specified. Not a copyright transfer. Nonexclusive unless otherwise specified. *info:* Not recommended for use in a license. An ambiguous term that frequently results in misunderstandings. Often confused with buy out and copyright transfer. *ex: The client requires a license for all reproduction rights to avoid any delays in releasing the pictures for future publication.* *preferred term:* Unlimited Use. *usability:* Caution.

All Rights [1230-00-00-0100]. The unrestricted right to reproduce, distribute, display, and perform a work for any purpose, unless restrictions or

limitations are specified. Not a copyright transfer. Not exclusive unless otherwise specified. ***info:*** Not recommended for use in a license. An ambiguous term that frequently results in misunderstandings. Often confused with buy out and copyright transfer. ***ex:*** *The client asked to license all rights.* ***preferred term:*** Unlimited Use. ***usability:*** Discouraged.

All Rights in Perpetuity [1555-00-00-0100]. The unrestricted right to reproduce, distribute, display, and perform a work for any purpose, for an unlimited time period, unless restrictions or limitations are specified. Not a copyright transfer. Not exclusive unless otherwise specified. ***info:*** Not recommended for use in a license. An ambiguous term that frequently results in misunderstandings. ***ex:*** *The client asked to purchase all rights in perpetuity.* ***preferred term:*** Unlimited Use. ***usability:*** Discouraged.

Amendment [3140-00-00-0100]. Formal revision or addition to an agreement or contract. ***info:*** As with other legal matters, any amendment is best made in writing and signed by representatives of all parties. ***ex:*** *We agreed to make an amendment to the contract, allowing more time to complete the project.* ***plural:*** Amendments.

Analog [1342-00-00-0100]. A form of information conveyed by a continuous and variable signal that can represent an infinite range of values. ***info:*** When duplicated from one generation or medium to another, the quality of analog information frequently degrades. In photography, film cameras are analog systems. ***ex:*** *Most silver-based photographic imaging is an analog system.*

Ancillary Rights [1231-00-00-0100]. An extension of a right to material in a main or primary work for appearance in subordinate, helping, auxiliary, consequent, or resultant materials that accompany or relate to the primary work. ***info:*** Examples include a student edition, teacher's edition, educational software, table of contents, and collateral. ***ex:*** *The publisher licensed ancillary rights to include the image in the book's table of contents and sales brochures.*

Archive [1135-00-00-0100]. To organize a repository of images, other materials, and/or electronic data so it is indexed for easy retrieval and reuse of the materials and/or data; or a repository of such images, materials, or data. ***info:*** Retrieval and use subsequent to an initial usage influences licensing. Many editorial clients archive past issues, online or otherwise, for public viewing, which requires a license. Hence, the ability to add a work to an archive may be restricted under a license. Offline (or physical) archives may not necessarily be organized for easy retrieval. ***ex:*** *The image is in our archive and available for reuse.* ***plural:*** Archives.

Art Buyer [4720-00-00-0100]. An advertising agency or creative department employee, or a contractor, with duties including but not limited

to identifying artists and stock images in relation to the production of advertisements, negotiating agreements with vendors involved in the production of artwork, and in some cases supervising production of artwork. *info:* The role and responsibilities of the art buyer position vary from company to company. *ex: The art buyer negotiated a license agreement with the artist representative to commission a photograph from the photographer.* *plural:* Art Buyers.

Assignment Confirmation [3970-00-00-0100]. A written document that specifies agreed terms, conditions, and expected results for a contracted creative project, stating approval by the contracting party to proceed. *info:* Should be signed by all parties, but may be enforceable without signatures. Typically follows acceptance of an estimate by a client and precedes an invoice and delivery memo for the project. *ex: We've received your signed assignment confirmation, and we'll begin work on the project tomorrow.* *plural:* Assignment Confirmations.

Author [1719-00-00-0100]. As used in licensing, a legal term referring to the initial copyright owner of a copyrightable work. *info:* With a work made for hire, the employer of the creator is the author. *ex: She is the author of the photograph.* *plural:* Authors.

AV [1084-02-00-0100]. Abbreviation for Audiovisual [1084-00-00-0100]. *ex: The AV presentation included slides and music.* *plural:* AVs.

Bid [1059-00-00-0100]. A preproduction document formulated by a licensor based on a project description provided by the licensee, including the scope of the license, and any applicable terms and conditions. Also, the act of formulating and presenting such a document. *info:* Unlike an estimate, if actual costs are higher than those cited in the bid, the licensor may not add to the bill, unless additional charges are approved by the licensee. If actual costs are lower than those bid, the licensee remains obligated to pay the entire approved bid amount. A bid may be legally binding if not signed by a licensee, provided the licensee indicates acceptance of its terms and conditions, and authorizes the licensor to proceed. *ex: The customer has asked us to provide a bid.* *plural:* Bids. *preferred term:* Estimate. *usability:* Caution.

Boilerplate [1510-00-00-0100]. Colloquial for the standard terms and conditions that appear in almost every contract, or the standard form of agreement sent to a party before negotiation. *ex: The boilerplate on the back is set in very tiny type.*

Budget [1608-00-00-0100]. The itemized sums of money and/or other resources (such as time) estimated and set aside for a particular purpose, project, or timeframe. *ex: We will not exceed the budget for this project.* *plural:* Budgets.

Buy Out [1060-00-00-0100]. An imprecise term used to describe acquisition of broad usage rights to a work, sometimes in a particular market or medium. *info:* Buy Out is a slang term, often misinterpreted as a transfer of copyright ownership of a work from the copyright holder to the client or client's agent. In the absence of a specific copyright transfer agreement executed by the copyright holder, there is no copyright transfer. If this term is used, an additional, precise list of rights granted or transferred should accompany any license. *ex: The clients asked for a buy out but agreed to a time-based license for a single campaign. plural:* Buy Outs. *preferred term:* Unlimited Use. *usability:* Discouraged. *variation:* Buyout, Buy-Out.

Cancellation Fee [1574-00-00-0100]. A sum agreed to be paid when a procuring party cancels the services of the providing party. *info:* Typically applicable when there is a short period before the production or due date, in order to offset costs and inconvenience to the seller. Cancellation fees typically are not refundable. *ex: The amount of the cancellation fee is reasonable, considering how much work was done in advance. plural:* Cancellation Fees.

Casting [4770-00-00-0100]. The act of interviewing or otherwise reviewing potential talent for a project. *info:* May be the responsibility of a photographer, art producer, client, or agency, depending upon an agreement associated with the project. *ex: The producer will handle all casting of talent at least two weeks before the shoot date.*

Change Order [1730-00-00-0100]. A specification of modifications to a contract after the terms and conditions are set and agreed upon. *info:* If the original agreement includes a term that states no changes except in writing, a change order must be in writing and executed by all parties. *ex: The change order includes more work to be performed. plural:* Change Orders.

Client [4820-00-00-0100]. The person or entity seeking to license or assign creation of a work. *info:* A photographer or illustrator might work directly with a client, or through an agent or representatives. *ex: The client wants to be present during production to ensure we produce the pictures she wants. plural:* Clients.

Clip Art [3300-00-00-0100]. A descriptor for royalty-free works purchased in bulk. *info:* The term "clip art" originated with large books of mostly generic artwork, arranged on pages that purchasers cut apart to obtain specific images for mechanical layout and reproduction. Used often in local advertising. Also applied to collections of digital illustrations, photographs, and even video clips sold on CD or DVD, or downloaded, with unlimited reproduction rights licensed to the buyer. *ex: We can't afford to commission an image for this ad; we'll have to go with clip art. plural:* Clip Art.

Clipping Path [1363-00-00-0100]. A graphics software function that allows a shape to mask part of an image. *info:* Used to isolate an object from its original background so that it can be dropped into a composite or page design. *ex: Some image files include a clipping path that makes it easy to knock out the background. plural:* Clipping Paths.

CMS [1364-01-00-0100]. Abbreviation for Color Management System. *ex: Make sure your CMS is set up properly for your monitor and output systems.*

CMYK [1365-00-00-0100]. A method of representing color using the four standard printing ink colors. *info:* CMYK color is based on the primary colors of pigment—cyan, magenta, and yellow—which combine in their purest forms to make black. In practice, black ink is added, since impurities mean most CMY inks combine to make a muddy brown. The range of possible colors in CMYK is much less than in RGB color, making problematic anything more than minor color adjustment of digital images in CMYK color. *ex: We had a CMYK color separation made for offset printing. variation:* Cyan Magenta Yellow and Black.

CODB [1559-02-00-0100]. Abbreviation for Cost of Doing Business *ex: Understanding your CODB is only one step in setting prices. plural:* CODBs.

Collateral [1061-00-00-0100]. Printed marketing and advertising pieces for use in direct request and personal contact, not in publications. *info:* Often reflects a larger broadcast, print, or direct mail campaign. May include leaflets, brochures, pamphlets, and business cards, among many other possible uses. However, collateral is often misunderstood to comprise an even longer list of uses. Listing individual uses may be more practical for most licensing situations. *ex: Collateral is delivered directly to the consumer or dealers rather than via mass media. usability:* Caution.

Collective Licensing [4000-00-00-0100]. A system for cooperative administration of copyrights. *info:* License fees may be set by the cooperative or by clearing party collective licensing individual participants, who often share the burden of marketing and sales administration. *ex: Some collective-licensing solutions aim to help control individual work and pricing while reaching a larger market as a group.*

Collective Work [1715-00-00-0100]. A legal term referring to a publication, such as an issue of a newspaper, magazine, or anthology, in which separate and independent works are assembled as contributions to a larger whole. *info:* A type of compilation. Publisher typically owns copyright in the publication, but copyright ownership in each element remains with its contributor unless otherwise negotiated. *ex: Our new magazine will be a collective work, including articles and pictures from many sources. plural:* Collective Works.

Color Management System [1364-00-00-0100]. A system for communicating color reproduction information about digital images between input, display, and output devices. *info:* Improves fidelity of image reproduction when properly configured and used by all involved in a production workflow. *ex: Make sure your color management system is set up properly for your monitor and output systems. plural:* Color Management Systems. *variation:* CMS.

Color Profile [1744-00-00-0100]. A standardized digital file containing color space information. *info:* Can improve color fidelity when embedded into a digital image file and referenced during reproduction. *ex: Be sure your system properly translates the color profile embedded in that image. plural:* Color Profiles.

Color Proof [1367-00-00-0100]. A representation of a final printed piece, used for checking color accuracy and other elements. *info:* May not be as accurate as a contract proof. *ex: The text on the color proof was correct, and the pictures looked good. plural:* Color Proofs.

Color Space [1369-00-00-0100]. A three-dimensional representation of a color profile, useful in imaging to understand color performance across a variety of input, display, and output devices. *ex: A CMYK color space reflects the ink and paper being used. plural:* Color Spaces.

Commission [1609-00-00-0100]. A payment to a sales agent or agency, usually a percentage of the gross or net sales amount. *info:* Can also be a fixed-dollar amount per item sold. *ex: My agent receives a 20 percent commission on all sales. plural:* Commissions.

Commissioned Work [1718-00-00-0100]. A work created by an independent contractor to satisfy an order placed by a customer or client. *ex: That assignment was a commissioned work for this year's annual report. plural:* Commissioned Works.

Comp (1) Comp (Publishing) [1143-00-01-0100]. A complimentary copy of a magazine or a book. *ex: I received this copy of the magazine as a comp. plural:* Comps. (2) Comp (Production) [1143-00-02-0100]. Visual rendering of a proposed advertisement or other printed piece. *info:* Usually indicates the planned placement of each photograph, each illustration, and/or all copy, along with examples of each. May have two stages: a rough outline (called a mock-up or visual), followed by the proposed or finished artwork (called a comp). *ex: The art director showed the comp to the client. plural:* Comps.

Comp Use [1144-00-00-0100]. Image reproduction in one or a very few copies of a layout or dummy that shows headlines, images, type, and text. *info:* Purpose of comp is to secure approval from all concerned parties prior to final production. An image delivered for comp use is typically, but not

always, delivered at low resolution, and a fee is sometimes charged. *ex: The image was licensed for comp use in a proposed layout for an advertisement.* *plural:* Comp Uses. *variation:* Comprehensive Use.

Compilation [1716-00-00-0100]. A work formed by the collection and assembly of pre-existing materials or data that are selected, coordinated, or arranged, so the resulting work as a whole constitutes an original work of authorship. *info:* Includes a collective work and usually requires a license for any copyright material included. *ex: In their next compilation, my photo will be used with the original article that accompanied it.* *plural:* Compilations.

Composite [1657-00-00-0100]. An image made up of separate, distinct visual elements merged into one visually continuous, seamless image. *ex: A colleague has licensed one of my images for use in a composite with his pictures.* *plural:* Composites. *variation:* Photo Composite.

Confidentiality [3320-00-00-0100]. Describes an agreement that limits how information or images may be shared with others. *info:* Confidentiality may be a condition set in a license, contract, model release, or property release, or in exchange for access to a particularly valuable property or technology. *ex: Before you can photograph next year's fashions for us, you must sign a confidentiality agreement.* *variation:* Confidential.

Consumer Advertisement [1062-00-00-0100]. Commercial communication that is directed to members of the general public. *ex: The consumer advertisement will appear in several popular magazines.* *plural:* Consumer Advertisements.

Consumer Goods [1204-00-00-0100]. Packaged products intended for mass markets and for consumption by an individual or household for personal, family, or household purposes. *ex: This image is being used in the packaging comp for a new line of consumer goods.*

Consumer Magazine [2808-00-00-0100]. A periodical targeted toward, marketed, and distributed to the public at large. *ex: This advertisement is geared to a consumer magazine.* *plural:* Consumer Magazines.

Consumer Print Advertising [1095-00-00-0100]. Advertising in newspapers, magazines, and/or other consumer publications targeted to the general public. *ex: The image will be used for the company's consumer print advertising.*

Consumer Publication [1145-00-00-0100]. A periodical targeted toward, marketed, and distributed to the public at large. *ex: This advertisement is geared to a consumer publication.* *plural:* Consumer Publications.

Contract [1556-00-00-0100]. A legally binding agreement, involving two or more competent people or entities, with terms and conditions that state

what the parties will or will not do, and which specifies consideration (some form of benefit to each party) for their performance. *info:* A contract requires: an offer, acceptance of that offer, agreement and consideration. Acceptance can include a signature (printed or electronic), taking an action (such as clicking an "I agree" online button), or in some cases, oral affirmation. *ex: The contract is ten pages long and includes penalties for any delays.* *plural:* Contracts.

Contract Proof [1648-00-00-0100]. A high-quality print, made with careful color management, of an image or layout, sometimes with text and graphics, intended to convey accurate predictions of how a press will reproduce color, registration, text, and other visual elements. *info:* Depending on contract terms and conditions, commercial printers may or may not guarantee final printed results will match the contract proof closely. *ex: We approved the contract proof yesterday and have assurance our work will print beautifully.* *plural:* Contract Proofs.

Contributor [1240-00-00-0100]. An author whose work is published as a part of a collective work, such as a book, magazine, or advertisement. *ex: As a contributor, he supplied two pictures and wrote a chapter of the book.* *plural:* Contributors.

Copyright [1241-00-00-0100]. A legal property right in an original work of authorship fixed in any tangible medium of expression, such as photographs, illustrations, architectural works, literary works, musical scores and recordings, and motion pictures. *info:* Copyright is more than the right to copy, it is a divisible bundle of exclusive rights. The owner of copyright in a work holds the exclusive right to reproduce, publicly display, adapt, distribute, and/or publicly perform the work, and to authorize others to do the same. *ex: She owns the copyright to those images.* *plural:* Copyrights.

Copyright Infringement [1557-00-00-0100]. The act of violating any of the exclusive rights of a copyright owner. *info:* Reproduction, public display, adaptation, distribution, or public performance of a work without advance permission from the copyright owner is a copyright infringement, unless such use constitutes fair use or a compulsory license under Copyright Law. *ex: Use of the photograph without the copyright holder's consent is a copyright infringement.* *plural:* Copyright Infringements.

Copyright Notice [1666-00-00-0100]. Printed text adjacent to the reproduction of a work that indicates the work is copyright protected. *info:* Consists of the copyright symbol (or the word "copyright" or abbreviation "copr."), the year of first publication and the name of the copyright owner. This is not required to protect copyright, but it may provide legal benefit to the copyright owner. Can appear on or adjacent to the reproduction of

a work, or on a separate page. *ex: The copyright notice appears in a small typeface below the image. plural:* Copyright Notices.

Copyright Registration [1558-00-00-0100]. In the United States, the process of registering and filing tangible copies of creative works with the Library of Congress Copyright Office. *info:* Registration is a practical prerequisite to bringing a claim against another party for copyright infringement in the U.S. Without timely registration, only actual damages may be awarded in a successful copyright suit filed in a U.S. district court. Registration allows a successful plaintiff to seek the recovery of attorney's fees and court costs, and to elect to recover statutory damages instead of actual damages, including enhanced damages for willful infringement. *ex: The U.S. Copyright Office is the office of public record for copyright registration and deposit of copyright material. plural:* Copyright Registrations.

Copyright Transfer [1242-00-00-0100]. An assignment of copyright ownership or an assignment of a copyright interest in a work (such as a photograph or illustration) from the copyright holder to another party. *info:* Often misunderstood because the term does not specify exactly which rights are being transferred. Use of more specific language may prevent misunderstandings. *ex: The clients asked about the cost of a copyright transfer for the image. plural:* Copyright Transfers. *preferred term:* Assignment of Copyright Owners [2815-00-00-0100]. *usability:* Discouraged.

Copyrighted [1724-00-00-0100]. Describes a work protected by copyright, whether or not a copyright registration has been submitted to record ownership of the work. *info:* Copyright in a work exists from the moment the work is fixed in tangible form. *ex: As soon as a photograph is made, it is copyrighted.*

Corollary Rights [2706-00-00-0100]. An extension of a right to material in a main or primary work for appearance in subordinate, helping, auxiliary, consequent, or resultant materials that accompany or relate to the main work. *info:* Examples include student guides, instructors' manuals, educational software, and duplicate transparencies. *ex: The corollary rights include in-class audiovisual presentations.*

Cost of Doing Business [1559-00-00-0100]. The sum of money required to open a business, and over time, keep it running and solvent. *info:* Includes rent, utilities, labor, taxes, and other costs that are not part of the cost of goods sold. Generally expressed as dollars per day. *ex: Understanding your cost of doing business is only one step in setting prices. plural:* Costs of Doing Business. *variation:* CDB, CODB.

Creative Commons [1736-00-00-0100]. An organization that proposes a license method allowing use without permission under certain circumstances.

info: Enables copyright holders to grant some of their rights to the public while retaining others, through a variety of different license and contract arrangements. See *http://creativecommons.org*. *ex: Creative commons licenses are used widely for Web pages.*

Creative Fee [1560-00-00-0100]. A charge by a creator for his or her efforts to complete a project, which is not based on time alone. *info:* Factors may include compensation for trade experience and special capabilities, or for any creative effort, contribution, or process required to complete a project. Typically does not include a licensee or usage fee. *ex: The estimate included the photographer's creative fee based on production of ten images for the campaign.* *plural:* Creative Fees.

Creator [1720-00-00-0100]. A person or entity causing an original work to be fixed in tangible form. *info:* Under the Copyright Law, the creator of a work is the author and copyright owner of that work upon its creation. Exception: if a work is a work made for hire made by an employee in the course of his or her employment, the employer of the creator is the author of the work and owns the copyright upon creation. *ex: A creator produces original works.* *plural:* Creators.

Credit Line [2767-00-00-0100]. A line of text identifying the copyright holder (and, optionally, the date of the copyright). *info:* Usually placed near an image, at the bottom of a page or screen on which the image appears, or in a separate area of the publication. Some licenses require specific wording, placement, size of type, and/or other details for a credit line. Many credit lines include a creator that differs from the copyright holder, such as one whose creation was a work made for hire or who has assigned the copyright. Some credit lines include an image provider, such as an agency or archive, that is not the copyright holder. *ex: The image has a proper credit line, including the photographer's name, copyright, and affiliation.* *plural:* Credit Lines. *variation:* Credit.

DAM [4850-01-00-0100]. Acronym for Digital Asset Management System *ex: Our DAM allows us to quickly locate and repurpose previous projects, in whole or in part.*

Day Rate [1561-00-00-0100]. A pre-agreed, flat-rate fee paid for up to one day of production work. *info:* Generally based on an eight-hour production day, but may require specific negotiation. *ex: The day rate for the project covers production efforts, but the usage fee is additional.* *plural:* Day Rates. *preferred term:* Creative Fee. *usability:* Caution.

Defamatory Use [1247-00-00-0100]. Use of a work in a derogatory context, such as part of a false statement concerning a person that could damage that person in the eyes of the community. *ex: Printing that photograph with this headline might be a defamatory use.* *plural:* Defamatory Uses.

Delivery Contract [1562-00-00-0100]. A document that describes a work or materials delivered by an owner or the owner's representative to another party. *info:* Contains terms and conditions relating to the delivery of the property and limitations on its use. *ex: The delivery contract was signed by the client. plural:* Delivery Contracts.

Delivery Memo [2717-00-00-0100]. A document that describes a work or materials delivered by an owner or the owner's representative to another party. *info:* Contains terms and conditions relating to the delivery of the property and limitations on its use. However, the title memo has caused problems enforcing such terms and conditions, especially when a signed copy is not returned. Use delivery contract instead. *ex: The client received a delivery memo with the prints but failed to sign and fax the document back. plural:* Delivery Memos. *preferred term:* Delivery Contract. *usability:* Discouraged.

Derivative Work [1630-00-00-0100]. A work derived from or based upon one or more pre-existing works. An alternative version of a copyrighted work. *info:* The right to prepare a derivative work is reserved exclusively for copyright owners. Permission from all copyright owners of pre-existing works involved is required before preparing a derivative work, unless the derivative work constitutes a fair use under the Copyright Act. The owner of the copyright in a derivative work does not acquire ownership of the copyright in the pre-existing works. *ex: This image is a derivative work. plural:* Derivative Works. *variation:* Derivative.

Digital [1382-00-00-0100]. The representation of information using binary numbers (zeros and ones) that correspond to voltage being either on or off in computers and associated processing, storage, and transmission technologies. *info:* Digital information may be copied many times with no loss of quality or degradation, and it can be altered in ways that are difficult to detect. *ex: Publishing and imaging have widely adopted digital technologies and depend on computers.*

Digital Asset Management System [4850-00-00- 0100]. A database or similar program designed for tracking and organizing digital files, including documents, images, video, animations, and more. *ex: Our digital asset management system allows us to quickly locate and repurpose previous projects, in whole or in part. plural:* Digital Asset Management Systems *variation:* DAM.

Digital Capture [1631-00-00-0100]. The process of acquiring visual information with a digital camera, or an image that results from such photography. *ex: We will use digital capture because it gets images into our computers faster. plural:* Digital Captures.

Digital Fee [1646-00-00-0100]. A charge made by a photographer for digital capture and subsequent processing or rendering of the digital image. *info:* A digital fee might be a lump-sum charge or a tally of itemized

charges, such as downloading files from camera to computer, RAW file postprocessing and editing, digital darkroom processing to enhance the digital capture, data storage, proof prints, delivery, and other services. *ex: The invoice includes a digital fee for postproduction of the captured images.* *plural:* Digital Fees.

Digital File [1805-00-00-0100]. An ordered set of binary numbers representing information in active computer memory, or stored on magnetic, optical, or other media. *info:* Can be electronically transferred or translated into a facsimile of an original analog form (on paper or a computer display). Digital files can be altered in ways that can be difficult to detect. *ex: We are downloading the digital file now.* *plural:* Digital Files.

Digital Image [1651-00-00-0100]. A visual recording of objects, scenes, and/ or people that is encoded into a digital file. *info:* Can result from a digital scan, digital capture, original input of artwork on a computer, or combinations of several sources. *ex: We will e-mail you a digital image.* *plural:* Digital Images.

Digital Negative [1741-00-00-0100]. A digital image file format akin to a digital original. Similar to a RAW file but an open format that does not include manufacturer-specific proprietary technologies. *info:* A digital negative requires postprocessing before it can be used. Capable of delivering more color, dynamic range, and resolution than a TIFF or JPEG digital image file. Adobe Corp.'s DNG is one such format. *ex: Few photographers deliver a digital negative file to a client.* *plural:* Digital Negatives.

Digital Rights Management [1763-00-00-0100]. The use of encryption or other technological means to regulate access to a licensable digital work, such as images, songs, movies, other software, or sensitive documents. *info:* Typically, special computer software enforces time limits and permits viewing, yet denies copying, or it ties usage to a particular device. *ex: The DVD uses digital rights management that prevents copying on a computer.* *variation:* DRM.

Direct Mail [1830-00-00-0100]. Advertising or marketing materials mailed directly to a specific market, target audience, group, or list of names, usually in large volume. *info:* Examples include (but are not limited to) a brochure, catalog, flyer, postcard, and CD ROM. *ex: That postcard is part of our direct mail campaign.* *plural:* Direct Mailings.

Distribution [2690-00-00-0100]. The process or act of moving a work, goods, or services, usually from manufacturer or publisher to wholesale or retail outlets (but also to end users), or a description of how widely the goods or services will be delivered. *info:* In image licensing, often refers to the geographical area in which reproductions (such as a publication) will be sold

and/or circulated, and is a key factor in pricing a license. *ex: That movie goes into North American distribution next week. plural:* Distributions.

Distribution Right [1249-00-00-0100]. Refers to a specific geographic region in which copies of an image or other work may be distributed by a license holder. *info:* Often associated with language rights, but distinct. The name of the area(s) should be specified, as well as the language(s) for which the image is licensed. Does not grant the right to distribute for reuse by a third party or parties. *ex: The client purchased a North American distribution right. plural:* Distribution Rights.

Distributor [5120-00-00-0100]. A company that stores, catalogs, markets, sells, and/or licenses on behalf of a number of creators or producers, consolidating costs for those services. *info:* May work through sub-distributors, who require additional fees for their services. *ex: We sell our products through a distributor. plural:* Distributors.

Domain [1689-00-00-0100]. A group of networked computers and the data they make available that share a common communications address. *info:* Users apply to one of several sanctioned domain registrars for name assignments. If available, the name is granted to the applicant. Special Internet servers translate the words and punctuation of a domain name into a set of numbers more readily used by computers. *ex: Our domain name is* www.usePLUS.org. *plural:* Domains.

Double-Page Spread [1387-00-00-0100]. A piece that covers two facing pages in a magazine, newspaper, book, or other printed publication. *ex: The advertisement will be a double page spread on pages 10 and 11 of the magazine. plural:* Double Page Spreads.

Double Truck [1386-00-00-0100]. A piece that covers two facing pages in a magazine, newspaper, book, or other printed publication. *ex: The story and pictures will run as a double truck on pages 10 and 11. plural:* Double Trucks.

DPI [1388-00-00-0100]. A measurement unit describing the resolution of a hardware device, such as a computer monitor or digital printer, that renders digital imagery as output using binary values for each colorant. *info:* Often used incorrectly as the resolution unit for a digital image, in which case the correct units would be PPI (pixels per inch). *ex: Many computer monitors display at 72 DPI. variation:* Dots Per Inch.

Duration [2692-00-00-0100]. Stated in days, weeks, Months, or years, the period during which a license is active. The end date of a license is defined by the duration and start date. *info:* May be limited by the number of allowable insertions during that time period. *ex: The duration of the license is two months. plural:* Durations.

Duration Exclusive [5190-01-00-0100]. See Duration Exclusivity. *ex: The client wants to purchase a duration exclusive for five months.* **plural:** Duration Exclusives.

Duration Exclusivity [5190-00-00-0100]. A right that, when granted, limits the rights of the licensor (and other parties offering licenses of the work) to further license or otherwise permit any third party to use the work during a specified time period. *ex: The client wants to purchase duration exclusivity for five months.* **variation:** Duration Exclusive.

E-Commerce [1189-01-00-0100]. Acronym for Electronic Commerce. *ex: Our Web site allows you to license a photograph and pay for the license using e-commerce.*

Editorial [1833-00-00-0100]. Describes work in a periodical, online, on electronic media, presentation, and/or broadcast that is educational or journalistic in nature, and which does not promote a product, person, service, or company based on sponsorship. *ex: The client wants to license the image for an editorial use in a magazine.*

Editorial Use [1149-00-00-0100]. A use whose purpose is to educate and/or convey news, information, or fair comment opinion, and which does not seek or accept sponsorship to promote a product, person, service, or company. *ex: The license specifies editorial use only in a newspaper.* **plural:** Editorial Uses.

Electronic Rights [1251-00-00-0100]. Permission that applies to an end use that includes digital media, such as online, CD-ROM, DVD, and e-mail. *info:* This term is sometimes understood to include broadcast. Clarification with the client is recommended regarding what is included in electronic rights or use of another term. *ex: The client wants the license to include electronic rights for his Web site.* **preferred term:** Online. **usability:** Discouraged.

E-mail Advertising [1103-00-00-0100]. A commercial communication sent via a specific Internet protocol to specific recipient addresses with the help of computers and appropriate software. *info:* Usually distributed to large lists of Internet addresses. Unsolicited or unauthorized commercial e-mail messages, often referred to as spam or unsolicited commercial e-mail, can be illegal. May include marketing and promotional messages. *ex: E-mail advertising is governed by U.S. law concerning digital communications and privacy.* **variation:** E-Mail Advertising.

Encryption [1394-00-00-0100]. A method of encoding information so that it can be read only by those who have appropriate translators—such as special software. *info:* Used to protect data as it travels over intranets and the Internet. Provides privacy for e-mail, electronic commerce transactions,

online banking, and other online commercial communications. Prevents unauthorized users from accessing proprietary information, such as high-resolution image files. *ex: To secure transactions, our Web site includes encryption software.* **plural:** Encryptions.

Estimate [1063-00-00-0100]. A preproduction document formulated by a licensor based on a project description provided by the licensee. Typically describes work to be produced and licensed, the scope of the license to be granted, any terms and conditions applicable to the transaction, and the fees and costs for the project and license. *info:* Unlike a bid, an estimate is a best-effort approximation of fees and costs—expected to be reasonably accurate but not necessarily precise. Estimates are typically subject to variance, which may or may not be negotiated in advance. An estimate may be legally binding whether or not it is signed by a licensee, provided the licensee is presented with the estimate, indicates acceptance of the terms, and authorizes the licensor to proceed. It is best to ensure that estimates or job confirmations are signed by the commissioning party or licensee. *ex: We told the customer we could provide an estimate for producing ten photographs on location.* **plural:** Estimates.

Exclusive [2720-01-00-0100]. See Exclusivity. *ex: The agency wants to purchase an exclusive for using the image in printed matter.* **plural:** Exclusives.

Exclusive License [4960-00-00-0100]. A privilege that, when granted, limits how a copyright holder (and other parties permitted) can offer a work to a third party for reproduction. *info:* An exclusive license may be broad or specific. The rights grant may provide the licensee with exclusive rights to use a work singly or in any combination of: a specified media, industry, territory, language, time period, product, and any other specific right negotiated by the licensor and licensee. *ex: The client needs an exclusive license for the image, restricting all other licenses for real estate advertising.* **plural:** Exclusive Licenses.

Exclusive Rights [2718-00-00-0100]. A privilege that, when granted by a licensor to a licensee, limits the right of the licensor (and other parties offering licenses of the work) to license rights in a work to a third party. *info:* An exclusive right may be broad or specific. The rights grant may provide the licensee with exclusive rights to use a work singly or in any combination of: a specified media, industry, territory, language, time period, product, and any other specific right negotiated by the licensor and licensee. *ex: The agency wants to purchase exclusive rights for using the picture in resort advertising for two years.*

Exclusivity [2720-00-00-0100]. Describes a right that, when granted by a licensor to a licensee, limits how the licensor (and other parties offering

licenses of the work) may license rights in a work to a third party. *info:* Exclusivity may be broad or specific. The rights grant may provide the licensee with exclusive rights to use a work singly or in any combination of: a specified media, industry, territory, language, time period, product, and any other specific right negotiated by the licensor and licensee. *ex: The advertising agency wants to license exclusivity for using the image in printed matter.* *plural:* Exclusivities. *variation:* Exclusive.

Fair Use [1565-00-00-0100]. A doctrine under U.S. Copyright Law that permits the use of copyrighted materials without permission from the copyright owner under certain circumstances and for certain purposes such as scholarship, news reporting, reviews, parody, and teaching activities. *info:* Not all such uses will qualify as fair use. See section 107 of the Copyright Act, listing the factors that determine a fair use. For more information, see publication no. Fl-102, available at *www.copyright.gov. ex: Your reproduction of my photograph in a review of my exhibition is fair use.* *plural:* Fair Uses. *usability:* Caution.

Fee [1623-00-00-0100]. A sum of money charged for a professional service or license. *ex: The photographer's fee is on the fourth line of the invoice.* *plural:* Fees.

Ferry Advertising [1851-00-00-0100]. A marketing or promotional piece, usually poster-size or larger, displayed on the interior or exterior of a public transportation vehicle. *info:* May be printed, or displayed on monitors or other digital devices. *ex: The campaign includes ferry advertising throughout the region.*

File Format [1398-00-00-0100]. A form or type of digital file used to store images and other information on computers. *info:* Some examples of image file formats are TIFF, JPEG, PSD, and DNG. *ex: Save the image in the JPEG file format, which the client can easily open.* *plural:* File Formats.

First Rights [1254-00-00-0100]. The right to publish, before others do, an image, article, product, or project. *info:* First rights need to be defined specifically, noting whether they are regional or global, in one medium or many. *ex: The first rights to this image in North America have already been sold.*

Flat Rate Fee [4010-00-00-0100]. A fee, including all creative and licensing charges, involved in creating and/or delivering a work or works. *info:* A flat rate fee typically precludes separate line items on an invoice for creative and licensing fees, and may include some or all production expenses. Such a fee is usually negotiated in advance of an assignment, and it typically does not include extra payments for extra time required due to changes in the job requirements. Terms, conditions, and licenses accompanying invoices for a flat rate fee should specify all that is included, especially

the terms of the license. *ex: We agreed on a flat rate fee that will cover the photographer, his staff and the usage we need. **plural:*** Flat Rate Fees.

Flat Rate Image [1256-00-00-0100]. A stock picture, licensed on a nonexclusive basis, allowing multiple uses by a licensee, typically with few restrictions and no requirement that the licensee contact the licensor for permission prior to each use. *info:* License may or may not specify a license period. *ex: The clients asked for a flat rate image license for a dozen images they planned to use broadly. **plural:*** Flat Rate Images.

Flexible License Pack [1257-00-00-0100]. A license model permitting the use of one or more images in multiple media without requiring individual license fees for each image or use. *info:* A number of different flexible license pack variations have been developed, presenting a wide variety of media combinations, such as unlimited usage in selected territories, industries or timeframes. *ex: We purchased a flexible license pack for these images. **plural:*** Flexible License Packs.

Frequency (1) Frequency (Advertising) [1022-00-01-0100]. The number of times an audience might see a particular message. *ex: With all the pass-along readers, the frequency of that advertisement was high. **plural:*** Frequencies. (2) Frequency (Magazine) [1022-00-02-0100]. The number of times in a year a publication is issued. *ex: Their magazine has a frequency of four times a year. **plural:*** Frequencies. (3) Frequency (General) [1022-00-03-0100]. The number of times an event occurs over a given time unit. *info:* Applies to sound and radio waves, among other occurrences measured. *ex: The electrical power frequency in the U.S. is 60 hertz, or cycles per second. **plural:*** Frequencies.

FTP [1703-00-00-0100]. An Internet communications protocol governing the transfer of files from one computer to another. *info:* FTP is relatively insecure but robust for large data transfers. *ex: Please upload those files to our FTP server. **variation:*** File Transfer Protocol.

Fulfillment [1023-00-00-0100]. The completion of certain specified obligations, or delivery of a product or service under contractually agreed terms and conditions. *ex: Fulfillment will occur when the files are delivered to the client. **plural:*** Fulfillments.

Full Page [2800-00-00-0100]. A promotion, editorial, or advertising piece that takes up one complete page. *info:* A full page license permits use of the image at any size up to the complete page. *ex: The ad will be a full page. **plural:*** Full Pages.

Geographic Exclusive [2725-01-00-0100]. See Geographic Exclusivity. *ex: The client purchased a geographic exclusive for the image in Europe. **plural:*** Geographic Exclusives.

Geographic Exclusivity [2725-00-00-0100]. Describes a right that, when granted to a licensee, limits how the licensor (and other parties offering

licenses of the work) may license rights in a work to a third party for use in a specified region of the world. ***ex:*** *The client purchased geographic exclusivity for the image in Europe.* ***plural:*** Geographic Exclusivities. ***variation:*** Geographic Exclusive.

Giclée Print [3570-00-00-0100]. A term applied, primarily in fine art marketing and transactions, for high-quality output from systems that spray ink on paper and other substrates (such as canvas). ***info:*** Giclée (pronounced zhee-clay) is French for squirt or spray. Giclée appeared about 1989 as a marketing term for plateless reproductions of fine art on art-quality paper. At that time, they were produced with large format ink jet printers designed for making prepress proofs with watercolor inks. Since then, many other types of ink, printers and paper have been used to produce giclée prints, which tend to have vibrant color and fine detail, combined with the texture of the paper or other substrate used. This term, however, offers no firm standard of quality or print longevity. ***ex:*** *We will donate a Giclée Print of the image to the exhibit.* ***plural:*** Giclée Prints. ***preferred term:*** Ink-Jet Print. ***usability:*** Caution.

GIF [3480-00-00-0100]. A very compact bitmap format that supports low-resolution transparency and animation, especially for Web site display. ***info:*** GIF is a legacy image file format from the early days of online communications. But because its files are very small, it's still used often for Web site display, especially for images with large expanses of flat colors, such as screen shots and logos. Capable of displaying continuous-tone photographs, but not very well. ***ex:*** *The designer wanted to use GIF image files on our home page, but we insisted that JPEGs would look better.* ***plural:*** GIFs. ***variation:*** Graphics Interchange Format.

Gigabyte [4370-00-00-0100]. A measure of file size and storage capacity referring to, depending on context, between 1,000,000,000 and 1,073,741,824, eight-bit data units or characters. ***info:*** Most software, memory chips, and systems consider a kilobyte to be 1,024 (the binary quantity of 2 to the 10th power) bytes, a megabyte to be 1,024 such kilobytes, and a gigabyte to be 1,024 such megabytes or 1,073,741,824 bytes. However, some key standards groups state that 1,000 (10 to the third power) bytes comprise a kilobyte, a megabyte is 1,000 kilobytes, and a gigabyte is 1,000 megabytes or one billion (10 to the 9th power) bytes. And many data storage manufacturers use this measurement to define their device sizes, meaning a computer may show less storage capacity on a drive than the drive's specified size suggests. ***ex:*** *A gigabyte of storage should be enough to store all the files from this small project.* ***plural:*** Gigabytes. ***variations:*** GB, Gig.

Guide Print [5000-00-00-0100]. An image output by a photographer to

indicate for the printer and/or prepress operator the colors, contrast, and tonality the photographer would like to aim for on press. *info:* A guide print offers goals or targets, not confirmation that color or tones will be properly reproduced—or even reproducible. *ex: We will try to match the guide print, but we cannot guarantee the match will be exact. plural:* Guide Prints.

Gutter [1411-00-00-0100], The center, vertical area where two facing pages in a magazine or book are bound together. *info:* Often considered unusable dead space, as content is not always visible in this area. *ex: Depending on the binding method for a piece, anything printed in the gutter may be difficult to see. plural:* Gutters.

High Resolution [1650-00-00-0100]. Refers to a relatively larger number of pixels per inch in a digital image or scan, which yields a larger digital file. *info:* Generally speaking, an image file that is larger than 10 megabytes (10MB) when opened in digital image viewing or editing software. Compression file formats can decrease the storage file size dramatically. *ex: The client asked us to deliver a high-resolution file. plural:* High Resolutions. *variation:* High Res.

Hold Harmless [1258-00-00-0100]. A term often used in a contract; one party assumes the liability inherent in a situation, relieving the other party of responsibility. *ex: The contract includes a hold-harmless term.*

Holding Fee [1641-00-00-0100]. A charge for retaining material beyond an agreed-upon submission or license period. *ex: Please return within 30 days or you will be billed a holding fee. plural:* Holding Fees.

HTML [1024-01-00-0100]. Abbreviation for Hyper Text Markup Language. *ex: Creating proper HTML code for a Web site requires a computer specialist.*

Hyper Text Markup Language [1024-00-00-0100]. Computer code that, when rendered to a monitor by Web browser software, controls how a Web page appears. *info:* Includes text, formatting, and layout instructions, font information, color specifications, coded instructions that allow interactivity, and coded instructions that link a Web page to graphics, images (still and video), dynamic content, and other Web pages. *ex: Writing proper hyper text markup language code for a Web site requires a specialist. variation:* HTML.

ICC [1419-00-00-0100]. An industry group responsible for setting technology standards that underlie color management systems for computer input and output devices, including monitors. *info:* International Color Consortium standards include the format for a color profile. *ex: Our images include ICC-compliant color profiles to help ensure accurate color reproduction. variation*: International Color Consortium.

Image Resolution [1421-00-00-0100]. The amount of visual information stored in an image file, measured in pixels per inch (PPI) at a given physical size, or more simply, by the dimensions of the file in pixels. *info:* Much confusion surrounds PPI and image resolution. A PPI figure has little meaning without image dimensions in inches. A 2- by 3-inch image at 300 PPI contains the same visual information as a 6- by 9-inch image at 100 PPI. Both measure 600 pixels by 900 pixels and offer the same reproduction capabilities. *ex: The clients asked for the pictures at actual size for the layout with an image resolution of 300 PPI. plural:* Image Resolutions.

In Perpetuity [1260-00-00-0100]. For an indefinite time period, without limits, forever. *ex: The images are licensed to the client in perpetuity. usability:* Discouraged.

Indemnification [1261-00-00-0100]. An agreement to remunerate for loss incurred or to protect from liability. *info:* When agreeing to indemnify, one accepts responsibility for actions and eventualities under one's control, implying—often stating—a warranty or guarantee. *ex: The contract includes an indemnification clause. plural:* Indemnifications. *variation:* Indemnify.

Indemnify [1261-01-00-0100]. See Indemnification. *ex: The contract includes a clause in which you indemnify us.*

Indemnity Clause [1567-00-00-0100]. A part of an agreement or contract that specifies remuneration for loss incurred and protection from liability. *info:* When agreeing to endorse an indemnity clause, you are accepting responsibility for various actions and eventualities, preferably those you can control. Such responsibility often takes the form of a warranty or guarantee, implied or stated. *ex: The contract includes an indemnity clause. plural:* Indemnity Clauses.

Independent Contractor [1568-00-00-0100]. An individual or company that agrees to perform a certain task or project, for a given period of time, according to that person or company's own methods. *info:* Unless otherwise agreed, independent contractors own the copyright to work they produce and license usage of the work to the client. They work when they choose in order to meet certain specifications using equipment and/or premises they own or lease, but they do not receive employee benefits (e.g., matching retirement savings, health insurance, sick days, paid vacations, etc.). *ex: Please sign our independent contractor agreement before beginning the project. plural:* Independent Contractors.

Industry Exclusivity [1263-00-00-0100]. A right that, when granted by a licensee, limits how the licensor (and other parties offering licenses of the work) may allow any third party to use the work in relation to a specified type or types of companies. *info:* Often combined with other types of

exclusivity, such as duration and geographic. *ex: The client purchased industry exclusivity for automotive advertising.* **plural:** Industry Exclusivities. **variation:** Industry Exclusive.

Infringement [3780-00-00-0100]. A violation or encroachment on a law or right. *info:* Copyright infringement takes place when a work is used without sufficient or with no license from the copyright holder. Infringement of rights to privacy, property (including trespass), and publicity are among other issues in picture licensing and use. *ex: Using that picture for an advertisement without a release and license would be an infringement on the rights of both the subject and the photographer.* **plural:** Infringements.

Insert [3800-00-00-0100]. A printed piece, often a single sheet or blow in card, inserted into a multipage publication. *info:* A newspaper insert can often be a full magazine, sales catalog, or additional section. *ex: The Sunday insert project will include hundreds of pictures.* **plural:** Inserts.

Insertions [1280-00-00-0100]. In a license, the number of times a work may appear in specified media. *ex: The client ordered three insertions of the advertisement, including our photograph.* **variation:** Number of Insertions.

Intellectual Property [1264-00-00-0100]. Refers generically to rights of ownership created through cognitive, creative, and/or discovery efforts of a creator. *info:* Intellectual property rights can be protected under patent, trademark, copyright, trade secret, trade dress, or other law. An intellectual property right is generally separate and distinct from any physical object and not transferred by mere sale of the object embodying the right. *ex: My writings and my photographs are my intellectual property.* **plural:** Intellectual Properties.

Internet [1109-00-00-0100]. A global collection of largely public information and networks generally linked together with telecommunications hardware and software. *info:* At its core, the Internet comprises mainframe computers and heavy-duty servers connected via fiber-optic cable and large data routing devices communicating through several data protocols. At its edges, the Internet is personal computers connected via cable, copper telephone lines, or wirelessly. All Internet communications are governed by protocols established by various standards bodies. *ex: The World Wide Web represents only one of several protocols on the Internet.*

Intranet [1192-00-00-0100]. A private computer network that uses the same kind of software and protocols as the Internet but for use only within an organization. Not accessible to the public. *ex: The image appears on a Web page that's available only on the client's intranet.* **plural:** Intranets.

Invoice [1569-00-00-0100]. A billing document listing fees, expenses, charges, and descriptions of the work licensed, work created, and/or goods

delivered. *info:* Often lists any right licensed or transferred, payment terms, other applicable terms and conditions, and additional pertinent information. Issued by a licensor to a licensee, or more generally, by any seller to a buyer or client. *ex: Here is my invoice, detailing the project and its costs.* *plural:* Invoices.

IP Address [1699-00-00-0100]. A set of numbers corresponding to a machine-readable Internet address of a server or domain. *info:* A special group of Internet servers translate the plain-language Web address domain names into these numbers, so Internet-connected computers can locate each other. IP stands for Internet protocol. *ex: Please tell us the IP Address of your server.* *plural:* IP Addresses.

ISP [1701-00-00-0100]. A supplier of Internet connections to business, education, and/or the public. *info:* Typically offers such services as e-mail, Web site hosting, and off-location server hosting. *ex: Our ISP runs our Web servers and e-mail.* *plural:* ISPs. *variation:* Internet Service Provider.

JPEG [1428-00-00-0100]. A file format featuring digital compression that reduces digital image file size, or an image file that has been so compressed. *info:* The common JPEG format deletes some image data when compressing a file. Application of a high-compression ratio when saving JPEG files may cause undesirable visual artifacts. Repeatedly editing and saving a JPEG file will magnify such artifacts. However, when created with low compression (larger file sizes and higher level settings), a JPEG image is almost indistinguishable from the original digital image from which it was generated. JPEG image file compression can be confusing, since most measures designate lower compression ratios with high numbers, intended to designate high quality. JPEG was originally an acronym for the Joint Photographic Experts Group, a standards group for still image compression, formed by the International Organization for Standardization (ISO) and the ITU telecommunication standardization sector (ITU-T). The popular JPEG image compression standards and the new JPEG 2000 file formats are the best known among this group's standards. *ex: She converted her image to a low res JPEG for Internet use.* *plural:* JPEGs. *variation:* JPG.

Keyword [5060-00-00-0100]. A search term that describes some aspect of an image and can be used to locate it, or the act of developing a list of such search terms. *info:* A single image may be associated with many keywords. *ex: Give me the right keyword combination, and I'm sure I can locate the image you need in our DIM.* *plural:* Keywords.

Kill Fee [2796-00-00-0100]. A payment that may be made (and may be called for by contract) to a creator when a client cancels a project. *ex: The amount of the kill fee is reasonable, considering the work that has been invested already.* *plural:* Kill Fees.

Language Exclusive [1709-01-00-0100]. See Language Exclusivity. *ex: The client purchased language exclusivity for Farsi. **plural:** Language Exclusives.*

Language Exclusivity [1709-00-00-0100]. Describes a right that, when granted to a licensee, limits how the licensor (and other parties offering licenses of the work) may license rights in a work to a third party for use accompanied by text in specified languages. *ex: The client purchased language exclusivity for Farsi. **plural**: Language Exclusivities. **variation:** Language Exclusive.*

Language Rights [1268-00-00-0100]. A permission that specifies the languages in which a creative work may be used. ***info:*** Each separate language must be named in the license agreement. Often confused with international rights and territory rights, although it may be combined with such rights. ***ex:*** *The client is requesting specific language rights for Arabic and Hindi.*

Late Fee [1771-00-00-0100]. A contract term that specifies an agreed fee if a balance due is in arrears. ***ex:*** *The parties agreed to a reasonable late fee.* ***plural:*** Late Fees.

Layered File [3190-00-00-0100]. A digital image or design document that is organized with virtual overlays, allowing a user to modify the appearance and attributes of visual data in the file and save those changes in the original file, while retaining its original unmodified attributes. ***info:*** Also allows users to reproduce only certain layers, something very handy for creating different versions of a piece or noting edits. ***ex:*** *Because the ad was designed as a layered file, exchanging its text without affecting the rest of the ad was a relatively easy step.* ***plural:*** Layered Files.

Layout [1160-00-00-0100]. A preliminary representation of an advertisement, page, or other graphic work, or the act of assembling and arranging on a page or in design software the text and visual components of a piece intended for reproduction. ***info:*** Usually indicates the planned placement of photographs and/or illustrations and copy, along with examples of each. May have two stages—a rough outline called a mock-up or visual, followed by the finished artwork (called a comp). ***ex:*** *The art director showed the layout, with all its components, to the client.* ***plural:*** Layouts.

Liability [1269-00-00-0100]. Amount owed for items received, services rendered, expenses incurred, assets acquired, work performed, and amounts received but not as yet earned. It also results from a breach of contract, infringement, or contingent acts. ***info:*** The main thrust of this term in the industry is to potential liability as a result of alleged breach, or breach, of representations or warranties. ***ex:*** *The building mortgage is listed as a liability on the balance sheet.* ***plural:*** Liabilities.

Libel [1270-00-00-0100]. Defamation in the form of a writing that is the tort of making a false statement of fact that injures someone's reputation. ***ex:***

Your calling him a liar in your newspaper column might be considered libel. ***plural:*** Libels. ***variation:*** Libelous.

Libelous [1270-01-00-0100]. See Libel [1270-00-00- 0100]. ***ex:*** *Your calling him a liar in your newspaper column might be considered libelous.*

License [1271-00-00-0100]. A legal agreement granting permission to exercise a specified right or rights to a work, often encompassed in an invoice, or the act of granting same. ***ex:*** *We granted them a license to use the image in the magazine.* ***plural:*** Licenses.

License Fee [5070-00-00-0100]. The price charged by a licensor to a licensee in exchange for a grant of rights permitting the use of one or more images in a manner prescribed in a license. ***info:*** A variety of factors, such as circulation, the size of reproduction, and specific image qualities affect the determination of a particular license fee. ***ex:*** *The licensor paid the licensee a license fee for use of the image in the advertisement.* ***plural:*** License Fees.

Limited Edition [3200-00-00-0100]. A pre-specified number of copies of a work that may be reproduced in a particular size or based on some other limiting factor. ***info:*** Historically processes such as wood cuts or stone lithography could only produce a limited number of clean copies. Modern reproduction methods allow production of an unlimited number of identical copies, reducing the significance of some types of limited editions. However, limiting the number of copies produced can increase the value of each, and the tradition continues even with processes that have no practical limits. Care should be exercised in defining the limits of limited editions, with attention to ethical considerations and applicable laws. ***ex:*** *The artist produced a limited edition of twenty platinum prints.* ***plural:*** Limited Editions. ***usability***: Caution.

Limited Rights [1633-00-00-0100]. A license restricting use or other reproduction in a manner that must be described in the contract or agreement. ***ex:*** *The client accepted a limited-rights license, which meant he could use it for his internal newsletter only.*

Local Distribution [1066-00-00-0100]. When circulation of a product, message, or usage is limited to a single city, or otherwise limited geographic area. ***info:*** Several instances are spot distribution. The next larger distribution area is referred to as regional distribution. ***ex:*** *They started as a small local-distribution magazine.* ***plural:*** Local Distributions.

Location [5100-00-00-0100]. A place, outside a studio, used for photographic productions. ***ex:*** *The school was used as a location for the photo shoot.* ***plural:*** Locations.

Location Fee [5090-00-00-0100]. The price paid for using and/or depicting a place in a production or finished work. ***ex:*** *The location fee covered both*

the cost of renting the property and of using the distinctive mansion in the background. **plural:** Location Fees.

Location Release [5110-00-00-0100]. A document signed by the owner or controlling entity of property (a building, statue, or other object or area belonging to that owner or entity) that allows a photograph of it to be licensed for commercial use. **ex:** *The photographer has a location release on file allowing him to license pictures of the building.* **plural:** Location Releases.

Low Resolution [1433-00-00-0100]. An image file that is under one megabyte (1,048.576KB) in size (based on a full page) when opened in digital image viewing or editing software. **info:** Useful for presentation purposes but generally insufficient for high quality printed reproduction except at very small size. Low resolution reproduced less than a full page would translate into a lower KB size, i.e., 500KB or less. **ex:** *Send the client a low resolution file for presentation use.* **plural:** Low Resolutions. **variation:** Low Res.

Magazine Print Advertising [1112-00-00-0100]. Attracting public attention to a product, idea or business using announcements printed in a periodical. **info:** This is typically a paid placement, unless provided pro bono to a nonprofit by the publisher. **ex:** *Magazine print advertising is the preferred method for many advertisers wanting to reach people who do not frequent the Internet.*

Marketing [1513-00-00-0100]. The direct application of advertising and public relations in order to promote and sell products to the buying public. **ex:** *The marketing plan included an extensive advertising campaign and speaking tour.*

Matchprint [4420-01-00-0100]. See Match Print. **ex:** *We could tell from the matchprint that the image was going to appear too red so we substituted it for a different one at the last minute.* **plural:** Matchprints. **preferred term:** Contract Proof. **usability:** Discouraged.

Media (1) Media (Journalism) [1678-00-01-0100]. The various forms of mass communication, including print (e.g., newspapers, magazines, and brochures), electronic (e.g., radio and television), and online (e.g., World Wide Web and e-mail). **info:** Singular form is medium. **ex:** *It's such an interesting story that we are seeing it appear in all types of media.* (2) Media (Digital) [1678-00-02-0100]. Digital objects or devices on which digital data is stored. **info:** The singular form is medium. **ex:** *Our images are stored on hard disks and tape media.*

Media Buy [1681-00-00-0100]. A license or contract to purchase selected space or time in specified media. Or, the total cost of all specific media purchases for a particular advertisement or campaign. **info:** Usually described in terms of total number of insertions in particular publications and/or the

total dollar cost for an entire campaign. *ex: The media buy for a year's worth of advertising in five different national publications plus will be $6 million.* *plural:* Media Buys.

Media Exclusive [1825-01-00-0100]. See Media Exclusivity. *ex: He could not grant a license to use that image for a newspaper ad campaign because it was already media exclusive to another client.* *plural:* Media Exclusives.

Media Exclusivity [1825-00-00-0100]. A right that, when granted by a licensor to a licensee, limits the right of the licensor (and other parties offering licenses of the work) to license the right to any third party to use the work in specified media. *ex: He could not grant a license to use that image for a newspaper ad campaign because he had already granted media exclusivity of that image to another client.* *plural:* Media Exclusivities. *variation:* Media Exclusive.

Media Kit [1814-00-00-0100]. A folder or bundle of promotional and/or editorial materials used to announce or promote something. *info:* Usually distributed to representatives of trade or consumer publications and other news outlets. *ex: The media kit contained two samples of the product and an advertising rate sheet.* *plural:* Media Kits.

Media Rights [1680-00-00-0100]. The listing of particular means of mass communication included in a given license. *ex: The media rights include print advertising and broadcast but not online use.*

Media Usage [1679-00-00-0100]. The use of a work in media. In a license agreement or contract, the listing of particular forms of mass communications media permitted under the given license. *ex: Permitted media usage, noted on the invoice, includes magazines, billboards, and bus shelters.* *plural:* Media Usages.

Megabyte [4360-00-00-0100]. A measure of file size and storage capacity referring, depending on context, to between 1,000,000 and 1,048,576, 8-bit data units or characters. *info:* Most software, memory chips, and systems consider a kilobyte to be 1,024 bytes (the binary quantity of 2 to the 10th power) and a megabyte to be 1,024 such kilobytes or 1,048,576 bytes. However, some key standards groups state that 1,000 (10 to the 3rd power) bytes comprise a kilobyte, and a megabyte (the "mega" prefix means million or 10 to the 6th power) is 1,000 kilobytes. And many data storage manufacturers use this measurement to define their device sizes, meaning a computer may show less storage capacity on a drive than the drive's specified size suggests. *ex: That image should compress down to a file size under one megabyte.* *plural:* Megabytes. *variation:* MB.

Metadata [3240-00-00-0100]. Data embedded or stored within a digital image file that provides information about copyright, credit, restrictions,

captions, keywords, or other quality characteristics, etc. *info:* There are several forms of image metadata; the oldest form is that popularized by the International Press Telecommunications Council, or IPTC. The IPTC image resource block (IRB) schema is the older version, while the newer is called IPTC core and is designed to work with newer XMP compatible applications. EXIF or exchangeable image file format, is another form of metadata that is used by digital cameras and provides information such as the make/model of camera, as well as apertures and shutter-speeds, etc. *ex: I looked in the image metadata to find the contact information for the copyright holder. variation:* Meta data, Meta-data.

Minor Release [3250-00-00-0100]. A document signed by a subject's guardian of an image or series of images that allows that image or series of images to be published for advertising or other commercial purpose. *ex: Because the subject was only seven years old, a minor release, signed by his legal guardian, was needed by the advertising agency before they would consider using the photographer's image. plural:* Minor Releases. *variation:* Release.

Model Release [1275-00-00-0100]. A document signed by the subject (or, if under age, the subject's guardian) to permit use of their likeness, voice or name for advertising or commercial purposes. *ex: Before the advertising agency will consider using the image, they need to know if the photographer has a model release on file. plural:* Model Releases. *variations:* Talent Release, Release, MR.

Moral Rights [1276-00-00-0100]. The right of authors to have their works correctly attributed, published anonymously or pseudonymously, and to prevent unauthorized alterations. Moral rights may also refer to not having work subjected to derogatory treatment, not having work falsely attributed, and in some cases may include the right of privacy. *info:* Moral rights are not fully recognized in the United States. For still photography, the Visual Artists Rights Act of 1990 limits moral rights to works of visual art (works created for exhibition only) produced in editions of two hundred or less, consecutively numbered, and signed by the artist. *ex: Moral rights vary from country to country and protection for artists is not guaranteed.*

Multimedia [1194-00-00-0100]. Information presented using multiple simultaneous formats, such as text, still or moving images and audio. *ex: The multimedia presentation on the 4th of July included cannon shots, fireworks, orchestral music, and holographic images. variation:* Multi-Media.

Multiple Rights [1277-00-00-0100]. Permission that allows more than one usage for the same image. *ex: The client wants the license to include multiple rights such as book, poster, and calendar usage.*

Multiple Use [1278-00-00-0100]. A usage that includes more than one medium. *ex:* *They purchased a multiple-use license and were covered for video, CD, and DVD usage.* *plural:* Multiple Uses.

National [3430-00-00-0100]. Of, relating to, or belonging to the whole of one specific country, which serves to distinguish it from local or regional rights. *info:* National typically refers to the same country in which the license is being given unless otherwise noted. *ex:* *Since the billboard was national, it was seen by motorists from coast to coast.*

National Distribution [1067-00-00-0100]. The process or act of moving goods or services, such as a piece, advertisement, other print form, or message within one specific country. *info:* Usage may cross state and regional lines but not international borders. *ex:* *Because the product had a national distribution, it was seen from coast to coast.*

NDA [3470-01-00-0100]. Abbreviation for Non-Disclosure Agreement *ex:* *We could not brag that our image was scheduled to appear on the ads for the new computer screen because of the NDA we had signed.*

Negotiate [1593-00-00-0100]. To confer with others in order to reach an agreement on definitions, terms, and conditions, including any obligations, liabilities, and/or responsibilities. *info:* Other types of things that may be negotiated include fees, expenses covered, and license granted. *ex:* *To negotiate an agreement that will endure, both sides have to believe it is fair and written in good faith.* *plural:* Negotiates.

Niche Marketing [1578-00-00-0100]. Marketing and promoting a product or service to a small, targeted group of buyers, such as people in a certain geographical region, or with a specific hobby or interest. *ex:* *Our niche marketing effort is aimed only at 45-year-old right-handed men.*

Non-Disclosure Agreement [3470-00-00-0100]. A contract stipulating that the party receiving information which is confidential and proprietary shall not disclose this information further during the time that the providing party has not publicly disclosed that information, and for which penalties for the receiving party's disclosure are outlined. *info:* Software developers, reporters, and sometimes beta testers are often required to sign these before they are given access to either information about upcoming products or the product itself. *ex:* *We could not brag that our image was scheduled to appear on the ads for the new computer screen because of the non-disclosure agreement we had signed.* *plural:* Non-Disclosure Agreements. *variation:* NDA.

Non-Exclusive License [2723-00-00-0100]. A grant of rights issued by a licensor to a licensee that does not preclude the licensor from granting the same rights to other licensees. *info:* Unless otherwise negotiated, licenses are non-exclusive. *ex:* *The stock agency granted a non-exclusive license to two different clients.* *plural:* Non-Exclusive Licenses.

Non-Exclusive Right [1279-00-00-0100]. A legal claim, title, or privilege granted by a licensor to a licensee giving official permission that does not preclude the licensor from transferring to other licensees the same permission within the same scope. *ex: The stock agency granted a non-exclusive right to two different customers. plural:* Non-Exclusive Rights.

Non-Exclusive Use [2724-00-00-0100]. A right to use, granted by a licensor to a licensee. It does not preclude the licensor from transferring to other licensees the same permission within the same scope. The ability to issue this is covered under copyright and trademark law. *info:* A purchase option that must be negotiated. *ex: The client's license includes a non-exclusive use in brochures and catalogs so others may be using the same image on similar products. plural:* Non-Exclusive Uses.

Non-Exclusivity [2722-00-00-0100]. A type of right granted by the copyright owner. The licensor (and other parties offering licenses of the work) may license similar, related, or identical rights to another licensee at any time. *info:* A purchase option that must be negotiated. Unless the right of exclusivity is expressly granted by a licensor to a licensee, any other rights granted under a license are non-exclusive by default. *ex: A competing magazine was able to use the same image on the cover because they had only negotiated for non-exclusivity of the photo. plural:* Non-Exclusivities.

One-Time Use [1281-02-00-0100]. See One-Time Use. *ex: The image is licensed for one-time use in an advertisement in the January issue of their magazine.*

Option [1627-00-00-0100]. Defines a future right and guarantees that the right will be available, usually for a fee. *info:* May be limited by duration. Fees may be specified when an option right is requested or granted, or may be negotiated at a future date. *ex: The client wants an option to extend the license past the initial two year term if necessary. plural:* Options.

Option Clause [1822-00-00-0100]. A clause in a license agreement giving the buyer the right to acquire additional rights, typically at a predetermined fee. *info:* May be limited by duration or other factors. *ex: There is an option clause in the agreement which will allow them to extend the license by one year. plural:* Option Clauses.

Original [1444-00-00-0100]. First or master version of a digital or analog image. *info:* It has come to be used when referring to an original transparency or digital image, to differentiate it from a duplicate or scan. *ex: The original transparencies are stored away and they only send out duplicates to their clients. plural:* Originals.

Out Take [4480-03-00-0100]. See Out. *ex: He licensed an out take from one of his assignments for use in a textbook. plural:* Out Takes.

Overhead [2756-00-00-0100]. The sum of money required to open a business and, over time, keep it running and solvent. *info:* Includes rent, utilities,

labor, taxes, and other costs that are not part of the cost of goods sold. Generally expressed as dollars per day. *ex: The assignment costs included fees for models, film, processing, and props, as well as a customary overhead fee.*

P.O. [4620-01-00-0100]. Abbreviation for Purchase Order. *ex: The agency needed a signed P.O. before they would remit payment.*

Paternity Fee [1283-00-00-0100]. A fee for failure to properly attribute authorship of a creative work. *ex: A missing credit line might trigger the paternity fee clause. plural: Paternity Fees.*

Pay-per-Download [4520-00-00-0100]. Used to describe content that can only be purchased on an individual basis, as opposed to a subscription basis. Licensing model by which products (e.g., images, footage, CDs of either) are purchased on an individual basis. *info: The term can also be used to describe the Web site on which these products can be purchased individually. ex: Because the book was available online at a pay-per-download rate, he was able to tell how many people had downloaded it more than once.*

Permission [1576-00-00-0100]. An agreement or license from copyright holders that grants the right to someone else to reproduce their work. *ex: They have permission to use the image for the cover of their album as long as they do not print more than one million copies. plural: Permissions.*

Photo Credit [1244-00-00-0100]. A line of text identifying the copyright holder (and, optionally, date of the copyright). Usually located near an image, at the bottom or side of a page or screen on which the image appears, or in a separate area of the publication. *info: Licenses issued by stock photo agencies require a credit line that includes their name as well as the photographer's. ex: If I had not seen his name in the photo credit, I would never have realized he took that image. plural: Photo Credits.*

Photo Illustration [1683-00-00-0100]. A photograph created or used to enhance, clarify, explain, decorate, or add meaning to a text. *info: Often includes illustration elements, and can stand alone or be the basis of an advertisement, poster, etc. ex: The client wants us to create a photo illustration to show the stages of photosynthesis. plural: Photo Illustrations. variation: Photo-Illustration.*

Photo Research [4550-00-00-0100]. To investigate, acquire, and edit images found through stock agencies, photographers, libraries, museums, governmental agencies, educators, video, film, and digital media producers. Skill set includes varying levels of knowledge about art, history, social and physical sciences, photography, imaging, Internet, copyright, permissions procedures, data, and image management. *ex: He performed extensive photo research to illustrate the encyclopedia. variation: Picture Research.*

Pixel [1453-00-00-0100]. The basic unit of which a video or digital image is

comprised. *info:* The unit of measurement for image resolution. *ex: Every pixel in that underwater scenic represents different shades and colors.* *plural:* Pixels. *variation:* Picture Element.

Pixelated [1454-00-00-0100]. An image in which the pixels are visible as squares or jagged edges. Usually recognized by large blocks of color lacking any definition. *info:* Sometimes desired by art directors or designers as a kind of visual look. *ex: The image is so pixelated that I cannot make out its subject.*

Placement [1821-00-00-0100]. The positioning and location of an image within a publication. *info:* Usually refers to image use in a prominent way which marks or enhances content (e.g., cover, back cover, frontispiece, or chapter opener). *ex: They switched the placement of the image from the table of contents page to the chapter opener.* *plural:* Placements.

Point of Purchase [1034-00-00-0100]. Sales, marketing, advertising, or other promotional piece placed at the location where a product or service is sold, often on a retail counter, near a cash register or front door. *ex: The point of purchase use he had in mind included printing the image on a counter card for placement by the cash register.* *plural:* Points of Purchase. *variation:* POP.

Portal [1702-00-00-0100]. A Web site considered as an entry point to other Web sites or online content. *info:* Usually provides a search engine. *ex: Their home page is a corporate portal to all their subsidiary Web sites.* *plural:* Portals.

Postproduction [3600-00-00-0100]. Everything that happens to a visual work after production, typically after images (either still or moving) have been recorded to film or digital media. *info:* Postproduction might include editing, color correction, etc. *ex: The color imbalance of the original image was corrected in post production.* *variation:* Post-production.

Postponement Fee [1781-00-00-0100]. A fee applicable when previously scheduled production of a work or works is delayed or rescheduled by a commissioning party. *info:* Postponement fee may vary based on the date/time that notice is given by the commissioning party. *ex: Please send us an invoice for the postponement fee, since the production of the assignment will not take place for at least six months.* *plural:* Postponement Fees.

PPI [1456-00-00-0100]. Pixels per inch, a measure of the resolution of an instance of a digital image at a specific size. Often confused with DPI. *info:* Usually given as a pair of figures, width × height and PPI. *ex: The resolution of that image is seventy-two PPI, which is satisfactory for the Web, but given its size of 2 × 3 inches, would not produce a high quality print on press.* *variation:* Pixels Per Inch.

PR (1) PR (Legal) [1284-02-00-0100]. Abbreviation for Property Release. *ex: The photographer has a PR on file and so has the right to license the use of this image*

of a house. (2) PR (Marketing) [1784-01-00-0100]. Abbreviation for Public Relations. ***ex:*** *The PR campaign includes several news releases and photos, and videotaped interview with the chairman.* ***usability:*** Discouraged.

PR Use [1636-02-00-0100]. See Promotional Use [1636-00-00-0100]. ***ex:*** *The image is being licensed for PR Use for the life of the product.* ***preferred term:*** Promotional Use. ***usability:*** Strongly Discouraged.

Prepress [1528-00-00-0100]. All preproduction and preparation steps required before a work can actually be printed. ***info:*** This might include conversion of the digital file from an RGB color space to a specific CMYK color space, or the sizing, and sharpening of the high resolution image to the specific size needed in the publication. ***ex:*** *That problem was fixed during prepress, and so the actual press run went very smoothly.* ***variation:*** Pre-Press.

Preproduction [1070-00-00-0100]. Work on a project or job that is related to preliminary preparations. ***info:*** Includes all planning and the making of any arrangements necessary to enable or facilitate final production. Typically billed as time plus any costs expended. ***ex:*** *Many phone calls will be made during preproduction so that the assignment runs smoothly.* ***variation:*** Pre-Production.

Press Kit [2764-00-00-0100]. A folder or group of promotional and/or editorial materials used to announce or promote something. May be in printed or digital form. ***info:*** Usually distributed to representatives of trade or consumer publications and other news outlets. ***ex:*** *The press kit included short bios on each of the officers of the organization, as well as their mission statement.* ***plural:*** Press Kits.

Press Release [1197-00-00-0100]. Information sent to the press to promote a product, event or person. Typically one or two pages of text, often accompanied by images. ***info:*** Sometimes supplied as digital text and image files on a CD-ROM disc, or downloadable from a Web site. ***ex:*** *The press release focuses on the benefits of our new product.* ***plural:*** Press Releases.

Press Run [1457-00-00-0100]. The actual operation of the printing device or the specific number of copies printed or supposed to be printed during a continuous operation of a printing press. ***ex:*** *Because the book will be so popular, we anticipate having to make more than one press run.* ***plural:*** Press Runs. ***variation:*** Pressrun.

Primary Rights [3980-00-00-0100]. The use of artistic work for its first (intended) reproduction. An example might include primary rights for a hardbound book and then secondary rights for a lesser quality book club edition. ***info:*** Secondary rights use the same content in lower quality and lower value, such as photocopies. ***ex:*** *The primary rights he sought in the usage license included use in a coffee table book, though he intended to*

relicense the work for companion notecards at a later date. **preferred term:** First Rights. **usability:** Discouraged.

Print on Demand [1458-00-00-0100]. Publisher's right (by permission or license) to electronically reproduce or license a work when it is requested by end users. **ex:** *The book will be produced using the latest print on demand technology.*

Print Run [2774-00-00-0100]. The specific number of copies made or requested during the continuous operation of a printing press. **ex:** *The first print run was 5,000, but we expect to need another print run in a few months.* **plural:** Print Runs. **variation:** Printrun.

Process Color [1459-00-00-0100]. The four pigments (cyan, magenta, yellow, and black) used in full-color offset printing. **ex:** *The brochure will be printed with black and one other process color.* **plural:** Process Colors.

Product Exclusivity [1711-00-00-0100]. A right that, when granted by a licensor to a licensee, limits the right of the licensor (and other parties offering licenses of the work) to license the right to any third party to use the work in relation to a specified product category. **ex:** *The client decided to purchase product exclusivity so he could avoid having the same image usage by his competitor.* **plural:** Product Exclusivities. **variation:** Product Exclusive.

Production Fee [1635-00-00-0100]. A charge related to the preparation, planning, setup, props and styling, gaffers, grips, and assistants. After production, it is related to post-processing and delivery. **ex:** *The production fee for the complicated assignment exceeded the budget by a great deal.* **plural:** Production Fees.

Property Release [1284-00-00-0100]. A document signed by the owner or controlling entity of property (a building, statue, or other object or area belonging to that owner or entity) that allows a photograph of that property to be published in advertising or other commercial use. **ex:** *The photographer has a property release on file and so has the right to license the use of its image.* **plural:** Property Releases. **variation:** PR, Release.

Proprietary Information [1745-00-00-0100]. Confidential information and documentation, usually related to technology that, if released publicly or to the wrong party, could be damaging to the interests of a company or entity that owns or developed it. **info:** Often specified in contracts and non-disclosure agreements (NDAS) between visual authors and their clients, and may affect the subsequent ability of the author to license his or her work to third parties. **ex:** *That is proprietary information, so please keep it confidential.*

Public Domain [1286-00-00-0100]. When a work is not considered to be the intellectual property of any copyright owner, for example when copyright

has been lost or has expired. Copyright protection expires in the U.S. and Europe after the life of the author plus 70 years. In Australia and Canada, it expires after the life of the author plus 50 years. *info:* Works in the public domain can be freely reproduced, distributed, or sold without obtaining permission of the creator. Works created before copyright laws came into effect are generally part of the public domain. *ex: Those images are in the public domain and can be used without authorization. plural:* Public Domains.

Public Relations [1784-00-00-0100]. Organized efforts to establish or maintain a media presence and public awareness of a client's products, services, or ideas. License for such use would include *gratis* editorial insertions but would exclude paid advertising insertions. *info:* Specialty public relations areas include crisis, reputation and issue management, investor relations, and word-of-mouth public relations. *ex: The public relations campaign includes several news releases and photos, and a videotaped interview with the chairman. variation:* PR.

Publication [1287-00-00-0100]. A work that is distributed to the public by sale, rental, or lease or the offering to distribute work to a group of persons for purposes of further distribution, public performance, or public display. A public performance or display of a work does not of itself constitute publication. *info:* Includes, but is not limited to, print, broadcast, and online. In the U.S., refer to the U.S. Copyright Act (17 USC 101) for a legal definition of publication. *ex: Our illustrations will appear in the organization's publication, which is sent to each of its members. plural:* Publications.

Publication Date [1543-00-00-0100]. The date on which a work is distributed to the public by sale, rental, or lease, or the offering to distribute work to a group of persons for purposes of further distribution, public performance, or public display. A public performance or display of a work does not, of itself, constitute publication. *info:* In the United States, refer to the U.S. Copyright Act (17 USC 101) for a legal definition of publication. *ex: The publication date for the next magazine issue is June 1st. plural:* Publication Dates. *variation:* Pub Date.

Publicity Use [1643-00-00-0100]. Use of a work in a press release, media kit or other public relations piece distributed for *gratis* editorial insertion in publications. Excludes use in advertising, advertorials, and other media involving paid or bartered insertions. *ex: The image was licensed for publicity use in addition to its use on the record album cover. plural:* Publicity Uses.

Publish [1685-00-00-0100]. To prepare or cause a work to enter public distribution or be placed on sale. *info:* In the United States, refer to the U.S.

Copyright Act (17 USC 101) for a legal definition of publication. *ex: They will publish the book next week, and it will appear in the bookstores within the month. plural:* Publishes.

Purchase Order [4620-00-00-0100]. A document generated by a licensor, often describing the works to be created or licensed and the license requested in association with the works. Typically specifies an approved budget for a project and/or license, a reference number for use in billing, and terms and conditions. *info:* Licensors and licensees should ensure that the descriptions and terms of the purchase order are consistent with terms negotiated by the parties, as memorialized in the licensor's estimate, invoice, and other related documents. *ex: The agency needed a signed purchase order before they would remit payment. plural:* Purchase Orders. *variation:* P.O.

Quantity [2713-00-00-0100]. The number or amount of reproductions made, displayed, or distributed. *info:* Related but not synonymous to frequency. While frequency might be used to refer to the number of insertions in a magazine (or whether the insertions are monthly, bimonthly, etc.), quantity indicates the circulation for the magazine. *ex: We need to publish a quantity of ten thousand books to meet the anticipated demand. plural:* Quantities.

Quote [3640-00-00-0100]. A pre-production document formulated by a licensor based on a project description provided by the licensee, describing work to be produced and/or licensed, the scope of the license, any terms and conditions applicable to the transaction, and the fees and costs for the project and/or license. *ex: We could not begin the assignment until he agreed to our quote. plural:* Quotes. *preferred term:* Estimate [1063-00-00-0100]. *usability*: Caution.

Rate Card [3650-00-00-0100]. A listing provided by magazines to advertisers and potential advertisers that show specifications and costs for ads based on the area in a publication that will be occupied by an advertisement, image, or other work. *ex: The magazine's rate card gave a choice of only full or half page ads at roughly the same cost as their major competitor. plural:* Rate Cards.

RAW file [1826-00-00-0100]. A digital camera file format akin to a film original. Similar to a digital negative but may include manufacturer-specific information or technology. *info:* Typical of more expensive digital cameras, a RAW file requires postprocessing before it can be used. Capable of containing more information and delivering more color, dynamic range, and resolution than a TIFF or JPEG digital image file, it also is a much larger file than a TIFF or JPEG. *ex: We put the RAW file on a CD ROM because it took up too much space on our limited hard drive. plural:* RAW Files

Re-License [4440-00-00-0100]. The renewal of a legal written agreement granting permission to exercise a specified right or rights to a work, often encompassed in an invoice, or the act of granting same. *ex: We granted them a re-license to use the image in the next edition of the book. plural:* Re-Licenses *variation:* Relicense.

Re-Use [1296-00-00-0100]. Subsequent utilization of a work by the same publisher in the same or related publication, advertising, or marketing venue. *info:* Some licensors grant a small discount for re-use, though this is not necessarily an industry-wide practice. Some clients expect a discount. *ex: We are licensing this image to you for re-use in the abridged version of the textbook. plural:* Re-Uses. *variation:* Re-use.

Regional Distribution [1290-00-00-0100]. Limited distribution of an advertisement, piece, or other message form, in one specific regional area such as Tristate, Northeast, or Southwest. *ex: That newspaper has regional distribution. plural:* Regional Distributions.

Regional Exclusive [2727-01-00-0100]. See Regional Exclusivity. *ex: The client purchased a regional exclusive. plural:* Regional Exclusives.

Regional Exclusivity [2727-00-00-0100]. A right that, when granted by a licensor to a licensee, limits the right of the licensor (and other parties offering licenses of the work) to license the right to any third party to use the work in specified geographic regions. *ex: Because this client purchased regional exclusivity, we cannot offer the same region to another client. plural:* Regional Exclusivities. *variation:* Regional Exclusive.

Release (1) Release (People) [1275-02-00-0100]. See Model Release. *ex: Before the advertising agency will consider using the image, they need to know if the photographer has a release on file.* (2) Release (Property) [1284-01-00-0100]. See Property Release. *ex: The photographer has a release on file and so has the right to license the use of this image of a house.* (3) Release (Minor) [3250-01-00-0100]. See Minor Release. *ex: Because the subject was only seven years old, a release, signed by his legal guardian, was needed by the advertising agency before they would consider using the photographer's image.*

Renewal Rights [1291-00-00-0100]. Permission to renew an existing license for use of a creative work. May or may not be included in the original license agreement. *ex: The client wants to include renewal rights in our agreement.*

Rep [3670-01-00-0100]. Abbreviation for Representative. *ex: He had to call the rep to go over the details of the assignment since the photographer was out of town.*

Repeat Use [1469-00-00-0100]. Multiple placements of the same image within one edition of a single title, project, or program. *ex: They requested repeat use for the anthology. plural:* Repeat Uses.

Representative [3670-00-00-0100]. A party authorized to act or speak for another. *info:* A representative can be—but isn't necessarily—an agent. *ex: The client called the representative to go over the details of the assignment since the photographer was out of town.* *plural:* Representatives. *variation:* Rep.

Reprint [1461-00-00-0100]. A reproduction substantially resembling a previous reproduction. Or, the act of creating reproduction(s) substantially resembling previous reproduction(s). *info:* Characteristics, quantity, distribution, timing, and other factors are often subject to the specifications of a license granting use of any incorporated images. *ex: The reprint was sent to new subscribers as a bonus.* *plural:* Reprints.

Reproduction [4460-00-00-0100]. The act of copying, or the condition or process of being copied. *ex: They purchased rights to reproduction of the image as an art print.* *plural:* Reproductions.

Reproduction License [2710-00-00-0100]. A legal contract or permission outlining the parameters under which a copyrighted work may be used. *ex: Refer to the reproduction license to double check the number of copies we can reproduce.* *plural:* Reproduction Licenses.

Research Fee [3680-00-00-0100]. A charge made by an agency, photographer, illustrator, or professional image researcher for investigative efforts to locate appropriate images on behalf of a client. *ex: Our research fee does not include copyright clearance services.* *plural:* Research Fees.

Research Use [1644-00-00-0100]. The application of an image for scholarly or art reference. No reproduction or redistribution rights are included. *ex: We licensed that image for research use.* *plural:* Research Uses.

Reshoot [4470-00-00-0100]. Rephotographing a job due to the initial results being unsatisfactory. *ex: A reshoot was scheduled because the initial images were underexposed.* *plural:* Reshoots. *variation:* Re-shoot.

Residual [3690-00-00-0100]. A fee paid for repeated broadcast of a film after original presentation or period of its use. *ex: He was paid a residual every time the commercial that contained his image was aired.* *plural:* Residuals.

Residual Rights [4500-00-00-0100]. Rights that have remained with the copyright owner of the work after some rights have been granted to another party. *ex: The client purchased first rights, but the artist retained the residual rights.*

Retail [1786-00-00-0100]. The sale of goods or services directly to consumers. *info:* Typically all sales made in department stores or supermarkets are retail sales. *ex: That magazine is available at retail outlets.* *plural:* Retails.

Reuse [1296-01-00-0100]. See Re-Use. *ex: We are licensing this image to you for reuse in the abridged version of the textbook.* *plural:* Reuses.

RF [1304-06-00-0100]. See Royalty Free. *ex: We licensed an RF image.*

RGB [1471-00-00-0100]. A method of displaying color that uses the three primary colors of red, green, blue. *ex: Computer monitors project light in RGB. variation:* Red Green Blue.

Right [1647-00-00-0100]. A legal claim, title or privilege. *ex: You have the right to use this image. plural:* Rights.

Right of Privacy [1298-00-00-0100]. The privilege to be left alone, free from unwarranted publicity, and to live without unwarranted interference by the public in matters with which the public is not necessarily concerned. *ex: The publisher is requiring the author to represent that the literary work does not violate any living person's right of privacy. plural:* Rights of Privacy.

Rights Managed [1303-00-00-0100]. A licensing model in which the rights to a creative work are carefully controlled by a licensor through use of exact and limiting wording of each successive grant of usage rights. *ex: Let's ask the stock agency if anyone else has licensed this rights managed image in the past year. variation:* RM.

Rights Management [1746-00-00-0100]. The processes associated with active control and management of the licensing history of a work. *info:* Exact and carefully limited wording of each successive grant of usage rights is a central concept. *ex: Be sure to check with the agency's rights management division about the past history of that image.*

Rights Package [1599-00-00-0100]. A bundle of rights allowing multiple uses of one or more images for a single fee. *info:* The fee for a rights package is typically less than the total fees for each use if licensed separately. *ex: The client wants to purchase a rights package to use the image in three separate promotions for a new product. plural:* Rights Packages.

Royalty [1511-00-00-0100]. A percentage-based portion of revenue that is paid by an agent or publisher or user to the creator of a work. *ex: Your royalty check is in the mail. plural:* Royalties.

Royalty Free [1304-00-00-0100]. Denotes a broad or almost unlimited use of an image or group of images by a licensee for a single licensee fee. License agreement typically specifies some limitations (e.g., resale of the image to a third party is usually prohibited). *info:* The terms of royalty free license agreements vary and often include warnings or disclaimers regarding liability in connection with model-released imagery. *ex: Royalty free licensing emerged in the early 1990s, consisting entirely of image collections on CD-ROM. variation:* RF, Royalty-Free.

Saturation [1658-00-00-0100]. The attribute of a color image that determines or describes its apparent colorfulness. *ex: The image has the correct level of saturation.*

Secondary Rights [1308-00-00-0100]. In the copyright environment, rights

to use content in applications of lower quality and lower value, such as photocopying of text. Content typically would appear in very small circulations or lesser media. *info:* Any usage fee is usually collected through blanket licensing by collecting societies. Digital technology is eliminating the quality distinction, and current practice bases value on size of the audience and type of media, making this term irrelevant. *ex: If you photocopy and distribute the book chapter at your meeting, you may be responsible for payment for secondary rights.* *usability:* Discouraged.

Secondary Use [1309-00-00-0100]. In publishing, an alternative, often lesser, product or use for the same image; in the stock business, any use after the initial use for which the work was created and used. *info:* An example would be an interior page use in a magazine in addition to usage on the cover. *ex: The image assigned and used on their magazine cover also had a secondary use in their public relations campaign.* *plural:* Secondary Uses. *preferred term:* Re-Use. *usability*: Caution.

Set Up [4260-00-00-0100]. A single scene in a particular locale, photographed using a particular set of techniques and equipment, from a single angle and perspective. *info:* A set up includes: minor changes in cropping, composition and/or poses; interchanging models and/or products; wardrobe changes; and subtle lighting adjustments. A new set up exists after a significant change in camera position, major relighting of the scene, a changed background, or moving to a new locale—nearby or distant. *ex: We can choose up to ten shots from that set up.* *plural:* Set Ups. *variation:* Set-Up.

Sharpening [1675-00-00-0100]. A digital imaging process that increases contrast, usually at the edges of tonal transitions, and adds apparent acuity or clarity to a digital image. *info:* The most common method is called unsharp masking, but there are others. *ex: We will need to apply some sharpening to counteract the softening effect of the halftone screen.*

Shoot [4640-00-00-0100]. The actual production during the making of a photograph. *ex: The shoot is scheduled for Saturday morning.* *plural:* Shoots.

Shot [4270-00-00-0100]. Slang for a single photographic work. *info:* Different shots may appear similar, but each is treated separately. There may be many shots in a set up. *ex: We wish to license only one shot from the set up.* *plural:* Shots.

Silhouette [1479-00-00-0100]. An image cross-faded into an empty background with either an abrupt or a soft-edged transition. *info:* In the design world an image that has been silhouetted or could easily be removed from its background and made into a silhouette. *ex: Make the silhouette against a plain white background.* *plural:* Silhouettes.

439

Similar [1480-00-00-0100]. An image recorded at the same time or on the same assignment as an image chosen by a publisher or an image that has the same or similar characteristics, such as subject, action, or appearance, to another image chosen for a particular usage. *info:* If viewed side by side, it is obvious that similars are from the same set, of the same subject, and recorded at the same time. *ex: The image used in the computer ad is similar to the one used in the photographer's promotional piece. plural:* Similars. *variation:* Series Similar.

Space Rate [1601-00-00-0100]. A compensation method based on the area in a publication occupied by an advertisement, an image, or other work. *info:* Calculated as a portion of the size of the page, and/or the size, position, or prominence of the page (e.g., one quarter page, front cover, interior page, etc.). *ex: Please tell us your space rate for an inside front cover. plural:* Space Rates.

Spec [1602-00-00-0100]. Creating work according to specific client directions without a contract, written agreement, or formal guarantee of payment. Abbreviation for speculation. *ex: The images the artist made on spec were used by the client several times. variation:* Speculation.

Statutory Damages [1315-00-00-0100]. Damages resulting from statutorily created causes of actions, as opposed to actions at common law. Under section 504 of the Federal Copyright Act, a registered copyright owner has the right to elect statutory damages in lieu of actual damages for copyright infringement. (The copyright registration must be made prior to an infringement or within three months of first publication of the work.) *info:* Statutory damages range from $750 to $30,000 and can be increased up to $150,000 if the infringement is willful. The amount is discretionary with the court. *ex: We sued for statutory damages.*

Stock Agency [4210-00-00-0100]. A company authorized to market and license existing photography for another company or individual. *ex: My stock agency markets my pictures for a percentage of the license fees. plural:* Stock Agencies.

Stock Agent [4220-00-00-0100]. A party authorized to market and license existing photography for another. *ex: His stock agent can provide more caption information on the images you chose. plural:* Stock Agents.

Stock Photograph [1638-00-00-0100]. An image that is available for licensing. *info:* Protected by copyright from the moment of creation when the image becomes fixed, be it on film or digital media. *ex: The client wants to license a stock photograph. plural:* Stock Photographs. *variation:* Stock Photography, Stock, Stock Photo.

Stock Sale [1603-00-00-0100]. The licensing of an image from a pre-existing

collection of images. *ex: The picture agency made a stock sale to the textbook publisher.* ***plural:*** Stock Sales.

Sub-Agent [4110-00-00-0100]. A company hired by an agency to store, market, and license goods or services to a specific market or markets. ***info:*** Sub-agents typically receive a percentage of the fees collected in each transaction. *ex: The artist's stock distributor has a sub-agent in France to handle image requests in that country.* ***plural:*** Sub-Agents. ***variation:*** Sub-agent.

Sub-Distributor [4100-00-00-0100]. A company hired by an allocator to store, market, sell, and/or license the same product or service as the original company. ***info:*** Generally requires additional payments beyond the distributor's fees. Must have permission of a copyright holder to use and bill for the sub-distributor's services. *ex: The artist recommended a subdistributor on the West Coast.* ***plural:*** Sub-Distributors. ***variation:*** Sub-distributor.

Subscription License [1318-00-00-0100]. An agreement or contract granting access and usage rights to a collection of royalty-free products by payment of a predetermined fee. ***info:*** Typically accessed via the World Wide Web. May be limited by duration or by the number or size of files accessible. The extent of access and rights granted under this business model varies by supplier. In all cases, the license granted is limited to the terms of the agency's royalty-free license terms, which sometimes places limitations on print runs and, in most instances, types of use. For example, most RF licenses specifically exclude the rights to use RF imagery as logos. *ex: We purchased a subscription license to their collection of images.* ***plural:*** Subscription Licenses.

Subscription Stock [2758-00-00-0100]. A collection of royalty-free products licensed in a way that grants access and usage rights by payment of a predetermined fee. ***info:*** Typically accessed via the World Wide Web. May be limited by duration or by the number or size of files accessible. The extent of access and rights granted under this business model varies by supplier. In all cases, the license granted is limited to the terms of the agency's royalty free license terms, which sometimes places limitations on print runs and, in most instances, types of use. For example, most RF licenses specifically exclude the rights to use RF imagery as logos. *ex: We purchased access to their subscription stock collection for six months.*

Subsidiary Rights [1319-00-00-0100]. Permission granted beyond the initial grant to publish a literary work in book form. ***info:*** Includes electronic rights, film and television rights, audio book rights, audiovisual rights, merchandising rights as well as dramatic or performance rights. *ex: The client wants the license to include subsidiary rights.*

Talent [4830-00-00-0100]. Subjects, usually paid models or actors, of a photographic, film, video, or illustration project. *ex: Make sure we have signed model releases from all of the talent.*

Target Audience [1579-00-00-0100]. A specific group of consumers likely to be interested in a particular product or project. *ex: Our target audience is the eighteen- to thirty-four-year-old professional.* **plural:** Target Audiences.

Tear Sheet [1796-00-00-0100]. Page or portion of a page clipped from a printed publication and sent to advertisers to verify that the ad was correctly run. *info:* Increasingly, newspapers and other print publishers are e-mailing PDF files as electronic tear sheets. Editors sometimes send tear sheets to a publication's editorial contributors to show them how their work was used. Photographers, illustrators, and models often use tear sheets in their portfolios. *ex: A tear sheet of the ad was sent to the client.* **plural:** Tear Sheets.

Term (1) Term (Legal) [1725-00-01-0100]. A word, phrase, or expression. In a contract, a stipulation. *ex: One term in the contract is about maintaining confidentiality.* **plural:** Terms. (2) Term (Duration) [1725-00-02-0100]. The period during which contractual stipulations remain in force. *ex: The agreement has a two-year term.* **plural:** Terms.

Terms and Conditions [1604-00-00-0100]. The collected operative statements in a contract or agreement that are not part of the rights, privileges, or compensations set out by the agreement. *info:* Many standard contracts or agreements will have a boilerplate of terms and conditions on the reverse of the printed document. *ex: The terms and conditions are on the last page of the agreement.*

Territory Exclusivity [1640-00-00-0100]. A right that, when granted by a licensor to a licensee, limits the right of the licensor (and other parties offering licenses of the work) to license the right to any third party to use the work in specified geographic regions. *ex: The client purchased territory exclusivity.* **plural:** Territory Exclusivities **variation:** Territorial Exclusivity, Territory Exclusive, Territorial Exclusive.

TIFF [1484-00-00-0100]. Tagged image file format. A standard digital image file format used for exchanging high quality black and white, and color images among computer software. *info:* There are several versions, all of which are controlled by Adobe Systems, Inc. Useful for master archive files and derivatives. *ex: Please download the TIFF file from our Web site.* **plural:** TIFFs. **variation:** TIF.

Time Exclusivity [1710-00-00-0100]. A right that, when granted by a licensor to a licensee, limits the right of the licensor (and other parties offering licenses of the work) to license or otherwise permit any third party the

right to use the work during a specified time period. *ex: The client wants to purchase time exclusivity. **plural:*** Time Exclusivities. ***variation:*** Time Exclusive.

Trade Publication [1676-00-00-0100]. A magazine or other publication that is targeted to the interests of a specific business, profession, or special interest group. ***info:*** Not usually available to the general public. ***ex:*** *The article and photos on the latest medical equipment appeared in a trade publication for hospital administrators.* **plural:** Trade Publications.

Trademark [1324-00-00-0100]. A word, phrase, symbol, or other design identifying the source of one product or service from that of another. ***info:*** Officially registered and legally restricted to the use of the owner or manufacturer. ***ex:*** *The trademark appears on the product's packaging.* **plural:** Trademarks.

Transfer of Copyright [2711-00-00-0100]. A transfer of copyright occurs when the owner of a work (such as a photograph or illustration) passes its interest to another party. Must be in writing and signed by the owner. ***ex:*** *The photographer made a transfer of copyright to her picture agency.* **plural:** Transfers of Copyrights.

Unauthorized Use [1605-00-00-0100]. Use of a work for which a specific license has not been granted. ***info:*** Considered copyright infringement. The new IPTC core metadata schema has a specific field where usage rights can be stored. These are found in the file info section of a digital file when opened in Adobe Photoshop. ***ex:*** *Unless you have a license, that is an unauthorized use.* **plural:** Unauthorized Uses.

Uniform Commercial Code [1325-00-00-0100]. One of the laws drafted by the National Conference of Commissioners on Uniform State Laws and the American Law Institute, governing commercial transactions (including sales and licensing, licensing of goods, transfer of funds, commercial paper, bank deposits and collections, letters of credit, bank transfers, warehouse receipts, bills of lading, investment securities, and secured transactions). ***info:*** The Uniform Commercial Code has been adopted wholly or substantially by all states. ***ex:*** *Our products are compliant with the Uniform Commercial Code.* ***variation:*** UCC.

Unlimited Use [1326-00-00-0100]. A broad grant of rights that permits utilization across all media types and parameters. ***info:*** Can be restricted in any usage type or parameter, singly or in groups; can include all uses, all media, all time. ***ex:*** *The client wants unlimited use in all media for all time.* **plural:** Unlimited Uses.

Unrestricted Use [2794-00-00-0100]. A broad grant of rights that permits usage across all usage types and parameters. ***info:*** Can be restricted in any

usage type or parameter, singly or in groups. *ex: The client asked for an unrestricted-use license. plural:* Unrestricted Uses.

Usage [1328-00-00-0100]. When a copyrighted work is licensed, the terms of the license that specify the type of media, size of reproduction, duration, and locations in which the work will appear, along with other parameters. *info:* Other parameters include but are not limited to: licensee, licensor, media, quantity, size, placement, industries, regions, languages, restrictions, exclusivity, and duration. *ex: We license images for various types of usage. plural:* Usages. *variation:* Use.

Usage Fee [1639-00-00-0100]. A charge made for a work to be shown in a specific media, based on terms in a license or contract agreement. *ex: The usage fee is due in 30 days. plural:* Usage Fees.

Usage License [1687-00-00-0100]. A legal contract or permission outlining the parameters under which a copyrighted work may be used. *ex: The client purchased a usage license for ten images. plural:* Usage Licenses.

Video (1) Video (Production) [2694-00-01-0100]. Technologies associated with the creation, processing, and storage of electronic signals representing moving pictures. *ex: He viewed the production on video. plural:* Videos. (2) Video (Media) [2694-00-02-0100]. An electronic recording or broadcast of stationary or moving visual images of objects, often in conjunction with audio. Used to distribute and view motion pictures and television programs. *info:* In licensing, refers to media such as VHS videotape, DVD discs, and television broadcasts. *ex: I brought home a video to watch tonight. plural:* Videos.

Virtual Reality [1798-00-00-0100]. Any of a variety of interactive media that allow users to experience a location or subject virtually in three dimensions—without having to actually go to that location or have the subject physically near them. *info:* Most often, a combination of electronic images (either motion or still) and / or audio. *ex: The image is being used as a background in a virtual reality sequence. plural:* Virtual Realities. *variation:* VR.

Watermark [1492-00-00-0100]. Logo, brand mark, or other visible identification mark superimposed on or impressed into an image, film, or video clip, or on paper. *info:* Watermarks can be made on physical items such as photographic prints or illustrations using different methods or embossing techniques. Digital versions of watermarks can be created that will identify the source of an image or provide additional information about the image. They can be undetectable to the human eye. *ex: Our watermark is in the lower right corner of all our online images. plural:* Watermarks.

Weather Delay [1077-00-00-0100]. Postponement of a production schedule due to inclement meteorological conditions. *info:* Compensation for weather delays is negotiated in the production contract and is not usually a part of a usage license. *ex: The hurricane forced a two-day weather delay.* *plural:* Weather Delays.

Web [1696-01-00-0100]. Abbreviation for World Wide Web. *ex: A great deal of information is accessible on the Web.* *plural:* World Wide Webs. *preferred term:* Internet. *usability:* Discouraged.

Web Banner Ad [1132-00-00-0100]. A marketing or promotion announcement embedded in a particular Internet page, usually placed at the top or bottom of the screen. *ex: This Web banner ad will be used for two weeks.* *plural:* Web Banner Ads.

Work for Hire [1659-01-00-0100]. See Work Made for Hire. *ex: The image was made by an employee of the company and is a work for hire.* *plural:* Works for Hire.

Work Made for Hire [1659-00-00-0100]. A defined term under the U.S. Copyright Act (17 USC 101) meaning (1) a work prepared by an employee within the scope of his or her employment; or (2) a work specially ordered or commissioned for use as a contribution to a collective work, as a part of a motion picture or other audiovisual work, as a translation, as a supplementary work, as a compilation, as an instructional text, as a test, as answer material for a test, or as an atlas, if the parties expressly agree in a written instrument signed by them that the work shall be considered a work for hire. *ex: The image was made by an employee of the company who understood that it would be a work made for hire.* *plural:* Works Made For Hire. *variation:* Work For Hire.

World Wide Web [1696-00-00-0100]. The complete set of documents residing on all Internet servers that are accessible to computer users. *ex: A great deal of information is accessible on the World Wide Web.* *plural:* World Wide Webs. *variation:* Web, WWW.

Worldwide Use [4730-00-00-0100]. Use that allows for reproduction in any country in the world. *ex: The book company purchased rights for worldwide use.* *plural:* Worldwide Uses.

Resources

The ASMP maintains an updated business resources page, available at *www.asmp.org/resources*. Use this URL to find the latest and best professional photography business information.

ASMP FORMS *www.asmp.org/forms*
Downloadable versions of suggested business forms: estimate, assignment confirmation, change order, delivery, and invoice.

ASMP © TUTORIAL *www.asmp.org/copyright*
From a concise history of copyright law to step-by-step instructions on registration, this module is the go-to resource on copyright for photographers.

ASMP LICENSING GUIDE *www.asmp.org/licensing*
This guide provides you an overview of the business of professional photography and outlines a practical methodology to license your images.

The guide also includes the ***ASMP Paperwork Share*** where fellow photographers share actual project invoices. This amazing resource offers you real-world insights into the business of licensing photography.

ASMP MODEL AND PROPERTY RELEASE GUIDE *www.asmp.org/releases*
Information on when and why you need releases. Downloadable forms. Members have access to a customizable forms feature.

ASMP TERMS & CONDITIONS GUIDE *www.asmp.org/t&c*
This module gives you real-world explanations for the how and why of terms and conditions. Downloadable forms. Customizable terms and conditions forms available to members.

PICTURE LICENSING UNIVERSAL SYSTEM (PLUS) *www.useplus.org*

The Picture Licensing Universal System (PLUS) is here to make image licensing easy. A worldwide coalition of leading companies, institutions, respected associations, and industry experts have joined this unprecedented nonprofit mandate to clearly define and standardize the communication and management of image rights information. Now we can all agree.

THE PLUS GLOSSARY *www.useplus.com/useplus/glossary.asp*

Simple. Comprehensive. Universal. This glossary puts into standardized language more than 1,000 licensing terms, definitions, and uses, all mutually agreed upon by the widest and most diverse worldwide coalition of organizations and industry professionals in the history of image commerce. Use the glossary when writing your assignment or stock licenses.

PLUS PACKS *www.useplus.com/useplus/pluspacks.asp*

PLUS Packs introduce a universal licensing standard for a streamlined form of image licensing. With licensors of all sizes worldwide offering the same conveniently standardized, numbered packages, rights-managed image licensing will be easier than ever.

THE UNIVERSAL PHOTOGRAPHIC DIGITAL IMAGING
GUIDELINES (UPDIG) *www.updig.org*

Follow the guidelines for image creators, and tell your clients your digital images are UPDIG-compliant. You look good, your images look good, and your client is happy.

Tell your clients about the UPDIG Submission Guidelines for image receivers and help clear up the photographer/client communication gap regarding the handling of digital files.

About the ASMP

THE AMERICAN SOCIETY OF MEDIA PHOTOGRAPHERS WAS ESTABLISHED IN 1944 to promote and protect the interests of working publication photographers. Founded by leading photojournalists of the day who saw the need to establish standards for an emerging industry, the ASMP now enjoys an international membership of more than 6,000 in thirty-nine chapters. Today our member rolls include many of the most prominent image-makers in the world of publication photography.

Having successfully advocated on behalf of members for more than sixty years, the ASMP has become universally recognized for its commitment to professionalism, high ethical standards, and technical excellence. To be a member of the ASMP today is to stand among the best in the business.

Our online application is available at *www.asmp.org/join*. Why should you join?

- **Information**. The ASMP will keep you informed on industry trends and relevant legislative activity. You will receive informational advisories and contract alerts.
- **Education**. The ASMP is dedicated to providing real-world education for the independent photographer. The ASMP brings you solutions through seminars, listservs, chapters, specialty groups, and resources at *www.asmp.org*.
- **Advocacy**. The ASMP is your watchdog in the industry. When you join, you contribute to the critical work of protecting your interests. Your dollars spent collectively through the ASMP make an impact none of us could make individually.
- **Benefits that bring or save you money**. The ASMP will provide you direct services and vendor discounts that far exceed the cost of your annual dues. For a complete list, go to *www.asmp.org/benefits*.

ASMP IS ABOUT PHOTOGRAPHERS HELPING PHOTOGRAPHERS
by Susan Carr

I love making photographs. From finding the subject matter to watching the light and capturing the image, it is a process I never tire of and long to repeat. The art of seeing is a lifestyle, not a profession, and like most photographers, I came to the business of photography because of this passion. I simply could find no other way I wanted to spend my time. This driving force keeps me going even when the stresses of business are heavy.

Photography is often a solitary activity. You must enjoy your own company to endure the early mornings, late nights, travel, deadlines, and long hours often associated with "getting the shot." But then again, that is the easy part, even the fun part. The demands of running a small creative business in a commoditized economy are vast. We need profitability, yet a balance of market forces and personal sensibilities is often difficult to find.

I have weathered these trials thanks to the camaraderie and generosity of fellow photographers. The ASMP has been the instrument that fostered these relationships. No one understands the idiosyncrasies of this business better than a peer, which is why the phrase "photographers helping photographers" is such an honored ASMP tradition.

Without the ASMP, the extreme economic challenges of the last few years and the necessary transition into digital would have been insurmountable. The community of the ASMP—my chapter, my specialty group, various listservs, and individual friends—gave me the tools I needed to move forward during this difficult period.

Robert Adams, photographer and writer, eloquently states how I feel about the photographic process in *Why People Photograph*: "At our best and most fortunate we make pictures because of what stands in front of the camera, to honor what is greater and more interesting than we are. We never accomplish this perfectly, though in return we are given something perfect—a sense of inclusion. Our subject thus redefines us and is part of the biography by which we want to be known."

The ASMP can be part of your biography—join us. *www.asmp.org/join.*

Index

Books from Allworth Press

Business and Legal Forms for Photographers, Third Edition
by Tad Crawford (8½ × 11, 192 pages, paperback, CD-ROM included, $29.95)

The Professional Photographer's Legal Handbook
by Nancy E. Wolff (6 × 9, 272 pages, paperback, $24.95)

Digital Stock Photography: How to Shoot and Sell
by Michal Heron (6 × 9, 288 pages, paperback, $21.95)

Pricing Photography: The Complete Guide to Assignment and Stock Prices, Third Edition
by Michael Heron and David MacTavish (11 × 8½, 160 pages, paperback, $24.95)

The Real Business of Photography
by Richard Weisgrau (6 × 9, 224 pages, paperback, $19.95)

The Photographer's Guide to Negotiating
by Richard Weisgrau (6 × 9, 208 pages, paperback, $19.95)

How to Grow as a Photographer: Reinventing Your Career
by Tony Luna (6 × 9, 224 pages, 40 B&W illustrations, paperback, $19.95)

The Education of a Photographer
edited by Charles H. Traub, Adam B. Bell, and Steven Heller (6 × 9, 256 pages, paperback, $19.95)

Sports Photography: How to Capture Action and Emotion
by Peter Skinner (6 × 9, 160 pages, 211 color and B&W illustrations, paperback, $24.95)

The Business of Studio Photography, Revised Edition
by Edward R. Lilley (6¾ × 9¼, 336 pages, paperback, $21.95)

How to Succeed in Commercial Photography: Insights from a Leading Consultant
by Selina Maitreya (6 × 9, 240 pages, paperback, $19.95)

Licensing Photography
by Richard Weisgrau and Victor S. Perlman (6 × 9, 208 pages, paperback, $19.95)

The Law (in Plain English)® for Photographers, Revised Edition
by Leonard D. DuBoff (6 × 9, 224 pages, paperback, $19.95)

To see our complete catalog or to order online, please visit *www.allworth.com*.